THE BRITISH ARCHAEOLOGICAL
ASSOCIATION

CONFERENCE TRANSACTIONS

For the year 1982

VIII

MEDIEVAL ART

AND ARCHITECTURE

at Lincoln Cathedral

1986

*Copies of these may be obtained from W. S. Maney and Son Limited, Hudson Road, Leeds LS9 7DL
or from Oxbow Books, 10 St Cross Road, Oxford OX1 3TU*

ISBN Hardback 0 907307 14 0
Paperback 0 907307 15 9

PRINTED IN GREAT BRITAIN BY W. S. MANEY AND SON LIMITED
HUDSON ROAD, LEEDS LS9 7DL

CONTENTS

LIST OF ABBREVIATIONS AND SHORTENED TITLES

in use throughout the volume. See also individual contributions

AASR	*Associated Architectural Societies Reports and Papers*
Archaeol. J.	*Archaeological Journal*
BAA CT	*British Archaeological Association Conference Transactions*
B/E	N. Pevsner *et al.*, ed., *The Buildings of England* (Harmondsworth various dates)
Bull. mon.	*Bulletin monumental*
CA	*Congrès Archéologique de France*
JBAA	*Journal of the British Archaeological Association*
JRIBA	*Journal of the Royal Institute of British Architects*
LAO	Lincoln Archives Office
LRS	Lincoln Record Society
NMR	National Monuments Record
PRO	Public Record Office
RCHM	Royal Commission on Historical Monuments
VCH	Victoria History of the Counties of England

Preface

The publication of this volume, the eighth in the series of Transactions, has been generously subsidised by Kathleen Major and by the National Westminster Bank. The editors would like, on behalf of the Association, to express their thanks. We are grateful, too, to Christopher Wilson for taking photographs especially for us and to George Carter who designed the cover. We would also like to acknowledge the kindness and help of the Dean and Chapter and the Cathedral staff during the conference and subsequently.

T. A. HESLOP
V. A. SEKULES
Hon. Editors

Archaeology in Lincoln

By Michael J. Jones

The history of the city of Lincoln is as rich as that of any in Britain. From modest pre-Roman beginnings, it rose quickly to importance in the mid-1st century A.D. when the Roman army recognised the strategic value of its situation, at a major river crossing on their principal east coast route northwards. The establishment of a legionary fortress on the hilltop created a market for a large extra-mural settlement and demanded the construction of good communications. These were further developed when the site of the fortress was, like that at Gloucester, reused for a settlement of discharged veterans in the late 1st century. The *colonia* was by definition a centre of wealth and prestige and of architectural magnificence, and in Lincoln's case commercial prosperity seems to have continued well into the 4th century. By that date the area of occupation extended well beyond the city walls in every direction, but particularly (as in the medieval period) to the south.[1] Some evidence is beginning to emerge, of the scanty sort, of continuity of settlement into the post-Roman period, possibly based on an aristocratic and ecclesiastical centre.

The 1970s saw a great growth in our knowledge of the late Anglo-Saxon town, for a town it was again by the 10th century. The Conqueror's decision to base a cathedral as well as a castle here had much to do with the size of the population in 1066, and the city's prosperity, founded in part on the wool trade, was second to none until the late medieval decline.[2] Even then, some fine buildings continued to be erected and several still stand.

In contrast to several towns of similar historical and architectural importance, however, Lincoln has only recently begun to receive the attention it deserves. Of course, it had its share of antiquaries, remarking on the 'decaying' state of the town itself and on that of its 'muniments', as well as on its attractions.[3] The surviving remains of its many Roman and medieval monuments have tended to be overshadowed in the public mind (and understandably so) by the awesome scale of the Cathedral. While the city has had its historians, notably Sir Francis Hill,[4] only part of the Victoria History for the county has been published, and no Royal Commission survey of the city has ever been in prospect. Only since 1970 has there been the beginnings of a comprehensive study of its medieval monuments.

One important element of the new progress is the study of the evidence, both historical and architectural, for the city's 'ancient houses', sponsored by Lincoln Civic Trust and described by Miss Kathleen Major in this volume. The first results of this work are beginning to appear in print,[5] as is Professor Kenneth Cameron's research on the place names of the city and surrounding villages.[6]

Both studies throw light on, and benefit from the light cast by, archaeological work. Before 1970, the main thrust of local archaeological activity, carried out at that time under the auspices of the Lincoln Archaeological Research Committee, was directed at uncovering the fortifications of the Roman fortress and *colonia*. With the increased scale of activity occasioned by major redevelopment schemes and made possible by substantial grants from national government, areas of the medieval city have now been investigated (Fig. 1). Over thirty major excavations have taken place since the foundation in 1972 of the Lincoln Archaeological Trust, and these continue, although the emphasis of Department of the Environment (now HBMC) funding is currently on post-excavation work and publication of the results. The Trust has no formalised, rigid research policy as such — each available site is considered on its merits — yet it is possible to point out those areas whose

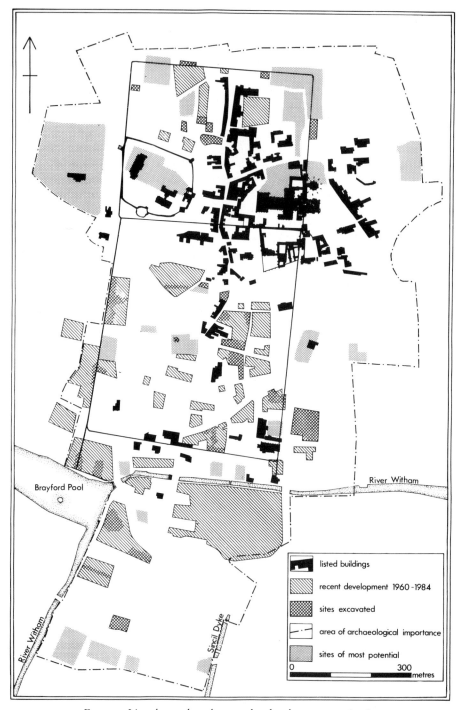

FIG. 1. Lincoln: archaeology and redevelopment 1960–84

examination would be of most value academically, and a provisional list of those likely to be available for rescue excavation and worth funding has been agreed with the Historic Buildings and Monuments Commission.

The value of urban excavations is not confined to the building plans they reveal, but covers a much wider area of interest — some topographical, for instance in understanding the origins of street layouts; others, for example, detailed study of the artefacts produced, for the light they throw on economic history and on technology. The finds from both house and church excavations invariably include a number of architectural fragments, the potential value of which my colleague David Stocker is exploring in several studies at York and at Lincoln.

The deepest stratigraphy (up to 5 m) lies in the lower part of the hillside, while that on the hilltop has been more subject to erosion. The steeper slope between is unpredictable in terms of survival, much having been lost by subsequent terracing, and frequently Roman levels are almost completely destroyed or are to be found close to the modern surface. Later deposits survive poorly in this area. Interpretation of such complex evidence is of course very difficult, but with the appropriate techniques for excavation and recording it can be highly prolific in information and at least as 'cost-effective' in the long term as rural excavation. Several large scale excavations have proved to be essential for providing a framework, although more modest programmes are often useful for answering specific questions. As Martin Carver has emphasised, sites worth excavating must be assessed not only in terms of their theoretical potential for uncovering important monuments, but equally in terms of the quality of their surviving deposits.[7] To that extent urban archaeology cannot be equated with architectural history.

As with all continuing programmes, any summary of the major results to date is soon outdated by new research. There are, however, several new areas of knowledge, and in some of them the evidence from Lincoln is of more than local significance.

Sir Francis Hill's *Medieval Lincoln* began with two chapters on 'The Roman pattern' and 'The English and Danish settlements', and an understanding of what happened to the city in these periods is an essential basis for the study of the mature medieval town. More than that, some of the principal questions of urban archaeology are the extent to which the Roman layout influenced that of later periods, the nature of the Anglo-Saxon settlement, and how far back in time the characteristic medieval pattern was established. On all these problems Lincoln has produced some exciting discoveries in the past ten years or so.

The Roman fortifications have been much studied. In particular it is now clear what a formidable barrier they presented by the 4th century — a thick wall 3 to 4 m wide and c.7 m high backed by a substantial rampart and fronted by a ditch perhaps 25 m wide.[8] In spite of detailed examination at a number of points, no evidence has yet come to light for the rebuilding or refurbishment of the Roman city wall in the post-Roman period, and it must be assumed that the 4th-century work survived almost intact. It took major political decisions, such as those of the Cathedral and Castle builders, to obliterate its line. Although much has gone since the 18th century, the wall's course can still be detected throughout much of the city today, especially where lanes grew up along the outside of the ditch.

Until 1975, it was taken for granted that the Roman grid pattern also survived to some extent within the walls. Much still remains to be learned of the Roman layout in both upper and lower city, but the discovery of the forum-basilica in 1978–9 in the centre of the upper city was a major step forward.[9] On the hillside, parts of several large Roman town-houses have been uncovered, in addition to both commercial and public buildings. Yet streets on the whole have eluded us — the major surprise being that the presumed Roman streets, now Grantham Street and Flaxengate, on the Roman grid alignment, turned out to be of later

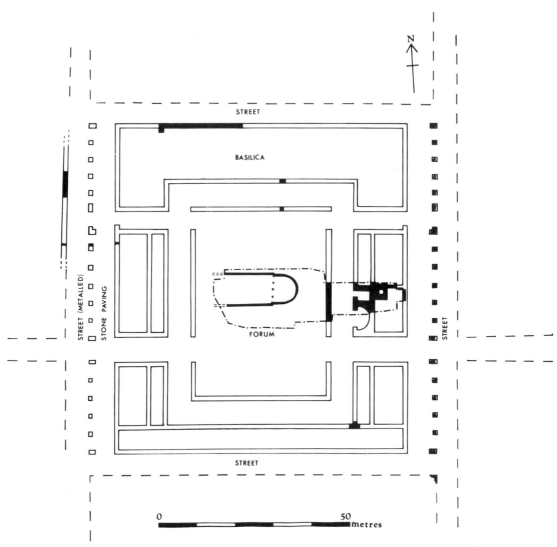

FIG. 2. Lincoln, St Paul in the Bail: suggested plan of the forum-basilica, with the earliest
(4th-century) church in courtyard

origin. The Roman street system did not survive the centuries following the end of Roman
rule, and it would appear from archaeological work that although a small settlement existed
in the area of the former Roman city in the 5th–9th centuries, most property boundaries and
alignments were lost. The most visible and lasting change perhaps was the establishment of
new lanes running diagonally across the Roman grid, over derelict Roman buildings, and
joining the gates (which did on the whole survive). Urban archaeologists have only recently
learned that there is a world of difference between survival of physical fabric and continuity
of settlement.

The documentary sources and numismatic collections have long made it plain that Lincoln was again a thriving market by the late 10th century and a major settlement before the Conquest.[10] Archaeological excavations at a number of sites in the city, but in particular at Flaxengate (Pl. IVA), have begun to articulate this important development in more detail and with some accuracy.[11] Stratified coins and imported pottery buried among ephemeral traces of timber buildings, fronting on to a newly laid street, tell us that settlement was increasing considerably before 900, and that the Danish invaders had a major part to play in this.[12] The evidence of the Domesday survey confirms that much of the area of the former Roman city was again built up by the time of the Conquest,[13] and it seems likely that, apart from major changes to the topography such as those occasioned by the construction of Castle and Cathedral and a number of minor changes, the layout of streets and properties was largely established by this date. The street of Flaxengate (formerly 'Haraldstigh') was laid out parallel to the Roman Ermine Street shortly before 900, and Grantham Street (the medieval 'Brancegate') no later than the mid-11th century

The economic activities of the people who lived along these new streets appear to have included a number of industrial processes, including glass- and bead-making, copper-working, the manufacture of textiles and metallic goods, jet-working, etc.[14] The emphases varied as time went on. Similar evidence, albeit on a much smaller scale, for industrial activity in the 10th and 11th centuries has been recovered from excavations in other parts of the city, including the suburbs to the south and east. What evidence there is for trade connects Lincoln with the Viking kingdoms as well as with the rest of England, and this mix is paralleled by the moneyers' names which show roughly equal proportions of English and Scandinavian. There are traces of increasing sophistication in timber building techniques, but evidence of this sort cannot be shown to demonstrate Scandinavian influence.

It was the late 12th century before houses were being constructed in stone, but by this time of course, church building had proliferated throughout the city. Many of the new churches were probably erected by the landowners, for their own use. There are documentary references to most of the city's 50 or so parish churches by c.1100, although few remaining churches display architectural details of that period. Those which do survive, St Mary le Wigford and St Peter at Gowts, have been examined by Taylor, and his dating would place them in the 11th century. Both lie in the southern suburb of Wigford, across the river from the walled city. Another church situated slightly to the north, on the south bank of the river, St Benedict's, has recently been shown not to contain Romanesque features in its rebuilt towers.[15] Two churches — St Mark's also in Wigford, and St Paul in the upper city or 'Bail' as it came to be known — were completely excavated in 1976–8 after being declared redundant. The first church on the St Paul's site may have been the earliest in the city. It was erected on the courtyard of the Roman forum (Fig. 2) at a date which is still uncertain but which most interpretations of the radio-carbon dating of associated burials would put in the 4th century. Was it perhaps the late Roman bishop's church? The plan recovered, lacking the western end which was outside the limit of the excavation, showed a long narrow nave without aisles and an apsidal chancel. Like much of the Roman city, the church must have been in a ruinous state by the 5th/6th centuries, for graves were dug over the line of its walls. Yet, in addition to the interesting continuity of Christian burial in this region of newly-established pagan control, something was preserved, for by the 8th century an important grave was dug on the same site, surrounded by a small single-celled structure.[16] Perhaps it was the mausoleum of a major ecclesiastic, but other interpretations are possible. While the body was later translated to another place, inadvertently leaving a finely decorated hanging-bowl for us to discover, the building became the basis of a 10th-century church. This was later extended and modified several times in keeping with the

changing liturgical fashions, and the growing population of the parish. In 1301 part of it collapsed, largely owing to the lack of foundations provided for the south aisle or chapels as revealed by excavation. The resulting rebuilding survived — but only just — into the late 18th century when it was the subject of a number of engravings. The most westerly bay of its earlier arcade is visible on these illustrations, having been blocked as part of the reconstruction. The Georgian replacement was modest, its Victorian successor grand.

Apart from the earliest phases, the history of St Mark's was not dissimilar. As at St Paul's the study of the architectural fragments is throwing light on the relationship of those involved in the construction of parish churches to the Cathedral workshops and those further afield. The site also yielded a large collection of early grave slabs. They show influences from Northumbria and East Anglia, in line with other evidence.[17] Here at St Mark's the principal historical problem is that the first church revealed by excavation, belonging to the late 11th century (Pl. V), cut through the earliest graves, for which radiocarbon dating suggests a 10th-century date. Was there a timber church or oratory here beforehand? Post-holes found to the south-east of the stone church may indicate its nave. The 11th-century structure consisted of a small narrow nave with a small square chancel entered through a narrow chancel arch. A west tower was erected in the 12th century, its huge foundations based on timber piles driven into the damp ground. The church was rebuilt in Early English style in the 13th century and a north aisle and chapel were added later, followed by a large south porch. The tower was destroyed in a storm in 1720, and the semi-ruinous body of the church was finally demolished in 1786 to make way for a modest replacement.

St Mark's was one of twelve churches in Wigford, the pre-Conquest suburb extending for a mile or so along the line of the Roman Ermine Street to the south of the walled city. It is clear from historical references that Wigford contained some wealthy citizens and the city's foremost socio-religious guild met here, at St Mary's Guildhall. The Guildhall is yet another remarkable Norman survival at Lincoln. Less well known than the Jew's House because of its location, it is currently being restored by the Lincoln Civic Trust. We are very fortunate that a detailed survey, including limited excavation, of the structure was possible in 1982 before the contractors moved in. Some interesting new architectural features were revealed behind modern accretions: they included a fireplace and a staircase. This was a high quality building with fine sculptural details, which date its construction to the period 1150–70. Removal of the modern floor showed that the front range sat directly on the solid surface of the Roman Fosse Way, on to part of which the building line had encroached by the 12th century. Trenches sited at judicious locations confirmed the presence of a north wing earlier than the existing range incorporating the post-medieval pastiche known as the Norman House. As first built the structure was certainly designed as a guildhall with an integral north range, and is a rare early example.[18]

Further remains of houses of the medieval period have been excavated at a number of sites. A useful sample of the suburb of Butwerk was obtained east of Broadgate in 1973, where several fine stone buildings of 13th to 15th-century date were uncovered along Friars' Lane in what was once regarded on documentary evidence as an area inhabited predominantly by the poor.[19] The majority of medieval houses excavated to date lie in the area around Flaxengate, to the east and south-east of the Jew's House (Fig. 3). Constructional details, as well as reflecting to some extent the successive prosperity and decline of the city as a whole, are also complementary to the evidence of the standing buildings, and can shed new light on such problems.

A further important area of study relates to the medieval fortifications and especially their gates. Some of these, like the extended western defences and Lucy Tower excavated in 1972,

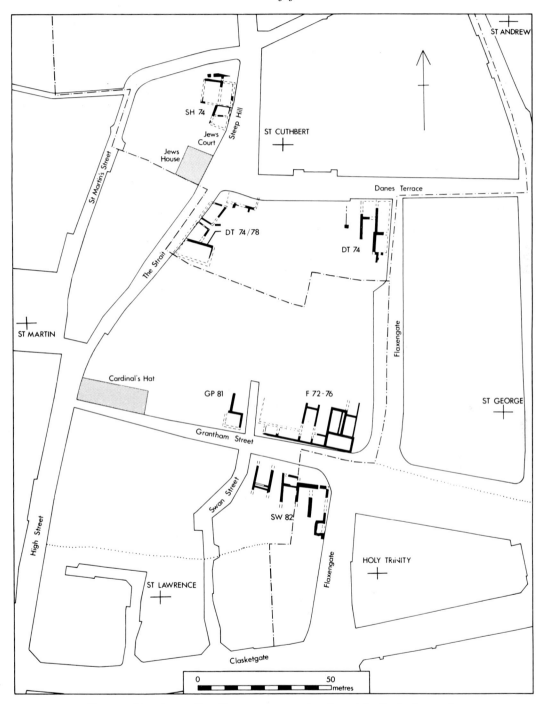

FIG. 3. Lincoln: medieval houses excavated and surviving in the lower city

are also useful for our understanding of the development of the waterfront and offer opportunities for sampling waterlogged deposits for environmental evidence — both growth areas in urban archaeology. There is a great deal to do here, as at the Close Wall, its towers, and its gates, at the Old Bishop's Palace, still being consolidated by the Department of the Environment after thirty years, and at the Castle. Our most recent survey was of the Castle's Norman West Gate (Pl. IVB) prior to its consolidation. Again a combination of detailed examination of the fabric and limited excavation has helped us to understand how the existing gate fitted into context, historically and architecturally. Not least, there are increased contacts with the Cathedral authorities, which are enabling the archaeologist and architectural historian to examine particular areas as trenches are dug and as fabric is restored. It will be many years before the results of archaeological study can evoke a comprehensive picture of the ancient city, but we can be sure that, with continued financial support and goodwill, Lincoln will reveal much new information about its medieval architecture before the end of this century.

REFERENCES

1. See most recently M. J. Jones, 'New Streets for Old: the Topography of Roman Lincoln', in *Roman Urban Topography in Britain and the Western Empire*, ed. F. Grew and B. Hobley (1985).
2. See the 'league tables' (Tables 53–4) in M. Biddle (ed.), *Winchester in the Early Middle Ages*, Winchester Studies, 1 (1975), 500–1.
3. See, for instance, the discussion of early accounts in J. W. F. Hill, *Georgian Lincoln* (1966), 1–4.
4. In addition to that referred to in no. 3 above, Hill's books include *Medieval Lincoln* (1948), *Tudor and Stuart Lincoln* (1956), *Victorian Lincoln* (1974), and *A Short History of Lincoln* (1979).
5. S. Jones *et al.*, *The Survey of Ancient Houses in Lincoln, Vol. 1, Priorygate to Pottergate* (1984).
6. *The Place-Names of the County of the City of Lincoln, Vol. 1*, English Place-Name Society (1985).
7. 'Sampling Towns: an optimistic strategy', in *Approaches to the Urban Past*, ed. P. Clack and S. Haselgrove, CBA Group 3 (1981), 65–92.
8. M. J. Jones *et al.*, *The Defences of the Upper Roman Enclosure*, The Archaeology of Lincoln, VII/1 (1980). Reports on lower enclosure in preparation.
9. M. J. Jones and B. J. J. Gilmour, 'Lincoln, principia and forum: a preliminary report', *Britannia*, XI (1980), 61–72.
10. Reviewed by Hill, *Medieval Lincoln*, Ch. II.
11. D. Perring, *Early medieval occupation at Flaxengate*, The Archaeology of Lincoln, IX/1 (1981); J. E. Mann, *Early medieval finds from Flaxengate*, The Archaeology of Lincoln, XIV/1 (1982); M. Blackburn *et al.*, *Early Medieval Coins from Lincoln and its Shire c.770–1100*, The Archaeology of Lincoln, VI/1 (1983). Reports on pottery and other finds forthcoming.
12. The earliest levels produced pottery sherds from a number of exotic locations in Europe and Asia which are presumed to have been brought in by new Danish settlers: see L. Gilmour and J. Young, *Early medieval pottery from Flaxengate*, Archaeology of Lincoln, XVII/2, forthcoming.
13. E.g., 166 houses were demolished to make way for the Norman Castle in 1068: quoted by Hill, *Medieval Lincoln*, Appendix II, 372–3.
14. See Perring (n. 11), 41–3 for a preliminary report. Detailed account in preparation.
15. See D. A. Stocker in *Lincs. Hist & Archaeol.*, 17 (1982), 82–3.
16. See B. Gilmour in *Med. Archaeol.*, 23 (1979), 214–18, for an early account. The dating of the earliest church is of course now superseded by the radiocarbon analysis.
17. See B. Gilmour and D. A. Stocker, *St. Mark's Church and Cemetery*, The Archaeology of Lincoln, XIII/1 (forthcoming).
18. Interim account in *Archaeology in Lincoln 1981–2* (10th Annual Report, Lincoln Archaeological Trust), 8–13.
19. See, for instance, the short account by Hill, *Medieval Lincoln*, 160 ff.

Lincoln Minster: Ecclesia Pulchra, Ecclesia Fortis

By Richard Gem

The surviving 11th-century façade of Lincoln Minster (Pl. VIc) has for long been of great interest to art historians: and rightly so, since it is a monument of crucial importance for English Romanesque architecture. The classic study was published by Fritz Saxl in 1946;[1] while in 1972 Peter Kidson re-examined Saxl's interpretation in a lecture to the Society of Antiquaries.[2] It may be thought that these scholars have exhausted all that there is to say on the subject: and, indeed, they have gone about as far as is possible using the style-critical method. It is the contention of this paper,[3] however, that style criticism cannot act as the sole key to unlocking the interpretation of the Lincoln west front. Much greater attention must be given to the *function* of the structure, allied with a re-examination of the documentary sources.

HENRY OF HUNTINGDON'S 'ECCLESIA FORTIS INVINCIBILIS HOSTIBUS'

The present approach is based upon a text from Henry of Huntingdon's *Historia Anglorum* wherein he describes the foundation of the Minster by Bishop Remi:

Mercatis igitur praediis, in ipso vertice urbis iuxta castellum turribus fortissimis eminens, in loco forti fortem, pulchro pulchram, virgini virginum construxit ecclesiam; quae et grata esset Deo servientibus et, ut pro tempore oportebat, invincibilis hostibus.[4]

(Having, therefore, bought lands in the upper city itself, next to the castle which was distinguished by its very strong towers, he constructed a strong church in that strong place, a beautiful church in that beautiful place, dedicated to the Virgin of virgins; it was to be both agreeable to the servants of God and also, as suited the times, invincible to enemies.)

Henry, writing this part of his work *c.*1129–33, is undoubtedly a reliable source for the early history of the Minster. Although he was probably born (*c.*1080–85) in the Fenland, he spent his early years in Lincoln in the household of Bishop Robert Bloet. Then in 1109–10 he was made Archdeacon of Huntingdon, possibly in succession to his father. It was in this office that he started, at the request of Bishop Alexander (1123–48), to write his *Historia*; a work that was to occupy him off and on until his death in 1155.[5] There is good reason, therefore, to accept the accuracy of Henry's account of affairs at Lincoln: but what precisely did he mean when he said that Bishop Remi built his cathedral as 'a strong church, invincible to enemies, as suited the times'?

HISTORY OF THE FABRIC FROM BISHOP REMI TO BISHOP ALEXANDER

Before proceeding to an examination of the surviving 11th-century fabric of the Minster, it is important to notice the historical evidence relating to it other than the passage already cited.

In 1067 there had died Bishop Wulfwig of Mid Anglia and Lindsey, whose see lay in the south-western corner of his diocese at Dorchester on Thames, and in his place was appointed Remi, almoner of the abbey of Fécamp. Following the re-affirmation at the synod of Windsor in 1072 of the ancient canon prohibiting the siting of episcopal sees in villages, Remi undertook the removal of his see from Dorchester to Lincoln — though probably this was not achieved until 1075 or somewhat later.[6]

The writ of William I authorizing the transfer of the see (and referring to the sanction for this of Pope Alexander III, who died in 1073) says that the king had 'given land there, free and quit from all customary dues, sufficient to construct the mother church of the whole diocese and the offices of the same'.[7] This presumably was the land which Henry of Huntingdon says that Remi purchased.[8] Whatever rights the bishop may have had already in the old church of St Mary in Lincoln,[9] such an acquisition of land suggests that before the Conquest he had no extensive land holding in the city.

It is reasonable to suppose that following the transfer of the see the construction of the new church began almost immediately. By 1092 Remi, who felt his death approaching, wished to have the dedication performed; but the archbishop of York, continuing a long dispute over jurisdiction in Lindsey, resisted this, and Remi had to bribe the king in order to proceed.[10] However, on the day before that fixed for the ceremony, 9 May 1092, Remi died (and the ceremony was not performed until sometime after the appointment of Robert Bloet to the see in 1093).[11] That Remi wished to see the church dedicated before he died limits the value this event might otherwise have had for the history of the fabric: it does not provide evidence that the church was in fact complete by 1092. The completion cannot have been very long delayed, however, for by the time of Henry of Huntingdon the tradition had grown up that the church was *iam perfectam* in 1092.[12] It is, indeed, perfectly feasible that within fifteen or twenty years of the foundation the greater part of the fabric was up, even if work continued on the more peripheral parts until the late 1090s.

The documentary sources are silent on the history of the fabric of the Minster for the next thirty years, until the early 1120s. Then on 19 May 1123 the *Anglo-Saxon Chronicle* records a disastrous fire that raged through the city.[13] If this is the fire entered under 1122 in the *Annals of Margam*, it is there stated that the Minster and bishop's palace remained untouched by the destruction.[14] But it was about this time according to Gerald of Wales that an accidental fire in the Minster damaged the tomb of Bishop Remi and led to the translation of his body, for he says that this took place after he had lain buried there thirty-two years.[15] This strictly would be the year from May 1124 to May 1125; but if the year is reckoned actually as the thirty-second, this would take it back to May 1123. None of the sources, however, refer to work carried out at this time on the fabric of the Minster itself.

Gerald in a later passage in his work refers again to an accidental fire from which the Minster sustained damage, but he does not relate this to the fire described beforehand, and the two events may perhaps be seen as distinct.[16] There is, indeed, confirmation of the burning of the Minster in a later fire, for the event is recorded in the *Peterborough Chronicle*[17] and the *Louth Park Chronicle*[18] under the year 1141. But if there was a fire in 1141, was it in fact accidental or was it connected with the military events of the civil war in that year?

Around Christmas 1140 Lincoln Castle had been taken by stratagem from King Stephen's garrison by Ranulph, Earl of Chester, and his brother, William de Roumare. The king, receiving news of this, marched to Lincoln, where he was received by Bishop Alexander (despite the bishop's treatment at his hands in 1139), and invested the Castle.[19] In pursuance of this, according to William of Malmesbury:

Ecclesiam beate Dei genetricis de Lindocolino incastelaverat.[20]

(He made a castle of the church of the blessed Mother of God in Lincoln.)

The Earl of Chester, however, escaped from the Castle to bring to his aid Robert, Earl of Gloucester. The army of the earls then defeated the king at the battle of Lincoln on 2 February 1141. Stephen himself was taken prisoner, and the city was sacked, with the

burning of houses and churches alike.[21] It is in this discreditable episode that the Minster well may have been burnt — while subsequent writers preferred not to describe the circumstances. The main objection to this precise sequence is that the Peterborough Chronicle dates the fire to 20 June 1141. However, even if the later date is accurate, the burning of the Minster may still not have been unconnected with Earl Robert's occupation of the city.

Following the battle, Bishop Alexander was to be counted among those who, with the Earl of Gloucester, received the Empress Mathilda at Winchester. Then at the end of the year an agreement was reached between the earl and the king which left Lincoln Castle in Robert of Gloucester's hands. The earl would have had good reason to wish to prevent any recurrence of the use of the Minster as a siege work against the Castle. Equally, Bishop Alexander could hardly have wished but to take his cathedral out of any involvement in the civil war that might lead to a repetition of its burning.

There existed in 1141, therefore, both the need to repair the Minster and also the motive for reducing any military capacity it may have had. It is reasonable to suppose that work was put in hand fairly quickly, and there is some confirmation of this in that it is in the section of his *Historia* written *c.*1145–6 that Henry of Huntingdon recounts how Bishop Alexander:

Ecclesiam vero suam, quae combustione deturpata fuerat, subtili artificio sic reformavit, ut pulchrior quam in ipsa sui novitate compararet, nec ullius aedificii structurae intra fines Anglia cederet.[22]

(So remodelled with subtle workmanship his church, which had been damaged by burning, that it appeared more beautiful than in its original state, and would not yield to the fabric of any other building in England.)

Henry places this description immediately after the return of Alexander in 1146 from Rome, whither he had set out in 1145. But it is not to be assumed, as did Roger de Hoveden, clearly basing himself on this passage, that the work began only in 1146:[23] if Henry wrote his description in 1146 the fabric must have been well in hand, and perhaps substantially complete by that year.

Unfortunately Henry does not actually describe what building work was carried out in the 1141–46 campaign. However, the passage in Gerald of Wales already referred to, which perhaps relates to the fire of 1141 (rather than of 1123), may supply this deficiency. He says that Alexander:

Ecclesiam tamen Lincolniensem casuali igne consumptam egregie reparando lapideis fideliter voltis primus involvit.[24]

(Admirably repairing the church of Lincoln, burnt by a chance fire, first erected stone vaults soundly over it.)

But since there remains an element of doubt as to whether Gerald is really referring to the events of 1141, his evidence alone is not conclusive proof for dating the vaulting of the Minster to 1141–6.

It would have been while the repairs to the church were in progress that, in 1144, King Stephen again laid siege to the Castle.[25] On this occasion, however, there is no record of his using the church: rather, he constructed a *munitio* (siege work) against the Castle.[26] The attempt was unsuccessful and was called off, and it was not until 1146, when the Earl of Chester transferred allegiance to the king's side, that the Castle came again into royal hands.

In 1147 Bishop Alexander travelled abroad again, to Auxerre, where he fell ill. He returned to England and died 20 February 1148.[27] His death provides a *terminus ante quem*

for the bishop's personal involvement in work on the Minster, but it need not be supposed that it brought to a peremptory halt any project actually in hand for which finance was already provided.[28]

SURVIVING ELEVENTH-CENTURY FABRIC

The only portions of the 11th-century fabric surviving above ground are at the west end, but the general plan of the whole church was reconstructed by Bilson in 1911.[29] It comprised an aisled presbytery of three straight bays, terminating in an apse flanked by side chapels with enclosed apses. There was a crossing for the choir, with flanking transepts which contained tribunes and which had rectangular eastern chapels. Westward from the crossing was a nave and flanking aisles[30] equivalent in length to twelve bays (of an average 5.5 m length) but comprising, it will be argued here, only nine bays before a massive western structure interrupted the aisles and perhaps the nave.

It is clear from the upstanding masonry that in the 12th century the main vessel of the aisled nave continued directly up to the west wall of the church. It is not impossible that this was the case also in the 11th century: but the evidence is not conclusive. In the westernmost bay of the present nave there is no Romanesque masonry visible at the ground storey level, but there are considerable portions at gallery and clerestory level on the north and south sides. The remains of the clerestory, with its evidence for a nave vault and with its fine, close-jointed masonry, obviously belong entirely to the remodelling of the 12th century (Pl. VIIA). In the middle storey the evidence is less clear, since considerable work took place here subsequently, in later medieval periods as well as in the 18th century. The Romanesque masonry here is fairly closely jointed and finely dressed, which would suit a 12th-century date. On the other hand, Kidson has pointed out one shaft base that he compares with the 11th-century work: yet this base does not appear very convincingly to be *in situ*. In both the the north and south walls is a large arch (Pl. VIIC), the crown of which reached up to the clerestory sill; flanking the arches are half-columnar shafts, without dosserets, marking the division of the bays — and the junction of the nave walls with the west wall. In the 12th century these arches, it is reasonable to suppose, were integrated into the nave gallery system: if they existed already in the 11th century the same may have been the case, but remains unproven.

If it is very difficult to interpret the arrangement of the 11th-century west end from its internal walls, it is somewhat less difficult from its external walls (Fig. 1). Here much of the 11th-century fabric is well preserved, including the main west façade, with at least part of its returns on the north and south elevations.

The west façade wall (Pl. VIC) is divided externally into three main bays by massive buttresses of deep projection. The central bay corresponds to the nave; the outer bays to chambers flanking the west end of the nave and projecting beyond the line of the aisles. The buttresses are connected by arches, the central one of which (though it no longer survives) must have been taller than the lateral ones. The arches are of four plain orders, but there are decorative colonnettes on the corresponding orders of the buttresses. Between the two middle orders of the soffits of the arches are pierced machicolations (Pls VIIB, VIIID, IXA) — a feature of great significance, which has not been explained adequately in previous discussions. The buttresses at the outer corners are decorated at ground level with arched, concave niches. These are of three orders that are similar to the great arches, except that the outer order is moulded (Pl. VIID).

The basic system of the west façade continues round the south return (now embedded in the Ringers' Chamber). The massive buttress at the corner has a concave niche, then comes a

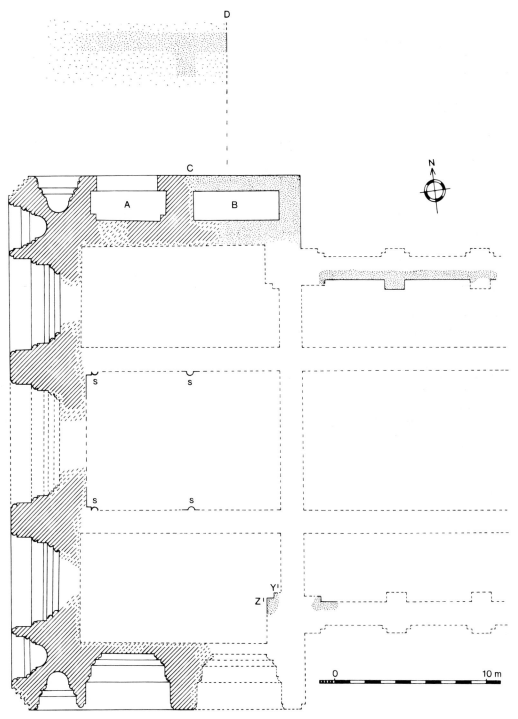

Fig. 1. Lincoln Minster. Plan of 11th-century west end (including discoveries published by Smith, 1905–6, and Bilson, 1911)

Cross hatched: walls above foundations. Stippled: foundations.

For explanation of letters A, B, C, Y1, Z1 see text. S: position of surviving 11th or 12th-century wall shafts at gallery level. D: foundation excavated by Stocker, 1983

bay with a great blank arch connecting the corner buttress to a buttress further east (the arch, however, has no machicolation). The latter buttress is in every respect similar to those dividing the central bays of the west façade, and this provides a first suggestion that originally it was a central buttress dividing two great blank arches (the east one having disappeared subsequently). Not only does a decorative colonnette on its east face suggest an arch springing eastward, but also a window in a mural chamber within the buttress establishes the return of the east face in a position comparable to that of the west face. More importantly, however, if a second bay is reconstructed on the south return of the façade, it brings the east face of the whole western massif precisely to the line on which Bilson discovered a change in the system of the south aisle wall (Fig. 1). Bilson said: 'I have been obliged to ignore the foundations found at Y', Z', of which I frankly confess I cannot offer any satisfactory explanation'.[31] They do, however, find a perfectly satisfactory explanation if at this point the aisle expanded to the width of the western structure — as in the reconstruction proposed here.

Confirmation of this hypothesis is provided by the north return of the façade (within the present Morning Chapel), despite the fact that this elevation is radically different from the south one. The corner buttress indeed has a decorative concave niche, but east of this in place of a great blank arch is a plain wall face (forming the north side of two chambers which will be discussed below). This stretch of wall terminates to the east with an angle colonnette which as various people have pointed out was part of a late 12th-century remodelling. This colonnette is best interpreted not as an eastward extension of the original wall, but as a making good where the wall has been shortened. J. T. Smith, who was clerk of works at Lincoln from 1870 to 1901, prepared an illustrated study of the Romanesque church following his retirement. This study incorporated the observations he had made whenever excavations were carried out during works in the Minster, and it may be assumed that his evidence (as opposed to his deductions) is a factual record. Having described the chamber marked A on his plan (Pl. IXD) he continues: 'there was originally another like space to this one (see B on ground plan), but it was destroyed before the building was completed, and in making good the eastern wall of the return they worked up a good-sized bead at the angle C'.[32] Presumably he had seen the foundations of this eastern chamber, for he marked it with solid shading on his plan. Since, however (contrary to Smith's interpretation), the colonnette at C is shown by the character of its masonry to be 12th-century, it cannot represent a change of mind during the original construction: the chamber B must have been completed as part of the 11th-century structure and survived until the 12th-century alterations.

The evidence from the north and south sides taken together may be regarded as demonstrating that the 11th-century western structure was originally two bays deep from east to west (equivalent to three of the remaining nave bays further east). But its more detailed arrangements remain obscure. Almost nothing can be said about the ground storey behind the external elevations except on the north side. There, in place of a blank arch, exists a tall, narrow chamber (Smith's chamber A). Apparently this had no opening towards the church, but in the north wall is a low archway (rising to only 1.41 m from the present floor level) springing from ground level and opening to the exterior, but subsequently blocked. The east wall of this chamber is original and so must have been separate from the chamber in the east bay (Smith's chamber B). The chamber is covered at a considerable height by a barrel vault divided into two bays by a transverse arch (Fig. 2). In the middle of each compartment of the vault is a rectangular opening, formed with large slabs at the edges. There is, perhaps, little doubt that Smith was right in interpreting this chamber together with that above as a garderobe.[33] The shoots lead down into the lower chamber,

which could have been cleaned out through the north archway (the latter could have been given a temporary blocking in between such cleanings). The solid south wall isolated it from the church.

On the west façade, the three main bays may be supposed to have contained portals at the ground level, in the places now occupied by the enriched 12th-century portals. The machicolations over these would have enabled them to be defended against armed attack:[34] the absence of any machicolation in the surviving south elevation then suggests that there was no lateral portal there. Of the ground storey arrangements behind the portals, in the central vessel and in the main lateral chambers, virtually nothing is known.

At the first-floor level the evidence for the main structure is almost equally thin. Even the means of access to the upper level is uncertain, though this may be because it was in the destroyed east bay rather than the west one. There do survive slight traces, however, of a small vice leading up into the upper chamber of the garderobe near its south-west corner.

The garderobe upper chamber is rectangular in plan (Pl. IXc), but at its west end has a narrow extension into the corner buttress. The east wall is a 12th-century blocking, and this suggests that at this level the west chamber continued straight through into the original east chamber without a dividing wall. The main part of the present chamber is two bays long, with pilaster buttresses dividing the bays. Further buttresses are incorporated into the blocking wall, and the whole must originally have been four bays long. There are windows in the north wall and in the west wall (Pl. VIIIa), but there are none towards the interior of the church. In the 12th century the south wall was thickened and the chamber vaulted to help support the present north-west tower (Fig. 2).

At the point where there are indications of a vice leading up into the garderobe chamber, but on the south side of it, not on the chamber side, there are also indications of a small 11th-century archway. This archway is now incorporated into a later medieval passageway ascending to the chamber from the sill level of the west window of the north aisle. Originally, however, the archway either must have led directly onto a floor level in the main north lateral chamber of the west front (continuing a supposed gallery floor level from the nave); or it must have led to a passage across the west wall if there was no floor at this level.

Across the greater part of the west front at first-floor level there are no further indications of 11th-century work except for two mural chambers contained within the two central buttresses (Pl. IXc). Access to these following the 12th-century alterations was gained from mural passages running through the junctions of the north and south walls of the nave with the west wall (and later connected to a walk across below the sill of the nave west window) (Fig. 2, Pl. IXa): but the masonry of these is not 11th-century. It may be assumed that the mural chambers were entered originally directly from the supposed floor level of the main north and south lateral chambers. The mural chambers themselves are L-shaped and are covered by barrel vaults. They lead to rectangular monolithic-headed openings (Pl. VIIIb), looking down over the portals of the west front, which presumably were designed to serve as loops.

A similar mural chamber occurs in the central buttress of the south elevation of the western structure, and this has loops opening to east and west. Of particular interest also on the south elevation at this level is the surviving part of the back wall of the great blank arch to the west of the buttress. This retains an original window which must have lit the supposed first floor of the south main chamber. Below the window are indications of one, and possibly a second, lintelled doorway — at the same height as the mural chamber in the buttress. This suggests the presence of an external wooden gallery or platform running across below the level of the window. Such a gallery may have been a substitute for the machicolations of the

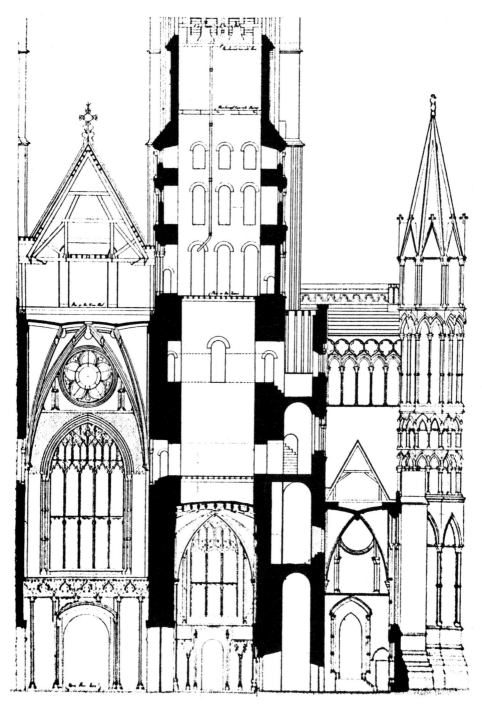

Fig. 2. Lincoln Minster. Section of north-west tower, looking west (after R. S. Godfrey, 1922)

arches of the west façade: though it cannot be discounted that there may have been galleries on the west elevation also.[35]

Contained in the south-west corner of the west front is a massive circular stair starting at first-floor level (Pl. IXc) and rising to the upper levels of the building. In its lower part it is of 11th-century construction, but it does not retain any original doorways (only windows — Pl. VIc) and so its evidence for the floor levels is minimal. However, its very presence does indicate that the original western structure had a second upper storey, and that this storey required a convenient and capacious means of access.

In the present structure there is a second-storey chamber occupying the south-west corner of the west front, and having its floor level at about the same height as the sills of the 12th-century nave clerestory windows. The lower parts of the south and west walls of this chamber are of 11th-century construction and form the backs of the great blank arches of the façade nearest the south-west corner. These walls rise from a chamfered plinth, which suggests that there was indeed an 11th-century floor at this level. The north and east walls of the chamber are clearly secondary, being built up against the west and south walls: the north wall forms the 12th-century nave clerestory.

On the north side of the church there is a comparable second-floor chamber, but of this only the lower part of the west wall is 11th-century, the rest being 12th. It is indeed clear at this level that the 12th-century builders retained only so much of the 11th-century masonry as formed the back of the great blank arches of the façade, and was necessitated by their decision to retain the arches in the remodelled design. The 11th-century north and south chambers at second floor level must have been two bays deep from east to west. And this may be taken as further, if not conclusive proof supporting the theory advanced by Kidson that, not only was there no *evidence* surviving for there being towers over the original west front (as Bilson had already pointed out),[36] but that in *fact* there never had been 11th-century towers.

There remains a problem relating to the west façade at this level, however, and this concerns the machicolations of the great arches. In the current arrangement there are 12th-century mural passages over the machicolations of the lateral arches, at a half level above the main second floor (Pls VIc, IXa). These passages could either be a replacement of a similar 11th-century arrangement (the original west wall at this level was the same thickness, 4.8 m, as the 12th-century wall); or there could have been a masonry platform over the machicolations open at the back to the second-floor chambers. The assumed machicolation of the central arch, however, was at a higher level, and, if it existed, would have had a correspondingly high access. This might reasonably have been from the parapet rather than (as in Pl. IXa) a mural passage.

TWELFTH-CENTURY REMODELLING OF THE FABRIC

Before passing to a summary of the evidence for the 11th-century west structure, and a reconstruction of it, it is important to consider briefly the 12th-century remodelling of the fabric — certain feaures of which have been alluded to already.

In the first place, the entire eastern half of the structure appears to have been demolished, while the outer north, west and south walls of the remaining western half were reduced to about the level of the sills of the nave clerestory windows. The surviving west bays of the lateral chambers were then used, suitably strengthened, as the bases for a pair of west towers, and the whole west façade was harmonised by the application of rich ornament and sculpture.[37] Internally it seems that the nave continued directly up to the west front between the towers, and the new nave vault and reconstructed clerestory thus continue this far west.

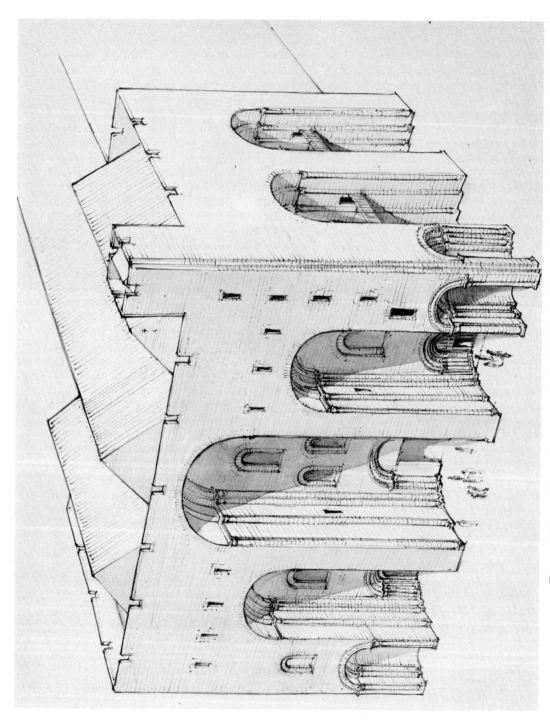

FIG. 3. Lincoln Minster. Reconstruction by W. T. Ball (following R. D. H. Gem) of the 11th-century west front, seen from the south west

The nave galleries likewise continued internally through the first storey of the towers, up to the west front; while evidence for their pent roofs can be seen against the east faces of the towers.

A RECONSTRUCTION OF THE ELEVENTH-CENTURY DESIGN

It is both from the surviving 11th-century fabric and also by deduction from the 12th-century remodelling that a reconstruction of the original design may be attempted (Figs 1 and 3). There survive in effect one and two halves of the original external walls, and these allow a sure knowledge of three of the external elevations: what remains obscure is the internal arrangement.

In plan the western structure was a massive rectangular block measuring approximately 34 m by 19 m externally. The west façade was divided into three bays by giant buttresses connected by arches at the top, while the south façade had two similar bays. On the north façade was a blank wall screening storied chambers in the place of the arched recesses. At least two of the three west-facing bays had machicolations in the arches, and mural chambers with loops to command the portals. The south-facing bays had a similar mural chamber and perhaps a timber gallery. The chambers built into the north façade probably served as a garderobe.

There can be little doubt that several of these features are part of the defensive system commented upon by Henry of Huntingdon, but this does not constitute an adequate explanation of the entire western structure — either of its scale, or of its relation to the rest of the church. If the western structure was to be truly defensible it must either have been segregated from the rest of the church; or the rest of the church must itself have been designed with a defensive capacity; or the rest of the church must have been enclosed within an otherwise defensible area. The area around the church will be considered below, following the discussion of the building itself.

Nothing of the superstructure of the 11th-century church survives further east to give any indication of whether the doorways and windows may have been defensible, so no conclusions may be drawn in this respect. Equally uncertain, unfortunately, is the nature of the east side of the western structure, where it adjoined the nave and aisles. In the 12th-century it is reasonably clear that the nave itself continued right up to the west front: but was the same true (as perhaps seems likely) in the 11th century or did the western structure (but as seems less likely) have a solid eastern return, up against which the nave and aisles ran and stopped? These are no more than questions which can be asked but not answered in the present state of knowledge — though archaeological excavation might throw further light upon them in the future.

These questions, however, are essential for understanding the whole western structure. For, either there was an almost standard church west end around which a defensive outer skin was wrapped; or there was a massive structure with a function largely divorced from the church. In the latter case there might have been first and second floors not only in the lateral chambers but across the whole area corresponding to the central nave further east. The second solution may seem *prima facie* so improbable that the former solution is to be preferred. But a warning against dismissing the second altogether is sounded by the plan which is two bays deep and not the single bay that would be expected in the more normal arrangement. The only way out of this difficulty would be to suppose that the east lateral bay on either side was an oriented chapel in a simplified 'westwork' or west transept arrangement.[38] In favour of this might be adduced the presence of extended chapels in an analogous position flanking the 13th-century west front.

The favoured interpretation of the whole western structure, therefore, in the current absence of further information, is as follows. The central nave ran through to the west façade uninterrupted — though possibly with a western gallery. The aisles, however, were expanded in width in their western bays to form broad, two-bay chapels flanking the nave: a similar arrangement was probably repeated at gallery level. There was probably an additional storey (but of uncertain function) above the gallery chapels and corresponding in height to the nave clerestory: this gave the external appearance of a massive transverse block set against the nave — the transverse emphasis being accentuated by the absence of any towers. The exterior, however, belied the more integrated internal relationship of western structure, nave and aisles.

SETTING OF THE MINSTER

Whether or not Remi's church was the successor in site to the pre-Conquest Minster of St Mary is unknown, but the 11th-century building was set (Fig. 4) squarely in the south-east corner of the enclosure of the Roman upper town.[39] This enclosure formed the outer bailey (hence its name the Bail) of the castle established in its south-west corner in 1068 by William the Conqueror.[40] The inner bailey of the Castle was irregular in plan and was defended by a broad ditch and a bank, surmounted from an early date by a masonry curtain (the *murus* is referred to in 1115). There was a gateway on the west side leading out of the town, and another gateway on the east side facing the Minster. The west gate (Pl. VIIIc) appears on the character of its masonry to be substantially of late 11th or early 12th-century date, and a similar structure forms the nucleus of the east gate.[41] There is a large motte crowned by a 12th-century shell keep interrupting the curtain on the south side, generally considered a secondary feature of the Castle and associated with Lucy, Countess of Chester, who died c.1136: the portal of this keep appears mid-century perhaps. A second motte with a rectangular masonry tower stands at the south-east corner of the curtain, and recent archaeological work has dated this by the presence of mid or late 12th-century pottery in the construction of the core of the motte.[42] A charter, possibly of 1151, gave Earl Ranulph leave to 'strengthen one of his towers in the castle of Lincoln', so presumably by the mid 12th century there was more than one tower in the Castle — and, indeed, Henry of Huntingdon's reference as early as c.1129–33 to the 'very strong towers' of the Castle should not be forgotten.[43] Hill suggested that the great strength of the Castle on its south and south-east sides indicated its primary purpose was to subdue the city of Lincoln;[44] this is certainly one factor to be borne in mind.

The defences of the Bail were clearly regarded originally as part of the Castle and were royal property. Thus it was not until 1133 that Henry I granted to Bishop Alexander the Eastgate as a lodging for himself (previously the bishop's residence was at a manor outside Westate), and not until 1137 that Stephen granted him a section of the wall in the south-east corner, parallel to the south side of the Minster, with land outside to build the Bishop's Palace on the site where it survives today.[45] Still in 1255 the chapter had to obtain royal permission for breaching the wall to the east of the Minster,[46] and presumably they had done so also in 1192 when the church was first extended eastward. These breaches, however, were to be made without detriment to the king or city. It is clear, therefore, that when Remi established his church in the south-east corner of the Bail it was enclosed on the east and south sides by the defences of the outer bailey of the royal castle; these defences, moreover, were a subject of royal concern throughout the period under consideration here.

The relationship of church and castle created problems from the start. Immediately facing the Castle gate stood a massive masonry building that could not avoid being of tactical

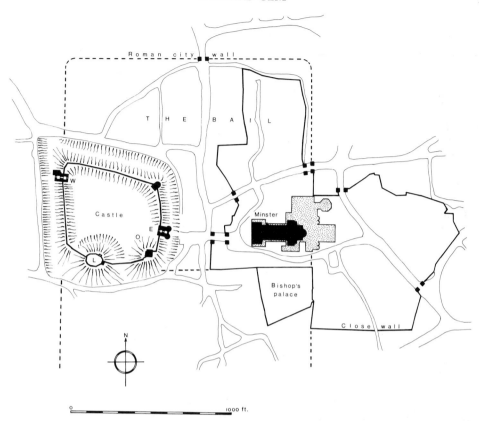

FIG. 4. Lincoln. Plan of the Minster in relation to the Castle and Roman city wall (after Major, 1974, and Stocker, 1983).

E: east gate of Castle. W: west gate of Castle. L: Lucy tower. O: Observatory tower

significance (Pl. VIA). Should the building fall into hands hostile to the holder of the Castle, as it did in 1140, it could be used as a siege work against the latter. Circumstances seem to demand, therefore, that the Minster be capable of isolation from the rest of the town — particularly if, as Hill suggests, the Castle was built with one eye on controlling the town. The present close wall was not itself begun until the late 13th century;[47] but this does not rule out the possibility that the 11th-century Minster stood in some sort of bailey of its own — perhaps with an earthen bank and ditch cutting off the south-east corner of the Bail. This, however, is an hypothesis that could only be tested archaeologically.[48]

STYLISTIC AND FUNCTIONAL SOURCES OF THE DESIGN

The sources for the design of the west front are twofold: stylistic and functional. Bilson pointed out that the plan of the greater part of the Minster was clearly related to the tradition of such Norman buildings as St-Etienne, Caen; a tradition represented in England by Christ Church, Canterbury, as rebuilt by Archbishop Lanfranc from c.1170 onwards, with a substantial part complete by 1075 or 1077 (around the time that Lincoln was

begun).[49] The most marked difference in plan was in the rectangular transept chapels, but these may be paralleled in the rectangular plan adopted for the eastern arm (and possibly transept chapels) of Rochester Cathedral, begun shortly after 1077; and Rochester was a building in other ways closely linked to Norman tradition.

Specifically Norman also are the decorative details of the west façade. The Corinthianesque capitals are related directly to the tradition of the capitals of St-Etienne; the tall colonnettes at the angles of the buttresses compare with the treatment of the jambs of the arch leading into the presbytery apses at St-Nicholas, Caen, and at Cerisy-la-Forêt;[50] the mouldings of the arrises of the arches are like those of the west portal of St-Etienne; the concave niches also occur in the latter building — in the transept walls at tribune level. If so much of the design, then, is rooted in Norman tradition, need more exotic models be sought for the basic elevation of the west end — such as Saxl's suggestion of St Mark's, Venice?[51] — it seems unlikely.

Whatever the arrangement behind it, that is, whether the nave continued up to the west front, or whether there was an independent western massif, the Lincoln façade appears as a screen placed in front of the nave and aisles. Equally, however, is this true of the façade of St-Etienne, Caen, where the towers rise above a rectangular block to which they relate visually hardly at all (Pl. VID). The façade of St-Etienne is divided into three bays by massive buttresses; a rather similar façade seems to have existed at Bayeux Cathedral,[52] but there the buttresses are of deeper projection and divide it into five bays (Fig. 5). If buttresses such as these were to be connected by arches, the result would bear a marked similarity to Lincoln. The possibility of this happening holds a high degree of probability, for the principle of arcaded buttresses was well established in Normandy and England: St-Etienne at Caen and Christ Church at Canterbury are two notable examples; while at Jumièges such arcaded buttresses had already been applied to a façade (Pl. VIB).[53]

If most of the major constituents of the Lincoln façade find seminal parallels in Norman architecture, yet it must be recognised that these elements have been welded into something new at Lincoln. The explanation of this transformation may be seen to lie partly in a deliberate aesthetic choice and partly in the defensive function of the west end and, in the latter connexion, it is undoubtedly significant that some of the closest parallels to the basic form of the great arches lie in military works. Earliest among these is the gate-house of the castle founded at Exeter early in 1068 (Pl. IXB).[54] The square gate tower is provided in front with deeply projecting buttresses, and at an upper level an arch is thrown across between them. The arch is not the full depth of the buttresses, but must have provided support for a wooden platform or gallery behind it at the probable parapet level — and this would have allowed for a machicolation over the entrance portal. Of significance also appears to be the west gate of Lincoln Castle itself (Pl. IVB, VIIIC),[55] for similarities in the masonry of this and of the Minster suggest that they may be nearly contemporary works by the same masons. The gate tower has two spur walls projecting forward from it and these evidently carried a wooden platform; but the loss of the front part of the structure makes it difficult to tell whether an arch was built across between the walls in front of the platform.

The closest parallels to the mural chambers in the buttresses at Lincoln may also be found in military architecture. In the Tower of London, c.1077–87,[56] at third-floor level in the White Tower is a complete circuit of mural passages giving access to the external openings. At second-floor level are small L-shaped mural chambers, though these serve as garderobes, not as access to loops.[57] Similar mural chambers occur at Colchester Castle about the same time.[58]

Lincoln thus seems to have aimed at providing a defensible western façade while starting from the tradition of a non-defensible design like that of St-Etienne, Caen. The buttresses

were deepened and arches were thrown across between them so that machicolations might be provided over the main portals, together with access to them from above. The mass of the buttresses was likewise expanded so that mural chambers might be placed in them. Provision was also made for garderobes, and there could have been a series of larger rooms at the uppermost level in the chambers flanking the central area. Easy communication within the upper parts of the structure, but not from ground level, would be afforded by the spacious stair at the south-west angle.

For the designer to have thought of elaborating a defensive structure in relation to the entrance rather than elsewhere in the church was fairly obvious. Not only was there the practical reason that this was the most vulnerable part of the building, but also this was the point at which purely military works of the 11th century often provided a degree of elaboration: for instance the gate towers of the castles of Exeter, Lincoln, Bramber.[59] It was,

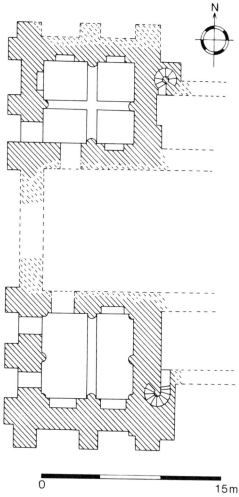

FIG. 5. Bayeux Cathedral. Plan of the 11th-century west front (after Vallery-Radot, 1923)

c

indeed, a long and diversified tradition, stretching back to and probably beyond the Carolingian period, as exemplified by the defended gatehouse (*domus belli*) and court-room (*locus iudicii*) built *c*.851–74 at the entrance to the cathedral precinct at Hildesheim,[60] or the gate-tower built *c*.847–55 over the entrance to the church atrium at SS Quatro Coronati in Rome.[61]

What remains unusual, but not without parallel, is for the defensive work to be brought into conjunction with the entrance to the church itself and not the entrance to the precinct. The parallels, admittedly, are all later in date; but what is important is that the designers of them, probably without any reference to Lincoln, came up with very similar solutions to the same problems. The most significant among these are perhaps the churches in the South of France reconstructed or remodelled around the time of the Albigensian crusade;[62] they include the cathedrals of Agde and Maguelone, the abbey of St-Pons-de-Thomière, the church of Les-Stes-Maries-de-la-Mer, a chapel of the abbey of Cruas, and the church of Vic-la-Gardiole. Particularly similar in conception to the west front of Lincoln is that of Agde, begun *c*.1173.[63] The façade is divided into three bays by deep buttresses, which are connected to one another by machicolated arches; similar machicolated arches are carried also right round the building.

To complement the evidence from surviving buildings for the construction in the central Middle Ages of fortified churches when circumstances seemed to call for them, there is the evidence of the action that the Lateran Council of 1123 found it necessary to take. Alongside canons against simony, lay investiture and other abuses, Canon XIV not only anathematized laymen who appropriated the offerings made at the altars of churches, but also:

Ecclesias a laicis incastellari, aut in servitutem redigi, auctoritate apostolica prohibemus[64]

(We prohibit with the apostolic authority the incastellation of churches by laymen, or their reduction to lay service.)

King Stephen's action at Lincoln in 1141 should have fallen precisely under this prohibition.

Turning from the façade itself to the putative arrangement lying behind it, it is rather difficult to trace the precise sources of the scheme, with its extended chapels flanking the west end of the nave on two storeys. Clearly there is here a current quite distinct from the twin-towered façades of Canterbury and Westminster, but where does it come from? Chapels in a comparable position are to be found in St Edmund's Abbey (as part of a scheme that remains to be fully elucidated) and at Ely Cathedral (as part of a west transept arrangement), but these are later than Lincoln. Possibly the key lies with Winchester, which had a western massif two bays deep (east and west) in which a square or rectangular central unit, in the line of the nave but slightly wider than it, was flanked by rectangular units breaking beyond the line of the aisles but markedly extended in an east and west direction.[65] Whether the central unit was surmounted by a colossal tower (possible), or whether the side units were (unlikely?), or whether indeed there were no towers at all, is unknown for certain. However, the possibility that the whole scheme was a devolved version of the 10th-century westwork of Winchester is distinctly likely.[66] Now at Lincoln also the arrangements suggest a tradition of devolvement from a westwork, and Winchester might provide a model for this if we were not to seek an independent source on the Continent (or another unknown English model). Ely may also be seen plausibly as in some measure deriving from Winchester: but this does not mean that either Winchester or Lincoln need be interpreted as western transepts. The key feature of Winchester may have been the idea of storied chapels flanking the west end of the nave, and these may have been copied at Lincoln and Ely — but

with only the latter introducing the open transept elevation. The position of St Edmund's remains obscure.

MOTIVATION AND CONTEXT OF THE FORTIFICATION

In September 1069 when an Anglo-Danish force was advancing on York the Norman garrison of the city, fearful that the approaching army might make use of a certain house near the castle in any siege of the latter, set fire to it; the flames spread to the whole town 'and consumed the Minster of St Peter with it'.[67] Such an incident illustrates well the insecurity during the years immediately following the Conquest for the Norman garrisons of English towns, and illustrates also how churches might become involved, even accidentally.

It must have been the consideration of this insecurity that led Earl Waltheof in 1072 to construct the castle of Durham, 'where the bishop could enclose himself with his men out of danger from invaders' as Symeon of Durham relates.[68] It was a precaution the real necessity of which was shown by the murder of Bishop Walcher eight years later at Gateshead. The castle at Durham cut off at its neck the spur of the hill — surrounded on its other sides by the River Wear — upon which the cathedral was sited, providing thus a defence for the approach to it. The defences were further strengthened by Bishop Ralph Flambard (1099–1128) when he built a curtain wall from the east end of the new Cathedral up to the Castle and levelled the space between them, forming thereby an outer bailey to the Castle.[69]

Three years after the construction of the castle for the bishop of Durham, that is c.1075, another bishop, Hereman of Sherborne and Ramsbury, transferred his see to (Old) Salsibury which, as William of Malmesbury said 'is a castle instead of a town, situated in a high place surrounded by no mean wall; and though being strong in one way or another with other provisions, yet is troubled with scarcity of water'.[70] The reason for choosing the new location is not actually recounted but, since it hardly accords with the supposed motive of leaving the village of Sherborne to find a large centre of population, it can best be supposed that Bishop Hereman was seeking security in a castle. The new cathedral lay in fact in the outer bailey.

Another cathedral about this time that seems to have made defensive provision for itself is Rochester. Gundulf, who was ordained bishop in 1077, undertook the rebuilding of his cathedral church. Standing in the angle between the north transept of this and its presbytery is a tower of obviously military character.[71] Either the tower must have been standing already when this part of the church was built, or else a transept chapel must have been demolished to make room for it: the former seems the more likely, which would favour a date not later than the 1070s for the tower. The cathedral it may be noted was sited fairly close to the castle of the immediately post-Conquest period. Following the construction of a new castle by Bishop Gundulf in the south-west corner of the Roman defences, the relationship of castle and cathedral was directly comparable to Lincoln.[72]

These examples are sufficient to show that the insecurity of the late 1060s and '70s led ecclesiastical magnates to think of defensive provisions for their churches. Bishop Remi's work at Lincoln then may be seen as simply the most ambitious project in this vein or, rather, the one in which ecclesiastical and military were welded most closely together. The cathedral stood within the outer bailey of the royal castle, and in the defence of the castle the bishop himself had a considerable stake — owing, as Hill has argued, the service of twenty knights there.[73] Yet the castle was not the bishop's own, as at Durham; nor did the bishop have direct access to it from his lodging outside Westgate until the time of Henry I.[74] Thus if he wanted security for himself and his men as well as for the canons of the Minster, and if,

furthermore, he did not wish his church to become a weak point in the defences of the castle, the logical solution was to defend the Minster itself.

It may today seem incongruous that a great church should double up as a military work, but it was, as Henry of Huntingdon said, a solution that suited the times. But if in the time of Bishop Remi the church was defended to some extent against the citizens of Lincoln, by 1146, following an unsuccessful attack upon the city made by the Earl of Chester:

Cives ... victoriosi, summo gaudio repleti, Virgini virginum protectrici eorum laudes et gratias insigniter exsolverunt.[75]

(The victorious citizens, filled with joy, paid their vows mightily with praise and thanks to their protectress, the Virgin of virgins.)

They may by then have come to see in the remnants of the fortified façade, now beautified by Bishop Alexander, a symbol of the Virgin as defender and patron of the city.

REFERENCES

1. F. Saxl, 'Lincoln Cathedral: the eleventh-century design of the west front', *Archaeol. J.*, CIII (1946), 105–18.
2. Unpublished lecture of 14 December 1972. Saxl's ideas have also been re-examined in an essay published after this essay was submitted for publication, viz. P. McAleer, 'The eleventh-century facade of Lincoln Cathedral: Saxl's theory of Byzantine influence reconsidered', *Architectura* (1984), 1–19.
3. This paper is based on a lecture first given to the Society of Antiquaries on 16 February 1978 and revised for the *BAA* meeting at Lincoln. I am most grateful to those who have discussed the material with me at different times: Christina Colyer, Paul Everson, Christopher Kelland, Peter Kidson, Warwick Rodwell, Roger Stalley, David Stocker, Timothy Tatton-Brown and others. My thanks are due also to the Dean and Chapter of Lincoln and to all those on the staff of the Minster who have facilitated my explorations of the west front.
4. Henry of Huntingdon, *Historia Anglorum*, vi. 41, ed. T. Arnold (Rolls Ser., LXXIV, 1879), 212.
5. For the dating of the *Historia* see ibid., x–xvi; for Henry's biography see *Dictionary of National Biography*, ed. L. Stephen and S. Lee (London 1891), XXVI, 118–19.
6. F. Barlow, *The English Church 1066–1154* (London and New York 1979), 48, 61. D. Owen, 'The Norman Cathedral of Lincoln', *Anglo-Norman Studies*, VI (1983), 188–99, became available only after this paper was submitted for publication.
7. C. W. Foster, *The Registrum Antiquissimum of the Cathedral Church of Lincoln*, I (LRS, XXVII, 1931), 3.
8. Loc cit. in note 4.
9. F. Hill, *Medieval Lincoln* (Cambridge 1948), 67 ff.
10. *Florentii Wigorniensis Chronicon ex Chronicis*, ed. B. Thorpe (London 1848–9), II, 30.
11. William of Malmesbury, *De Gestis Pontificum Anglorum*, ed. N. E. S. A. Hamilton (Rolls Series, LII, 1870), 313.
12. Op. cit. in note 4, 216.
13. *The Anglo-Saxon Chronicle*, ed. D. Whitelock (London 1961), 190.
14. *Annales Monastici*, ed. H. R. Luard (Rolls Ser., XXXVI, 1864), I, 11.
15. *Giraldi Cambrensis Opera*, ed. J. F. Dimock (Rolls Ser., XXI, 1877), VII, 25.
16. Ibid., 33.
17. *Chronicon Petroburgense*, ed. T. Stapleton (Camden Soc., XLVII, 1849), 2.
18. *Chronicon Abbatie de Parco Lude*, ed. A. R. Maddison (Horncastle 1891), 5.
19. For the historical events of 1140–1 see Hill, op. cit. in note 9, 177 ff., with further references.
20. William of Malmesbury, *Historia Novella*, ed. K. R. Potter (London 1955), 48.
21. *Gesta Staphani Regis Anglorum*, ed. R. Howlett, *Chronicles of the Reigns of Stephen, Henry II and Richard I* (Rolls Ser., LXXXII, 1886), III, 70: 'domibus passim et templis praedatis et succensis'.
22. Op. cit. in note 4, 278.
23. *Chronica Magistri Rogeri de Hovedene*, ed. W. Stubbs (Rolls Ser., LI, 1868), 208.
24. Op. cit. in note 15, 33.
25. See Hill, op. cit. in note 9, 180, with further references.
26. Op. cit. in note 4, 277: 'cum munitionem contra castellum ... construeret ...'.
27. Ibid., 280.
28. Cf. the donation made 'operi ecclesie' c.1154–1166: C. W. Foster and K. Major, *The Registrum Antiquissimum of the Cathedral Church of Lincoln*, IV (LRS, XXXII, 1937), 279.

29. J. Bilson, 'The plan of the first cathedral church of Lincoln', *Archaeologia*, LXII (1911), 543–64. Miss Colyer believes that account should be taken of more recent work at York Minster in interpreting Bilson's discoveries (personal communication to the author 18 February 1978).

30. Bilson found evidence only of the outer nave walls, not of any inner arcade walls. Whether the nave was aisled remains strictly unproven on his evidence therefore. However, the fact that Lincoln was some 6 m broader than York between the outer walls makes it extremely unlikely that these belonged to an unaisled building in the former case.

31. Op. cit. in note 29, 563 n.

32. J. T. Smith, 'Architectural drawings of Lincoln Cathedral in Norman times', *AASR*, XXVIII (1905–6), 97 and plate facing 96.

33. Ibid., 98.

34. The possibility that the machicolations may also have been used for secondary purposes such as suspending ecclesiastical banners (cf. Owen, op. cit. in note 6, 198–9) does not itself provide sufficient explanation of their construction. The permanence and monumentality of these features indicate their primary function as defensive.

35. Relevant to a possible western gallery may be the indications that the controversial *Daniel* panel of the 12th-century frieze on the west front appears to be inserted into a blocked opening, which originally rose three courses above the frieze level to a lintel.

36. Op. cit. in note 29, 553. It should be added that I reject the suggestion that the lowest window in the east wall of the north tower is 11th-century: it appears to be merely a simpler but contemporary version of the 12th-century window above it.

37. See G. Zarnecki, *Romanesque Sculpture at Lincoln Cathedral* (Lincoln Minster Pamphlets, 2nd ser. II, 1964).

38. Kidson (loc. cit. in note 2) has suggested the existence of a transeptal arrangement on the basis of the evidence of the interior. I do not consider the word 'transept' appropriate to describe the most likely arrangement.

39. K. Major, *Minster Yard* (Lincoln Minster Pamphlets, 2nd ser. VII, 1974), 1 and fig., 16–17. For the Roman defences see M. J. Jones, *Archaeology of Lincoln*, VII–1, *The Defences of the Upper Roman Enclosure* (Council for British Archaeology 1980).

40. For the castle see R. Allen Brown, H. M. Colvin, A. J. Taylor, *The History of the King's Works, The Middle Ages* (London 1963), 704–5; F. Hill, op. cit. in note 9, 82–106; idem, 'Lincoln Castle', *Archaeol. J.*, CIII (1946), 157–9.

41. Recent excavation of the west gate by David Stocker has demonstrated that the masonry gate succeeds an earlier timber one, and that it is subsequent also in construction to the curtain wall. I am grateful to Mr Stocker for telling me about his findings, of which an interim publication has now appeared in *Eleventh Annual Report of Lincoln Archaeological Trust* (1983), 18–27.

42. N. Reynolds, 'Investigations in the Observatory Tower, Lincoln Castle', *Medieval Archaeol.*, XIX (1975), 201–5.

43. Loc. cit. in note 4.

44. Op. cit. in note 9, 84.

45. Major, op. cit. in note 39, 5; see also H. Chapman, G. Coppack, P. Drewett, *Excavations at the Bishop's Palace, Lincoln 1968–72* (Occasional Papers in Lincs. Hist. & Archaeol., 1, 1975).

46. Major, op. cit. in note 39, 25.

47. Ibid., 26.

48. Recently David Stocker has excavated on the north side of the Morning Chapel and discovered a broad foundation earlier than the chapel, with its eastern edge running north and south (see D on Fig. 1). While the significance of this is not yet entirely clear, it does seem that the almost blank northern return of the Minster façade had another structure closely proximate to it. I am grateful to David Stocker for discussing this with me.

49. Op. cit. in note 29, 553 ff.; for St-Etienne see R. Liess, *Frühromanische Kirchenbau des 11. Jahrhunderts in der Normandie* (Munich 1967), with further bibliography; for further illustrations see L. Musset, *Normandie Romane* (La-Pierre-qui-Vire 1967). For Canterbury (and Rochester) see *BAA CT*, V (1982).

50. Liess and Musset, op. cit. in note 49.

51. Op. cit in note 1.

52. Liess and Musset, op. cit. in note 49; for the façade especially see J. Vallery-Radot, 'La façade de la cathédrale de Bayeux', *Bull. mon.*, LXXXII (1923), 66–94.

53. Liess, op. cit. in note 49.

54. Allen Brown et al., op. cit. in note 40, 647–9. S. R. Blaylock, 'Exeter City Gatehouse', *Exeter Archaeology 1984–5* (Exeter Museums Archaeological Field Unit 1985), 18–24.

55. I am grateful to Miss Colyer for urging me in the first instance to examine closely the west gate which had received no proper modern survey. The only hitherto published account was H. C. Engelfield, 'Additions to Mr King's account of Lincoln castle', *Archaeologia*, VI (1782), 376–80; manuscript survey drawings are in the

Society of Antiquaries, Willson Collection. Now David Stocker has undertaken a detailed study of the gate, with accompanying excavations (see note 41 *supra*).

56. Allen Brown *et al.*, op. cit. in note 40, 29.

57. *London*, v, *East London* (RCHM London 1930), 89.

58. Allen Brown *et al.*, op. cit. in note 40, 31; *Essex*, III, *North-East Essex* (RCHM London 1922), 52.

59. K. J. Barton and E. W. Holden, 'Excavations at Bramber Castle, Sussex, 1966–67', *Archaeol. J.*, CXXXIV (1977), 11–79.

60. J. Bohland, 'Die Kirche zum Heiligkreuz in Hildesheim', *Niedersächsische Denkmalpflege* (1965), V, 1–33.

61. R. Krautheimer *et al.*, *Corpus Basilicarum Christianarum Romae*, IV (Vatican 1970), 1–36.

62. R. de Lasteyrie, *L'Architecture Religieuse en France à l'Époque Romane* (Paris 1929), 372–5. Many more of the fortified churches in France belong to the later Middle Ages, and this is a phenomenon that can be paralleled elsewhere. In Ireland, at Kildare the new cathedral begun *c.*1225, by Bishop Ralph of Bristol, had along the nave a series of buttresses connected by arches which were (until the 19th century) machicolated (A. C. Champneys, *Irish Ecclesiastical Architecture*, London 1910, 163. I am grateful to Roger Stalley for this reference). At Cashel Archbishop Richard O'Hedian (1406–40) built into the west end of the 13th-century unaisled nave of his cathedral a massive fortified residence (H. G. Leask, *Irish Churches and Monastic Buildings* (Dundalk 1966), II, 90). The relationship of church and fortified western massif at Cashel bears some resemblance to Lincoln — though the functions are not parallel.

63. J. Vallery-Radot, 'l'ancienne cathédrale St-Etienne d'Agde', *Congrès Arch.*, CVIII, *Montpellier* (1950), 201–18.

64. J. D. Mansi, *Sacrorum Conciliorum Nova Collectio* (Venice 1776), XXI, col. 285.

65. See the plan by E. C. Fernie, in *BAA CT*, VI (1983), fig. facing 16.

66. Work by A. W. Klukas has also led him to the view that the western massif of Winchester was a devolved version of the Anglo-Saxon westwork. See A. W. Klukas, 'The architectural implications of the *Decreta Lanfranci*', *Anglo-Norman Studies*, VI (1983), 150–3. This was published after the present paper was submitted for publication, but it is worth observing that Klukas' reconstructed plan of Winchester (fig. 4) is comparable at ground level to that here proposed for Lincoln.

67. Op. cit. in note 10, 3; op. cit. in note 13, 149–50.

68. Symeon of Durham, *Historia Regum*, ed. T. Arnold (Rolls Ser., LXXV, 1885), 199–200.

69. For a description of the development of the castle see W. T. Jones in *VCH Durham*, III (1928), 64–91.

70. Op. cit. in note 11, 182–3.

71. W. St J. Hope, 'The cathedral church and monastery of St Andrew at Rochester', *Archaeol. Cant.*, XXIII (1898), 194–328; see also F. H. Fairweather, 'Gundulf's cathedral and priory church of St Andrew Rochester', *Archaeol. J.*, LXXXVI (1929), 187–212 — though Fairweather's views on the development of the church do not stand up to close scrutiny.

72. Allen Brown *et al.*, op. cit. in note 40, 806–7; R. Allen Brown, *Rochester Castle, Official Guide* (London, 1969).

73. Op. cit. in note 9, 87. See also Owen, op. cit. in note 6, 192.

74. Major, op. cit. in note 39, 5.

75. Op. cit. in note 4, 279.

St Hugh's Choir

By Peter Kidson

On 15 April 1185, the Romanesque Cathedral of Lincoln suffered grievous but unspecified damage as the result of what contemporary chroniclers described as an earthquake. The catastrophe was described in suitably lurid language. Roger of Hoveden asserted that it was 'heard [sic. *auditus*] throughout nearly the whole of England, such as had not been heard in that land since the beginning of the world'. Unaccountably, however, the havoc which it wrought seems to have been confined to the fabric of the Cathedral of Lincoln. The minster was said to have been split from top to bottom. A hundred years later there was practically nothing left of the Romanesque minster except the west front. Throughout that period there was hardly a moment when no work was in progress. It has therefore often been taken for granted that what emerged at the end was intended from the start, and that the calamity of 1185 was comprehensive enough to make an entire rebuilding necessary.

But we should not be misled by the grandiloquent language. Medieval chroniclers were notoriously given to hyperbole, especially when they were telling tales of woe. The truth was often less lurid, and as William of Malmesbury was candid enough to admit in a similar context, that invocations of acts of God often concealed explanations of a more prosaic kind. Talk of earthquakes was another way of saying that the building fell down, and the cause could well have been human incompetence rather than misadventure. It cannot be ruled out that a collapse mechanism was touched off by an earth tremor; but with no record of damage elsewhere, a more accurate description of what happened in 1185 is likely to be that the structure failed. But if so it is unlikely that the destruction was total. Structures seldom fail everywhere at once; and among medieval churches the parts that were peculiarly prone to fall down were towers and vaults.

As the western towers survived 1185, any tower that collapsed must have stood over the crossing. That there was a Romanesque crossing tower may be inferred from the close analogies between Remigius' Lincoln and Lanfranc's Canterbury or St Etienne at Caen. By 1237 or 1239, however, there was over the crossing at Lincoln something that could be described as a *nova turris*; and whenever this was built, it hardly dated from the 11th century. It can therefore be argued that a Romanesque tower disappeared and was replaced before 1237. The events of 1185 could have provided the occasion. The plinth of the present western transept proves that it was conceived as part of what was started in 1192, and a new transept implies a new crossing. But though the hypothesis is plausible, it is not the only one that would fit the evidence. It is an open question whether the new transept was required because the old tower fell down, or whether a new tower was required because a new transept was deemed necessary for other reasons.

If the picturesque language of the chroniclers is to be taken seriously, it sounds like an attempt to describe the collapse of a vault. By 1185 Lincoln, like Durham, was a completely vaulted church. Giraldus Cambrensis gave the credit for introducing masonry vaults to Bishop Alexander, and traces of his work can still be seen on the walls of the towers at the west end of the nave. But despite Giraldus's testimony it is not impossible that the choir of Remigius' Cathedral already had a vault in the 11th century. The family of Romanesque churches to which it belonged, certainly made provision for some sort of vault in the form of solid choir walls. Whenever they were built, if it was a vault that collapsed in 1185, there is a choice: nave or choir?

The vault which Alexander put over the nave was added to a building that had not been designed with a vault in mind, and this could have been a source of structural weakness. The choir vaults undoubtedly had more substantial support. But these considerations are not conclusive. The history of the vaults of Durham followed a pattern that was curiously similar to that of Lincoln. There the choir was built to receive a vault and the nave was not; yet the vault which was added to the nave is still with us, whereas the one over the choir was threatening to fall down and had to be replaced little more than a century after it was put up. The critical factor was not support but the weight and curvature of the shells; and in this respect decisive improvements were made in the technique of vault construction between the end of the 11th century and the second quarter of the 12th century.

Everything conspires to suggest that in 1185 the vault over the Romanesque choir collapsed. It is beyond question that the first concern of the Gothic builders was to provide a new east end. So far as we can tell, no part of the nave was taken in hand until well into the 13th century. Nor do we hear of any repairs to the nave before the new choir was started, although there was time enough between 1185 and 1192. Various episodes in the two Lives of St Hugh imply that the Cathedral remained in operation throughout the years of rebuilding; and as, to begin with, everything east of the crossing was in the hands of workmen, this must surely mean that the nave itself was still intact. Finally there are features at the junction of the south-west transept and the south aisle of the nave which only make sense if it is assumed that the transept was originally meant to extend somewhat further to the north than it does at present, and to join a building narrower than the Gothic nave, possibly not quite on the same axis. This must have been the Romanesque nave. From all this it follows that the scope of the works which were begun in 1192 was limited to a new east end and a new western transept. The decision to replace the nave was taken later and had nothing to do with the damage done in 1185.

If this deduction is correct, various aspects of the first campaign fall into place. First the delay. The disaster occurred in 1185 but nothing was done to replaced the old choir until 1192. This leisurely response to the situation indicates that the inconvenience was not unbearable. Money had to be raised. A fabric fund was opened soon after the disaster, and in 1205 there is mention of a special chantry founded by Bishop William of Blois in an effort to encourage the pious to contribute. But donations came in slowly. There seems to have been no lack of response from the peasantry, always anxious for the spiritual benefits that were to be had on such occasions. But although their offerings were no doubt welcome, peasants were not exactly the kind of benefactor at whom the appeal was aimed. Yet there is little need to wonder at the low level of enthusiasm on the part of lay folk with real money, for what was started in 1192 was not for them. Nor, in spite of what some of the sources may say, was it to any degree the special concern of St Hugh. As bishop, Hugh no doubt did all that was required of him; but his Carthusian background and the lofty conception of pastoral duty which inspired his episcopate, testify to levels of spirituality that were out of sympathy with the novelties and extravagance of the new building. If Hugh had views of his own about ecclesiastical architecture, they are more likely to have found expression in the Charterhouse at Witham than in the choir at Lincoln that bears his name. By the end of the 12th century responsibility for the fabric of the choir belonged first and foremost to the Dean and Chapter. It was their corporate needs and their taste which were reflected in its design. The only way they could arouse widespread public interest and support was by promoting the cult of a popular saint. In fact something of the kind seems to have been attempted, though without much success.

Another cause of delay was the site. The short choir of the Romanesque Cathedral terminated against the ancient Roman wall which still served to protect the Bail of Lincoln.

There was no prospect of extending the choir eastwards without breaching this wall; and evidently this was not a practical possibility when Bishop Alexander improved the nave and west front earlier in the 12th century. As a result of this inhibition Lincoln had been left behind in the all-important matter of ecclesiastical accommodation by more up-to-date English cathedrals such as Canterbury and York, or even Old Sarum. However, the events of 1185 presented another opportunity, and this time the problem of the wall was not considered insurmountable. Already in France Gallo-Roman walls at Noyon and Bourges had been breached for cathedrals to extend beyond them. Le Mans was soon to follow. At Lincoln itself, the whole process had to be gone through again the middle of the 13th century when the Angel Choir was built. Exactly what was entailed by such an operation is not entirely clear. Royal permission was essential, and securing it would be no formality. A new wall would have to be constructed further out in order to make good the defences of the city. The salient at Lincoln was large enough to accommodate the chapterhouse as well as the choir, from which it may perhaps be inferred that the idea of the chapterhouse was part of the initial scheme. All this would take time and so presumably would the efforts of the Dean and Chapter to acquire vacant possession of property beyond the old wall. So in the circumstances seven years was probably not too long for all the preparatory work that was necessary.

When compared with its predecessor the most striking thing about the new east end of Lincoln was its immense length. Despite the notable example of Cluny the idea of an extended eastern limb was not taken up on the Continent, and it was left to the English to make of it their most distinctive contribution to the stock of medieval ideas about cathedral design. By the end of the 12th century several versions of the arrangement were in existence, and the canons of Lincoln can be shown to have consulted at least two of them: Canterbury and Old Sarum. The choir which Prior Ernulf built for the monks of Canterbury at the beginning of the century was in a sense the archetype for the whole series. Liturgically the essential point was to stress the separate identity of the choir proper, i.e. the *schola cantorum*, and the presbytery. At Canterbury this was helped by the presence of a second or eastern transept between the two. That idea was borrowed from Cluny and it survived the fire of 1174. It was taken up at Lincoln in 1192. The restoration of Canterbury after the fire of 1174 introduced two further features: the Trinity Chapel which was in effect the first English cathedral retrochoir: and another reliquary chapel in the form of an eastern rotunda, known as Becket's Corona. Something akin to the Corona found its way into the 1192 design at Lincoln, while the function of the retrochoir as a place of honour for the principal relics of the cathedral was duly acknowledge in the later Angel Choir.

At Old Sarum the enlargement of the east end that was undertaken in the time of Bishop Roger, differed from Ernulf's Canterbury in having no eastern transept; but as if to compensate, it included a new western transept and a crossing tower. The first Gothic campaign at Lincoln could be described as a conflation of ingredients borrowed from Canterbury and Old Sarum. It was an ambitious formula, perhaps too expensive to exercise much influence. Every cathedral plan that followed Lincoln in England was a simplification, although it may have inspired the large transept that was added to York Minster in the 13th century.

York, Sarum and Lincoln were all served by chapters of secular canons. It is tempting to see a connection between this fact and the presence in their cathedrals of spacious western transepts that went architecturally with the choir rather than the nave; but the significance is not clear. What is not in doubt is the effect the canons of Lincoln hoped to achieve. The contrast between a nave that was already decrepit and old-fashioned, and an eastern limb built in accordance with the most advanced structural and aesthetic ideas of the time, must

have been striking. It would have been well suited to convey those allegorical confrontations dear to the theologians of the 12th century: the contrast between this world and the next; between the old order of the law and the new dispensation of grace; the superiority of clergy over laity in the spiritual hierarchy; above all perhaps the relation between the abode of the saints, and the probationary state of purgatory, which was as far in the direction of salvation as the hopes of ordinary mankind dared to aspire. All of this was lost, or actually reversed when the new nave was built, even more resplendent than the choir. The nave may represent further advances in ecclesiastical imagery; but it may also warn us against the seductive power of these interpretative ideas.

Not everything started in 1192 has survived. Whatever lay beyond the eastern transept was swept away in the 1250s to make room for the Angel Choir. The previous arrangement has to be deduced from some enigmatic foundation brought to light in a brisk excavation that was carried out in November 1886. The elucidation of what was found is difficult partly because the excavation was incomplete, partly because the foundations were incomplete, but most of all because they resembled nothing that was known elsewhere (Fig. 1). There seems to have been a wedge-shaped apse surrounded by an ambulatory and either three or five chapels. The two westernmost chapels were apparently round. Between these and the axial chapel were two smaller compartments not much more than 10 ft in diameter. They were hardly big enough to be chapels, and could perhaps have been staircases. However, the excavation disclosed no evidence of newels, and one of them seems to have had a stretch of straight wall, something not normally found in spiral staircases. The difficulty is not insuperable. The piece of straight wall could have been part of the approach to the steps rather than part of the stair well; and all trace of the newels could have disappeared with the treads. The point is of some importance from the point of view of interpretation because if there were staircases in this position, the force of certain analogies would be enhanced. Be that as it may, the axial chapel was hexagonal. It was also larger than the others and seems to have been related to the main body of the church in a more direct way. While many problems associated with this chapel are likely to remain unresolved, there are grounds for regarding it as the focal point of the design. The whole apse seems to have converged on its altar wall.

What was the purpose of the axial chapel? One suggestion is that it was the Chapel of St John the Baptist where St Hugh was buried in 1200. Unfortunately the words of the *Magna Vita* on which this theory is based, are irretrievably ambiguous, and the supporting evidence falls a long way short of being conclusive. The idea has much to recommend it, especially in view of the subsequent veneration of St Hugh. Even so the chapel can hardly have been designed with that particular cult in mind. Yet it has the unmistakable look of a reliquary chapel. The similarity with the Corona at Canterbury is too close to be ignored. Another church of the time which had a large centrally planned chapel attached to its east end, and which had close connections with Lincoln, was the cathedral of Trondheim in Norway. Both the Corona and the chapel of St Olaf belonged to a long tradition of eastern rotundas, usually devoted to the cults of founder saints or martyrs. For the chapel at Lincoln to belong to the same category, a suitable saint was required.

In 1192 Lincoln possessed no reputable saint. It had to be content with a dedication to the Virgin. This was one of the penalties of its late foundation. But it was an age when such accidents of history could be corrected. If saints did not exist, there was machinery for their creation. At this point it is expedient to remember the *Vita Remigii* of Giraldus Cambrensis.[1] This was not a spontaneous, unsolicited exercise in biography; nor was it a speculative venture. It was a work specially commissioned by the Dean and Chapter, and Giraldus, who was living in Lincoln between 1192 and 1198, spent three years collecting

ANGEL CHOIR

FIG. 1. The eastern limb of Lincoln Minster with the foundations of St Hugh's apse (from the
Archaeological Journal, XLIV (1887)

material for it. To nobody's surprise Giraldus concluded that Remigius deserved to be a saint. A work of this kind was one of the preliminary moves required by the procedure for canonisation. In the event the whole affair came to nothing, and in due course Lincoln acquired a saint hardly less eminent than St Thomas himself. If the *Magna Vita* of St Hugh is to be believed, it was already taken for granted when Hugh was buried that he was to be the saint of Lincoln. But the preoccupation of historians with the achievements and personality of St Hugh has tended to obscure the part which these preliminary feelers on behalf of his predecessor played in the building history of the cathedral. In 1192 the axial chapel was destined for a founder's cult focused on Remigius.

The foundations of the whole east end seem to have been laid out in a single concerted effort, before any attention was given to the superstructure. This may be inferred from the plinth, the distinctive moulding of which can be followed around both transepts and the choir between them. Originally it no doubt extended around the apse as well. Walls of more than one style stand on this plinth. There are also certain anomalies, which make sense if the setting out started at the north end of the west wall of the south-west transept, and proceeded in an anti-clockwise direction to the equivalent point on the north-west transept. Laying the foundations was an important part of the planning process. No doubt the dimensions had been decided before work began. There may have been drawings but they were not indispensible. The sense of the plan was in its geometry. Lincoln is an untidy building and does not invite thoughts of mathematical precision. But like every major medieval church it was conceived in terms of regular shapes and recognised ratios, however much they may have been deformed or concealed in the process of execution. The basic lineaments of its form can still be elucidated.

The essential components of the Canterbury scheme: choir, eastern transepts, and presbytery, were repeated at Lincoln, but the geometrical definition of each was entirely different. In the past much ingenuity was lavished on efforts to bring the apse into line with familiar designs. These were manifestly misguided, and in more recent studies its idiosyncrasies have been discreetly and briskly passed over. The one thing that emerges unambiguously from the drawing published by the excavators in 1886 is that it had long, straight sides with a constant angle of inclination. This suggests that the basic shape was a three-sided wedge with chapels grouped around it. But it must have been an eccentric wedge. The three sides cannot have been of the same length, and they were not taken from one of the regular polygons. This is proved by the angle of inclination. Three sides of a regular octagon would require an angle of 45°. For three sides a hexagon, it would have to be 60°, and for three sides of a pentagon 72°. The angle at Lincoln was in the vicinity of 67°. Careless though they undoubtedly were, the Lincoln masons are not likely to have got their geometry wrong to the extent of five or seven degrees.

Now there is a way in which it is possible to make sense of angle of 67° (Fig. 2). It is virtually half the angle between the sides of a regular octagon (135°). For this to have any bearing on the Lincoln apse, it would have to have been based on half an octagon, i.e. four sides, not three, with an east–west axis coinciding with one of the angles, rather than passing at right angles through the mid point of one of the sides. In other words the octagon would have to be 'twisted' through $22\frac{1}{2}$°. There is confirmation that the designer had such an idea in mind. If the four sides of the hypothetical octagon are superimposed over the excavator's drawing, two of the angles would coincide with the axes of the two large circular chapels, and if these axes are projected across the apse they would pass through the points where the apse and transept meet. It would therefore follow that each of the three main chapels was placed symmetrically around one corner of the octagon. The geometry turns out to be tight and tidy after all.

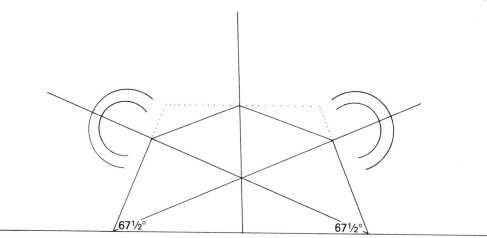

FIG. 2. Lincoln Cathedral, St Hugh's Choir: schematic reconstruction

Exactly what this may have meant in architectural terms is by no means clear. The recorded remains are not sufficient to clarify the matter. The geometrical constructions would control both the presbytery and the outer wall of the ambulatory. Normally these were concentric and their sides parallel to one another. But such orthodox symmetry is just what cannot be taken for granted at Lincoln. It is just possible that the shape of the presbytery was actually defined by the half-octagon, and that it terminated eastward in an angle rather than a wall. This would have had the effect of placing a column opposite the entrance to each of the chapels, and the two components would have been out of phase. On the other hand neither presbytery nor ambulatory need have made any further reference to this octagon. Each would easily have been transformed into a trapezium. This arrangement would have blurred the distinction, at least in plan, between the presbytery and the hexagonal, axial chapel, and conveyed that sense of everything converging on the chapel which is undoubtedly a feature of the drawing. It is perhaps idle to speculate too far about possibilities that cannot be verified; but this shape of the presbytery is a matter of far-reaching importance because it would have affected the form of the vault.

The habit of twisting polygonal shapes out of their customary alignments was not unknown in 12th-century England, especially East Anglia. The man who set out the piers of the arcades of Peterborough choir, took a perverse pleasure in doing so: and likewise the man who built the stair turrets on the western transept at Ely. But no one had done anything on the scale of the Lincoln apse, and in the context of that most eccentric building, it has the aspect of a significant mannerism.

The eastern transept is a narrow band whose function, apart from separating the presbytery and the choir, was to give access to four small chapels opening eastward. Geometrically the most important part of the transept is the crossing bay. This is a golden-section rectangle, i.e. the width and the length of the bay are related by the ratio of the golden section or some very close approximation. The length of the transept north–south is simply twice the overall width of the choir, although the two arms are not quite the same. St Hugh's choir together with its side aisles, is notionally a square, and its cross section is clearly based on the ration of 1:2:1. But in fact the square became deformed in the process of setting out. The north aisle is half the width of the choir proper, and the choir is half the

overall width. But the south aisle is appreciably narrower than the north. The source of this discrepancy can be traced back to the apse. The excavators' drawing shows that the angle of inclination of the north side was not quite the same as the south, and the effect was to displace the line of the north aisle wall somewhat to the south of where it ought to have been. The main arcades of the choir seem to have been measured correctly from the north wall, with the consequence that all the error was concentrated in the south aisle. An attempt was evidently made to off-set the inequality when the famous contrapuntal double arcading was applied to the aisle walls. This is about four inches deeper on the north side than on the south, and the result is to bring the spans of the aisle vaults into closer accord.

Pragmatic adjustments of this kind abound at Lincoln, and they make it unusually difficult to be precise about the mathematical elements in the design. Geometrically it is an exceedingly sloppy building; but this is only another way of saying that geometrical precision was not high on the list of priorities, and that the designer was quite prepared to sacrifice abstract symmetry to more important considerations. Thus on occasions bay shapes were distorted, ribs bent obliquely, and buttresses displaced. The usual explanation for these deformations seems to be that they allowed bigger or better windows. This could be a useful clue for interpreting other features of the design.

The plan of Lincoln can best be described as a free variation on the 1174 design for Canterbury. The same might be said of the elevation. In view of the very considerable departures from the Canterbury model that Lincoln presents, this pedigree needs to be emphasised. It is most apparent in the structural system, and this discloses itself most readily where the upper and the lower parts of the building meet, that is in the galleries. What Lincoln and Canterbury have in common, and what distinguishes them from every other early Gothic church in England, is a method of making the side aisle compartments as supports for the superstructure. The essential feature is that much of this masonry of the galleries is carried on the haunches of the transverse arches of the aisle vaults. Seen in section the upper parts extend well beyond the arcades on which they rest, and without the buttressing effect of the aisles the whole wall would be wildly unstable. It is this that makes slender piers and wide arcades possible, and these in turn permit the exploitation of light and colour in the aisle windows. This is Gothic in the way that St Denis and Laon are Gothic, and quite different from the Gothic of Wells or the north of England, which is purely cosmetic. There has been a great deal of talk over the years about Lincoln as the epitome of English Gothic. This may be true in the restricted sense that Lincoln produced an alternative set of cosmetic dressings which proved more attractive to English taste than those of Wells; but even so the proposition stands in need of qualification, and such talk tends to disguise the extent to which Lincoln had its roots in European as well as insular attitudes and experience.

When the elevations of Lincoln and Canterbury are placed side by side, similarities and differences are equally apparent. The similarities apply to the basic dispositions: the height of the three storeys, the design of the gallery, the presence of a clerestory passage. More specific Canterbury features at Lincoln are hexagonal shafts with concave sides; the trick of standing the responds of the aisle vaults at some distance from the aisle walls, and the peculiar shape of the girder-buttresses inside the galleries. From the latter it may be inferred that Lincoln, like Canterbury, was going to be vaulted from the outset. In the past it has sometimes been claimed that the vaults of Lincoln were later additions, but in the context of the design as a whole such an idea is a nonsense. There may be room for argument about what sort of vault was intended at the outset, but not about the basic contention.

The differences are in matters of detail and treatment. The piers at Lincoln are by and large more elaborate than their equivalents at Canterbury. Polished shafts occur in far

greater profusion, and are distributed in such a way as to produce an impression of uniform density as opposed to a calculated intensification of ornament along the approaches to the saint's shrine. There is nothing at Canterbury to match the 'Trondheim' pillars at Lincoln.

Comparison of the upper storeys is even more instructive. In both cathedrals the gallery comprises paired arches, and each arch is further subdivided into paired openings. At Canterbury this results logically in a gallery articulated in two places. But at Lincoln for no practical reason there are three, and as every arch has its own supporting shafts at either end, there are more shafts and narrower apertures than at Canterbury. Moreover the openings are not always located in the same place and for good measure the foiled performations that decorated the tympana vary from arch to arch.

Inside the galleries the differences take on a more bizarre aspect. Behind the paired arches at Canterbury there is a single arch, spanning the full width of the bay. This arch was in effect a Romanesque inheritance, and it performs the useful structural function of carrying the outer wall of the clerestory. It actually rises above the level of the clerestory passage, although the segmental opening found between its crown and the passage cannot easily be seen from the floor of the choir. There is no equivalent arch at Lincoln. Instead the window-wall of the clerestory rests on two pointed arches that correspond to those on the visible, open side of the gallery. In the middle of the bay these need the support of a pier which stands directly on the apex of the arcade arch below, not the best position for a load-bearing member and something the Canterbury arrangement was designed to avoid. Rather perversely the Lincoln architect then introduced three entirely superfluous relieving arches in lieu of the segmental opening at Canterbury. Elsewhere at Lincoln there are signs that he was nervous about the effect of loads on the points of arches, but when it suited his purpose he was evidently prepared to put the structure at risk for the sake of appearances. One has the impression of a man with a somewhat uncertain grasp of structural first principles, who either did not understand the logic of his Canterbury model or else had a different order of priorities.

At clerestory level the bias in favour of formal congestion manifests itself in the multiplication of windows. Canterbury was content to have a single window in each bay. In the eastern transepts of Lincoln there are two, and in St Hugh's Choir three windows. The consequences for the vaults were far-reaching. At Canterbury there was an unobtrusive alternation in the piers of the main arcade which hinted at a double-bay system. Wherever possible the vaults were conceived in the orthodox French manner, as sexpartite over double bays. At Lincoln by contrast the transept bays were given sexpartite vaults over single bays, while St Hugh's Choir received a vault that was in its own day and for long afterwards *sui generis*.

The vaults of St Hugh's Choir are the most celebrated, one might almost say notorious feature of the building. Paul Frankl christened them the crazy vaults and the name has stuck. This is perhaps regrettable because they were by no means the work of an idiot, but represent thinking about vaults which in its way was just as intelligent as any other. It just happens to be different from what we have been persuaded to think of as the correct, i.e. the French way. The real offence of these vaults is that they are anachronistic. They belong to a world of ideas which only came into its own with late Gothic. If they really were conceived in 1192 then we have symptoms of late Gothic before high Gothic was properly established, an intolerable state of affairs for tidy-minded art historians. Several scholars have tried to evade the issue by arguing that the vaults were inserted after the choir was built. An obvious occasion when this could have happened would have followed the collapse of the central tower in 1237 or 1239. This clearly entailed considerable restorations to St Hugh's Choir. The vaults would still be early, but less alarmingly so.

The most ingenious solution along these lines was proposed by Carl Nordstrom in 1955.[2] Nordstrom sought to connect the extraordinary visual effect of the vaults with Robert Grosseteste's theories about optics. Grosseteste was not only a great scholar but bishop of Lincoln between 1235 and 1253, i.e. at the time the tower collapsed. It is the sort of explanation that would have appealed to Panofsky: the invocation of the highest levels of contemporary learning to account for an unusual art-historical phenomenon. Unfortunately it is beset by improbabilities. It is by no means certain that the canons of Lincoln ever read Grosseteste's scientific works, or that they would have understood them if they had. But even if they were convinced by the argument they are still not likely to have done him the honour of sanctioning a kind of experimental verification if only because they spent most of the time he was bishop strenuously resisting his claim to exercise his right of visitation over them. They cordially hated him, tried hard to keep him out of the Cathedral, and the last thing they would have wished is to have a permanent reminder of his presence and his authority literally hanging over their heads.

Nordstrom's hypothesis also runs into serious archaeological difficulties. It is a hazard of theories of this kind that they may create more problems than they solve. In the present instance complications set in as soon as we try to visualise what was there before the crazy vaults, and to make it consistent with all the evidence that has survived. If the crazy vaults are not the original vaults, they were preceded by others of a different kind. That much is implied by the buttressing system which could not possibly have been inserted into an unvaulted building that was already standing. The alternating large and small buttresses along the aisle walls were anticipated when the foundations and the plinths were laid, even though the buttresses are not bonded into the walls; and the girder-buttresses in the galleries which are so patently borrowed from Canterbury, make much better sense in 1192 than in the 1240s.

The only serious alternative to crazy vaults in 1192 is sexpartite vaults over single bays. This would bring St Hugh's Choir into line with the two transepts and the whole eastern limb would then have had a uniform system of vaulting. Apart from the inherent attractiveness of the idea, there is specific evidence which can be adduced in its support. The minor buttresses on the aisle walls, which exist primarily to support the fifth rib of the quinque-partite aisle vaults, do not stop at the point where they have performed this function, but extend further up on to the gallery walls, as though they had more work to do at that level. They seem designed to take the thrust of a non-existent girder-buttress in the gallery which in turn would have taken the thrust of the intermediate rib of a sexpartite vault. As it is, the tops of these wall buttresses are entirely useless.

There are two possible explanations. One is that the sexpartite vaults and the girder-buttresses once existed and were later removed. The other is that they were never built. We can be fairly confident that the second is the correct interpretation. If the girder-buttress had ever been there, footings for them would exist against the aisle walls, between the shells of the aisle vaults. These have recently been cleared and not only are there no signs of any footings, but there are no scars on the wall where redundant masonry was removed. A comparison with the equivalent stretch of wall on the eastern side of the western transept, where the intermediate girder-buttresses are in position, makes it absolutely certain that when the galleries of St Hugh's Choir were built, girder-buttresses were placed only over the transverse arches of the side aisles, i.e. where they are now. This effectively eliminates any possibility that single sexpartite vaults ever covered St Hugh's Choir. In strict logic single quadripartite vaults cannot be ruled out; but in the context of Lincoln any such hypothesis is unthinkable and untenable. So we are forced back to the position that the crazy vaults were the first vaults to be built. The most that happened subsequently is that the bay adjacent to

the central tower was restored with a sexpartite vault in the 1240s, and some of the keystones of the eastern crossing were replaced when the Angel Choir was built.

The external buttresses on the gallery walls remain something of a puzzle. They cannot be dismissed out of hand, and they seem to indicate that there was a period during the first stages of construction when sexpartite vaults were intended. If they were never built it must be because the design was changed in the course of operation. There are two contexts in which we can imagine an important issue like the form of the high vaults being reopened. There could have been an argument about the way sexpartite vaults would affect the clerestory windows, and the unusual shape of the apse may have created some special vaulting problems.

If the original intention was to have a uniform system of sexpartite vaults over single bays, then there were going to be two clerestory windows in each bay of St Hugh's Choir. The crazy vaults made it possible to have three. The vaults were almost certainly altered for the sake of that extra window. In the eastern transepts where the first scheme was carried out, the high lancets are for the most part lost to view, squeezed in the tight embrace of the webs of the vault. As sources of light they are not at all effective. In the transepts this need not have been a serious handicap. But the choir was another matter. As Geoffrey Webb always maintained, the crazy vaults were an ingenious attempt to combine the texture of a sexpartite vault with the broad expanses of window permitted by a quadripartite vault.

This defines the problem but it does not prescribe a solution. The novel feature of the crazy vaults is that there are two keystones in each bay. It is precisely this that makes them 'crazy', which was Frankl's way of saying asymmetrical. Each keystone has two ribs coming from one side and only one from the other. The two discords cancel each other out insofar as together there are three ribs on either side in each bay. Any propensity for the keystones to shift is partially inhibited by the presence of a ridge-rib, which is really a device for keeping them at a fixed distance from one another. Given the condition that all ribs should spring from the corners of the bays, it follows that a symmetrical rib pattern can only be achieved with an odd number of keystones. One will produce an ordinary quadripartite vault. There are three along the ridge elsewhere at Lincoln, and five at Exeter and Norwich. That is the practical limit. But symmetry is not possible with an even number. So the genesis of the crazy vaults at Lincoln can be associated with the decision to have two keystones.

Why two? It may be that no special explanation is needed. Two is next after one and progress may have taken the form of one at a time. Or it may have been a simple matter of aesthetic judgement. The bays of St Hugh's Choir are not big enough for more than two keystones. In the nave where there are three, the bays are nearly half as big again as those of

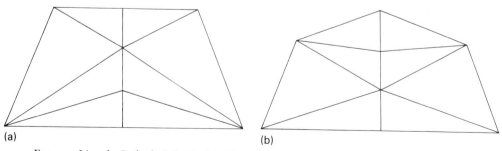

(a) (b)

Fig. 3. Lincoln Cathedral, St Hugh's Choir: schematic reconstructions of possible vault patterns in the apse

D

the choir. But the situation confronting the architect may have included two features that affected his decision. Neither of them is still available for us to assess, so they have to remain in the realm of conjecture.

One is the vault of the apse. As the shape of the apse has not been established, it may seem unduly hazardous to speculate about the character of its vault. However, the one thing that is not in dispute is that the part adjacent to the eastern transept had inclined sides. It is therefore in order to ask how a trapezoid bay would be vaulted? It is not actually necessary to propose any specific answer. It will suffice to point out that the diagonals of a trapezium do not cross in the centre. The intersection is displaced toward the shorter of the unequal sides. Given the *horror vacui* of the design of Lincoln, a second keystone and its attendant cluster of ribs might well have recommended themselves as a suitable way of filling an undesirable void; and once the pattern was established in the apse, it would be easier to repeat it along the choir than to change it (Fig. 3a and b).

The other unknown factor in the case was the vault of the Romanesque nave. We know nothing whatever about this vault except that it was the work of Bishop Alexander (1128–48). We do not even know its date. Ever since Freeman it has generally been supposed that it belonged to the later years of Alexander's episcopate and that the occasion was a fire that followed the battle of Lincoln in 1141. Elsewhere I have suggested that the 1140s were not the best period for ambitious architectural enterprises in the Bail of Lincoln;[3] and Giraldus Cambrensis who must have had access to local information when he was preparing his Life of Remigius, was quite explicit that the disaster in question occurred thirty-two years after the death of Remigius, i.e. 1124. The point is of some interest because if the vault was the work of Alexander's first years at Lincoln, it may even have proceded the nave vaults at Durham (1128–33). At any rate they could have been virtually contemporary. This does not allow us to infer that one was a copy of the other. For what it may be worth, however, one of the curiosities of Durham is the use of quadripartite vaults in a double bay system, which produces two keystones between each pair of transverse ribs. There is no need to suppose that the Romanesque nave of Lincoln resembled Durham at all closely. The Durham arrangement merely invites one to wonder whether in this particular there may have been something similar at Lincoln. If the keystones of the nave were paired, there would be an obvious inducement to follow suit in the choir.

Whatever the reasoning which led to the introduction of the crazy vaults, they were evidently considered appropriate only for the choir. The western transept reverted to sexpartite vaults over single bays, and there is evidence in the gallery over the south aisle that the nave was prepared for the same system. This seems to suggest that far from being hailed as a 'breakthrough', the crazy vaults were regarded by contemporaries as an aberration. The man who recognised their aesthetic possibilities was the one who devised the actual vault of the nave. The focus of disapproval was certainly their asymmetry, and the immediate instinct was to reject two centres and return to patterns with one centre. The second architect of the nave realised that the bolder course was to go on to three centres rather than back to one. It was from the nave, not St Hugh's Choir, that all the complicated English vaults based on tiercerons really descended, and it took quite a time for the taste to become a fashion.

This assessment leaves the crazy vaults in a somewhat ambivalent position. In a general sense their significance was no doubt immense. It is hardly too much to claim that the second keystone undermined the primacy of the bay in Gothic church design. Visually the ribs diverged from points on the walls between the bays rather than converge on points at the centres of the bays. As a result the ribs seem out of phase with the bay system. This effect is still unobtrusive in St Hugh's Choir, but it becomes emphatic in the nave and the Angel

Choir. In this sense the crazy vaults were portents. On the other hand no one in England was keen to exploit the liberation offered by their asymmetry. It was left to the late Gothic Germans to take up the theme in their '*springgewölbe*'. MittelEuropa made them welcome. They appealed to that expressionistic streak latent in all German art which seems to find something profound and meaningful in discords.

As this has been the prevailing aesthetic mood of much of the twentieth century, the crazy vaults have perhaps attracted more than their fair share of attention. Instead of being treated as an isolated phenomenon, they ought to be considered in the context of the design of the apse, the contrapuntal arcading of the choir aisles, the 'Trondheim' pillars, and all the gratuitous superfluity of ornament, as symptoms of a style. Lincoln has an incredibly strong aesthetic flavour, and there has been an understandable disposition to explain this in terms of national idiom. By comparison Canterbury seems positively French; and by a typically insular process of thought, Lincoln has come to be regarded as the quintessential master-piece of English Gothic as though these were the only polarities to enter the reckoning. When Englishmen talk of the Englishness of Lincoln, they are playing their own version of a game which Jean Bony invented with his notion of resistance to Chartres. For Bony Canterbury could take its place in the avant-garde of the opposition; but it needs only a slight shift of critical viewpoint for Canterbury to change sides. In a far more radical sense than Bony contemplated, Lincoln can be regarded as the veritable headquarters of the resistance movement during most of the 13th century.

Meditations of this kind conjure up different historical categories. While there is no harm in thinking of architecture as an outlet for the expression of national character, always supposing that there was such a thing in the Middle Ages, it may be more profitable to consider architectural styles as a matter of conscious choice rather than unconscious bias, and to enquire what purposes they were intended to serve. This is not the place for a fully-fledged discussion of the aesthetic symbolism of medieval architecture, although a building such as St Hugh's Choir forces the issue to the surface. It is not the sort of structure to encourage flights of fancy on the theme of the Heavenly mansions; nor does it evoke another favourite image of architectural iconographers: the Church Universal and Triumphant. If anything one has an impression of clerical exclusiveness. It was the private chapel of a privileged religious corporation, anxious to keep secular Christian society at a suitable distance. The other inescapable note is that of opulence. This is not only visually prominent; it is almost tactile. The ornament is everywhere applied in the manner of encrustations, like gold and jewels on a casket. One wonders how it struck an austere Carthusian like St Hugh. No doubt there were apologists for such ostentatious vulgarity, but they are not likely to have relied upon the cerebral language needed to justify that other manifestation of conspicuous ecclesiastical extravagance: the soaring spaces of Amiens or Beauvais. The architecture of St Hugh's Choir was designed to appeal to earthier minds and an older strain of imagery, which found its excuse in the time-honoured equation of the material splendour of art with the true values of the spirit. To detect a resemblance between the choir and an encrusted casket is almost certainly not just a poetic fancy. The aim of the exercise was to suggest the presence of holy relics. The building was more than a reliquary chapel; it was seeking to partake of the character of an actual reliquary. This can virtually be proved. Over and above its formal and decorative functions, the contrapuntal arcading of the choir aisles provided a convenient row of niches in which busts could be placed. Some are still in position. The heads seem to have been replaced but the draperies look authentic. These little figures resemble nothing so much as the busts of the apostles which adorn the *Annoschrein* at Siegburg in Germany (*c.*1183), and their purpose can hardly be different. The aisles thus confirm the diagnosis of the hexagonal chapel at the east end as a place intended for the

relics of a saint. But the whole choir is pervaded by the same exuberant mood. The fact that in 1192 Lincoln did not yet possess a saint was clearly no deterrent.

REFERENCES

1. Vita Remigii, in *Giraldi Cambrensis, Opera*, VII, ed. J. S. Brewer (Rolls Series 1861–91), 9–31.
2. F. Nordstrom, 'Peterborough, Lincoln and the science of Robert Grosseteste', *Art Bulletin*, 37 (1955), 241–72.
3. In a forthcoming publication on Lincoln Minster, edited by Dr D. Owen.

The Trusses of the St Hugh's Choir Roof

By R. R. Laxton

The design of the trusses in the Choir's roof is relatively sophisticated (see Fig. 1). It is a solution to certain problems that confronted the medieval builders — problems to do with the nature of the varying forces exerted on the member timbers of the trusses. This article looks at these problems to see why the builders' design for the roof is a solution to them. This will not involve any calculation of forces within the beams (apart from one given in the appendix) since it will be seen that this is not relevant here. This approach is very closely modelled on the pioneering work of Professor J. Heyman in his analyses of the timber roofs of Westminster Abbey and Westminster Hall[1] and the author is grateful to Professor Heyman for discussing it with him.

An oak beam can withstand very high tensile and, to a lesser extent, compressive stress when the force is applied along its axis (Fig. 2). Such forces exerted along the axes of the thick beams of the trusses in the choir are well below their critical values and pose no threat to them (see the appendix for a simple calculation). The analysis given here is not concerned with the magnitude of these forces. Rather it is about the *nature* of other forces not applied along the axes which can ultimately give rise to critical conditions and the ways in which the design of the trusses constructed by the medieval builders is dictated by these.

Each truss was made entirely of oak and pegged at its joints. There are 36 trusses in the roof (see Fig. 3 on page 49) and together they have to

i. support their own weight and the weight of the wooden battens and lead covering the whole roof (see Fig. 1)

ii. resist the action of the forces of the wind — which can be substantial for a roof of this size at this height.

Now in general, a wooden structure is a combination of various pinned and jointed timbers which resists being deformed when forces are applied to it, but if slightly deformed by them returns to its original shape when these are removed. A rectangle of pegged timbers is not a structure in this sense (Fig. 3). The simplest example of such a structure is a small triangle (Fig. 4) as it resists deformation at all three joints when the forces are applied to it in any direction. For example, with the force as shown in figure 4 and with the triangle held firmly in its bed along the bottom c, a resisting tensile force is set up along timber a and a compressive one in b. More complicated structures can be made from several triangles put together in various ways. The trusses in the Choir are compound structures of this type — triangles within triangles.

The simplest roof truss possible is two rafters pegged together at the top and with their feet resting on the tops of the walls (Fig. 5a). However, as the rafters are leaning against each other at their tops there is an outward thrust on each wall which would eventually lead to the walls crumbling and the rafters slipping outwards and ultimately collapsing. One way of overcoming this is to complete the triangle by the addition of a tie-beam to which the feet of the rafters are pegged (Fig. 5b). These tie-beams need to be very special since they need to support themselves without sagging over a length of 46 ft (the cross-section at the centres of the tie-beams are about 12 in. × 12 in.). It may have been very difficult indeed to find 36 oak trees with thick straight trunks over 46 ft tall. Indeed only one in three of the trusses has a tie-beam. To overcome the outward thrusts in the trusses without tie-beams, each rafter is pegged to a sole piece on top of the wall and these are linked to the trusses with tie-beams by

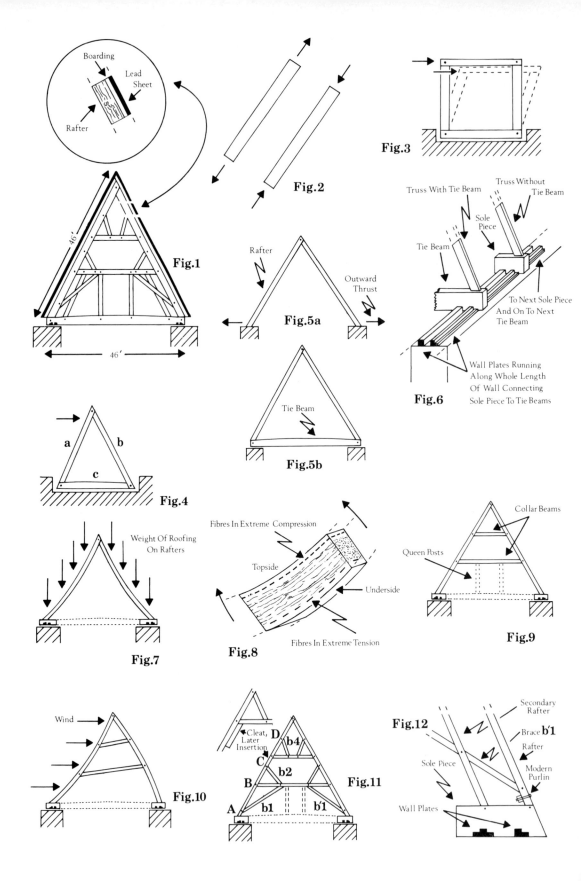

Boarding

Lead Sheet

Rafter

Fig.1

46'

46'

Fig.2

Fig.3

Rafter

Outward Thrust

Fig.5a

Tie Beam

Fig.5b

Truss With Tie Beam

Truss Without Tie Beam

Sole Piece

Tie Beam

To Next Sole Piece And On To Next Tie Beam

Wall Plates Running Along Whole Length Of Wall Connecting Sole Piece To Tie Beams

Fig.6

a b

c

Fig.4

Weight Of Roofing On Rafters

Fig.7

Fibres In Extreme Compression

Topside

Underside

Fibres In Extreme Tension

Fig.8

Collar Beams

Queen Posts

Fig.9

Wind

Fig.10

Cleat, Later Insertion

D

b4

C

b2

B

A b1 b1

Fig.11

Secondary Rafter

Fig.12

Brace **b'1**

Rafter

Modern Purlin

Sole Piece

Wall Plates

wall-plates running along the top of the walls as shown in figure 6 (see also Fig. 3 on page 49). This gives a series of trusses each of which is a structure in the sense described above.

These two forms of trusses are still not satisfactory — simply because they are very large. The rafters themselves are about 46 ft long with a cross section of about 7 in. × 7 in. — which is much smaller than that of the tie-beams. Under their own weight, and the combined weight of the battens and sheet lead covering the entire roof, these rafters would tend to sag somewhat as shown in figure 7 (notice the direction of the forces in relation to the axes of the rafters). If left like this, the roof would have become misshapen over the centuries. But also, and more importantly, with the forces applied as they are along and *across* the rafters, the rafters are put into stress in a manner to which wood is not best suited. As remarked previously, oak timbers can take a considerable amount of stress when applied along the axes. But when applied the length of and across the rafters, they bend so that there is an extremely high compressive stress on one side (upper side) of the timber and tensile stress on the other (underside) (see Fig. 8). This can cause those outer fibres in extreme compression or tension to break which would cause the rafters to have a permanent sag. With these fibres broken the rafter has, effectively, a smaller cross sectional area of useful wood (the shaded area shown in Fig. 8) to take other additional forces. Since this would weaken the structure as a whole, bending in timbers must be avoided.[2]

Collar-beams inserted in the truss shown in figure 9 largely overcome this problem since they will resist the sagging in the rafters and the forces across them by being themselves in compression along their axes, which as remarked, is safe. Each truss has been stiffened by the collar-beams. In those trusses with a tie-beam, queen posts have been inserted between this beam and the lower collar-beam (Fig. 1).

However, the problem for the carpenters does not end there. The roof is in a very exposed position and the wind forces on it can be considerable at times. A truss as shown in figure 9, even with collar-beams, cannot be expected to resist the sideways thrust of a large force of wind — which would tend to deform it in the manner shown in figure 10. Again the long rafters would be bent by forces which are applied along their lengths and across them. To resist these forces the rafters have been further stiffened by braces (Fig. 11). In St Hugh's Choir three have been inserted on each rafter. By placing two braces about the point B, and so making two small triangles, the whole lower portion of the rafter from A to C has been stiffened against the sideways thrust of wind. A gust which tended to distort the truss as

Captions to the figures on the facing page.

1 Trusses with tie-beams in St Hugh's Choir roof
2 Tensile and compressive forces applied along the axes of timbers
3 Rectangle of pegged timbers — forces not resisted
4 Triangle of pegged timbers — forces resisted
5a Truss without tie-beam
5b Truss with tie-beam
6 Wall-plate connecting trusses without tie-beams to ones with tie-beams
7 The bending action of weight on long rafters
8 Fibres in compression and tension in a bent timber
9 Collar-beams introduced to prevent the sagging of rafters
10 Effect of the sideways thrust of wind
11 Braces introduced to resist the bending action of rafters under the sideways thrust of wind
12 Introduction of secondary rafters to place the weight of the trusses uniformly over the sole-pieces

illustrated in figure 10 would result in forces being applied along the axes of the two braces b1 and b2 (which is safe), and their opposite numbers on the other rafters, and so thereby resisted. Brace b4 and its opposite number will resist bending in the uppermost part of the rafters. Here in the choir there is no complementary brace below b4, where we might expect to find one. It is interesting to note that cleats have been inserted later below some of the upper collar-beams — possibly to stiffen the rafter at this point (Fig. 11) — though other explanations are possible. (There are such braces below the upper collar-beam in each truss of the slightly later Angel Choir roof. This might be because all the rafters are two-piece in this roof (scarfed between middle and upper collars) and the rafters are of younger, less substantial timbers than those of St Hugh's Choir.)

Finally, a secondary rafter has been introduced on both sides of the truss (Fig. 1 and Fig. 12). Its function is, presumably, to distribute the load of the trusses evenly over the whole of the sole-piece, thereby keeping it horizontal and the weight equally distributed on all the wall-plates.

To summarise: the long rafters have been stiffened by the addition of collars and braces. The dangerous forces applied across the rafters have been relieved by less dangerous ones applied along the axes of the collars and braces. Stiffening is the primary problem the medieval carpenters had to solve when making the trusses.

The spacing between the 36 trusses which support the roof is kept fixed by the means of purlins (see drawings of St Hugh's by N. Foot), though the present ones may be later additions or replacements. The whole roof is kept in place atop the walls by its own weight. One point of interest is that the wall-plates on both walls have rotted. This may even have happened some time ago and escaped replacement during earlier repairs. They have now been replaced by two purlins, one on each side running along the entire length of the roof and bolted to the lower part of the rafter (Fig. 12).

All the roof trusses at the east end of the cathedral, apart from some in the north-east transept, are close variants of the design of the St Hugh's Choir roof truss.

APPENDIX

The weight of lead covering and wood per frame of St Hugh's is approximately 6,000 lb. So the total thrust down the axis of each rafter is about 3,500 lb. The cross-section of a rafter is close to 50 in^2 and so the compressive stress in the rafter is about 70 lb/in^2. Since the compressive strength of oak is in the region of 4,000 lb/in^2 it is clear that the dead-weight loading along the axes of the frames is very far from critical.

ACKNOWLEDGEMENTS

Thanks are due to G. Simpson for commenting on an earlier draft of this article, and D. Taylor for the drawings.

REFERENCES

1. J. Heyman, 'An Apsidal Timber Roof at Westminster', *Gesta*, xv (1976), 53–60; idem, 'Westminster Hall Roof', *Proceedings of the Institution of Civil Engineers*, 37 (1967), 137–62.
2. J. Heyman (1976) op. cit. 54–55. See also J. E. Gordon, *Structures or Why Things Don't Fall Down* (Penguin 1978), Ch. 11, 12, for a readable and informative introduction to these problems.

The High Roofs of the
East End of Lincoln Cathedral

By N. D. J. Foot, C. D. Litton and W. G. Simpson

INTRODUCTION

The work of Hewett[1] has shown that the oak roofs over the entire length of Lincoln Cathedral are largely complete and contemporary with the building they cover, as are those of the minor transepts. Only the principal transepts, the Chapter House and some of the roofs over aisles and chapels have been replaced in recent times (Fig. 1). Lincoln probably has more of its original roofing surviving than any cathedral in the country.

This paper is largely concerned with those roofs to the east of the central tower which comprise the earliest and the latest of the medieval roofs as well as a fair sample of post-medieval repairs and replacements. The roof of the nave[2] is very similar to that of St Hugh's Choir (Fig. 3) both in its original design and in the character of the post-medieval work, while the western chapels have roofs of a design very similar to that of the Chapter House

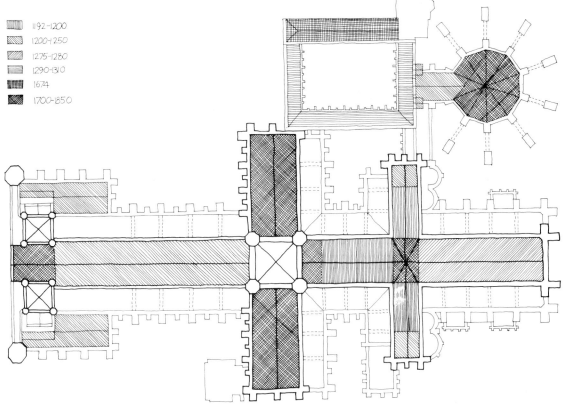

1192–1200
1200–1250
1275–1280
1290–1310
1674
1700–1850

FIG. 1. Roof plan of the cathedral

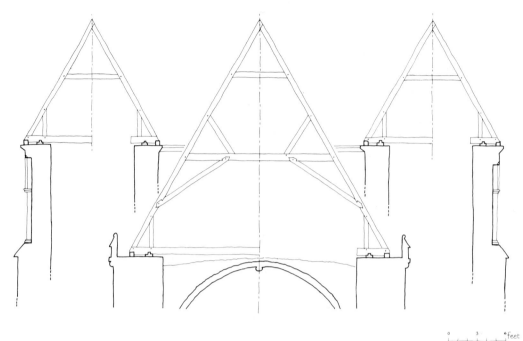

FIG. 2. Chapter House vestibule and stair towers

vestibule (Fig. 2). It is intended therefore that this paper should serve as an interim report on the results of the detailed architectural study of the roofs throughout the Cathedral and of the analysis of the timber of which they are constructed. This survey was begun in 1979 at the start of an extensive programme of repairs by the Cathedral authorities. These works involved the stripping of the lead covering and of the underlying battens and the replacement of split or decayed timber. It meant that the roof space was opened up to natural light and easy access was afforded to all parts by the carpenters' ladders and scaffolding, while the discarded timber provided ample material for tree-ring analysis.

THE ROOFS OF ST HUGH'S CHURCH

Bishop Hugh of Avalon initiated the rebuilding of the Cathedral in 1192 and by the time of his death eight years later much of the stone building east of the central tower was probably complete — i.e. the presbytery, later demolished and replaced by the Angel Choir — the choir transept, the choir and perhaps even a substantial part of the central tower — later rebuilt after its collapse c.1238. To the first building period belong the roofs of the choir transepts and the choir. Surprisingly, they are all of slightly different designs.

The Choir Transept

The plan of the choir transept is of three bays, the inner of which is the aisle of the church. Its roofing consists of twenty-eight individual frames over the south transept and twenty-nine

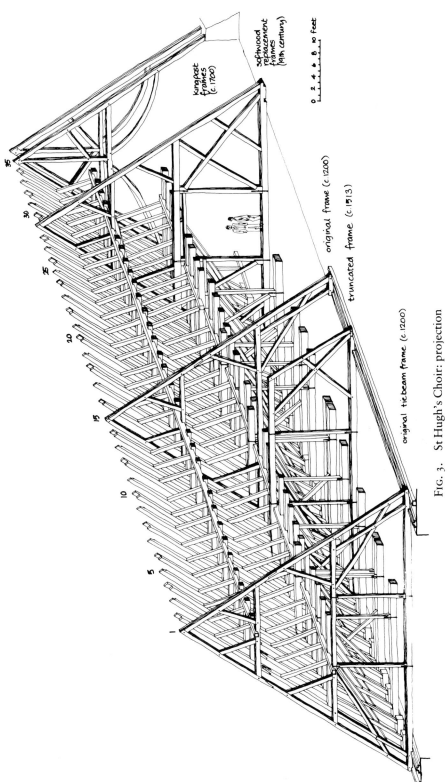

softwood
replacement
frames
(19th century)

kingpost
frames
(c.1700)

0 2 4 6 8 10 feet

original frame (c.1200)

truncated frame (c.1513)

original tie beam frame (c.1200)

35

30

25

20

15

10

5

1

FIG. 3. St Hugh's Choir: projection

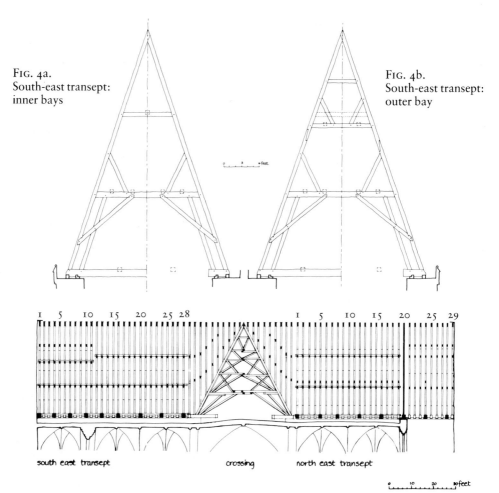

FIG. 4a.
South-east transept:
inner bays

FIG. 4b.
South-east transept:
outer bay

FIG. 4c. Section through east transept

south east transept crossing north east transept

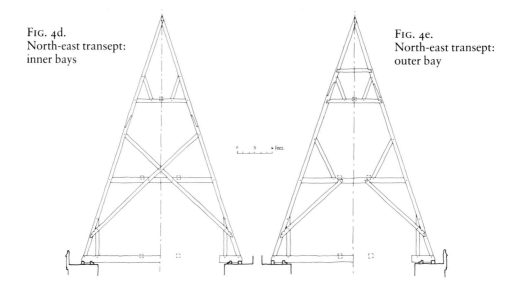

FIG. 4d.
North-east transept:
inner bays

FIG. 4e.
North-east transept:
outer bay

over the north corresponding therefore to about ten frames for each bay of the substructure (Fig. 4c). The pitch of the roof is 70°, the width between wall centres 28 ft, and the height 40 ft. In the north-east transept the frames over the inner two bays are scissor-braced (Fig. 4d). There are two collar-beams, the upper having struts to the rafters and the lower having the scissor-arms obliquely half-jointed across its north face. An ashlar-piece supports the foot of the rafter and the end of the scissor-arm passes across just below its top to fasten in the north face of the rafter with an open notched-lap joint. All other joints are mortice and tenon. The ashlar-piece and rafter foot are based on a sole-piece or, at every fourth frame, on a tie-beam. These, as in all other of the medieval roofs, rest on wall-plates which here are double, the inner having a broad fillet cut along the top which slots into a trench in the soffit of the sole-piece or tie-beam.

In the roof over the inner two bays of the south-east transept the horizontal components of the roof are exactly as described in the north-east transept (Fig. 4a). However, here it is the lower collar that has struts, and soulaces with a notched-lap joint at either end on the north face passing across truncated secondary rafters. These together, carry out the functions of the scissor-braces and ashlar-pieces in the north transept. Carpenters' marks are found in these roofs only in the middle bay of the north transept.

The Choir

The roof of St Hugh's Choir consists of thirty-six individual frames of which twelve at the west end are later replacements (Figs 3, 5a and 5b). It seems likely however that the original number was the same. The pitch of the roof is 60°, its width between wall centres 46 ft, and its height 40 ft. The horizontal components are exactly as described in the choir transept roofs. The tie-beams are at every third frame. Both collars here have struts to the rafters, the extra support perhaps being required because this roof, unlike the transept, has few rafters of a single timber. Most are of two pieces scarfed approximately at mid-length using a scissor-splay-stopped joint (Fig. 6a) — a type that has only been previously recorded at the Blackfriars, Gloucester.[3] The lower collar is supported by truncated secondary rafters and soulaces with open notched-lap joints at either end as in the south transept with the addition, on account of the greater roof span, of queen-posts (Figs 7a and 8). These were originally jointed at either end with mortice and tenon which is used, apart from the soulaces, throughout the roof. The notched-lap joints are on the west face of the frame and there is a consistent series of carpenters' marks throughout the roof.

The Presbytery

The roof of the present presbytery (Angel Choir) contains over eighty pieces of re-used timber which were very probably part of the roof of St Hugh's presbytery. Certainly their dendrochronology is consistent with this conclusion (see Table II, 1). They suggest that the main part of the roof had passing-brace construction since collar-beams with two obliquely cut half-joints occur commonly[4] (Pl. XA). The re-used timber is restricted to the thirty frames which cover the three western bays of the Angel Choir and the quantity is such as to suggest that as far as possible all the timber from the roof of St Hugh's presbytery was re-used in its replacement. It is hoped that by making measured drawings of its components it will be possible to reconstruct its original form. As with the transept roof, carpenter's marks appear only sporadically on its timbers.

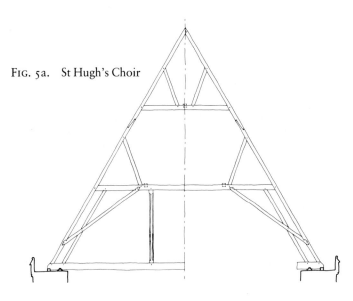

FIG. 5a. St Hugh's Choir

0 3 6 feet

angel choir crossing St. Hugh's choir

0 10 20 30 feet

FIG. 5b. Section through choirs

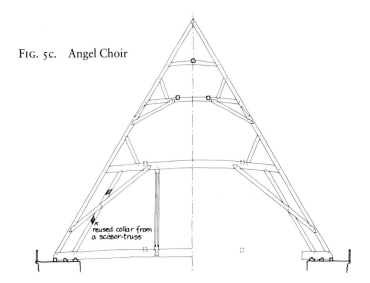

FIG. 5c. Angel Choir

reused collar from
a scissor-truss

0 3 6 feet

THE LATER MEDIEVAL ROOFS

The Principal Transept

Hewett has described the roofs of both arms of the principal transept and suggested that the south transept roof (Fig. 9) if not original in its entirety, is at least rebuilt to its original design.[5] Both roofs appear to be built almost entirely of pine although there is some evidence for the re-use of both oak and pine in the southern roof. There is no evidence for the use of pine in the construction of the Cathedral roofs before Essex' use of it for the Chapter House in 1762 and in fact the documentary evidence is quite clear that both roofs were constructed in the 1830s and 1840s, perhaps reusing timber wherever possible (see below p. 66). Hewett's theory that the roof of the south transept is basically of the original design, though attractive, needs therefore to be regarded with some caution.

A certain amount can be deduced about the design of the original roofs from the Cathedral architects' surveys which were carried out before c.1830.[6] They strongly suggest that the medieval roofs survived up to this date, though clearly much repaired. In both roofs reference is made to rafters, tie-beams, sole-pieces, collar beams and queen-posts. Reference to 'cross-braces' in the south roof might be taken to mean scissor-braces and as queen-posts are also mentioned, a roof like that of Salisbury choir transept is a possibility and chronologically acceptable.[7] Sir Robert Smirke says in his report of 1826 that the timber of the north roof is 'of slight scantling and bad workmanship'.[8] As will be shown this aptly summarises the character of the Angel Choir roof and the general impression that emerges is that the main transept roofs were probably similar or related in their design to others in the Cathedral.

Another feature of the roofs of the principal transept referred to in Cathedral architects' reports of the late 18th and early 19th century was that their frames were leaning away from the central tower (racking). This applied also to the roofs of the nave and the choir. In the roofs of St Hugh's church the only features giving any vertical stability above wall-plates were the battens and their lead covering. All the roofs now have collar-purlins but none can indubitably be shown to be original. Many are of re-used timber and those in the choir transepts are of pine and so are most probably no earlier than 18th century.

The Angel Choir

The roof of the Angel Choir is of the same pitch and dimensions as that of St Hugh's Choir and is made up of fifty-five frames so that each bay of the masonry structure is covered by eleven frames of roofing. They are basically of the same design as those of St Hugh's Choir but with a number of distinctive features. The rafters are of two pieces scarfed using splayed joints with taced and under-squinted abutments (Fig. 6b). The scarf-joints are invariably between the top and middle collars. The collars and the tie-beams which are now much altered by repairs, were originally slightly cambered and tapered at the ends. There is an extra collar and soulaces below both the middle and lowest collars. Hewett gives this roof collar-purlins, one lapped over the upper collar and two over the middle one (Pl. XID).[9] The notched-lap joints of the soulaces are on the west face of the frame and there is a consistent series of carpenters' marks throughout the roof (Fig. 5b and c). The queen-posts, though jointed into the collars everywhere with mortice and tenon, have lap-dovetail joints with square, housed shoulders at their bases in the western half of the roof (Fig. 7d, Pl. Xc). This is the only occurrence of that joint in the roofs but it is found elsewhere in contemporary contexts, as for example, at Kersey Priory, Suffolk.[10] In the eastern half of the Angel Choir roof the notched-lap joint is used in this position as also in the western part of the nave roof

(Fig. 7b). At the east end of the nave, mortice and tenon joints are used at both ends of the queen-post, as in St Hugh's Choir roof (Fig. 7a).

Additions to the Choir Transept

The only medieval high roofs at the east end not yet described are those over the end bays of the choir transept (Fig. 4b, c and e). A number of the Cathedral's architectural historians, of whom James Essex was the first[11] have put forward the idea that these were originally of only one storey and so roofed at about triforium level.[12] Later, it was suggested, the bays were raised to the full height of the rest of the transept. An alternative, perhaps preferable theory, is that it was originally intended to have towers terminating the transepts as seen at Exeter and Ottery St Mary.[13] This would explain the thickness of the wall dividing the north end bay from the rest of the transept. At some stage after the roofs over the two inner bays were completed it was decided not to proceed with towers, and the roofs were extended a further ten frames. At the south end, the original south wall and the first storey vault were demolished and replaced with an arch decorated in 13th-century style. Whatever explanation is preferred, a change of design is apparent, both in the masonry of the end bays of the transept and in their roofs. The timbers are of lesser scantling than those over the two inner bays, and this is most apparent in the rafters which are scarfed using splayed joints with taced and under-squinted abutments, as in the nave and Angel Choir roofs (Fig. 6b). At the south end the frame design (Fig. 4b) is much as in the main part of that roof except that there are three collar-beams, only the lowest of which corresponds in level with that of the original roofing. There are also re-used timbers.

　　At the north end (Fig. 4e) the added roof also has three collars. The upper two have lap-joints into the rafters, as in the roof of the Consistory Court at the west end of the Cathedral. One frame has scissor-bracing in pine which is certainly a later addition. All the other frames have struts on the bottom collar and soulaces with ashlar-pieces, a combination found only in the smaller roofs of Lincoln at the west end and in the Chapter House vestibule (Fig. 2). A single timber from the latter has given a tree-ring date which suggests that it was built shortly after c.1234 and a similar or slightly later date would be acceptable for these additions.[14]

THE TIMBER OF THE MEDIEVAL ROOFS

Samples of timber for study have been obtained by taking cross-sections with a chain saw from beams being replaced by the carpenters. This has given ideal samples and plentiful material for study. However, the quantity of samples and the limited financial resources available has left little time for other work and it is only with the recent purchase of a core-extraction kit that it has been possible to supplement the routine 'rescue' sampling with 'research' sampling and so to begin to answer problems such as those posed in the previous section.

　　About a hundred and fifty samples have been taken from the roof of St Hugh's Choir and over a hundred, up to the time of writing, from the Angel Choir. These were analysed in the Tree-Ring Dating Laboratory at Nottingham University. The results are important not only for the dates obtained, but also for the information they have provided about the sources of the timber and the use the medieval carpenter made of the available resources. They show over a period of less than a century a decline in the quality of timber available compelling the carpenter to practise greater economy in its use (see Fig. 10).

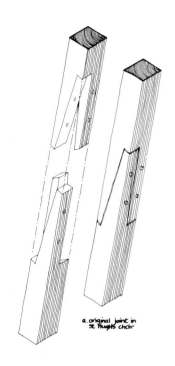
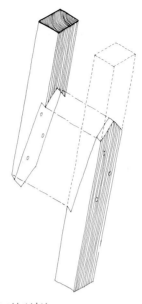
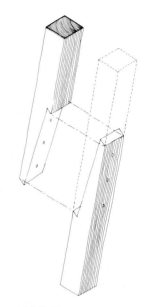

a. original joint in St Hughs Choir

b. original joint in nave, outer bays of the eastern transepts and angel choir

c. original joint in inner bays of north east transept

FIG. 6. Rafter splice joints

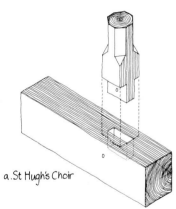
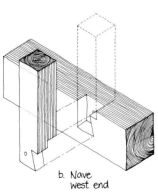
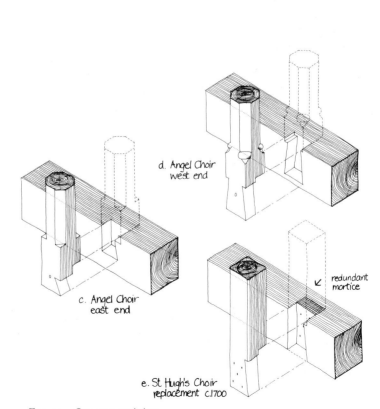

a. St Hugh's Choir

b. Nave west end

c. Angel Choir east end

d. Angel Choir west end

e. St Hugh's Choir replacement c.1700

redundant mortice

FIG. 7. Queen post joints

E

Fig. 8. St Hugh's Choir: details of joints

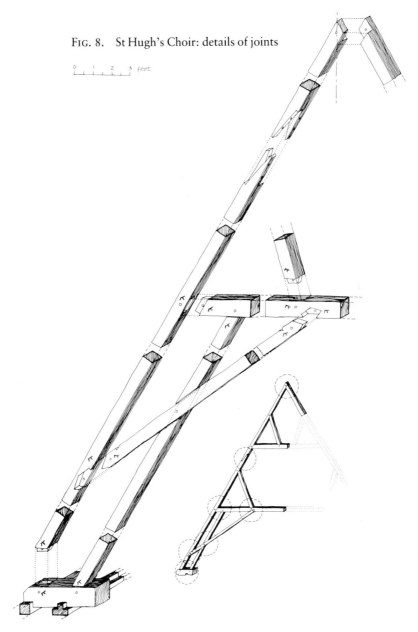

The oakwood of St Hugh's Choir was at least 130–260 years old when it was felled. Its dendrochronology extends from 882 to 1195–6.[15] If it is assumed that it all came from a single woodland then it was already in existence in the early 10th century and many of its trees were already mature at the time of the Domesday Survey.[16] The boundary between heartwood and sapwood on all those samples where it was present, ranged in date from 1158 to 1189 (see Table I). The method of estimating the average felling date of a group of

Fig. 9. South-west transept

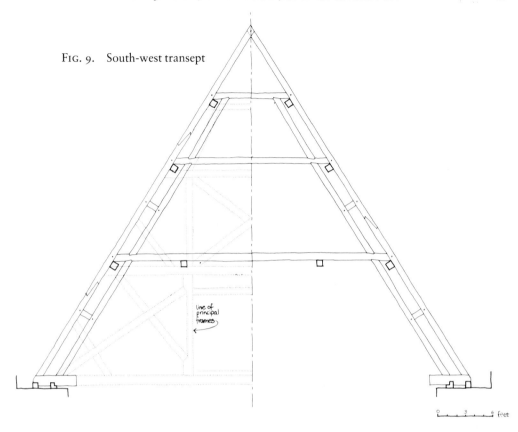

line of
principal
frames

0 3 6 feet

timbers, for which there is no reason to suppose felling did not take place within the space of a few years, is to add thirty years to the average date of the last heartwood rings.[17] It has been shown as a result of statistical evaluation that thirty rings is the average sapwood growth to be expected on a mature oak with a 95% confidence interval of between twenty and fifty rings.[18] The result for St Hugh's Choir timbers is a felling date of 1202–3 (see Table II, Summary, I1) which, assuming the timber was used 'green' as was usual, should be very close to the construction date. However, where a very large project was involved as in this instance it is perhaps unrealistic to expect all the felling to have taken place in a single year. The historical evidence together with the dendrochronological evidence makes it virtually certain that none of the timber was felled before 1192. There is no evidence for the re-use of timber. The only sample (no. 148, see Table I) with complete sapwood on it gave a felling date of 1195–6. This is, however, probably too early a felling date to be generally applicable. For example, the sample (142) from a comparatively young tree with heartwood/sapwood boundary at 1189 showed a greatly increased ring width in the last five years of the heartwood (average ring width, 2.9 mm). If this growth pattern was continued into the sapwood then thirteen or fourteen rings (i.e. a thickness of about 4 cm) would be a reasonable estimate. Because of the inclusion of this particular timber in the roof its construction date is unlikely to be any earlier than the averaged felling date of 1202–3, and the possibility remains that the felling date of some of the timbers may have been later.

The re-used timber in the roof of the Angel Choir is so homogeneous, with similar growth rates and patterns with that from St Hugh's Choir, that it very probably all came from the same source, for the statistical quality of the match between the two chronologies has the very high t-value of 14.4.[19] It is possible, however, that older trees were selected first, for of the ten samples of re-used timber that have yet been dated all seem to have started growing in the 10th century and most of them in the early part of that century (see Table II, 1).

No timber in the choir transept has yet been sampled but the indications are that it is of similar age and character to the earliest of that in the choirs. The rafters over the two inner bays of the south transept (seventeen couples) have all been sawn (Pl. XIc) from huge oaks over 40 ft in usable length. The same is true also in the inner bay of the north transept (nine couples) but those of the middle bay are scarfed (ten couples) just below the upper collar (Fig. 6c), as are most of those in St Hugh's Choir. The tie-beams too are expensive in timber since straight pieces 28 ft long were required — those over the major roofs are 46 ft long. Together with the rafters they are the longest members in the roof.

The first mention of timber for the Cathedral is in a letter of King John dated January 1209 requesting that the canons of Lincoln be allowed to take from the forest the timber that they have acquired and also the lead they had purchased for the building of their church.[20] This must have been roofing material. The use of the word *maeremium* in the original document indicates that timber suitable for heavy construction was involved and its association with lead leaves little doubt of it. This implies that there was building ready to be roofed. Unfortunately the dendrochonology of St Hugh's Choir roof is not sufficiently precise to make it clear if that was the one in question. It is, however, possible that some of the timber (e.g. Table I, Sample nos 09, 68, 78, 90, 114 and 142) was felled c.1209 and used in that roof together with the last of the timber from earlier felling(s) (e.g. Table I, sample nos 53/61, 98, 106, 120, and 148). Alternatively it may have been used for lesser roofs over aisles and chapels. As nothing is known of the quantities involved further speculation is pointless as sampling in the east end of the nave roof and elsewhere should eventually give further information.

The concern of the king in the matter implies that the forest (*foresta*) referred to was royal forest. The nearest available source of lead to Lincoln was in the royal forest of High Peak, north-west Derbyshire — one of the royal forests, like Dartmoor, where trees were thin on the landscape. Lead could have been bought at Lenton Fair (Notts.) as the monks of Lenton Abbey had a tythe of lead produced from this source.[21] Sherwood Forest was the nearest and most likely source of the timber.

The timber might have been felled before 1209 for in his letter the king is pleading for the canons to be allowed to take what already belonged to them. This implies some delay in the progress of the work. A likely cause was a dispute between the clergy and royal officials in connection with the Interdict which had been declared about nine months earlier.[22] Evidence of a break in the construction of the nave at Wells Cathedral has been observed in both the masonry and the roofing and has been convincingly attributed to effects of the Interdict.[23] Another cause of delay, or at least slow progress, could have been the lack of a bishop at Lincoln to give direction and encouragement to the work for much of the first decade of the 13th century. William of Blois held office no more than three years (1204–6) and although his successor Hugh of Wells was appointed (May) and consecrated (December) in 1209, work presumably ceased when he sought refuge on the Continent and may not have resumed until the end of the Interdict in 1213. Even then Bishop Hugh would still have had over twenty years of cathedral building ahead of him although the only documentary record of it is the opening of a new quarry in the ditch of Lincoln Castle by royal grant in 1231.[24] At his death in 1235 another substantial part of the Cathedral must

TABLE I

St Hugh's Choir roof. Analysis of timber samples. (All have base of sapwood)

Sample nos	Frame nos	No. of heartwood rings	Average ring in mm	Centre ?	Sap rings	Dates Start	End†
	East End						
82	1	114	2.0	No	13†	1063	1176
131	2	115	1.3	No	—	1058	1172
09	4	164	1.5	No	—	1015	1178
122	5	120	1.2	Yes	—	1052	1171
34	9	98	1.9	No	—	1079	1176
142	9	122	1.6	Yes	—	1068	1189
120	10	224	1.0	Yes	—	938	1161
117	12	96	1.4	Yes	—	No match‡	
106	13	123	1.1	No	17†	1042	1164
113	13	110	1.3	Yes	—	1068	1177
114	14	85	1.5	Yes	—	1097	1181
137	15	99	1.3	Yes	—	1078	1176
100	Wall-plate	177	1.0	No	—	998	1174
98	16	179	1.2	No	—	980	1158
148	16	198	0.7	No	35/6*	963	1160
94	16	231	1.1	Yes	—	935	1165
06	17	130	1.3	Yes	—	1039	1168
90	17	116	1.7	No	—	1066	1181
65	18	150	1.6	Yes	—	No match‡	
86	19	219	0.8	No	—	956	1174
78	19	159	1.2	No	—	1023	1181
73	19	108	1.4	Yes	7†	1070	1177
68	19	146	1.4	No	—	1033	1178
60	21	101	2.2	No	—	1077	1177
56	21	163	1.2	No	—	1009	1171
53/61	22	162	1.5	No	—	997	1158
76/79	23	110	1.8	No	—	1067	1176

* Complete sapwood
† Sapwood rings are not included in the dendrochonology which extends up to
 heartwood/sapwod boundaries only
‡ Identified as original timbers due to carpenters' marks

TABLE II

Angel Choir roof. Analysis of timber samples

1. The reused timbers

Sample nos	Frame no.	No. of heartwood rings	Av. ring in mm	Centre ?	Sapwood ?	Dates From	To
161	51	190	1.0	No	Base?	980	1169
170	50	134	1.5	No	No	1024	1157
190	44	147	1.5	No	No	939	1085
191	42	178	1.1	No	No	949	1126
193	42	107	1.1	No	?	950	1056
194	42	133	1.4	No	No	954	1086
214	42	114	1.0	No	No	955	1068
215	38	167	0.9	No	No?	955	1121
219	36	243	0.8	No	No	912	1154
220	35	201	0.8	No	Base?	963	1163

2. The tie beams ('transversar')

157	52	167	1.3	Yes	No	1022	1188
200	46	176	1.9	Yes	?	1073	1248
202	43	130	1.7	No	No	1109	1238

Summary — Conclusions

No.	No. of samples	Average no. rings heartw'd	Average ring width	Average sapwood start	Estimated sapwood Total	Estimated age of trees (yrs)	Estimated felling years	Royal Grants	Comments
I 1	25	142+	1.3	1172/3	30	130–260	1195–1202+	—	St Hugh's Choir
II 2	10	170+	1.1	c.1166	30–35	over 200	c.1195	—	Angel Choir reused
II 3	3	158+	1.6	c.1248?	30?	about 200	c.1277–79	1276	Angel Choir tie beams

have been nearing completion for in his will dated the same year the Fabric Fund of the Cathedral received the sum of one hundred marks and all the timber that was felled on his estates at that time, reserving to his successor only the right of redeeming it for fifty marks.[25] Whether Bishop Grosseteste did so is not known but in April of the same year, in another royal grant to the Cathedral, one hundred trees from Mansfield Wood in Sherwood Forest were given.[26] Repair of damage done by the collapse of the central tower and the roofing of the Chapter House, the principal transept and nave would probably have taken all this timber (see p. 54). Nearly twenty years later there were two further grants from Sherwood Forest of fifty oaks in 1252,[27] and sixty oaks in 1254 on the accession of the new bishop, Henry Lexington.[28] Some of this was probably used to complete the roofing of the nave and western chapels, and dendrochronology suggests that some was probably left over for the roof of the next great building. This must have started sometime after 1256 when the Dean

and Chapter received licence from the king to demolish part of the city wall in order to extend the Cathedral eastwards.[29] Twenty years later, in 1276, just four years before the consecration of the new Angel Choir there is a grant of '50 oaks in Sherwood Forest whereof 6 shall be *transversar*' for the new works of the king's gift'.[30] Oliver Rackham has suggested (pers. comm.) that *transversar*' here indicates the need for trees of a particular quality for a special purpose.

Tables I and II give particulars of the age, growth rates and dendrochronology of the timber used in the roofs of St Hugh's and Angel Choirs. These data, together with the distributions plotted in figure 10 show that at least three different qualities of timber were used in the Angel Choir. The re-used timber is contemporary and very probably from the same source as that of St Hugh's Choir (see p. 58). The different character of these timbers felled in late 12th and early 13th centuries from those felled in the later 13th century and used new in the Angel Choir roof is clearly shown in figure 10, which compares their radial measurements and their age (number of rings). The contrast between the two groups is in fact even greater than is here apparent, for the data for the early timbers are minimum figures since, because of the greater size and age of the trees used, many have lost rings in their reduction to the required dimensions, whereas those for the later timbers are maximum figures, the radii extending in all cases from the centre of the tree to the base of the sapwood. It is estimated that the earlier timbers came from trees 130–260 years old and the later timbers from trees 85–120 years old. As most of the latter have lost their outer rings of sapwood through insect attack and decay only 65–90 rings of their growth remains. Such short ring-sequences are difficult to match into a dendrochronology and further samples will be required before this can be done with confidence. The original (i.e., new) timber in the Angel Choir roof was identified as being of late 13th-century date by its lack of any indication of re-use and from the original carpenters' marks on the members sampled. Three of the later 13th-century timbers it will be noticed are grouped with the earlier timbers (Fig. 10). These samples are the only ones yet taken from tie-beams in the roof (Table II, 2). They match together to form a dendrochronology of 226 years from 1022 to 1248.[31] If it is assumed that the final ring is at the base of the sapwood this would allow a felling date of c.1278. From this date and the distinctive character of the timber there can be little doubt that these tie-beams are the *transversar*' referred to in the grant of timber from Sherwood Forest in 1276.

The re-used timber in the Angel Choir roof, like that of St Hugh's Choir is comparatively straight-grained and knot-free with few waney edges, while the later timber is more often knotted, crooked and shows the full circumference of the trunk indicating that the carpenters were getting the required length from their timber only with difficulty (Pl. XIB). They also had the problem of constructing a rigid structure from timbers some of which would warp and shrink and others of which would not. A means devised to counteract these potentially destabilizing effects was to pair the re-used timbers when used in a vertical position. Thus, for example, a soulace of re-used timber on the south side of a frame is matched by one of re-used timber on the north side also. Such preliminary dating results as have been obtained for the new timber used in the roof suggest that seasoned timber — presumably from the royal grants from Sherwood Forest in the 1250s — may have been used as well as 'green' timber of the 1276 grant. This mixing of timber of different felling dates and the use of timber from comparatively immature trees which has split and shrunk and shed its sapwood since it was built into the roof, and been patched and repaired in recent centuries, contributes to a general impression of 'slight scantling and bad work-manship' which Sir Robert Smirke also noted in the original roof of the principal transept. The fact that this roof has survived is a tribute not only to generations of Keepers of the

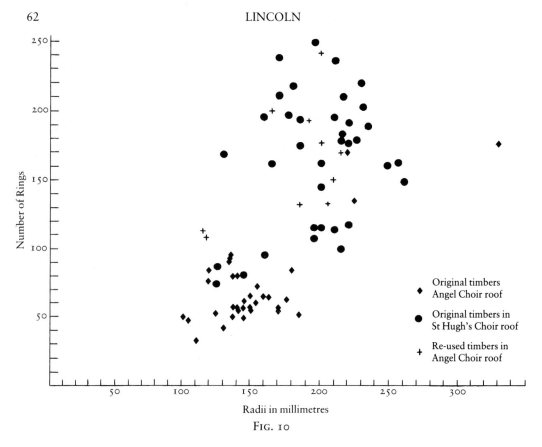

Number of Rings

Radii in millimetres

Original timbers
Angel Choir roof

Original timbers in
St Hugh's Choir roof

Re-used timbers in
Angel Choir roof

Fig. 10

Fabric but also to the master who, *c.*1200 designed a roof which has stood the test of time, and with minor modifications was suitable, not only for the earliest choir and the latest, but for most of the Cathedral's high roofing.

REPAIRS AND ADDITIONS TO THE MEDIEVAL ROOFS

For over two hundred years after the consecration of the Angel Choir in 1280 there is no evidence for any major work in the medieval roofs of the Cathedral. Nevertheless it is probable that routine maintenance and minor repairs took place. The lead, particularly on the steeply pitched east transept roofs, would not have remained in good order for so long. It was presumably following a stripping of the roof covering of St Hugh's Choir in preparation for re-leading that the four curious frames truncated above the bottom collar were inserted (Fig. 11). It is difficult to see how it could otherwise have been done. They are also in the nave roof and are spaced at six frame intervals as opposed to four over the choir. Four samples, from a brace and tie-beams of those in St Hugh's Choir roof have given a tree-ring date for the felling of the timber of *c.*1513.[32] Apart from their truncated form, the frames differ from the original tie-beam frames in the bracing of the basal angles. The passing brace construction used with secondary rafter and soulace in the medieval roof is here used with struts and simple braces which in the nave roof are curved. Mortice and tenon joints are used throughout and the occurrence of other joints (as in the queen-posts) or ironwork are, as will be shown, the result of later repairs.

Indication of the function of these frames may perhaps be found in the collar-beams which invariably have their soffits about level with the tops of the lowest collars of the original frames. Thus short purlins lapped over the original collars abut against the faces of the intrusive collars and so help to prevent racking of the roof frames. Their squat form and solid tie-beams give them a much lower centre of gravity than the medieval frames and so make them anchor-points against which the latter are held by the ends of the purlins. If this theory is accepted it provides the earliest secure evidence for the introduction of purlins into any of the roofs. Further progress on this problem will involve more extensive sampling for dating purposes of the purlins themselves. Even then the interpretation of the results will be fraught with difficulty as purlins seem often either to be made from young trees, re-used timber or pine.

There is no evidence for further work in the roofs until the late 17th century. As in the medieval period the results obtained by dendrochronology are complemented by documentary evidence of varying quality and detail. Work resumed following the Restoration after

the Dean, Chanter, Chancellor and sub-Dean out of zeal to God's Glory and their good affection to the Church did declare — on May 11th, 1661 — that they would give £1000 towards the repairs of the cathedral church.[33]

Major new works were undertaken also with the building of the fine new library presented by Dean Honeywood and designed by Sir Christopher Wren in 1674.[34] In the high roofs of the Cathedral, new frames (nos 35 and 36) were erected over the west end of St Hugh's Choir (Figs 3 and 12). These are two king-post frames — there may once have been more — and five samples taken from their collars, rafters and curved braces gave a date of c.1682 for the felling of their timber. They provide the first evidence for the use of iron (other than nails which are found occasionally in even the earliest roofs) for the bridled scarfs of the rafters are secured with forelock bolts. Other repairs done with oak felled c.1700 were, the replacement of some of the lead-covered parapet boards along the eaves of the Angel Choir or eastern transept, and of some of the queen-posts of the St Hugh's Choir roof (Fig. 7e).[35] The latter were tenoned into the original mortices in the collars, but the joint into the tie beam was a lap-joint cut just in front of the original mortice and supported by an iron stirrup secured with a forelock bolt.

Repair works recorded in documentary sources from the 18th century onwards consisted of small scale operations like those just described interspersed with major works. The first of the latter was undertaken in the roof of the Angel Choir and for it, oak felled in 1703–5 was used.[35] The work involved the replacement of rotted wall-plates, sole-pieces, rafter-feet and ends of collar-beams and was probably completed within the first decade of the century. Then, similar repairs were carried out in the roof of St Hugh's Choir. Here the felling dates of the timber span a much longer period, from at least 1713–25, and this makes it difficult to know if the work progressed slowly, the trees being felled as required, or quickly, using timber which had been in store for varying lengths of time.[36] Perhaps the latter is more likely for there is documentary evidence for fund-raising in 1723 when a circular letter was sent to the prebendaries appealing for subscriptions towards repair of the Cathedral.[37] Three years later a general subscription was raised[38] and Bishop Reynolds gave the Dean and Chapter authority to use the medieval bishop's palace as a source of building material for the same purpose.[39]

From about the middle of the 18th century there is a fairly comprehensive series of architects' surveys, fabric accounts and contractors' bills. This is fortunate because about this time imported pine, which it would be difficult to date by dendrochonology, was

generally used for roof repairs. In mid-19th-century accounts it is called Crown Memel or 'best Baltic timber'. James Essex, son of a joiner, became architect to the Cathedral *c*.1760 and seems to have first used 'fir' which was shipped up the Trent to Gainsborough in 1762 for the rebuilding of the roof of the Chapter House the same year.[40] The ironwork, particularly the stirrups and forelock bolt fastenings used here (Pl. XB) are readily distinguishable from the lighter type used in late 17th and early 18th centuries.[41] They can be found also in the roofs of the Angel and St Hugh's Choirs.

Work in St Hugh's Choir in Essex's time is recorded on a small lead plaque nailed to the north side of frame 23 naming J. Hayward, C[lerk] o[f] W[orks] (?) and dated 1765. Documentary confirmation of this is given, without being very clear about the extent of the work, in the copy of Essex's 1761 survey of the fabric in the Lincoln Archives Office[42] where he has added dates of completion for the repairs he proposed. It is unfortunately not clear if the ten massive frames (Fig. 3, nos 25–34; fig. 13) over the westernmost bay of St Hugh's Choir belong to this time. Much of their ironwork looks comparable to that of the Chapter House, but there are also screw-threaded nuts and bolts. The earliest evidence for their use in the Cathedral roofs comes in a general report of the Clerk of Works, William Hayward, dated 1799 in which he recommends their use to tighten loose joints in the roof of the north-west transept.[43] They are found in their most primitive, and so presumably earliest, form in the heightened roof of the Chapter House which belongs to the early years of 19th century (Pl. XB).[44] So the frames in pine in St Hugh's Choir roof probably belong to the 19th century and were the last major repairs there until those of 1979–80.

The roof over the eastern crossing has not yet been studied in detail but it certainly has oak members, which must belong to the earliest and/or latest phase of medieval building, as well as softwood timbers and elaborate iron strapping, some of which must have been inserted by Essex. In his survey of 1764 he has a sketch of the crossing roof supported on a central post which rests on the top of the stone vault beneath.[45] He recommended that this be removed and the weight taken by raking struts midway up the roof.

The roof of the Angel Choir has been extensively repaired over the last 250 years. Since much of the new timber has been softwood it is only possible to learn the details by study of the documents and the typology of the ironwork. Correlation of these sources suggests the general course of the repairs and additions to the roof. As indicated above, one of Essex's major concerns in his two surveys of the Cathedral was with the stresses laid upon the walls and vaults by roof frames 'running from the perpendicular' (racking) and with the injudicious attempts of his predecessors to correct the fault. Attempts had been made to counter the racking by bracing the sole-piece frames against the centres of the tie-beams. The extra weight upon them and their weakness from rotting at the ends caused them to sag which made their joints with the queen-posts spring. So they became ineffective in their function of holding the roof-line together laterally and its spreading outwards caused stress upon the wall-tops. This in turn put stress upon the vaults, as did the insertion of props, under the tie-beams to prevent them sagging, which rested on the vaults. Essex's solution to the problem was that:

In all parts of the roof the [tie] beams may be restored to their original use by hanging them to the collar-beams as they were at first and to hinder the rafters from running braces [i.e. raking shores?] should be placed under them so as to press upon the ends of the [tie] beams and not upon the middles of them, or near it, as many do now.[46]

These observations were occasioned by his examination of the roof of the north-west transept, but he stated that they were equally applicable to all the high roofs. In his survey of 1764 he recorded what had been done in the intervening three years:[47]

The roofs over the East end and over the nave which have been repaired are done very well and made secure. The smith however has overloaded the roofs with iron. Many of the king (*sic*) posts have heavy straps at the bottoms and for the same quantity of iron he could have put them also at the tops where they are much needed now on account of the additional weight of iron below.[48]

The above remarks and quotations from Essex's surveys give an insight into his scholarly interest and thorough understanding of the Cathedral and its maintenance requirements. In the Angel Choir, Essex's contribution to the repair and maintenance of the roof must have been the introduction of raking shores in softwood, the use of softwood for repair or replacement of existing timber and the securing of queen-posts to collar and tie-beams with iron stirrups and forelock bolts.

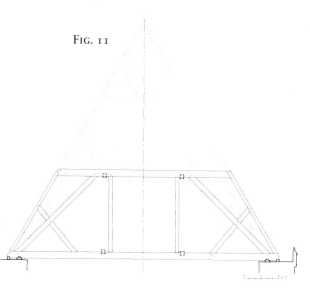

FIG. 11

FIG. 11.
St Hugh's Choir: truncated frame

FIG. 12.
St Hugh's Choir: frames 35 and 36 against the Tower (*c.*1700)

FIG. 13.
St Hugh's Choir: softwood frames

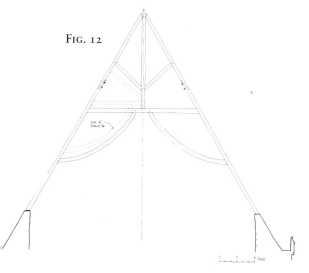

FIG. 12

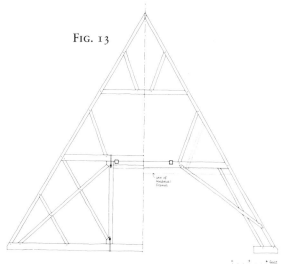

FIG. 13

The next occasions when the Angel Choir roof features prominently in the Cathedral archives were in Charles Hollis's report of 15 September 1825 and Sir Robert Smirke's report of the following year.[49] They noted that rotting of the timbers due to damp affected particularly the sole-pieces, wall-plates, tie-beams and rafters in the area of the eaves angle. Some of the collar-beams and queen-posts were also decayed and loose from the framing. The replacement of rotted timber with new pieces scarfed onto the old was advocated. Hollis wrote:

As most of the tie-beams require to be replaced it would be injudicious to trust so extensive a building to so many pieced and repaired tie-beams. It would be proper to introduce some new beams and truss framing and connect the rafters by purlins.[50]

This was very much what was done, presumably following his advice and under his supervision. The rotted ends of the tie-beams were cut off and either a new piece of softwood was scarfed onto what remained of an original oak tie-beam or two pieces of original tie-beams were scarfed, bound with iron stirrups and bolted together with screw-threaded nuts and bolts to make up the length of one (Pl. XD). Only the tie-beam of frame 52 survived this drastic operation intact — until it too had its south end replaced in recent repairs. This work left eight major frames without tie-beams and these were rebuilt in softwood below the bottom collar. The same design was used as for frames nos 25–34 in St Hugh's Choir (Figs 3 and 13).

Eastward racking in the roof was still a serious problem, the rafters being (in 1826) between 6 in. and 3 ft out of perpendicular.[51] Purlins, which Hollis advocated, were helpful but 'struts and braces placed to correct the evil (have) introduced other faults' — as Essex found.[52] The medieval builders expected that the frames of the roof would be kept in place by the horizontally laid battens connecting the rafters and by their own weight and that of the covering lead. The great advantage of having stabilising properties built into the covering skin was that the weight was equally distributed over the whole structure and dangerous stresses would not be generated. Unfortunately the skin was not up to this task — at least not over long periods of time. What was needed was a covering having the strength and flexibility of a clinker-built boat. A means to achieve this was found probably sometime in the 19th century by laying the battens diagonally across the rafters and in opposite directions on either slope of the roof.[53] At Lincoln battens laid diagonally in the same direction on the lower roof slopes and horizontally above are found in the eastern transept, the east end of the Angel Choir and in the south-west transept. In the latter roof it seems quite likely that the battens are of the same date as the roof itself (see p. 53) and a board inscribed in chalk 'James Smith, 1847' nailed to the rafters just below the middle collars of the east end of the Angel Choir roof suggests work in progress there at about the same time. It is not known when or where this technique was first introduced, but it is found also in the roofs of the nave and south-west transept of Westminster Abbey where Sir Gilbert Scott was consulting architect from 1849–78.

DISCUSSION AND CONCLUSIONS

Dendrochronological study of the re-used timbers in the roof of the Angel Choir and the original timbers of the roof of St Hugh's Choir has shown that they were probably felled at about the same time and came from the same source. Superficial examination of the timber of the two inner bays of the eastern transept suggests that it too was of the same period. If it is accepted that the re-used timbers were part of the roof of St Hugh's presbytery then it had

scissor-braced frames. It would have been the first roof of the church to be erected and the order of construction of the existing roofs can be deduced from the joints and associated carpenters' marks which are on one face only of the frames: that facing the direction in which the work was progressing. So it can be deduced that the south-east transept roof was built from the south towards the crossing, the north-east transept from the crossing northwards and St Hugh's Choir from the crossing towards the central tower. The roofs were probably built in this order. The crossing would have required some of the longest and most substantial timbers for the valley rafters and horizontal cross-members. Such timbers were also used in the roof over the two inner bays of the south-east transept and the inner bay of the north-east transept where every rafter was a single piece of timber. The notched-lap joints have the same profiles in these bays. It is only in the middle bay of the latter that the rafters are of two pieces scarfed together and the use of carpenters' marks and other slight differences of construction from the inner bay must indicate a different team of carpenters at work here. Whether or not it was roofed before work started on St Hugh's Choir is not certain, but here again another team of carpenters was involved for not only are the frames of a different design but the carpenters' marks are quite different.

The tree-ring dates for all those timbers from St Hugh's Choir roof which have trace of sapwood are given in Table I. They are not arranged in chronological order of their final ring-dates as is usual, but grouped frame by frame in sequence. It can be seen that the dates are entirely random in that there is no trend of early to later dates from east to west. This suggests that the timbers may have come from a yard where they had been accumulating over a number of years. The only timber with sapwood surviving complete was sample no. 148, from a tree well over two hundred years old felled in 1195–6, which was used in frame 16 right in the middle of the roof. Probably the last tree to be felled — a comparative youngster of 140 years growth — is represented by no. 142 which came from frame 9 at the east end of the roof. The chances of this having had only six or seven rings of sapwood and thus the same felling year as no. 148 are extremely small. Thirteen sapwood rings is about the minimum that can be expected. Clearly the Choir, although well-advanced in construction by the time of St Hugh's death in November 1200, cannot have been roofed and vaulted until some years later. At the consecration of the church in that year only the presbytery, the south-east and perhaps the north-east transepts can have been finished, for it is assumed that construction of the vaults would have closely followed completion of the roof which would have kept the weather off them while the mortar was setting. Their tie-beams might have formed a working platform and means of access from above.

The survival of two-thirds of the original roof of the choir with comparatively few repairs is in marked contrast to its western third which was entirely rebuilt in late 18th–early 19th century. On this evidence alone it can be confidently concluded that the western twelve frames (nos 25–36) of the original roof were destroyed in the collapse of the tower c.1238, and that their replacements, being less well constructed than the originals, in turn themselves needed replacing. That this is the correct explanation can be seen in the crown of the vaults beneath. To the east of frame 26 the upper surfaces have a mortar rendering as elsewhere over the original vaults of the east end, but to the west there is no rendering and their rough, uncoursed rubble construction can be seen. The roof and then the vaults would have suffered the severest damage from the falling masonry and the clerestory walls above the vaults rather less. From the eastern crossing the latter are of squared ashlar in random courses with a continuous chamfered plinth along the inner edge. The extent of damage done to the walls is indicated by its absence to the west of frame 29. The actual point of change is not easily seen as it is hidden by a modern walkway to a door giving out onto the roof parapet. These conclusions are consistent with ones reached from study of the

underside of the vaults, clerestory windows and other masonry details of the western bay of the choir.[54]

There seems to be some indication in the early 13th-century roofs of the east end of a tendency to use more substantial timbers and older trees in the earliest work (see Table II.1). It is not yet known if there is a continuous decline in the age and quality of the timber used in the successively later roofs but figure 10 makes this contrast between the earliest and the latest roof very clearly. That suitable timber for the roof of the Angel Choir was difficult to obtain is shown by the special mention of the requirement of trees of sufficient size for tie-beams. It can also be seen in the roof itself in the re-use of timber, the quantity of waney edges, roundwood and timbers running out (Pl. XIB) and the need for additional soulaces and a third collar (Fig. 5c) to the frame designed originally for St Hugh's Choir roof. Here the carpenters were having to make do with timber of smaller dimensions than that to which they had been accustomed, and perhaps high demand on timber resources over the previous century had a lot to do with this state of affairs.

As the high roofs of Lincoln survive almost complete it can be seen how minor and comparatively few were the changes of design made over the period of about seventy-five years. Apart from those just mentioned, the only others of any consequence were to the rafter scarfs (Fig. 6) and the jointing of the queen-posts to the tie-beams (Fig. 7). Changes in the queen-post joints show attempts at the early solution of a problem which was noted by James Essex. The queen-posts were subject to tension and in the original (St Hugh's Choir) design hung literally upon the two pegs holding the tenons in their mortices. As the timbers seasoned *in situ* and the frames settled, the collars and tie-beams sagged at differential rates, the tension increased and the pegs gave way. It was probably the realisation of this eventuality which led to the adoption of the lap-joint in this position in the western half of the nave roof and the eastern half of the Angel Choir roof, where the cambering of the tie and collar-beams would have to some extent alleviated the stressful tendencies. Finally the lap-dovetail with square, housed shoulders was adopted in preference to the lap-joint in the western end of the roof. It is of interest to note that these members where they appear in French roofs are termed *clés pendantes*.[55]

In the analysis of the roof of the presbytery at Westminster Abbey it was observed that, in common with continental church roofs of 13th century, it had a pitch which was steeper than Romanesque predecessors.[56] This is nowhere more apparent than in the roofs of the eastern transept at Lincoln. The particular reason for their steepness must be that these minor transepts were not as wide as other parts of the Cathedral, yet it was desired that their roof lines should be level with those of choir and presbytery. The reason for the greater pitch of Gothic roofs is not known. As McDowall points out, buildings were generally not bigger than before but the thrust upon the walls would be reduced, following the reduction in the number of tie-beams to lighten the roof load — a development which is seen in continental churches.[57]

Although there is supporting evidence for this development in the roofs of continental churches there is very little evidence in this country. Such as it is, Waltham Abbey roof of mid-12th century on Hewett's reconstruction[58] has tie-beams to every frame, but is otherwise more comparable in design to other roofs which according to Hewett are either contemporary[59] (East Ham) or earlier[60] (Chipping Ongar) and apparently have no tie-beams at all. The same basic design on a larger scale is found in the early 13th-century roofs over the nave of Wells Cathedral. Here by reason of the greater span, additional supporting timbers were required. The addition of soulaces below the lowest collar together with the ashlar-pieces and the rafters, make a seven-canted void. There is also an upper collar and a post between it and the lower one, and presumably there were originally tie-beams at

regular intervals. Hewett had Wells Cathedral particularly in mind, when he suggested that the Waltham Abbey roof was basic to a long series of developments traceable in English high roofs.[61] A later form of the design is found at Lincoln in the roof of the Chapter House vestibule (Fig. 2) which has a tree-ring date of *c*.1234. The frames have tie-beams every fourth couple and span 26 ft. There are two collars, with V-struts to the rafters on the lower, and below, soulaces and ashlar-pieces framing a seven-canted void. At the west end of this roof smaller, contemporary roofs of almost the same design are found over the stair turrets, except that here, since the spans are less, the soulaces are omitted, so that ashlars, rafters and collar frame a five-canted void. These roofs are of the same design as those over the West Range at Ely and the nave of the parish church at Little Hormead, Herts. which, if contemporary with the buildings they cover, should date to the end of the 12th century.[62] At the west end of the Cathedral the Consistory Court (*c*.1250) has a roof spanning 30 ft of a similar but slightly modified design to that over the Chapter House vestibule.

The roofing tradition outlined above has its beginnings in Romanesque building, perhaps even before the Conquest. All the roofs so far discussed are church roofs designed to sit atop stone walls. It is perhaps unfortunate, therefore, that much of the discussion about the introduction of continental forms of diagonal bracing into Britain has involved early domestic buildings also, and so obscured the fundamental importance of church roofs which was first recognised by Fletcher and Spokes.[63] They have summarised the continental evidence and described three types of diagonal (or 'passing') braces which appear in France in the second half of the 12th century. They are scissor braces, secondary rafters and lateral longitudinal braces. The first two forms were used contemporaneously in the east end of the Cathedral (Fig. 4).

Roofs with secondary rafters comparable to those at Lincoln are found in primitive form over the north transept of Noirlac Abbey, the nave of Lisieux Cathedral and later in the roof over the chapel of the hospital of St John at Angers,[64] founded by the English king Henry II. Most features of the roof of the south-east transept at Lincoln are found in the 12th-century roof over the nave of the church at Hermonville (Marne).[65] The principal differences are that the secondary rafters pass across V-struts in the base angles rather than soulaces, as at Lincoln, and it has the low pitch (42°) of a Romanesque roof. Frames with sole-pieces alternate with tie-beam frames (Table III).

Scissor-bracing on the Continent may not occur quite so early or so often. It is found in the roofs at Lisieux and Angers just mentioned. The latter is of great size with tie-beams 59 ft (18 m) long of two timbers scarfed together. They are spaced at every five frames and are supported at third intervals along their length by two queen-posts (*clés pendantes*) which are halved across them and across the scissor-arms and are lap-jointed into the rafters.[66]

These two types of bracing, which occur in north-east France either separately or even at Angers, with queen-posts, together in a single roof, do not seem to be found in English roofs over stone buildings before the late 12th century when they are found at Lincoln. It is doubtful if there is any lateral longitudinal bracing at Lincoln in any of the original roofs. Its function, like purlins, was to link the frames together and keep them upright. Deneux observed that although wall-plates were normal there was not much evidence for either lateral longitudinal bracing or purlins in French roofs before the 13th century, although many of those roofs without had one or both added later.[67] It is not unexpected, therefore, that there should be no evidence of either in the earliest Lincoln roofs, but perhaps rather more surprising that there is little firm evidence of either in the later medieval roofs also. A useful summary of the principal characteristics of French roofs of the 11th and 12th centuries is given by Fletcher and Spokes.[68]

TABLE III

Earliest Continental and English roofs on stone buildings

	FRANCE, W. GERMANY, BELGIUM			ENGLAND		
	Romanesque tradition	Early Gothic (passing braces) Secondary rafters	Scissor braces	Romanesque tradition	Early Gothic (passing braces) Secondary rafters	Scissor braces
1100	Soignes Cathedral (nave)[57]			Chipping Ongar (chancel)		
1150	Soignes Cathedral (choir)[57] Paris, Montmartre (nave)[65]	Noirlac Abbey		East Ham (chancel) Waltham Abbey (nave) Adel Church (chancel)[81]		
1200	Troyes, La Madeleine (nave)[63] Blaton Church (nave)[63]	Lisieux Cathedral Angers (St Johns Hospital Chapel) Hermonville (nave)	Tournai Cathedral[63]	Little Hormead Church Ely, West Range Wells Cathedral (nave)	Lincoln Cathedral (choir & transept)	Lincoln Cathedral (presbytery & transept)
	*Mantes, Notre-Dame[65]	*Etampes, Notre-Dame choir[63]		Lincoln, Chapter House	Lincoln (nave)	
1250		*Grossenbuseck[80] (chancel)	Bayeux Cathedral[7] *Tours Cathedral[63]	Roydon Church (nave)[5]	Beverley (choir)	*Salisbury (transept) Ely (presbytery)
		Marburg (nave)[4] (St Elizabeth Church)		Lincoln, Consistory Court	York (north transept)	*Westminster Abbey
1300	*Paris, St Leu-St Gilles[65]		†Bourges Cathedral[7]			*Merton Coll, Oxford
						York, Chapter House

* Indicates roofs which have contemporary lateral longitudinal bracing and/or purlins
† With ridge-pieces only

The Lincoln roofs are perhaps a few decades later than the French examples cited. Their remarkable features are the very steep pitch of the transept roofs, the contemporary but discrete use of scissor bracing and truncated secondary rafters in those roofs, evidence for at least two teams of carpenters at work, and the appearance (over St Hugh's Choir) of a roof design with secondary rafters and queen-posts which was to be used in the Cathedral for the next seventy-five years. The width of the eastern transept roofs is such that there would have been no difficulty in roofing them with a traditional type of Romanesque roof without passing-braces. The nave and the choir were presumably considered too wide for a roof of this type. It was used over the nave at Wells but there the span was at least 5 ft less than Lincoln. The significance of the variety of the roofing of the east end of Lincoln Cathedral is probably that innovation and experiment were in progress. The roofs are perhaps the earliest with passing-braces in the country and built at a time when carpenters had yet to reach a satisfactory solution of the problems of building higher roofs which combined the advantages of the new continental technology with the old form of Romanesque truss.

The Lincoln design of roof truss seems to have been seldom imitated elsewhere. The only obvious example is at Beverley where there are many points of comparison with Lincoln in the masonry detail also.[69] It may be significant too that some of the roofing there is built of timber from Sherwood Forest. A grant of twenty oaks to the provost of Beverley is recorded in 1240;[70] there was another of forty oaks to him in 1244;[71] and a grant of sixty oaks 'to the treasurer of St John's Church for its building' was made in 1252.[72] The earlier grants may have been to the provost personally and the later one has been taken to refer to the choir, but it is possible that all three were used in the Minster, the latest and largest being intended for the greatest area of roofing over the principal transept.[73] The roof over the north transept at York Minster, of probably mid-13th-century date, is known from a drawing by A. Pugin.[74] It had a design which, like Angers, combined secondary rafters with scissor braces and is in some respects comparable also to the present roof of the south-west transept at Lincoln, which gives credence to Hewett's views on it (see p. 53). The roof over the north-east transept of Salisbury Cathedral c.1240 has scissor-braces with queen-posts but there similarity ends, for here there are original and more advanced features, not found anywhere at Lincoln, such as secret notched-lap joints and side purlins.[75]

By contrast the scissor-braced design rejected at Lincoln seems to be at the head of a long succession of almost identical designs:[76] (Ely presbytery, c.1245 and Blackfriars, Gloucester, c.1255) or derivative designs[77] (Salisbury, c.1240 and Westminster Abbey, N. transept and presbytery, c.1269), which continue to the end of the century[78] (Merton College Choir, Oxford, c.1294) and into 14th century[79] (York, Chapter House vestibule), (Table III). Blackfriars, Gloucester is the only other building where the rather weak scissor-splay-stopped scarf joint used in the roof of St Hugh's Choir has been found.

The roof construction of St Hugh's Choir, was original and innovative when first built, but the Lincoln carpenters repeated the design with few significant modifications of their own or adoption of new developments taking place elsewhere. Other master carpenters, among them builders of scissor-braced roofs, were more innovative or readier to accept new technology as the example already given of the north-east transept roof of Salisbury serves to show.

ACKNOWLEDGEMENTS

We are grateful to the Dean of Lincoln, the Very Reverend, the Hon. Oliver Fiennes who has permitted us access to the Cathedral roofs; to Reg Godley and Peter Hill, successive Clerks of Works, and their staff for their assistance with problems of sampling and surveying; to Keith Murray, consultant

architect to the Cathedral; to Professor M. W. Barley, Mr A. Cameron, Dr P. W. Dixon and Dr Oliver Rackham for helpful discussion of the results; to Dr C. Salisbury for his photographic record of the roofs and to Dr R. Laxton for his help and encouragement in many aspects of the work, both academic and administrative; to Arthur Robinson and John Bloor of the Works Department, University of Nottingham for their assistance in the preparation of samples and maintenance of equipment and to Mrs Ruth Robinson for the typing of this manuscript.

SHORTENED TITLES USED

HEWETT (1974) C. A. Hewett, *English Cathedral Carpentry* (London, 1974)

HEWETT (1980) C. A. Hewett, *English Historic Carpentry* (London, 1980)

SMITH (1974) J. T. Smith, 'The Early Development of Timber Buildings', *Archaeol. J.*, 131 (1974)

McDOWALL *et al.* (1966) R. W. McDowall, J. T. Smith, and C. F. Stell, 'Westminster Abbey. The Timber Roofs of the Collegiate Church of St Peter at Westminster', *Archaeologia*, 100 (1966)

LAXTON *et al.* (1985) R. R. Laxton, C. D. Litton, and W. G. Simpson, 'Tree-Ring Dates for East Midlands Buildings', *Vernacular Architecture*, 16 (1985)

REFERENCES

1. Hewett (1974).
2. Ibid., fig. 9.
3. W. J. Blair, J. T. Mumby and O. Rackham, 'The thirteenth century roofs and floor of the Blackfriars priory at Gloucester', *Med. Archaeol.*, 22 (1978), 105–22.
4. Smith (1974), 238–63.
5. Hewett (1980), figs 139 and 234. The terms used for the carpentry joints and structural ironwork and reinforcement in this article are those used by Hewett.
6. LAO, D & C. The Ark, no. 22.
7. Hewett (1980), fig. 79. McDowall *et al.* (1966), 167.
8. LAO, op. cit., note 6.
9. Hewett (1974), fig. 19.
10. Hewett (1980), fig. 278.
11. British Library, *Add. Ms.* 6769, 122.
12. F. Bond and W. Watkins, 'Notes on the Architectural History of Lincoln Minster from 1192 to 1255', *RIBA Journal*, 18 (nos. 2–3; 1910), 34–50, 84–97.
13. Rev. E. Venables, 'Notes of an examination of the Architecture of the Choir of Lincoln Cathedral with a view to determining the chronology of St Hugh's work', *Archaeol. J.*, 32 (1875), 229–38.
14. R. R. Laxton, C. D. Litton, W. G. Simpson and P. J. Whitley, 'Tree-Ring Dates for some East Midland Buildings', *Trans. Thoroton Soc.*, 86 (1982), 73–8.
15. Ibid., No. 13a.
16. H. C. Darby, *Domesday England* (Cambridge 1977), fig. 62 gives some idea of the local sources from which this timber may have come.
17. R. R. Laxton, C. D. Litton and W. G. Simpson, 'Tree-Ring Dates for East Midland Buildings: 2', *Trans. Thoroton Soc.*, 87 (1983), 40.
18. M. G. L. Baillie, 'Some thoughts on Art-Historical Dendrochonology', *J. of Archaeol. Science*, 11, no. 5 (1984), 381–3. M. K. Hughes, S. J. Milson and P. A. Leggett, 'Sapwood Estimates in the Interpretation of Tree-Ring Dates', *J. of Archaeol. Science*, 8, no. 4 (1981), 381–90.
19. Laxton *et al.* (1985), 40. For the significance of t-values see M. G. L. Baillie, *Tree-Ring Dating and Archaeology* (Croom Helm 1982).
20. *Cal. Patent Rolls I* (1201–16), 88. The translation of the text which has been followed here is that given by G. A. Poole, 'The Architectural History of Lincoln Minster', *AASR*, 4 (1857–8), 18 and 39.
21. VCH *Nottinghamshire*, 2, 91. We are grateful to Mr Alan Cameron of the Manuscripts Department, University of Nottingham for this reference and also for helpful discussion of the text.
22. A useful discussion of the Interdict and its effect, particularly on the sees of Wells and Lincoln may be found in J. A. Robinson, *Somerset Historical Essays* (London 1921), 141–59. For a good, more recent account of its wider implications see W. L. Warren, *King John* (London 1978), 164 ff.

23. Hewett (1974), 15 and Hewett (1980), 69.
24. *Cal. Close Rolls* (1227–31), 472.
25. C. W. Foster, *The Registrum Antiquissimum of the Cathedral Church of Lincoln*, 2 (LRS, v. 28, 1933), 72.
26. *Cal. Close Rolls* (1234–37), 77. We are grateful to Dr Rackman for bringing this source to our notice.
27. Ibid. (1251–3), 36.
28. Ibid. (1253–4), 296.
29. *Cal. Patent Rolls* (1247–58).
30. *Cal. Close Rolls* (1272–9), 277.
31. Laxton *et al.* (1985).
32. Op. cit., note 17.
33. British Library, *Add. Ms.* 32639, f. 256.
34. The contract between Dean Honeywood and William Evison, the builder, dated June 1674 is published in full in *Wren Society Publications*, 17, 76–77.
35. Laxton *et al.* (1985).
36. Op. cit., in note 14.
37. LAO, A/4/10, no. 45.
38. T. Cocke, 'James Essex, Cathedral Restorer', *Architectural History*, 18 (1975), 12–22.
39. T. Ambrose, *The Bishop's Palace, Lincoln*, Lincolnshire Museums Information Sheet, Archaeology, 18 (Lincoln 1980).
40. LAO, Bj/1/13–16. British Library *Add. Ms.* 6772, 264ᵛ–265.
41. Hewett (1980), figs 241–2.
42. LAO, D & C. The Ark, no. 22.
43. Ibid. For a history of the development of these fastenings see 'Nuts and Bolts', *Scientific American*, 250, no. 6 (June, 1984), 108–15.
44. Rev. E. Venables, 'Architectural History of Lincoln Cathedral', *Archaeol. J.*, 40 (1883), 397n.
45. British Library *Add. Ms.* 5842, 341.
46. LAO, D & C. The Ark, no. 22. 7.
47. LAO, D & C. The Ark, no. 22, 9. and British Library *Add. Mss.*, 6769, 121–7.
48. Op. cit., note 45.
49. LAO, D & C. The Ark, no. 22.
50. Ibid.
51. Ibid.
52. Ibid.
53. McDowall *et al.* (1966), 158, 166.
54. J. Baily, 'Some preliminary observations on the history of Lincoln Minster in the years 1195–1255' (unpublished Ms. Leeds School of Architecture, no date), 53. B/E, *Lincolnshire* (Harmondsworth 1964), 97.
55. Smith (1974), 251.
56. McDowall *et al.* (1966), 173.
57. J. M. Fletcher, 'Medieval Timberwork at Ely', in *Medieval Art and Architecture at Ely Cathedral. BAA CT* (1979), fig. 2, 62.
58. Hewett (1980), fig. 46.
59. Ibid., figs 31 and 32.
60. Ibid., fig. 30.
61. Ibid., 57, 72 and fig. 71, 83.
62. J. M. Fletcher and F. W. O. Haslop, 'The West Range at Ely and its Romanesque Roof', *Archaeol. J.*, 126 (1969), 171–6. C. A. Hewett and A. V. B. Gibson, 'The Nave Roof of the Parish Church of St Mary, Little Hormead', *Herts. Archaeol.*, 3 (1973), 126–7.
63. J. M. Fletcher and P. S. Spokes, 'The origin and development of crown post roofs', *Med. Archaeol.*, 8 (1964), 157.
64. Ibid., 158–66. Smith (1974), fig. 2.
65. H. Deneux, 'L'évolution des charpentes du XIe au XVIIIe siècle', *L'Architecte*, n.s. 4 (1927), 50, fig. 72.
66. Smith (1974), 243, fig. 2; 251, fig. 6.
67. Ibid., and op. cit. in note 65, 53 (6).
68. Op. cit. in note 63, 158–9.
69. L. Hoey, 'Beverley Minster in its 13th century context', *J. Soc. Architect. Historians*, 43, no. 3 (October 1984), 209–24.
70. *Cal. Close Rolls* (1237–42), 181.
71. *Cal. Close Rolls* (1242–7), 182.
72. *Cal. Close Rolls* (1251–3), 63.
73. Smith (1974), 245n.

74. Ibid. It was published as Pl. XXVIII in John Britton's *History and Antiquities of York Cathedral* (London 1819) and is reproduced in P. Kidson, P. Murray and P. Thompson, *A History of English Architecture* (Penguin 1969), 91, fig. 33.

75. Hewett (1980), 91–2.

76. Op. cit. in note 57, fig. 1 and op. cit., note 3.

77. Hewett (1980), 91–2; McDowall *et al.* (1966).

78. Op. cit. in note 63, fig. 49c.

79. Hewett (1974), and E. A. Gee, *York Minster: The Chapter House* (Royal Commission on Historic Monuments, 1974), fig. 41.

80. C. A. Hewett, 'The dating of French timber roofs by Henri Deneux: an English summary', *Trans. Ancient Monuments Soc.*, n.s. 16 (1968–9), 97, fig. A.

81. W. H. Lewthwaite and R. D. Chantrell, 'The Norman Roof of Adel Church, near Leeds', *AASR*, 19 (1887), 100–20.

The Medieval Painted Decoration of Lincoln Cathedral

By David Park

The surviving medieval painting of Lincoln Cathedral is much less distinguished than that of many other great churches in England, and likely enough goes unnoticed by the average visitor. Nevertheless, there are various remains which are of interest in their own right, and it is of course important to know as much as possible about the original painted decoration in order to be able to visualise how the cathedral would have appeared in the Middle Ages. Certainly, it would have been much more colourful than it is now. Some of the most interesting remains of painting have only been discovered within the last quarter of a century, and all the painting deserves much more attention that it has received hitherto.[1]

Even the sculptures of the west front were probably originally painted. In the 19th century, traces of colour were recorded on the Romanesque frieze: in the Feast of Dives, red on the hair of all three figures, and a light blue or blue green on the inside of Dives' cloak; and in the scene of the Soul of Lazarus on Abraham's Bosom, the ground was found to be painted red.[2] According to Kendrick, the 14th-century kings on the façade 'were originally coloured and gilt'.[3] Such painting of external sculpture would not be in the least surprising. As is well known, substantial traces of the original colouring survive on some of the 13th-century west front sculptures of Wells Cathedral.[4] In the case of the 14th-century west front of Exeter Cathedral, remains of colour have been found on various of the sculpted figures during recent conservation work, and in the Fabric Accounts a payment is recorded in 1341 '*In auro argento et diversis coloribus pro ymagine beati Petri depinguend*', presumably referring to the figure in the west gable.[5]

No Romanesque wall painting survives in Lincoln Cathedral, nor are there records of any. Slight traces of colouring survive, however, on fragments of Romanesque sculpture such as the figure of St Paul (*c*.1140–5), probably originally from the choir screen or the reredos of an altar.[6] From the end of the 12th century, Giraldus Cambrensis, in his *Life of St Hugh*, describing the eastern part of the Cathedral built during Hugh's episcopate (1186–1200), says that it was built 'with Parian stones and marble columns, alternately and fittingly arranged, and also with varied pictures in white and black, and indeed a variety of natural colours'.[7] *The Metrical Life of St Hugh* (*c*.1220) describes the rood screen, predecessor to the present pulpitum, which was presumably destroyed when the central tower collapsed in 1237 or 1239. The Latin text, which is rather unclear, is translated thus by St John Hope:

> Concerning the Rood and golden table at the entry of the quire,
> A golden majesty adorns the entry to the quire
> And the Rood with its proper image of Christ is suitably represented;
> The progress of his life is perfectly introduced there.
> Not only the cross or image, but the broad surface of the six pillars
> And of the two wooden beams glitters with refined gold.[8]

A splendid image of glittering gold is thus conjured up, and it may be that the scenes of Christ's life were painted, rather than carved or represented in gilded metal panels.

Slight remains of painting came to light in St Hugh's Choir in 1959,[9] and there seems no reason to doubt that they were contemporary with the fabric. On the main vault, traces of

painting were found on and beside the ridge-rib (Pl. XIIA). These traces indicated that the different mouldings of the ridge-rib were coloured red, blue and black and that the rib was accentuated on either side by a foliate border, each with an outer brown band. Further foliate painting was found next to at least one of the transverse ribs, and on these ribs themselves remains of painting were found extending 18 in. from the bosses. The bosses themselves were 'gilded solid, with red in the deep-cut crevices'[10] Unhappily, the painting on the vault has since been limewashed over again. Particularly interesting traces of painting were found in 1959 in the clerestory, in the second bay from the west on the north side (Pl. XIIB). The traces then recorded were simply a brownish-yellow stain on the stonework, and comprised painted circles around the trefoil and quatrefoil openings in the clerestory, smaller *painted* cinquefoil and other shapes, and painted crockets around the edges of the arches (one of these can still be seen, beside the main arch). If this record is accurate, and the conservator was right in believing that all the painting was originally in monochrome, then the suggestion also seems justified that a *trompe-l'oeil* effect was intended here, to suggest carved decoration from floor-level.[11] Dr Kidson has spoken of the variation of foiled forms in the clerestory and triforium of St Hugh's choir,[12] and this must have been even more striking when more of the painted cinquefoils and other shapes survived. Indeed, the use of painting here to fool the eye would be particularly appropriate to a part of the Cathedral so famous for the optical effects of its architecture.[13]

The most significant remains of medieval painting still visible in the Cathedral are on the vault of the south-west transept (Pl. XIIC). The ridge-rib is bordered on either side by red scroll pattern on a yellow ground, and white scrollwork on a green ground, with an outer border in red of alternate semi-circles and trefoil-ended stalks. As in St Hugh's Choir, painting on the transverse ribs themselves extends a short distance out from the bosses. In the interstices between the ridge-rib and the northernmost transverse ribs are two roundels each 16 in. in diameter, one enclosing the head of Christ with a cross-nimbus, and the other the head of a bishop (Pl. XIID). All this painting was fully uncovered in 1962; before that it was only dimly visible, and it was not realised that the roundels enclosed heads.[14] The surviving painting terminates half-way along the vault, though a few small fragments were found in bays further to the south where the cells had been largely replaced in brick in the 17th or 18th century.[15]

The western transepts seem to have been completed by c.1220, and it is possible that the painted decoration is as early as this, although it could have been carried out twenty years later at the same time as that in the nave (see below). It has been suggested that the bishop represented might be St Hugh (canonised 1220),[16] but this is impossible to verify, and it is noticeable that unlike Christ he has no nimbus. A similar use of painted borders to accentuate the ridge-rib has already been seen in St Hugh's Choir and is apparent in 13th-century painting elsewhere. Borders of a much more elaborate type flanked the vault ribs of the presbytery of St Albans,[17] whilst far simpler borders articulate the ribs of the chapter house of the Cistercian abbey of Cleeve.[18] Roundels enclosing scenes, single figures or busts are typical of English wall painting of the first half of the 13th century. Thus, in Winchester Cathedral, roundels enclosing busts of prophets and kings, and of angels, occur respectively on the vaults of the Holy Sepulchre Chapel (c.1220)[19] and Chapel of the Guardian Angels (c.1230).[20] The use of roundels is equally typical of stained glass and manuscript illumination of the period; indeed early 13th-century roundels enclosing figure subjects occur at Lincoln in the south window of the south-west transept itself.[21]

Identical vault decoration, though without roundels, can also still be seen in the north-west transept, though it has been entirely repainted at least once, and as a consequence of this treatment is darker in colour.[22] The bosses are gilded, and it can be seen more clearly

here how the parts of the transverse ribs next to the bosses are painted.[23] Recently, a surviving fragment of the original painting has been rediscovered in one of the Cathedral's store-rooms.[24] There is also an 18th-century record of an image of a painter on this vault, which will be discussed below.[25]

The vault of the nave also has painting, which has again been totally renewed but which appears to follow original work of *c.* 1240. In three places the ridge-rib is bordered on either side by decoration which, strangely, is a little simpler than that in the same position on the main transept vaults: it comprises scrollwork in red, and reserved in white on a yellow ground (Pl. XIIIA). It has been suggested that this painting originally bordered the entire length of the ridge-rib,[26] but there seems to be no evidence for this. In each case, the existing decoration links three bosses, and is thus reminiscent of the discontinuous ridge-rib in the nave south aisle, which likewise links three bosses at a time.[27] However, there seems to be no particular logic governing which bosses the painting links: in two cases, it is the central three bosses of a bay, and in the other the eastern three of a bay.

Painting of greater interest still surviving on the nave vault comprises three repainted inscriptions, each next to a transverse rib: FRICABON~; BRAUD꞉; and ꞉ WE꞉ PARIS꞉ (Pl. XIIIA).[28] More names were formerly visible; Sympson, who was Clerk of Works in the 1730s and 40s, recorded in his notes on the Cathedral that the following could be seen: Helias Pictor, Walterus Brand, Wilhelmus Baldwin, Ricardus de Ponte, Robert Saris, and Wilhemus Paris.[29] As Hill pointed out, at least some of these names probably commemorate men connected with the building or decoration of the nave.[30] Walter Brand was, at several times in the middle of the 13th century, one of the two keepers of the fabric, associated with the Works Chantry; whilst Richard de Ponte and William de Paris were both mayors of Lincoln in the mid 13th century, and might well have been associated with the building work.[31]

Helias Pictor was presumably one of the painters at work in the Cathedral; and this brings us back to the figure formerly visible on the vault of the north-west transept. Governor Pownall, writing on the subject of painters' dress, in the volume of *Archaeologia* for 1789, mentions 'a picture of one *Serrio*, which I remember was painted on the vaulted roof of the North transept of Lincoln Cathedral (but now washed out) . . . he was represented in a long gown, with long sleeves, as a master in his art, and of a party colour'.[32] Presumably, the only way Pownall could have identified this figure as Serrio — possibly a misreading of Serlo?[33] — was if his name was painted beside him. Whether the figure was really a painter must also be uncertain from Pownall's brief description; Serlo was an unusual name, but a Master Serlo was a canon of Lincoln in the mid 13th century.[34] This painting may have been of the same date as the nave vault names, and indeed as the decorative painting on the transept vault itself. Perhaps it still exists beneath the limewash on the vault.

In the nave aisles there is some very simple vault painting, consisting of trefoil-headed cusping in red beside the ribs. Although again entirely modern, it seems likely to reproduce the original decoration. The same trefoil-headed motifs decorate the edges of the painted borders of the ridge-ribs in the main transepts (Pl. XIIC). Identical cusping also borders the arches of the north arcade in the 13th-century painting in the nearby parish church of Nettleham; while the pattern is also paralleled in 13th-century painting at Stone (Kent),[35] and on the vault of the Treasury of Canterbury Cathedral.[36]

A large expanse of painting, originally of 13th-century date, decorates the east wall of the Ringers Chamber, under the south-west tower (Pl. XIIIB). As will be expected by now, it has been completely repainted, but by and large seems fairly faithful to the original.[37] The painting comprises single-line masonry pattern in black (a rather unusual colour for 13th-century masonry pattern, which is normally red), and four horizontal borders. Two of these

are of foliate scrollwork, whilst the most elaborate consists of a chevron pattern enriched with fleurs-de-lys, and with trefoil-headed and other stalks springing from it on either side. The lowest border is of lozenges containing quatrefoils, but is largely covered by a 17th-century foliate border.[38] When the repainting was carried out on this wall in the 17th century, the masonry pattern was utilised in an interesting way, with some of the blocks formed by the pattern filled with the names of bell-ringers, the earliest dating to 1614.[39]

The Angel Choir must have looked even more splendid than it does now when it had its original painted decoration. Begun in c.1256, the Choir was presumably finished by the time St Hugh's shrine was translated there in 1280.[40] In the triforium, in the third bay from the east on the north side, there are slight remains of red and blue paint on the draperies of the central angel, and of the same colours on the background of the spandrel occupied by the left-hand angel. A number of the triforium angels are represented holding long scrolls, and these may originally have had painted inscriptions. Although now a mere stain on the stonework, the most interesting surviving fragment of the Choir's painted decoration is on the spandrel behind the angel with remains of colour on its draperies (Pl. XIIIc). Here, there is a pattern of joined crosslets beneath the angel's right wing. Crosslets were, of course, a common heraldic device, and they are similarly used in decorative painting in a line-ending in the almost exactly contemporary Alfonso Psalter (c.1281–4).[41] Behind the angel playing a viol, in the second bay from the east on the north side, the spandrel is patterned with a sprinkling of tiny annulets.[42] Remains of colour still survive on the ridge-rib and bosses of the main vault, as well as gilding on at least one of these bosses. The cells of the vault were also painted; it is recorded that, in the Victorian period, when the vault 'was unfortunately stripped of its original plaster, a great quantity of painted ornament was discovered, and destroyed'.[43]

The Decorated sculpture for which the Cathedral is so notable retains some of its original colouring. The combined 'Easter Sepulchre' and tomb of Remigius (c.1300) has remains of colouring in blue, green, red and black. Colouring survives on, for example, the sleeping soldiers of the Sepulchre, and in the spandrels of the quatrefoils at the base of the Remigius tomb. The interior of both parts retains a good deal of colouring, as on the vault bosses, one of which — in the tomb part — is still almost completely red. There are also remains of blue, red and gold on the early 14th-century Pulpitum, and of colouring on the screen in the south choir aisle behind the choir stalls (c.1310). Thus, one capital of this screen retains almost complete the blue background to its naturalistic foliage carving, as well as as a band of red on its necking. On some of the tracery mouldings of the screen there are remains of imitation marbling, with black 'commas' (perhaps intended to imitate fossil shells) on a green ground. This is a standard decorative formula in painting of the 13th and first half of the 14th century, when Purbeck and similar 'marbles' were extensively used in buildings (as, in the 13th century, in Lincoln Cathedral itself), though the green colour used here is somewhat unusual.[44] The shrine of Little St Hugh was sited before this screen (its Purbeck base still survives), and a drawing in Dugdale's Book of Monuments shows parts of it coloured red, and part blue.[45] In the Chapter Acts, John of Belvoir is recorded as having left in his will in 1389 a legacy of £10 ad faciendum depingi imaginem et tumbam of Little St Hugh.[46] The image was almost certainly a sculptured figure, and probably the 'statue of a boy, made of freestone painted' which Wordsworth records as being shown to a visitor in 1736.[47]

A fascinating problem is presented by the large painting of four bishops standing beneath an arcade, on the west wall of the north-east transept (Pl. XIIID). This painting, in an oil medium, was executed by the Venetian painter Vincenzo Damini in 1727 or 1728.[48] Tristram relates that when it was being restored in 1932, 'traces of early paintings were found beneath the later work, and this discovery suggests that the space was originally

occupied by representation of Saints within niches, apparently executed c.1300, of which the present paintings are in a sense no more than remote semblances'.[49] Certainly, the canopies are basically of a c.1300 type, and contrast strikingly with the Baroque figures below; such a Gothic feature is extremely unusual in early 18th-century painting.[50] It can be seen even now that there is indeed medieval painting underneath, since single-line red masonry pattern is clearly visible emerging from beneath the 18th-century painting at top and bottom, and also at the right-hand side. At the top, this masonry pattern fills the space between the painting of the bishops and the apex of the transept arch above, and it could formerly be seen extending more than a third of the way down the wall below the painting.[51] As definite confirmation that bishops were indeed painted here before Damini's time, a passage in Sanderson's survey of the monumental inscriptions in the Cathedral, of 1641, describes four of the 12th-century bishops of Lincoln as painted in this position — Robert Bloet, Alexander de Blois, Robert de Chesney, and Walter de Coutances — all of whom were buried in the transept.[52] If these bishops were originally painted in c.1300, the reverence thus shown for the early bishops of the see would be reminiscent of that displayed at the same date for their more illustrious predecessor, Remigius, in his splendid new tomb in the sanctuary. They would also relate to other series of representations of earlier bishops in 13th- and 14th-century painting and sculpture: for example, the painting recorded as being of six Anglo-Saxon 'bishops of Ely' (sic) on the north wall of the choir of Ely Cathedral, assigned to the 14th century;[53] and, in Wells Cathedral, the 13th-century series of sculptured figures of its Saxon bishops.[54]

In the passage leading from the north-east transept to the cloister, foliate scroll pattern in red was formerly visible on the vault, bordering the ribs.[55] It had (of course!) been repainted, but there seems no reason to doubt that the original pattern was coeval with the passage, i.e. c.1300. The pattern was rather more delicate, and a little more naturalistic, than the earlier scroll pattern seen elsewhere in the Cathedral. Unfortunately, it was whitewashed over in the 1960s.

One last area of wall painting remains to be considered: that in Bishop Longland's Chantry Chapel, the westernmost chapel on the south of the Angel Choir. Longland was bishop from 1521–47, and his intention of founding a chantry here was, in fact, never carried out; his heart was buried in the chapel, and his body at Eton.[56] The painting covers much of the upper part of the wall, and is now simply an amorphous mass of dark green paint (some turned black), applied probably in an oil medium, and including towards the north end of the wall a small black-letter inscription 'ECCE HOMO' on a scroll. Behind a carved angel corbel at the other end of the wall are slight remains of turquoise paint. Presumably, the painting formed the background for a sculpture, which included a figure of Christ. At the centre of the wall there are several plugged holes in the masonry, which were probably for attaching the sculpture by means of dowels.

In conclusion, two general points may be made. First, although it is clear that in the Middle Ages the Cathedral was a much more colourful building than it is today, it is equally apparent that the painted decoration was far from being just a mass of bright colours indiscriminately applied. None of the decoration described above should offend even the most squeamish of present-day architectural historians. It is noticeable, for instance, how often the painting was applied to accentuate architectural features such as vault-ribs, and how quite large areas of wall and vault were left either unadorned or painted only with the simplest decoration. Secondly, the conservation history of the paintings in modern times is a rather unhappy one. Although some of the painting has only been found in recent decades — as in St Hugh's Choir and in the south-west transept — it is a great pity that so much of the coloured decoration of the Cathedral has been either crudely repainted or whitewashed

over. The Damini painting of bishops in the north-east transept is again in need of cleaning and conservation treatment, with its paintwork blistering in places. Such conservation work would provide an ideal opportunity for discovering exactly what painting does exist underneath: possibly the most important surviving medieval painting in the Cathedral.

ACKNOWLEDGEMENTS

The paintings were recorded in 1981–2 for the National Survey of Medieval Wall Paintings, which is being carried out by the Courtauld Institute of Art and the Royal Commission on Historical Monuments (England). I am grateful to the Leverhulme Trust for funding my work for the Survey, and to Mr Leonard Furbank of the Royal Commission for taking the photographs. The Cathedral officials were most co-operative during this operation. I am also indebted, for help of various kinds, to Jane Ashby, Sharon Cather, Sandy Heslop, Dr Christopher Norton, Dr E. Clive Rouse, Veronica Sekules, David Stocker, and Dr Christopher Wilson.

REFERENCES

1. A useful short discussion of some of the early decoration is provided by F. R. Horlbeck, 'Decorative Painting in English Medieval Architecture' (unpublished Ph.D. thesis, University of London 1957), 33–8. Horlbeck wrote, however, before the St Hugh's Choir painting had come to light, and before the removal of the limewash coating over the south-west transept painting. Apart from a brief article by Canon Binnall on the latter painting (see n.14 below), publication of the medieval paintings in the Cathedral has been confined to scattered references in E. W. Tristram, *English Medieval Wall Painting: The Thirteenth Century* (Oxford 1950), and other works.

2. E. Trollope, 'The Norman Sculpture of Lincoln Cathedral', *AASR*, VIII (1865), 287.

3. A. F. Kendrick, *The Cathedral Church of Lincoln*, rev. ed. (London 1922), 52.

4. See W. H. St John Hope and W. R. Lethaby, 'The Imagery and Sculptures on the West Front of Wells Cathedral Church', *Archaeologia*, LIX (1904), 150, 163, 177; and P. Tudor-Craig, 'Wells Sculpture', in *Wells Cathedral: A History*, ed. L. S. Colchester (Shepton Mallet 1982), 120–1.

5. I am grateful to Eddie Sinclair for information about the recent finds of colour. For the reference in the Fabric Accounts, and for another referring to the painting of the 'bishop in the gable', see A. M. Erskine, ed., *The Accounts of the Fabric of Exeter Cathedral, 1279–1353. Part 2: 1328–1353*, Devon and Cornwall Record Society, n.s. XXVI (1983), xxxiii, 269, 270.

6. For this sculpture, see most recently *English Romanesque Art 1066–1200* (Arts Council Exhibition catalogue, London 1984), 180. Professor Zarnecki here suggests that a drilled hole in the same slab, next to a fragment of a carving of Christ in Majesty, was for fixing a gilded metal sheet as a background to the Majesty.

7. . . . ex Pariis lapidibus, marmoreisque columnellis, alternatim et congrue dispositis, et tanquam picturis variis, albo, nigroque, naturali tamen colorum varietate distinctis: *Giraldi Cambrensis, Vita S. Remigii, et Vita S. Hugonis* ed. J. F. Dimock, (Rolls Series, London 1877), 97.

8. De crucifixo et tabula aurea in introitu chori.
 Introitumque chori maiestas aurea pingit
 Et proprie propria crucifixus imagine Christi
 Exprimitur vitaeque suae progressus ad unguem
 Isinuatur ibi. Nec solum crux vel imago
 Immo columnarum sex lignorumque duorum
 Ampla superficies, obrizo fulgurat auro.,

From *Metrical Life of St. Hugh, Bishop of Lincoln* ed. J. F. Dimock, (London 1860), lines 950–5. See W. St John Hope, 'Quire Screens in English Churches', *Archaeologia*, LXVIII (1916–17), 55; and also A. Vallance, *Greater English Church Screens* (London 1947), 72.

9. The painting was recorded in water-colour drawings by Miss Janet Lenton, under the supervision of E. Clive Rouse. Copies of the watercolours, which are reproduced here, are in the Cathedral Library, and in the possession of Dr Rouse.

10. Janet Lenton, caption of drawing of vault painting.

11. Lenton, in the caption to her drawing.

12. In his lecture to the Lincoln conference, printed in this vol.

13. For these, see P. Frankl, 'The "Crazy" Vaults of Lincoln Cathedral', *Art Bulletin*, XXXV (1953), 95–107, and B/E *Lincolnshire* (1964), 87–95. A more famous example of *trompe l'oeil* painting of slightly later date (*c*.1220) is the nave ceiling of Peterborough Cathedral, which from certain angles looks like an openwork roof; see F. Nordström, 'Peterborough, Lincoln and the Science of Robert Grosseteste', *Art Bulletin*, XXXVII (1955), 253–9.

14. See Tristram, *Thirteenth Century*, 559, Supp. Pl. 55; and P. B. G. Binnall, 'Thirteenth-Century Vault Paintings in Lincoln Cathedral', *Antiquaries Journal*, XLV (1965), 265–6, pl. LXXXIV. The painting was uncovered by Janet Lenton, under the supervision of Clive Rouse. When the vault was subsequently limewashed, the painting was left with an un-whitened margin.

15. Ibid.

16. Ibid.

17. Tristram, op. cit., 499–500, pls 168–9.

18. Ibid., 529, Supp. Pl. 32. See also D. Park, 'Cistercian Wall Painting and Panel Painting', in *Cistercian Art and Architecture in the British Isles*, ed. C. Norton and D. Park (Cambridge forthcoming).

19. Tristram, op. cit., 613, pl. 37.

20. Ibid., 616, pls 44–9, Supp. Pl. 19.

21. See N. Morgan, *The Medieval Painted Glass of Lincoln Cathedral* (Corpus Vitrearum Medii Aevi, London 1983), 21–4, pls 3–5; and D. King, 'The Glazing of the South Rose of Lincoln Cathedral', this vol.

22. It is already described as 'restored' by C. E. Keyser, *List of Buildings having Mural Decorations*, 3rd ed. (London 1883), 160.

23. Horlbeck, op. cit., 34, mentions several French parallels for this device, e.g. at Chartres.

24. It was found by David Stocker, and I am grateful to him for drawing it to my attention. The fragment is about two feet square, has been mounted on canvas, and is kept in a wooden case in the roof-space above the walk leading from the north-east transept to the cloister.

25. See p. 77.

26. Horlbeck, op. cit., 36.

27. See B/E *Lincolnshire* (1964), 99.

28. Tristram, op. cit., 369, records one of these differently, as 'FRAUDE'.

29. J. W. F. Hill, *Medieval Lincoln* (Cambridge 1948), 113 and n. 4.

30. Ibid., 113.

31. Ibid.

32. T. Pownall, 'Observations on Ancient Painting in England', *Archaeologia*, IX (1789), 154.

33. I am grateful to Miss Kathleen Major for this suggestion.

34. C. W. Foster, ed., *The Registrum Antiquissimum of the Cathedral Church of Lincoln*, II, LRS XXVIII (Lincoln 1933), 61, 316–17, 322.

35. Tristram, op. cit., 601, Supp. Pl. 45b.

36. F. Woodman, *The Architectural History of Canterbury Cathedral* (London 1981), fig. 50. This painting has itself been repainted in modern times, but seems more likely to be originally of 13th-century date, than 14th-century as tentatively suggested by Woodman.

37. The foliate borders on the vault, however, appear completely modern.

38. For copies of sections of all the 13th-century borders, see Tristram, op. cit., Supp. Pl. 55.

39. See Kendrick, op. cit., 85. On the north wall of the Chamber is an 18th-century cartouche containing the names of further ringers. In August 1984 a further example of masonry pattern, consisting of thin, single horizontal and vertical lines in the more normal red colour, was discovered on the wall above the doorway to the Cathedral Treasury (I am grateful to Mr David Perry for this information).

40. See B/E *Lincolnshire* (1964), 105.

41. London, British Library MS Add. 24686, f.14ᵛ. For a large-scale reproduction, see B. Yapp, *Birds in Medieval Manuscripts* (London 1981), 123.

42. See E. S. Prior and A. Gardner, *An Account of Medieval Figure-Sculpture in England* (Cambridge 1912), fig. 287; and Tristram, op. cit., 559, Supp. Pl. 55. Tristram, 559 n.1, is mistaken in saying of these traces of painting behind the angels that they had been destroyed in recent years.

43. F. Sutton, 'Painted Roofs', *AASR*, X (1869–70), 87.

44. For marbling, see Tristram, op. cit., 42; and idem, *English Wall Painting of the Fourteenth Century* (London 1955), 5. White brush-strokes on a green ground occur on the tomb of Aymer de Valence (d.1324) in Westminster Abbey; ibid., 34. A particularly extensive use of painted marbling occurs in the late 13th-century decorative scheme at the east end of Norwich Cathedral; idem, *Thirteenth Century*, 583–4, pls 201–4.

45. W. Dugdale, *Book of Monuments*, on loan to the British Library as MS loan 38.

46. LAO, Chapter Acts, A. 2. 27.

47. C. Wordsworth, *Notes on Mediaeval Services in England, with an Index of Lincoln Ceremonies* (London 1898), 162. The 'ad faciendum depingi imaginem' has been translated as 'for painting the picture'

(D. Williamson, *Lincoln Muniments* [Lincoln Minster Pamphlets No. 8, Lincoln 1956], 25), but 'imago' in medieval records is much more likely to mean a sculptured image.

48. See Tristram, op cit., 370; E. Croft-Murray, *Decorative Painting in England 1537–1837*, II (London 1970), 20, 197. Damini also undertook some painting in the church of St Peter-at-Arches in Lincoln; ibid., 20.

49. Tristram, op. cit., 370. On p. 559 he gives the date of the restoration as 1930.

50. See Croft-Murray, op. cit., 20, 197.

51. See D. C. Dunlop, *Lincoln Cathedral* (Pitkin Pictorials, London 1974), photograph on p. 10.

52. *Lincoln Cathedral; An exact copy of all the Ancient Monumental Inscriptions there, as they stood in M, DC, XLI.; collected by Robert Sanderson . . . and compared and corrected by Sir W. Dugdale's MS. Survey [from Desiderata Curiosa by F. Peck]* (London 1851), 19. I am very grateful to Veronica Sekules for this reference. For the burial of the bishops in the north-east transept, see ibid., 52, no. 19; and Browne Willis, *A Survey of the Cathedrals of Lincoln, Ely, Oxford and Peterborough* (London 1730), 47–9.

53. E. W. Tristram, *English Wall Painting of the Fourteenth Century* (London 1955), 168. These figures no longer exist. In the paintings of c.1220 formerly on the vault of the Trinity Chapel, Canterbury Cathedral, the figures included three Canterbury archbishops: SS. Dunstan, Thomas, and Alphege (?); see M. Caviness, 'A Lost Cycle of Canterbury Paintings of 1220', *Antiquaries Journal*, LIV (1974), 68, pl. XIX.

54. See W. Rodwell, 'The Anglo-Saxon and Norman Churches at Wells', in *Wells Cathedral: A History*, ed. L. S. Colchester (Shepton Mallet 1982), 20–1; and P. Tudor-Craig, 'Wells Sculpture', ibid., 123–4. Tudor-Craig, 123, mentions other series of retrospective effigies of bishops at Peterborough, Lichfield, etc.

55. See Horlbeck, op. cit., 36. It can be seen in a photograph in the National Monuments Record, BB49/2589 (received January 1949).

56. P. B. G. Binnall, 'Notes on the Medieval Altars and Chapels in Lincoln Cathedral', *Antiquaries Journal*, XLII (1962), 76.

The Thirteenth-Century West Window of Lincoln Cathedral

By Georgina Russell

The large quantities of Early English blind arcading on the west front of Lincoln Cathedral make it immediately obvious to the observer that there was a major campaign of building there in the middle of the 13th century. What is less often realised is that the centrepiece of this design was a large traceried window which was subsequently replaced in the 14th century. Close examination reveals that the frame of this 13th-century window is still in place, and this allows us to reconstruct with some certainty the original pattern of the tracery it contained.

It is easy to identify the 13th-century work in the top of the central section of the west front (Pl. XIVA): the cinquefoil which does duty as a rose window, the diaper pattern around it, which is also found on the upper (and later) part of the central tower; then further down, in the area of the central window, the jamb-colonnettes with their stiff-leaf capitals, and the arch that springs from them with its typically 13th-century mouldings. The bottom of the window and the courses below it are hidden from view outside by the row of seated kings.[1] Inside one can find evidence that, except for the top course which bears the Perpendicular mullions, all the stonework below the window down to the level of the wall-passage inside the windows is untouched 13th-century work. This takes the form of a deep 'windowsill' and it is faced with the same deeply-cut diaper that is found outside above the window; this diaper runs across joints in the stone, so any reorganisation would be apparent. Furthermore, the area of diaper is surrounded here (as elsewhere in the building) by a smooth plain band left uncut round the edge of the outermost stones of the panel, in the manner of a frame, even though it is an integral part of the panel. This 'frame' would show evidence of trimming if anything of that nature had taken place.

It is also possible to show that the head of the window has not been lowered from a previous more acutely-pointed 'equilaterally arched' head[2] to its present flattened contour, since the present window rises right up to the level of the cinquefoil 'rose' above it; a more acutely pointed arch would pierce the cinquefoil. The outer mouldings of the window-head are evidently coeval with the jambs and also with the cinquefoil. On the inside of the window the same outsize dogtooth moulding which surrounds the cinquefoil also surrounds the head of the main window and continues down through the capitals of the jamb-shafts to their bases on the 'windowsill' above the level of the wall-passage floor (Pl. XIVB, C).

One may conclude from this evidence that the frame of the window dates from the 13th century. A century or more later, perhaps as the result of a large bequest or the desire to modernise the appearance of the façade, the 13th-century tracery and its immediate mouldings were removed to make way for a new window of Perpendicular tracery.[3] The contiguous mouldings would have had to be removed, since the beginning of each bar of tracery is carved in one piece with the moulding from which it springs. Similarly, the course of masonry below the glass would have been removed as it would have incorporated the bases of the mullions. (See Pl. XVA showing the ruined west window of Newstead Abbey, where the mullions appear to 'grow' out of the sill.)

To attempt a reconstruction of the 13th-century tracery of the west window would seem to be hazardous. Crucial evidence however is provided by the window-arch. It may be

remembered that two 'families' of tracery design can be identified. First is the 'equilateral arch' or 'Westminster' type, exemplified at Lincoln by the east window of the Angel Choir, where the arcs which form the window-arch are struck from the opposite springing-point of the window. The result of this is that the width of the window is equal to the shortest distance from each springing-point to the apex. The tracery consists of a number of small individual tracery lights, each with its own 'equilaterally arched' head (made from arcs of a much smaller radius which is equal to the width of a single light). These lights are grouped — usually in pairs — beneath a super-arch, and if necessary these groups are combined under even bigger arches, in order to fill up the window with lights of a width convenient to the glazier. The inevitable space at the top of the window is filled with some kind of oculus. Second is the 'intersecting arch' type of tracery; here, both the head of the window and the arcs which divide up the tracery head are all of the same radius. This radius is usually equal, not to the width of window, but to the width of the total number of lights minus one. (In algebraic terms this can be expressed as: $r = (n \times w) - w$, where r is the radius of the arch employed, n is the number of lights and w is the width of a single light.) The east window of St Etheldreda's, Ely Place, London provides a good example since by way of contrast the tracery is set in an 'equilaterally arched' frame.

If we consider the west window of Lincoln nave in this light, it will be seen that the arcs which form the head of the window are of a radius equal to two-thirds the width of the window. One must conclude that the window was originally filled with 'intersecting arch' tracery, not merely because of the above-mentioned formula but because any tracery based on equilateral arches could not be made to fit the space. But it would be a mistake to suppose that the Lincoln window was of three lights (as the two-thirds ratio would seem to suggest) since each light would have been approximately 1.60 m. wide. Even at Westminster Abbey, which appears to have the largest light-width in windows of two or more lights at this period in England, the standard two-light windows of the chevet have main lights averaging only 1.20 m. wide.

Two unusual Decorated windows that survive, between them suggest an alternative scheme. The first is the north window of the Nine Altars at Durham, in which the window area is first divided by major mullions as if it were a three-light window, by means of intersecting tracery.[4] The areas between the major mullions are then treated as individual windows and subdivided with minor mullions. At this point the Durham designer broke what seems to have been the accepted rule against mixing the two 'families' of tracery by placing three two-light 'equilateral arch' units in these spaces. This seems unlikely as an analogue for Lincoln since the equilateral arch is not found in the nave or in the 13th-century fabric of the west end. A viable alternative is provided by the west window of the nave of Newstead Abbey, Nottinghamshire. The window has lost most of its tracery, but its system of major and minor mullions is evident from the bowtell-bases on the sill and there are enough traces in the head of the window to enable one to reconstruct the pattern of the tracery (Pl. XVB).[5] It can be seen that all the arches are of the 'intersecting' variety; but contrary to the usual practice of employing one radius throughout, the three pairs of main lights are treated as individual 'Y' tracery windows without their superarch. (The two four-light windows in blind tracery on the façade are treated in the same way: see Pl. XVA). The west windows of Lincoln and Newstead exhibit similarities also in the arrangement of the shafts of the window-jambs (including the use of shaft-rings) and in the stiff-leaf capitals. I do not seek to challenge the accepted placing of Newstead at an appreciably later date, rather to suggest that the copying of details which must by that time have seemed retardataire is more understandable if they accompanied a reproduction of the Lincoln tracery design (Fig. 1a).

Support for the theory that Lincoln's west window was filled with a kind of prototype intersecting arch tracery, comes from the presence of an early example of 'Y' tracery in the upper parts of the Consistory Court (in the south-east window), which appears to be of the same campaign as the west end of the nave.[6] This example is in an early form of bar tracery; there is also an example in plate tracery in the external east window of the gable of the Consistory Court. It is my submission that three two-light units such as these went to make up the west window of the nave in the same manner as they did at Newstead. The presence of versions in both plate and bar tracery at Lincoln, however, precludes certainty about which technique was used in the west window at Lincoln, though a return to plate tracery would seem a retrograde move.

This smaller problem is involved with the larger one of dating. It has been accepted for so long that bar tracery first appeared in England at Westminster Abbey that the case for a

FIG. 1a. Newstead Abbey, west window; also reconstructed Lincoln Cathedral west window.

FIG. 1b. Bayeux group standard design of 4-light opening.

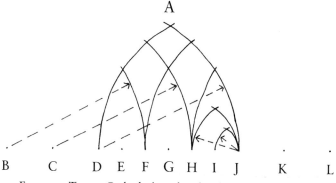

FIG. 1c. Troyes Cathedral, 2nd and 3rd bays of nave aisles.

FIG. 1d. Troyes Cathedral, window in transept west wall.

FIG. 1e. Agnetz parish church (nr. Compiègne, Oise), transept north window.

six-light bar tracery window at Lincoln prior to 1245 will have to be argued carefully. Neither of the two windows at Durham or Newstead which have been cited as analogues can be nearly as early; their debt would have been to Lincoln rather vice versa.

One argument in favour of Lincoln's priority is that the building owes no debt at all to Westminster prior to the designing of the Angel Choir. Both the existing 'Y' tracery windows and the 'intersecting arch' tracery window that I have hypothesised are not of the 'Westminster' family of tracery.[7] In fact they are closely related to the use of two-centred non-equilateral arches in the nave arcades at Lincoln and the lancets in the aisles and clerestories. Surviving details of the west window, such as substantial colonnettes on the jambs, large-size dogtoothing in the spaces between, extremely luxuriant stiff-leaf, and prominent shaft-rings, are very much in the Lincoln tradition but have little in common with Westminster. Almost the only stiff-leaf capitals at Westminster are on the central column of the Chapterhouse and there are a few flanking the windows.

Bar tracery had been used in France as early as 1215 at Reims, but there is no indication that it reached England until the 1240s when Westminster certainly (and Windsor and Binham probably) took up the idea. The currently accepted dating for the western campaign at Lincoln would put its west window between c. 1240 and c. 1245, right at the beginning of the sequence. This date is based on the evidence for a break in design and construction, observed by Dr Kidson, between the main part of the nave, the Morning Chapel and the lower parts of the Consistory Court on the one hand, and the Court's upper parts and the west front on the other. Similarities in tooling between the diapered stonework below the west window and the internal jambs of the window of the Consistory Court for example support this theory. Details of the west front, such as the diaper, relate it to the similarly decorated upper part of the central tower, which seems to be repair-work dating from after the fall of the earlier tower in 1237/9. In fact it may have been the immediate need to repair the central tower which caused the break in construction of the western part of the church.

The technical innovations of this last campaign at the west end would have been a good preparation for the design of a six-light window in the west end of the nave, where the width is anyway much less than in the main part of the nave, due to the decision to keep the Romanesque west towers.[8] Not only does it have 'Y' tracery windows, but the omission of the central pillar in the Consistory Court meant that the vaulted area could not be divided into discrete compartments. Instead a network of continuous ribs is applied to the interior surface of the dome (*sic*) as a whole, and indeed the visual effect is very similar to the intersecting arcs in window tracery. Designing a six-light window would be almost child's play after this technical *tour de force*. Since the completion of the west end of the cathedral was a comparatively small campaign, the design and the construction of the west window would not have been far apart in date. I would suggest dates around 1242 and 1244 respectively, but it would be a mistake to be too dogmatic in view of the lack of evidence.

Regrettably there are few examples — or at any rate surviving examples — of windows which could have been based on this design. The only two are those at Durham and Newstead, which have already been cited. There is, however, a strong possibility that the high east window of Exeter Cathedral, where (as at Lincoln) the Decorated tracery was replaced by Perpendicular within the original frame, was designed on the same lines, since there too the arcs which make up the head of the window are of radii equal to two-thirds the width of the window. There may be two reasons for this. One is that these prototype 'intersecting arch' tracery windows were not thought to be aesthetically pleasing, hence their replacement with something else when funds were available. The second lies in the timing: from 1245 onwards, the designer of Westminster was able to show what could be done with equilateral arch tracery if the technique of bar tracery was practised. In contrast, the potential of intersecting arch tracery may have been hard for other designers to realise. The only 'Y' tracery window at Westminster (as mentioned above) is not really a success, and one of the earliest surviving dated examples of a multi-light intersecting arch tracery window may be the east window of St Etheldreda's, Ely Place, London, of *c.*1284–6.[9] Hollar's preparatory drawings suggest that intersecting arch tracery was also well represented in the choir at Old St Paul's, London, from *c.*1258 onward but this cannot be proved.[10] The proximity of St Etheldreda's, however, makes this an attractive hypothesis, which would explain the sudden popularity of this type of tracery all over the country in the late 1280s and 1290s.

That 'intersecting arch' tracery in all forms (including the simple 'Y') is a typically English phenomenon is suggested by the scarcity of examples in France at any period, and especially during the period 1220–50 (except in Normandy, which I shall discuss below) when the French were working out ideas for Rayonnant tracery which was to be so influential throughout Europe. During these three decades no 'Y' or intersecting tracery (to my knowledge) was installed in the Ile de France. Even the three-light transept gable windows of St Urbain at Troyes (consisting of stepped 'Y' lancets under an 'equilateral' arch)[11] could not possibly be earlier than the mid 1250s, and are more likely to date from the second phase of construction from *c.*1275–86.[12]

Normandy certainly possesses early examples of 'Y' tracery, but even in windows of more than two lights the great step of continuing the arches over to form intersecting tracery was never taken, nor was the feature of a two-centred arch employed. The buildings in which 'Y' tracery appears all belong to a closely associated group independent of Lincoln which is ultimately dependent on Bayeux Cathedral, and which can be divided into two subgroups (Fig. 1b).[13] The first, characterised by the use of plate tracery and of capitals on the bowtels (the latter a quite un-English feature in this context),[14] appears to span the period from *c.*1220 to *c.*1245. The earliest is the nave of Bayeux itself, which influences such buildings as

Coutances and Sées (where the 'Y' tracery in the straight bays of the choir is executed in bar tracery but where capitals are again found on the bowtels). The influence of the choir at Bayeux extends to the second campaign at Le Mans Cathedral as identified by Miss Grant.[15] This campaign was begun *c.*1230 and included the canted bays of the choir to the top of the triforium of the central vessel (featuring pairs of 'Y' tracery openings), and the whole of the inner choir aisle, which has 'Y' tracery in both clerestory and triforium, in varying combinations of two and three lights. The second group of buildings are all much smaller, and are probably datable to the later 1240s and 1250s. Here the 'Y' tracery does not usually feature capitals, and it is executed in bar tracery. A few examples from this group are Langues and Ardenne abbeys, Bernières, and the east end of St-Pierre-sur-Dives.[16]

In all these Norman examples, contemporary with Lincoln nave, it will be noticed that there is a predilection for the simple two-light 'Y' design, and that even where there are more than two lights under a superarch, no attempt is made to make the design more complex in the English manner. This is still true several decades later at Lisieux, where there is a series of four-light 'Y' tracery windows (2 + 2 lights divided by a larger 'Y') in the nave aisle chapels, which are datable on documentary evidence to the 1290s.[17] In the roughly contemporary west end of St-Pierre-sur-Dives, the façade window departs from the standard Norman layout by introducing equilateral arch tracery to subdivide the areas on each side of the main 'Y', in the 'hybrid' manner of Newstead. No attempt to make the arcs intersect seems to have been made before about 1305, in the second and third bays of the nave aisles of Troyes Cathedral (Fig. 1c).[18] Even here, however, the six-light windows are treated as three-light designs for the purposes of intersecting arch tracery, and subdivisions are subsequently made using equilateral arch tracery; and, as in all French examples, the whole is placed under an equilateral arch.

It will be seen that all the French examples mentioned so far are either contemporary with Lincoln but unlike the postulated west window, or else so much later in date as to have no direct connection. An exception to this is Agnetz (near Compiègne), datable to *c.*1245, where the three façade windows all have a basic 'Y' division, while further subdivision is affected by means of equilateral arch tracery to achieve a total of four lights (five in the case of the west window, where an extra is inserted) (Fig. 1e). These examples of hybrid 'Y' tracery probably reflect a lost prototype, possibly among the parish churches of Amiens.[19] This group of designs represents the results of combining Norman 'Y' tracery with the Ile de France tradition of equilateral arch tracery.

It is quite possible that the designer of the west window of Lincoln knew of the experiment in hybrid 'Y' tracery in the Amiens milieu, and that he saw in it a convenient means of subdividing the three large lights resulting from his pioneering use of intersecting arch tracery. This essentially English feature, usually placed under a two-centred head, became a *leitmotif* of Decorated architecture, and it continued to play a part in the design of many Perpendicular windows. It is only right that credit for such a seminal idea should now be given where it is due.

REFERENCES

1. Mr Nicholas Hall (personal communication) considers that the series of eleven kings (which may represent the kings of England from the Conquest to the previous reign) probably dates from *c.*1380, during the Treasurership of John of Wellbourne (1350–80) on evidence of armour; the 'pairs of plates' worn by all except one king (Edward III?) preceded the solid breastplate.
2. G. A. Russell, 'Decorated Tracery in Winchester Cathedral', *Medieval Art and Architecture at Winchester Cathedral*, BAA CT, VI (1983), 95–6 and figs 1 and 2.
3. Undocumented but probably also associable with Wellbourne's Treasurership (personal communication from Dr Christopher Wilson); probably contemporary with the entirely Perpendicular aisle windows.

4. G. A. Russell, 'The north window of the Nine Altars Chapel, Durham Cathedral', in *Medieval Art and Architecture at Durham Cathedral*, BAA CT, 1 (1980), 87–9, and pls XIA–D.

5. I am indebted to Dr Kidson for this reconstruction of the tracery shown in Plate XVB.

6. It had been suggested that the 'Y' tracery in the south-east window is a later addition, since the stones of the tracery are not bonded into the jamb. It would not, however have been a later medieval addition, since 'Y' tracery was often removed to make way for something more up to date; and Dr Thomas Cocke considers that, among the later restorers, Essex is unlikely to have done such a thing, while Pearson is an extremely unlikely candidate since his work is well documented. Whereas he may have replaced more stone than was strictly necessary, he added no new features to the building. In addition, Pearson would have known that tracery should be bonded in; this anomaly is more likely to be due to the inexperience of the 13th-century masons.

7. Westminster paradoxically borrowed from the tradition of 'Y' tracery for the hybrid south window of the south transept eastern aisle.

8. I am again indebted to Dr Kidson for this idea.

9. The window is unusual in that orthodox intersecting arch tracery is placed under an equilateral arch, so that the arcs diverge.

10. Oxford, Ashmolean Museum, Dept of Prints & Drawings, no. C1222 (eighth bay from east end).

11. Authenticated by a photograph of 1852 (copy in Courtauld Institute, Conway Library).

12. The gable windows must have been among the last parts to be built; Pope Urban's nephew, Ancher Pantaléon (d. 1286) was responsible for the second phase. See C. T. Clay, *York Minster Fasti*, II, York Minster Archaeological Society Records Series, 124 (1958), x.

13. Lindy Grant, forthcoming Ph.D. thesis, 'Gothic Architecture in Normandy 1150–1250' (London University).

14. Presumably because 'Y' and intersecting arch tracery were thought of as a means of subdividing for convenience's sake a large window-space (which in fact needs no internal support), while equilateral arch tracery is the result of a 'build-up' of numerous 'miniature' windows, each of which is equipped with its own capitals.

15. Op. cit., note 13.

16. The two-light window in the south transept of Lisieux is an insertion of uncertain date, and the west window of this church should be associated with the 16th-century repairs to the west end, so the monument cannot be considered as part of the group for present purposes.

17. I am indebted to Miss Grant for drawing my attention to all the above examples and to the grounds for dating them.

18. Chapels datable to 1305/20 from foundation dates of some altars situated in these bays (personal communication; information to appear in S. Murray, *Building Troyes Cathedral*, Indiana University Press, forthcoming 1986). A three-light window of intersecting arch tracery under an equilaterally arched head in the west wall of the north transept forms part of fabric datable probably to the 1330s and 1340s (same source); see Fig. 1d. This window is similar in design (and possibly also in date) to the central openings on each face of the south-west tower of Strasbourg Cathedral (façade begun 1277). The nave aisle windows at Amiens are variations on those at Troyes, and are probably contemporary.

19. The cathedral workshop may have been responsible for Agnetz (Alan Brodie, forthcoming thesis on Early Rayonnant Architecture in North East France, London University). Given the lack of true intersecting tracery in France before about 1290, it is unlikely that the lost prototype was more complex than the design at Agnetz.

The Angel Choir and its Local Influence

By Mary Dean

As had been the case with St Hugh's Choir and east transept, the Angel Choir of Lincoln Cathedral was one of the first English buildings to experiment with a new, French style of architecture; in this case, the Rayonnant. The early Gothic choir had exerted considerable influence upon other buildings in its region, and the Angel Choir also proved to be an important conduit for new architectural ideas. I propose to examine the question of the influence of the Angel Choir with an eye to several separable although not separate issues: its particular character, its immediate influence upon regional architecture, and some aspects of the influence it exerted upon English Gothic in general.[1]

The Angel Choir, a five-bay retrochoir added to the east end of Lincoln Cathedral between 1256 and 1280, is generally recognised as an early manifestation of the influence of Westminster Abbey (Pl. III). The Lincoln retrochoir was one of the first projects undertaken after Westminster and it seems to demonstrate a strong degree of London court influence, particularly in the use of the bar tracery window. Lincoln is also considered to demonstrate more dramatically than any of its contemporaries an English 'response' to Westminster; namely, the continued strength of native, ultimately Anglo-Norman traditions of conservative building proportions and structure. French tracery windows appear in a context otherwise English: low and wide proportions, clustered piers, incomplete bay division, tall false tribune elevation, thick wall with clerestory passage, tierceron vaults and strong polychromatic and sculptural emphasis.

This characterisation is useful but oversimple. One must begin with a more precise identification of the sources of inspiration and the intention of the designers of the Angel Choir.

There is no question that Westminster Abbey was an important source of ideas for the Lincoln Angel Choir. The sculptural program of the retrochoir is specifically dependent upon the example of the Abbey.[2] The idea of placing full-figure angels in the spandrels of the gallery arcade is one derived from the transept ends at Westminster. The foliage scrollwork of the aisle walls (Pl. XIXB) is even more precisely a quotation from Westminster Abbey, where it appears not only in the tympanum of the chapter house vestibule door but throughout the Abbey on the arch spandrels which are not covered with diaperwork. The south porch of the Angel Choir, the Judgement porch, is the best example of this close relationship between the sculpture workshops of Westminster and Lincoln. Like the north transept of Westminster Abbey, the Judgement porch has a double portal with statue niches outside the jambs, and a gable crown. As at the Westminster chapter house vestibule portal, a single scene plays over the whole field and the field is extended down into the spandrels of the door arches. Westminster was also the immediate source for the various archivolt patterns, including an order with figures in deeply undercut leafwork frames. One difference has received notice: the iconographic program of the Judgement porch is more extensive than anything surviving at Westminster and in the past this has been credited to other, French influences.[3] However, it has recently been demonstrated that the iconography of the porch, particularly that of the image of Christ, is unusual for the date and is best explained as a reflection of historical circumstances at Westminster, and that in fact the Judgement porch probably follows the scheme of the lost central portal of the north transept of the Abbey.[4]

The Lincoln sculptors were thus deriving their vocabulary of forms from Westminster. Some have even seen the same hands at work on both projects.[5] However, when one turns from the sculpture to the architecture of the building one does not, in fact, find the same manifest influence.

The plan of the retrochoir is independent of Westminster; the north transept of the royal abbey may have encouraged the use of a rectangular end wall, but that façade is stepped back and arranged in horizontal stories, whereas Lincoln has a proper *chevet plat*. The proportions and structure of the Angel Choir also exhibit no knowledge of Westminster. The desire to integrate the retrochoir with the existing building in matters of proportion must have influenced the architect, but the structure might have been modernised to reflect French ideas at Westminster: alterations to the wall section and buttresses had been made before at Lincoln.[6] Far from learning any lessons from Westminster, however, the designer of the Angel Choir used a structural system even more archaic than that of Lincoln choir or nave, including a flying buttress placed at such a remarkably low pitch that severe structural difficulties might have resulted if the building were not so low and the walls so heavy (Pl. XIXB).

The example of the royal abbey must have encouraged Lincoln's use of colour, sculptural emphasis and certain details such as the triforium design of two sub-divided arches per bay, but all of these have precedent at Lincoln Cathedral itself, as well. The only unarguable novelty in the architecture is the use of the bar tracery window, and the adoption of this feature must be credited to the influence of Westminster. However, even here one cannot find any specific reference to the Abbey in either the form of the windows or their tracery patterns. Westminster inspired Lincoln to use the Rayonnant window, but it did not serve as model.

This independent stance is remarkable, for most other English Rayonnant buildings of the first generation after Westminster quote the Abbey church in a more specific manner. Compare the north transept of Hereford, the project of Bishop Peter d'Aigueblanche, a Savoyard. Such patronage might lead one to anticipate strong and perhaps extraordinary French influences and, as Professor Bony has shown, Hereford draws upon the parish churches of the Paris region for the form of its elevation and perhaps for the idea of filling a terminal wall with a single enlarged window.[7] The tone of the design is also distinct, with an emphasis on sharp line and angle that goes beyond anything at Westminster. Nevertheless, as is always noted, Hereford also quotes the Abbey church in a number of ways, most obviously the clerestory windows of curved triangular shape and the diaperwork on the wall.

By contrast, the sources for the tracery patterns at Lincoln must be sought in France. Each subsidiary arch of the eight-light east window (Pl. XVIA) has a design comparable to the four-light windows of the Ste Chapelle; Lincoln differs in having the lancets uncusped but this simpler handling, while older, was still prevalent.[8] In the late 1250s the use of an eight-light pattern could only be associated with France,[9] specifically with Amiens, where clerestory windows of eight lights flank the western crossing piers. Amiens was also a source for the uninscribed trefoils of the aisle gables; uninscribed trefoils are characteristic of that cathedral, where they appeared in bar tracery before 1242–3. They were used in tracery at an even earlier date closer to Paris at Cambronne, and were current in Paris in the 1240s: they are found, for example, at the Ste Chapelle.[10] The cathedrals of Amiens and Paris also form the background of another unusual detail, the double cusping of the oculus in the main gable.[11] Analysis of other details at Lincoln would demonstrate the same approach; namely, passing over Westminster Abbey as his model, the designer drew upon the French sources of Westminster, the sources of the Parisian court style of the 1240s.

The Angel Choir uses its Rayonnant models in a fresh, sometimes innovative way that often frustrates their identification. For example, the aisle windows have a pattern of three lights and three oculi, a general form found in France most recently as a reduced variant of the classic four-light Dionysian window[12] and used at Westminster for the cloister screen and, later, as the basis for the north transept roof gable pattern (Pl. XVIc). At Lincoln, however, the design is eccentric (Pl. XVIa). The lancets are cinqufoil cusped like an arcade opening or a portal and the oculi vary in size, with the smallest at the apex.[13] The Lincoln master appears to have introduced this variation to bar tracery.

Another example of this independent approach is found in the main gable window. Its unusual five-light design is an idea which might have come from the Amienois, where it appeared at Agnetz in the 1250s, or from Old St Paul's in London, where it was used for an exceptionally wide aisle bay about 1265–70;[14] alternatively, it might have been derived from the six-light pattern of the Westminster north gable. However, the details of the Lincoln design bear no resemblance to the others and it is equally possible that the designer of the Angel Choir was indulging himself in experimentation.

The most important of the innovative designs at Lincoln is that of the great east window. Both the general idea of one enormous window filling a rectangular end wall and specific features of the pattern were prefigured in France, but the Lincoln man again used those ideas as points of departure for a design which is significantly different. He enlarged the window to more completely replace the end wall with glass and he filled the outsize oculus of the window head with a new type of pattern, treated neither as a whole — that is, cusped, — nor filled with a centrifugal or centripetal pattern like a rose window. For the first time in bar tracery, the designer divided the field into small independent units. The oculi of comparable French tracery designs always retain a central focus, like a rose window,[15] whereas the Lincoln pattern is more balanced, suggesting fragmentation. Precedents are found only in plate tracery, in the gables of St Denis, Paris north transept and the Ste Chapelle. The same effect had been seen in England, in sculpture, at Westminster Abbey north transept, where roundels played freely across the face of the tympana of the side portals (Pl. XVIc).

Thus the architectural design of the Angel Choir makes no specific claim on the authority of Westminster Abbey, and the designer is likewise making comparatively unspecific use of French models. Its particular source of inspiration was in fact a local English design, the retrochoir of Ely Cathedral, which had been dedicated four years before in 1252.[16] Bishop Northwold's retrochoir is exceptionally rich in colourful and sculptural effects, comparable to the shrine of St Etheldreda and her companions which it was designed to house[17] (Pl. XIXa). In this respect it may at first appear to be itself little more than a reflection of earlier work at Lincoln Cathedral,[18] but there was in fact an important difference. Such a taste for architectural decoration had originally been introduced into the region by St Hugh's Choir at Lincoln, but the Lincoln workshop had drawn away from that type of expression. By the time the nave was designed, the emphasis was rather more upon grandly conceived space achieved by enlarging the height of the aisles and the width of the bay. The nave continued to use a decorative vocabulary based upon that of St Hugh's choir, but the individual motifs have less impact when the system of proportions is more generous.[19]

By contrast, the Ely retrochoir, built at approximately the same time as Lincoln's nave, exhibits a style more decorative and plastic than Lincoln's choir. For example, the sunken panels of pointed trefoils and quatrefoils now decorate every area of blank wall, and rather than being simply a pattern cut into the ashlar they now contain slabs of dark limestone, making the play on the depth of the wall and the contrast of light and dark even more emphatic (Pl. XIXa).

The Ely *presbiterio nobilissimo*[20] gave new currency to an established taste for colour and surface effects. At Lincoln its influence can be seen to have been at work even before the Angel Choir was undertaken.[21] For the new Lincoln retrochoir, where the designer was called upon to create a suitable architectural setting for the shrine of a saint, not only Westminster Abbey but also the Ely retrochoir provided a recent, prestigious model from which to draw inspiration. With hindsight we know Westminster Abbey to have been the most significant building of the previous decade, but to a Lincoln mason or patron of 1256 Ely might be imagined to recommend itself as forcefully. Not only was it more accessible both geographically and stylistically, but it would have appeared the latest word in established local fashion, a more obvious point of departure than the London coronation church.

The Angel Choir thus proves to have an important English element to its design not just because of the weight of general tradition or Lincoln precedent but because it is emulating Ely. The two retrochoirs share a common plan, a common type of eastern elevation,[22] and many specific motifs; for example, on the interior, canted 'Purbeck'-filled trefoils in the spandrels and long cones covered with foliage for the vaulting corbels. The arch mouldings also suggest the connection. Unlike the profile used for the arcade of the Lincoln nave or of Westminster Abbey, that of the Angel Choir has two rolls on the soffit. This is an idea which has been traced to Wells and Salisbury.[23] Wells was one of the sources for the design of the Ely retrochoir, and there one also finds the double soffit roll.

The most striking and significant difference between Ely and the Angel Choir is the introduction of the Rayonnant style, specifically the Rayonnant window, at Lincoln. Yet even this may have depended upon the stimulus of Northwold's retrochoir, where the amount of window area in the east façade (Pl. XVID) went beyond anything in England at the time. The south transept façade of Beverley, probably another design of the 1230s and one with which is Ely is often compared,[24] has by comparison very narrow lancets separated by broad bands of solid wall. Other buildings followed Ely in this emphasis. Lincoln employed the tracery window, including the technical knowledge which came with its use, to open and subdivide the wall to an even greater extent.

There are thus three facets to the design of the Angel Choir. It is at the same time a manifestation of the influence of the London court style of the 1250s and a design rooted in English tradition, but it was not a conservative reaction to Westminster Abbey. Its point of reference was instead the retrochoir of Ely Cathedral and its use of French vocabulary was remarkably knowledgeable; we might better call it a Rayonnant response to Ely. The designer of the Angel Choir was also innovative in his approach to tracery patterning, able to produce novel, even unorthodox designs. Thus the Lincoln design went beyond Westminster, introducing alternative French tracery patterns and developing new variations, but these innovations were so fully integrated into a design of otherwise heartily English character that their novelty has gone unnoticed.

Lincoln Cathedral had first introduced the Gothic style of architecture into its region and, although it never dominated its region to the exclusion of outside ideas,[25] throughout the early 13th century its workshop exerted a powerful influence. For this reason the area was predisposed to the leadership of the Cathedral in architectural matters.

The accessible design of the Angel Choir was also encouraging to followers: its new Rayonnant features, the enlarged windows and bar tracery patterns which reveal a debt to the inspiration of Westminster Abbey and its French sources, were deliberately presented in a way which was consonant with established local taste. The walls into which they were set were otherwise of familiar character, with conservative proportions and structure and an

emphasis upon plasticity. In the hands of the designer of the Angel Choir big tracery windows did not necessitate the abandonment of the heavy Norman wall or the sculptural richness which was so much to the taste of many local Gothic masons and their clients. He presented them instead with a modernized version of the regional Gothic fashion and like previous Lincoln styles it exerted considerable influence.

The local project which is perhaps most obviously derived from the Angel Choir is the west façade of Croyland Abbey (Pl. XVIB). An early Gothic façade reportedly suffered damage in a gale in the time of Abbot Radulphus de Merske (1254–81),[26] and the central part was built by men from the Lincoln Angel Choir. The lower level of the design is most specifically dependent upon Lincoln. The portal is a close relative of the Judgement Porch, with monolithic jamb shafts arranged in relief, the major ones framed by two small filleted colonettes. In both cases the capitals are crocketed, with continuous abaci. There are major differences; for example, Croyland has no foliate orders or voussoir figures, but the arch mouldings compare with those of the Judgement porch. Both are double portals with arched cinquefoil heads and a tympanum whose field extends down into the spandrels of the portal. Both, like the main portal of the Westminster north transept, have a central quatrefoil frame. The imagery is different — the Croyland tympanum has scenes from the life of Guthlac in the quatrefoil — but the foliate scroll surround is a quotation from another of the Westminster models, the door to the Chapter House vestibule. To either side of the portal and on the upper walls, flanking the centre window, statues on brackets are framed by arcading or covered by gable canopies like those provided at Lincoln (or, earlier, on the Wells façade). At Croyland the mason also uses blind tracery to frame the statuary.

Croyland also possessed another feature which would immediately have recalled the Angel Choir: a large tracery window of four or more lights.[27] Unlike the Angel Choir, Croyland rejected the concept of a wall replaced by glass. The tracery window is allowed to occupy only half of the width of the wall, and the rich sculptural composition on either side competes successfully for attention. Even more than Lincoln itself, this is a case of the combination of the Rayonnant window and a particularly English love of massing and sculptural richness.

The emphasis on sculpture at Croyland is exceptional: in most cases the big window was the message carried from the Angel Choir to major projects in the surrounding region, such as the north aisle of the parish church of St Wulfram in Grantham, (Pl. XVIIIA) an important town and royal manor lying along the highway to Lincoln. Grantham church was already an ambitious building in the late 12th century, with north and south aisles and early quatrefoil piers. Banded diagonal shafts and some good foliage sculpture suggest that an association with Lincoln was established early. Later, stimulated by the activity of the Lincoln workshop at Newark (Notts.),[28] Grantham began a western tower of similar concept and a general reconstruction of the building, as well, which began with a north aisle.

The new aisle was conceived on a cathedral scale, even wider than the old nave. It is seven bays long, with an elaborate north portal in the centre bay and enormous windows which fill the wall space between buttresses. Each of these windows had four uncusped lancets and three oculi arranged according to the standard Rayonnant pattern of subdivisions introduced at the Westminster chapter house. Hamilton Thompson compares these windows with those of Salisbury, suggesting that the influence of that cathedral may have extended to Grantham by virtue of the fact that it was a prebendal church to Salisbury.[29] Pevsner claims that they are quotations from the Angel Choir.[30] Neither is true; assuming that they are correctly resored,[31] they differ from four-light examples at Westminster, Lincoln and Salisbury in the diagonal arrangement of all of the foils, including the quatrefoils of the lower oculi. This was the pattern of the Amiens nave clerestory, copied here with a suitable

reduction of the upper oculus. By contrast with Westminster Abbey, which favoured more recent Parisian models, Amiens was a particularly important source of influence at the Angel Choir, so we may suggest that this was a design transmitted by the Lincoln workshop to Grantham.

Lincoln's role as a primary source for the north aisle of Grantham is further suggested by the design of its west window (Pl. XXA) which is conceived like that of Lincoln's east façade, occupying the full height and breadth of the end wall. It is of six lights. A six-light tracery pattern is unusual; the Westminster gable had one, but in that case it began as a three-light, three-oculus design with each lancet subdivided to produce a six-light window. At Grantham the six-light design is produced by the reproduction rather than the subdivision of the unit. Another distinction is found in the arrangement of the parts of the pattern. At Westminster the centre light is distinctly taller and it seems to force the lower oculi apart. This design was a very popular one in England (particularly in the West Country), but it did not inspire the design at Grantham, where the centre light is only slightly taller and the oculi remain contiguous. Among English buildings it is the aisle windows of Lincoln which offer the closest comparison. The main oculus confirms an association with Lincoln. It contains seven circles, like the oculus of the Lincoln east window, where the pattern was apparently first introduced.

It is difficult to suggest a date for the Grantham aisle: the relatively conservative pattern chosen for the north windows and the conscientious articulation of the window mullions argues for an early date, but the window arch mouldings and other filleted details make one cautious. On the north portal (Pl. XVIIA) the pierced cusping of the side niches and the complex arch moulding look late, but the pattern of jamb colonettes and capitals is distinctly old-fashioned. The acutely pointed triple gable is related to the court style, but the delicate surface pattern which attends it is a sort of Lincoln signature found in work of the 1240s such as the Lincoln west façade or, in the Fenland, at West Walton parish church. One must entertain the possibility that Grantham was designed as early as the 1260s.

When the expansion of Grantham church was begun, parish churches, even town churches, did not so commonly aspire to this scale. There are other unusual features of the design, as well, specifically the magnificence of the north portal and the fact that the original north porch (which was as tall as the aisle) was destroyed in the early 14th century in favour of an even more ambitious, two-storey porch with open arches on three sides. Hamilton Thompson called attention to a pair of spiral staircases serving the upper chamber of the new porch and to a screened opening which communicates directly between it and the church, from which he concluded that it may have been designed for the storage and veneration of the relics of St Wulfram and for their display to pilgrims in the north aisle.[32] This is just an hypothesis and is supported by no documentary evidence but it is attractive and there are some reasons to pursue it. For some reason it was essential that the new building be put on the north side, where a fine new portal had to be mutilated, rather than on the south, where a modest early 13th-century porch was left unimproved. If that reason were an association between the north side of the church and the cult of St Wulfram, it would explain not only the exceptional size of the works but also the use of a style associated with other shrine-houses, most recently that at Lincoln.

Among the buildings which may represent early examples of the early influence of the Angel Choir the only one to bear a date is the Lady Chapel of Peterborough Cathedral, begun in 1272 by the prior, William Parys.[33] It was destroyed about 1652 but testimony to its form and character survives in the descriptions by Walter of Whittlesea in the 14th century and Symon Gunton in the 17th century, the Suppression Inventory of 1539, an illustration by Daniel King (Pl. XVIIIc) and in physical evidence left in place on the outer

walls and buttresses of the cathedral.[34] It stood east of the north transept, with which it communicated directly, and north of the presbytery, to which it was linked only by a vestibule. The chapel was five bays in length, two transept bays in width, and taller than the Norman aisle and tribune of the transept. Each bay was demarcated by chamfered buttresses which rose to the height of the wall, and each bay contained a large tracery window. There was an east window praised by Gunton as 'the fairest in the church' 'scarce a fairer in any other cathedral,' but of this window no trace or record remains. The interior was lavishly decorated with a series of English kings with accounts of their lives beneath and a Jesse Tree — all this probably in the glass. The Suppression inventory also mentions an image of the Virgin of gilt wood in a tabernacle and 12 large and 34 small figures 'of the same work' in other parts of the chapel. In addition, a wall arcade apparently decorated the wall beneath the window.

Such an elaborate scheme of decoration — one might call it an 'illuminated' interior — recalls Westminster and one of its sources of inspiration, the Ste Chapelle. However, the windows of the Peterborough chapel did not quote the royal abbey but were more closely related to the aisle windows of the Angel Choir, with three lights and three contiguous oculi.[35]

Croyland façade, Grantham north aisle and the Peterborough Lady Chapel are presented here as examples of the influence of Lincoln because they use specific features associated with the Cathedral workshop. All Rayonnant-inspired buildings in the region did not depend upon Lincoln. Information about Westminster Abbey or about French architecture was available from a variety of sources, including continued contacts with workshops in the West Country as well as alternative contacts with London itself. This was true for sculpture as well as architecture: a well-known example of direct London influence is the west porch of Higham Ferrers church in Northamptonshire, which can easily be seen to be independent of the Judgement porch or the portal at Croyland.[36]

A more difficult case is presented by the west façade of Binham Priory on the north coast of Norfolk (Pl. XVIIIB). Binham begs comparison with the east façade of the Angel Choir, for it features a single Rayonnant tracery window which fills the entire end wall and is framed by wall arcades below and on the buttresses. This is the same combination of big window and richly modelled thick wall that Lincoln so dramatically displays. Furthermore, those who know the Binham window from the illustrations in the *Architectural Antiquities of Great Britain* (1811) or in Sharpe's *Decorated Windows* (1849), both of which show it with eight lights, must presume a connection with Lincoln, for Lincoln was the only eight-light window in England at the time.

These similarities to Lincoln are, however, only specious ones. The great window at Binham was inserted into an existing façade, one built about 1240 by a man from Ely.[37] The present combination of new tracery window with older ideas about wall massing and decoration was thus not necessarily the choice of the second designer. Nor did Binham have an eight-light window. Rather than representing the window before the destruction of the mullions, John Britton's 1811 view appears to have been a reconstruction, for other views from the time show the opening already bricked up.[38] Neither does it appear that the reconstruction was accurately based on the surviving evidence. Early drawings of the window are unfortunately entirely inconsistent about the number of mullion fragments or bases, but none before Britton suggests eight lights. A comparable number suggest six, which is an impossibility, or four.[39] The surviving physical evidence on the interior includes the lines of two arches and a lost mullion preserved in the plaster infill and the base of that mullion still in position. This evidence, together with the proportions of the pattern overall, suggest that the window had only four lights.

Unlike those at Grantham or Peterborough, the Binham window does not reproduce any of the patterns used at Lincoln or its known models; instead, it refers to orthodox Parisian work of the early 1240s, specifically to the windows of the refectory of St Germain des Prés, which have an identical pattern. The aisle windows at Binham refer to the same model, which is attributed to Pierre de Montreuil,[40] and the details are also handled in an orthodox French way with delicate shafts on the mullions and multiple ranges of fine lines to distract the eye from the fact of the wall thickness rather than, as at Lincoln, to use that thickness to decorative advantage.

Comparisons can be made with Lincoln but they are never telling and usually involve things found in other court-related projects as well. Lincoln may well have influenced Binham, but it was merely a matter of encouraging the use of an enlarged window for an end wall. The work itself was not done by Lincoln men but by someone more orthodox in his approach, perhaps a French-trained mason at liberty after the Westminster shop began to disband.

Among smaller buildings the Angel Choir cannot be said to have inspired a wide-spread local following comparable to that produced in the wake of St Hugh's Choir or the nave. Sutterton church (Lincs.) makes a specific although crudely wrought reference to the pattern of the Lincoln aisles in three-light transept windows which have an upper oculus much smaller than the lower pair (Pl. XVIIB). The oculi have no cusps, but that too may argue for some connection with the Lincoln workshop inasmuch as uncusped tracery seems relatively common in this area. The Grantham west window had no cusps before its restoration and a number of windows related in design, such as Bourne (Lincs.) south transept, are without cusping. The Lincoln workshop would be a logical source for this idea not just because it was nearby but because the pattern comes from Northern France, origin of many of the ideas used on the Cathedral itself.[41]

Two other buildings in southern Lincolnshire appear to be early examples of the new style. Swaton church, near Heckington, has a chancel with good detail including an east window of two lights with shafted mullions and jambs and stiff-leaf capitals (Pl. XVIIID). The tracery pattern is more orthodox than most we have seen, but the inner shaft of the window arch has a ring as was the case at Grantham and the foliage capitals are also comparable to those inside the Grantham west window, so Swaton is probably a design of the 1270s by a man from the Lincoln group.[42]

The other building is Irnham church, south east of Grantham, a large part of which was rebuilt in the late 13th century (Pl. XVIIc). The three-light three-oculus windows of the north side seem to be related to Lincoln work, but the handling of the tracery is considerably different from other examples in the area: it is much thicker. Furthermore, the details of the pattern are different, closer to a variant in the west of England with three small contiguous oculi and uncusped lights, and the east window is also reminiscent of West Country patterns.[43] Irnham may in fact be an example of outside influence.

Lincoln influence had been very strong in the Fenland in the first half of the 13th century but, despite the fact that the Croyland façade was employing Lincoln men, the Angel Choir wasn't influential there. The nave and transepts of the large parish church at Spalding were reconstructed in 1284,[44] but they don't betray a knowledge of Lincoln. Paradoxically, one of the most beautiful early tracery windows in the diocese is found in the Fenland, inserted into the south wall of West Walton (Pl. XXc). This window is not orthodox court work and may have been by someone who had been working at Lincoln when the interior portals to the aisle of St Hugh's Choir were carved, but one cannot be confident about the attribution.

Northamptonshire, by contrast, is generally well informed about the new Rayonnant style and about Lincoln. This was in most cases due to the activity of a workshop from

Peterborough Abbey. Peterborough masons were well established in the region and, perhaps because of the court connections of Abbot John de Caleto (1250–66) were apparently already working in a Rayonnant style before the construction of the Lady Chapel. Among the Peterborough masons the example of the Lincoln Angel Choir encouraged the use of bigger windows and windows with three and five lights, as at the Lady Chapel. The south transept of Castor church has a window related to the Lincolnshire examples of Grantham and Bourne, and three-light windows are also found at Oundle, Pilton and Clopton.[45] The east window of Raunds church (Pl. XXB) is the most clearly dependent upon the example of Lincoln. Not only is it a six-light window (so large that the existing wall had to be heightened considerably in order to receive it) but each group of three lancets specifically quotes the Lincoln aisles in the use of an upper oculus which is smaller than the others.

The design of the Angel Choir inspired other local work even after tastes began to change and more up-to-date forms had come to be known in the diocese. For example, the blind tracery of the chapter house of Thornton Abbey (Lincs.)[46] quotes the Lincoln aisle windows almost verbatim. Its later date, 1282, is suggested only by the substitution of trefoil-headed lights for cusped lancets. The chapter house of Southwell also decorates its blind walls with tracery which quotes the same source in the use of the smaller top circle and a foliage pattern on the wall above (Pl. XIXC). The glazed windows of the chapter house are also conservative for their date (c.1290) although they do use more modern details such as the double lancet with enclosed trilobe.

The west façade of Newstead Priory (Notts.) was likewise a conservative work touched by new ideas from outside the region (Pl. XVA). It was begun by Lincoln-trained masons, who depended upon the Angel Choir for the form of the western aisle responds, the gable-headed wall arcades, and the portal design. The upper storey of the façade is, however, more up to date, with a six light window of a pattern originally comparable to that of the Durham Nine Altars north window and blind tracery patterns which, like the Hereford aisles, use Y-tracery for the main subdivisions. Both Durham and Hereford were London-inspired,[47] and inasmuch as Newstead was a royal foundation close to Edward I's hunting lodge at Clipsham, we may postulate some court influence here. In fact the convent was seriously in debt at this time and the king appointed a receiver to administer their estates and relieve their debts in 1274, 1295, and 1300.[48] The façade may have been begun by the convent in the 1280s with men from Lincoln, but was completed only in the 1290s with help from London. This stylistic shift is not unique to Newstead; it could be seen to be taking place in many parts of the Lincoln region, including at the Cathedral itself, where court styles influenced work on the central tower and cloister.

The buildings of the diocese which were influenced by the Angel Choir show that it was a major source of ideas between about 1265 and 1285. It first introduced the bar tracery window into the Southeast Midlands, and its example encouraged the frequent use of forms extraordinary in more orthodox Rayonnant circles, particularly three-light windows of a certain type and windows which were enlarged to fill a rectangular end wall.

With regard to the nature of the influence exerted by the Angel Choir upon English architecture, two points should be noted as coda to this analysis and as a beginning point for further investigation. Most note the importance of its unusual plan with centre space continued unbroken to a cliff-like end wall, the plan derived from Ely, which raises a larger question of the relationship between the Angel Choir and Old St Paul's. However, a detail of its tracery, the division of the field of an oculus into small separate units, is as particular and significant. The scale of the east window precluded simple cusping, and, as noted, the

Lincoln designer arrived at a new formula: whereas French precedents continued to use a central focus, a centripetal or centrifugal arrangement, Lincoln's approach was to begin to fragment the design. The heritage of this idea in bar tracery was first, perhaps, a matter of local influence, for it was repeated at Grantham. It was, however, quickly adopted elsewhere, as at Exeter in the 1270s where it was already fully integrated into a window design otherwise purely western in character. As the earliest English effort to liberate tracery pattern design from orthodox Rayonnant precedent this was perhaps the most important heritage of the Lincoln Angel Choir.

REFERENCES

SHORTENED TITLES USED

BONY (1979) — Jean Bony, *The English Decorated style* (Ithaca 1979).
BRANNER (1965) — Robert Branner, *St Louis and the Court Style in Gothic Architecture* (London 1965).

1. This paper incorporates material originally presented in my doctoral dissertation, 'The Beginnings of Decorated Architecture in the Southeast Midlands and East Anglia' (University of California, Berkeley 1979) which has since been presented publically in papers read to the College Art Association ('A New Perspective on the Lincoln Angel Choir', annual meeting, 1981) and the British Archaeological Association conference at Lincoln Cathedral ('The Influence of the Angel Choir', 1982). For all these studies I gratefully acnowledge my debt to my teacher, Professor Jean Bony.
2. As noted, for example, by Edward S. Prior and Arthur Gardner, *An Account of Medieval Figure Sculpture in England* (Cambridge 1912), 276, and Arthur Gardner, *English Medieval Sculpture*, 2nd ed. (Cambridge 1951), 123.
3. William R. Lethaby, 'Notes on the Sculpture in Lincoln Minster: The Judgement Porch and the Angel Choir', *Archaeologia*, LX (1907), 379–90.
4. Marion E. Roberts, 'The Relic of the Holy Blood at Westminster Abbey and the Sculptural Program on the Central Portal of the North Transept', presented to the College Art Association, 1980, and at Harlaxton in 1984. See W. M. Ormrod, ed., *England in the Thirteenth Century* (Harlaxton 1985), 129–42.
5. Lawrence Stone, *Sculpture in Britain: the Middle Ages* (Baltimore 1955), 126–7.
6. Among these the choir section, following Canterbury, featured an overhanging *culée*, whereas in the nave the pier was enlarged to rest firmly beneath the clerestory wall.
7. Bony (1979), 4–5.
8. The apse at St Martin aux Bois (begun *c*.1245) is another example which similarly draws upon Amienois and Parisian sources, Branner (1965), 73.
9. Robert Branner, 'Westminster Abbey and the French Court Style', *Journal of the Society of Architectural Historians*, XXIII (1964), 7.
10. Branner (1965), 73–4.
11. Double cusping appeared first in the south transept of Amiens in the 1250s and was used inside the north transept of Notre Dame.
12. Branner (1965), 17–18.
13. Multiple cusping was not uncommon in 13th-century England, particularly among buildings inspired by Wells, including Salisbury (west doors) and Ely (west doors and exterior arcading). However, until the 14th century most cinquefoil cusping was, as in these examples, restricted to doorway and arcade arches. French windows which use three oculi sometimes have a larger circle in the apex (St Maur des Fossés, Tournai and Arras), but a precedent for the Lincoln variation has yet to be found.
14. Bony (1979), 10–11.
15. Examples include the east window of the Dominican Priory at Rouen (1257), which is very similar to the Lincoln pattern except that the central motif is markedly smaller, making an obvious central focus (Branner (1965), 89–90, compares the design to gable patterns), and the east window of La Cour Notre Dame les Gouvernay (Yonne), *c*.1260 (Marcel Aubert, *L'architecture cistercienne en France*, II (Paris 1943), 182 and figure 519).
16. Peter Draper also calls attention to the relationship between Ely and Lincoln in 'Bishop Northwold and the Cult of St Etheldreda', *Medieval Art and Architecture at Ely Cathedral, BAA CT*, II (1979), 15.
17. Surviving fragments of the shrine base exhibit the same style (*VCH Cambridge*, IV (1953), 72 and figure 71; Nicola Coldstream, 'English Decorated Shrine Bases', *JBAA*, CXXIX (1976), 17). Details like inlaid sunken

panels and nichework depend upon the influence of metalwork and other wrought objects. Draper, op. cit., is most essentially concerned with the relationship between function and form at Ely.

18. Ely begins with a thorough knowledge of St Hugh's Choir and uses its black-and-white colouration, banded pier shafts and vertical bands of crockets. Common to both Ely and Lincoln nave are the pier type, an arch moulding in three orders, spandrels with geometrical decoration, triple vaulting shafts on cone-shaped corbels and a tierceron vault pattern.

19. Peter Draper, op. cit., 9 characterised the situation thus: 'It is as if the architect at Ely had employed the architectural vocabulary of the Lincoln nave in the decorative spirit of St Hugh's choir'.

20. Matthew Paris, *Chronica Maiora* ed. H. R. Luard (Rolls Series 1872–3), v, 455.

21. In work of the 1240s, the central lantern and upper parts of the west front, there was an increased emphasis on deep mouldings, framed trefoil- and quatrefoil panels, vertical bands of dogtooth and foliage sculpture, all features of Ely. There is also a renewed interest in other decorative details like crocket bands.

22. It is true that by this time the *chevet plat* can no longer be seen strictly in terms of the native English series of which Ely was the latest example. The plan was gaining popularity in France, particularly around Paris, and was probably among the French ideas circulating in the workshop at Westminster (Bony (1979), 5 and footnote 14). However, there are no examples of the *chevet plat* in England which can be linked to the French series, and the group to which Ely and Lincoln belong, one previously found in Yorkshire, is independent.

23. Virginia Miller Jansen, 'The Architecture of the Thirteenth Century Rebuilding at St Werburgh's, Chester', Ph.D. dissertation (University of California, Berkeley 1976), 172.

24. Peter Brieger, *English Art 1216–1307* (Oxford 1957), 48.

25. The Ely retrochoir, for example, brought ideas from the West Country, which at an earlier time may also have been the source of the drier and more acutely pointed style of the Peterborough façade.

26. A. W. Clapham, 'Crowland Abbey', *Archaeol. J.*, LXXXIX (1932), 350.

27. This was destroyed when the façade was remodelled in the 15th century, but the jambs survive.

28. The tower of Newark church was rebuilt using Lincoln's style of the 1230s and 1240s. The Bishop of Lincoln was lord of the town and castle.

29. Alexander Hamilton Thompson, 'Grantham Parish Church', *Archaeol. J.*, 2nd ser., LXXVI (1909), 403.

30. B/E *Lincolnshire* (Harmondsworth 1964), 541.

31. The uncusped lancets are correct but the rest of the cusping is 19th century, probably by Scott between 1866 and 1875. Buckler recorded the state of the north side of the church in 1811 (British Library Add. Ms 36369, f. 59).

32. Hamilton Thompson, op. cit., 404.

33. He is said to have completed it before his death in 1286 (Walter of Whittlesea, printed in *Historiae Anglicanae Scriptores Varii*, Joseph Sparke, ed. (London 1723), 149–50) although the altar was only consecrated in 1290 (*Rolls and register of Bishop Oliver Sutton 1280–1299*, ed. Rosalind M. T. Hill, LRS, XLVIII (1954), III, 15).

34. For a full history and analysis of the Lady Chapel see Mary A. Dean 'Gothic Architecture at Peterborough', *JBAA*, CXXXVII (1984), 121–4.

35. The oculi of the aisle windows are also double cusped, suggesting Lincoln, but the cusping is modern and old illustrations are ambiguous on this detail, so one must reserve the point.

36. Virginia Wylie Egbert, 'The Portal of the Church of the blessed Virgin Mary, at Higham Ferrers', *Art Bulletin*, XXXIV (1959), 265–9, and Jean Bony, 'Higham Ferrers Church', *Archaeol. J.*, CX (1953), 190–1.

37. In addition to exhibiting Ely's attitude toward hollowing and ornamenting the wall, Binham shares a number of specific details with the Cathedral retrochoir and Galilee porch, including the design of the arcade hood-mould terminals and the use of an octofoil oval, a pattern originally found in the tympanum of the Ely west portal (see the illustration in James Bentham, *The History and Antiquities of the Cathedral Church of Ely*, 2nd edition (Norwich 1812)). Bony (1979), 9, discusses the physical evidence for the window insertion.

38. For example, an engraving by George Isham Parkyns, dated 1792, first published in *Monastic Remains and Ancient Castles in England and Wales* (London 1792), I, opposite 113.

39. The first of the series, 'The Southeast View of the Church of Binham Priory, in the County of Norfolk', by S. and N. Buck, 25 March 1738, clearly shows four lights.

40. Branner (1965), 68–9.

41. For example, at St Maur des Fossés. Related windows outside the region include the western bays of the north aisle of Chichester, built around 1270. These have Lincoln's three-light pattern with smaller circle in the apex, and they were originally uncusped. Lincoln influence upon Chichester is also to be seen in the sculpted figures of an angelic choir installed in the gallery of its choir about 1276, on the occasion of the translation of St Richard (Brieger, op. cit., 128).

42. The details of the window tracery are questionable. I haven't been able to verify them from early sources and I am inclined to attribute them to some fanciful restorer. Edmund Sharpe does not mention them in his description, 'Swaton Church', *An Account of the Churches Visited During the Lincoln Excursion of the Architectural Association* (London 1871), 73.

43. Later in the century western Lincolnshire received at least one other anomalous church by such a mason, Caythorpe.
44. William Dugdale, *Monasticon Anglicanum*, new ed. (London 1846), III, 209.
45. Mary A. Dean, 'Lost Churches of the Nene Valley and the Rediscovery of St. Peter's, Clopton', *Northampton-shire Past and Present*, VII (1984–5), 90, fig. 4.
46. S. E. Rigold, 'Thornton Abbey', *Archaeol. J.*, CXXXI (1974), 373–7.
47. Bony (1979), 12; Richard Morris, 'The Remodelling of the Hereford Aisles', *JBAA* 3rd ser., XXXVII (1974), 21–39.
48. John C. Cox, 'Newstead Priory and the Religious Houses of Nottinghamshire', *Memorials of Old Notting-hamshire*, E. L. Guildford, ed. (London 1912), 62.

The Sculpture of the Angel Choir at Lincoln

By Virginia Glenn

In general terms the architect of the Angel Choir may be said to have produced an interior (Pl. III) which resembled the exterior of an enlarged metalwork reliquary, an effect which must have been even more pronounced in its original painted and gilded state.[1] The box-like shape and the rich decoration which covers every surface bring to mind contemporary shrines like that of St Gertrude at Nivelles, or more remotely that of St Taurin at Evreux. Just as they had every surface enriched with enamels, jewels and repoussé work, so in the Angel Choir an impression of overall decorative intensity is achieved by architectural means; and where any gaps in this intensity threaten, sculpture is used to ornament, to punctuate and to connect the patterns created by the tracery, the vaulting and the shafts.

The triforium could have been such a gap. Its structure imposed a series of dark apertures with at least some areas of solid wall in the spandrels; these might have formed a blank and heavy interruption between the delicate filigree appearance of the upper walls and the brightly-lit spaces of the aisles below. No sculptural decoration was felt to be necessary in the clearstorey apart from the capitals. The double skin of the tracery was itself elaborate enough, and in any case occupied all the wall space, apart from a narrow blank lancet on either side of each window. The tall slender piers go almost unnoticed as one looks through the arcade arches into the aisles beyond, where walls are mostly given up to glass, and where the parts below the windows are filled by complex blind tracery.

It was in order to match the profusion of ornament in the aisles and the clearstorey that sculpture was introduced into the triforium of the Angel Choir. Each spandrel contains a vigorously animated angel figure in relief, curling leaves are inserted under the hood mouldings, and crockets sprout between the shafts of the triforium arches. In so far as these are solid and three dimensional they create a contrast with the airy lightness of the aisles and clearstorey. Nevertheless, the triforium is their equal in intricacy and visual impact. It may even be argued that the sculpture of the triforium was essential for the aesthetic balance between the other two levels of the design, counterpointing and binding them together.

The angels themselves are unexpectedly unobtrusive and difficult to see from the floor of the church; they can simply be read as a fairly minor element in the general luxuriance. They are small in scale (the head-stops further down the wall are in many cases as large as the heads of the angels) and in relief they project no further than the triforium hood mouldings immediately below. By far the most conspicuous motifs in the whole elevation are the large trefoils in the spandrels of the arcade. However, if the function of the triforium sculpture is to encrust a whole horizontal band of the wall with opulent ornament, the trefoils serve to negate the plain masonry behind them and indeed would actually pierce it, if the presence of the aisle vaults did not render this a structural impossibility. At this arcade level the only other sculpture is a series of long, finely foliated corbels which carry the vaulting shafts down to merge with the mouldings of the main arcade arches.

Visually therefore, the angels are no more important than voussoirs would be in the composition of a portal, and iconographically they fulfill a somewhat similar function. There are two separate schemes: one is made up of musician angels, the other of angels associated with the Apocalyptic vision of the Last Judgement. Exactly how the distribution of the two schemes relates to the Judgement Portal outside, and to the liturgical arrangements

of the interior of the Angel Choir is not entirely clear. While in many ways the Apocalyptic angels extend and appear to overflow from the portal iconography, their designer was presumably very conscious of the positions of the high altar and of St Hugh's shrine over which he was erecting an appropriate canopy.

The pilgrim entering the choir by the Judgement Portal would have found, it is almost certain, St Hugh's shrine immediately ahead[2] in the third bay from the west. In this bay and in the two bays west of it, are grouped what from the scriptural point of view are the most significant of the spandrel figures. Above the high altar are the Madonna and Child (Pl. XXID); an angel with a book; an angel with the spear and sponge, i.e. instruments of the Passion; an angel with the crown of thorns,[3] another instrument of the Passion; an angel holding up a naked soul (Pl. XXIC) and another generally labelled the Angel of the Expulsion (Pl. XXIA). The significance of the angel with the book is lost along with the inscription which was presumably painted on the open pages. All the other figures, however, except the Madonna and Child, fit neatly into the type of Last Judgement programme which was firmly established by the later 13th century and had become one of the most frequently employed portal schemes in French sculpture. Without suggesting any form of direct contact, it would perhaps be convenient to illustrate this point by comparing the Lincoln iconography with that of the tympanum of the great west doorway of Bourges of about 1255–60.[4] At Bourges the angels with the instruments of the Passion appear on either side of the enthroned Christ in the apex of the tympanum and in the horizontal zone below there is a series of scenes which goes far to explain the two middle figures facing each other across the west bay of the Angel Choir. The French scheme shows Abraham on one side receiving the blessed and on the other, fiends thrusting the damned into the great cauldron of hell, with a host of angels between them separating the saved souls from the lost. At the centre is the archangel with his scales weighing souls (a figure which appears in the next bay above the site of St Hugh's shrine at Lincoln) while on his left angels with swords reject the damned and thrust them off into outer darkness and on his right they offer up the blessed to Abraham. These two functions are performed by the Lincoln figures. One with partly draped hands offers up a praying blessed soul while the other with upraised sword casts two rejected souls into the realm of the damned. The design of the so-called 'Expulsion angel' (N14) is certainly based on the scene of the Expulsion from the Garden of Eden complete with foliage background, but its significance here is of a much more general nature and is surely meant to be part of the same scheme as the surrounding figures, rather than an isolated incident from the Genesis narrative.

The Madonna appears in a non-Apocalyptic guise. As an Intercessor she certainly has a place in most Last Judgement schemes, but here she is a mother with her child attended by a censing angel, reflecting more clearly perhaps the dedication of the church as a whole and of the high altar immediately beneath.

In addition to the angel with the scales (Pl. XXIIC), the bay which contained St Hugh's shrine is also decorated with a figure of Christ showing his wounds and being offered a soul by a small attendant angel; an angel with a censer; two angels with scrolls (Pl. XXIB), whose significance has again unfortunately disappeared with their inscriptions; and an angel with a hawk on his wrist. The last figure engaged on such a wordly, even frivolous pursuit defies explanation.

The Judgement angels continue along the north wall. Opposite the portal are two angels one with a sword and one with two crowns representing the final heavenly reward or punishment. The angel with the palm in the next bay may also be part of this programme and there is no doubt about the angel with the sun and moon in the bay furthest east. At Bourges two angels display these symbols above the head of Christ in Judgement. Otherwise

H

all the remaining angels, on the south wall and the two east bays of the choir, either carry scrolls or form an orchestra led by a winged king (David?) playing the harp (Pl. XXIIA).

Some light could be shed on the meaning of the angels if we knew what St Hugh's shrine originally looked like. In particular, it is interesting to speculate as to whether they relate to the scheme of decoration on the reliquary itself. Peck[5] tells us that it was of beaten gold, eight feet long and four feet broad. Henry VIII's commissioners have left us a fairly precise account of the gold and jewels which had accrued to it by 1540,[6] and further scraps of information can be gleaned from the shrine accounts of 1520,[7] but none of these documents mention figures or scenes which might have been depicted on it. Angels would almost certainly have played some part in its decoration. In reliquaries of the Mosan School made around 1200 there are numerous examples of shrines where angels or angel busts fill the gables and spandrels.[8] By the latter part of the century they played an even more prominent part. The reliquary crown made for the sacred thorn presented by St Louis to the Dominicians of Liège in 1267 was ringed with them and when a relic of St Louis himself (a finger) was presented to San Domenico in Bologna soon after 1300[9] it was actually encased in a small shrine with a spire held aloft by two much larger and very elegant gilded angels. Angels had in fact become one of the main components of a certain class of reliquary design. Similarly, when St Hugh's own finger was placed in a separate reliquary, at some unknown date, this was held aloft by an angel standing on six lions.[10]

The possibility of there being a connection between angels as a common reliquary ornament and their extension to the actual architecture of the building designed to house the shrine, finds support in the decoration of the Sainte Chapelle. There the important collection of relics for which the chapel was built were kept in the 'Grande Châsse' known to us from 17th century drawings and inventory descriptions.[11] The Grande Châsse may already have been installed by 1248 when the chapel was dedicated. If not, it formed a part of the alterations made after St Louis' first crusade. But either way, it was certainly integrated with the architecture of the chapel itself which to some extent, it imitated. It was decorated with scenes of the Passion and angels, and in the Sainte Chapelle angels also spread to the architecture where they appear as busts in the spandrels all round the wall arcade. The Lincoln scheme was equally well suited for the purpose of ornamenting a pilgrimage chapel which was designed as a final abode for the relics of a major saint.

The separate head reliquary of St Hugh seems to have played no part in the original lay-out of the Angel Choir. The head was removed from the main relics in the course of the Translation [12] when it was taken back to the chapel of St John, and only re-introduced into the Angel Choir after its theft in 1364. The present base, now between the two north-east piers, is a mid 14th-century construction and the 'great feretrum, silver and gilt, with one cross isle, and one steeple in the middle, with twenty pinnacles'[13] which stood upon it was presented by the treasurer John Welburn after the thieves had stripped the head of its original container. Given these circumstances, the east end of the choir, under the angel orchestra must originally have had less significance.

The distribution of the angel figures does, however, also relate in some ways to the chronology of the building programme. The distinction between musicians and judges does not take the form of a neat line running north and south across the choir. Nor does it divide the shrine from a less hallowed area, nor even mark the place where work halted during the removal of the old apse and the building of the Judgement Portal. However, it does coincide with one minor change in architectural detail in the upper walls. On the trefoil heads of the triforium there are handsome carved cusps, but on the south wall these occur only in the first two and half bays from the east and along the north wall in the first half bay. In the rest of the Angel Choir these are absent. This implies a building procedure whereby, although

the lower walls may have progressed steadily from east to west, the upper, i.e. triforium level, was erected first on the south for at least three bays presumably in order to allow work to begin on the porch outside. The porch itself was clearly intended to receive a programme of sculpture devoted to the Judgement theme from the outset; yet its design was curiously ill-suited to accommodate all the components of the full French iconographical scheme. On the other hand, inside the new choir the decorative figures in the immediate vicinity of the high altar and the shrine ought to have been more important than the rest. It may therefore have seemed expedient to allow those elements for which there was no room in the portal itself, to spill over into the interior, and take their place in the appropriate spandrels of the triforium.

Yet it may not be necessary to look abroad for the sources of the Lincoln angels. Angels in spandrels, whether purely decorative or forming a heavenly choir, were already an established feature of English church decoration by the late 13th century. The designer of the Angel Choir could have taken the idea from the eastern transepts of St Hugh's church, where small delicately carved busts of angels with spread wings, now very much mutilated, occupy the spandrels of the wall arcade. Of those in a decipherable state, there is an angel with a book, a praying angel and two with scrolls. Small harping angels were carved about a quarter of a century later on the spandrels of the choir screen at Salisbury. With the series of angel busts in the quatrefoils across the west front of Wells we move nearer to the iconography of the Angel Choir with a series part-decorative, part-musical and part-liturgical. The comparison with the Westminster Abbey transepts is even closer. There we have not only the large censing spandrel angels, but in the north transept a little choir of angels carved in roundels on the window soffits. They also combine musician angels with others whose iconographic function is more specific, such as the angel with the chalice and the angel with crowns. This programme too, was originally above a Judgement Portal. After the establishment of the prominent series of angels in such a nationally celebrated shrine as that of St Hugh, expanded programmes combining Last Judgement and musician angels were used on the roof bosses of both Tewkesbury and Gloucester.

The Lincoln angels seem to be the work of a large workshop, and the hands of a number of different sculptors can be clearly distinguished. Considerable variations in both size and style are to be observed among the figures. One group stand out as the work of a single hand. For example, the angel with the blessed soul (Pl. XXIc) and the angel with the damned souls (Pl. XXIA), which face each other across the bay furthest west resemble each other closely. Both rest their feet on female heads with broad triangular faces, slanting eyebrows and similar head-dresses and hairstyles; both have widely spread wings lying flatly against the wall and the wings have the same pattern of feathers; the square-jawed faces and the hair curling around them are treated in the same way as are the broad shoulders and the angular folds of the drapery.

Another equally distinctive talent produced the elegant miniaturist style of the Virgin (Pl. XXID) and the angel with the book (S13). Their heads are small and their faces gently smiling; the more rippling robes are belted in the same manner; the gestures share an almost affected daintiness; there are no large heads under their feet, but small grotesque quad-rupeds with human faces.

The sculpture at the eastern end of the choir is evidently the work of several sculptors. The angel with the pointing finger (Pl. XXIIB) has a round face, a grimacing smile, banded curls, a wide cummerbund and evenly striated wings like the angel with the scroll (S6) and both rest their feet on formalised clouds. Further comparisons are possible between the angel with the viol (N5) and that with the sun and moon (N2). The fact that figures similar enough to be attributed to the same sculptor are always placed close together in this way, suggests that they were executed as the building progressed and set in position soon after they were

carved, rather than the whole set being prepared in advance and then distributed as required. Either the carvers of the east end figures had disappeared, or had changed their style beyond recognition by the time the crossing was reached at the west.

Altogether there are grounds for supposing that a number of distinct sculptors were employed. In some cases more than one seems to have worked on the same figure. Thus, two of the angels with scrolls (Pl. XXIb) and (S12) have crossed wings with jagged edges which overlap with the string course above. Their heads and drapery, however, are quite dissimilar. Apart from its wings, S12, is close to the elegant small-scale style of the Virgin (Pl. XXId) and also to the Christ (N12), while that shown on plate XXIb has particularly bold and flowing drapery and a large square head.

Apart from the large triforium spandrel figures the other sculpture in the Angel Choir includes a liberal scattering of head stops, varying in size, many of them delicately carved; much foliage both stylised and naturalistic and a handsome series of roof bosses. The foliage proliferates on the corbels of the vaulting shafts, gives depth and decorative interest to the slender spaces above the aisle windows and covers most of the bosses. The naturalistic foliage predominates on the bosses of both the high vault and the aisles. It is fairly evenly distributed from east to west, and alternates with clusters of formalised leaves resembling seaweed. All the high vault bosses, which are very difficult to see from the ground, are decorated with foliage of one kind or another, but on the more easily visible aisle vaults there are thirteen bosses carved with figures.

There is no obvious iconographic scheme governing the choice and distribution of these bosses, although predictably the most intricate are to be found in the three east bays of the south aisle just inside the main Judgement Portal entrance to the choir. These with their miniaturist style, complex draperies, elegant postures and curly hair are related both to the voussoir figures in the porch and to the Virgin and Christ figures in the triforium. The other figurative bosses which occur in the north aisle and furthest west in the south aisle are more robust in style and grotesque in subject.

All the figure subjects of the first group are framed by coiling conventionalised foliage very like that surrounding the porch voussoirs and both seem to owe their ultimate origins to a Jesse Tree design, indeed one boss actually shows the sleeping Jesse, with foliage springing from his side to enclose King David playing his harp, and two other prophet figures with scrolls (Pl. XXIId). Perhaps meant to be seen as an extension of the same Jesse Tree are two bosses in adjacent bays in the south aisle; one has two bearded men engaged in discussion, one holding a scroll; the other shows a similar group of an elderly man gesticulating to a crowned king. Two other bosses in this style present the Coronation of the Virgin and an apparently entirely secular scene of a queen and a courtier playing with two little dogs. After the three eastern bays of the south aisle, and the building of the Judgement Portal, the energies of this sculptor or group of sculptors seem to have been redirected to the triforium decoration of the western bays.

Not only do the grotesque bosses (Pl. XXIIe) form a contrast to the first group in both style and content, but they are either framed by naturalistic foliage or none at all. The scaly winged monster in the south aisle is biting grapes from a vine which entwines his body; the man and monster fighting in the north aisle do so among maple leaves; while the nearby kissing heads are attached to long distorted bodies which disappear unadorned under the vaulting ribs. Where human figures are used, they differ from those of the Jesse Tree group in that they are short and stumpy with ugly contorted faces, rudimentary indications of hair and in most cases no drapery at all. Although the subjects such as the combats between men and half-human monsters may call to mind the celebrated bosses of Westminster Abbey Muniment Room, the styles could hardly differ more. The monsters in the Angel Choir are

vigorous to the point of crudity and in fact probably represent the continuance, or at least the revival, of a presumably local school, unaware of court fashion and imported European manners, which also produced the figurative bosses in the nave aisles of Lincoln itself.

There is no very obvious external source for the styles of any of the Angel Choir sculpture. It is tempting to see court influence on the miniaturist and more refined figure style, descending perhaps from the sculptors of Westminster itself. However, none of the Lincoln angels actually repeat the fine flat pleats of the drapery, or the half-flying, half-standing poses of the large spandrel figures there. All the Lincoln figures are firmly seated on their pedestals. On the other hand, there is a surprising and marked affinity between some of the sculpture in the Angel Choir and some of the less prominent Westminster carving such as the rough corbel heads hidden in the triforium and some of the head stops in St Faith's chapel. The malevolent distorted features of the so-called 'Expulsion angel' (N14) with its large ears, exaggerated lop-sided mouth, broad short nose and continuous furrowed brows are strikingly similar to one of the corbels in St Faith's chapel. The awkward angular position of the raised arm of the same angel also resembles the ungainly limbs of the triforium corbels at the Abbey normally known as 'a craftsman' and 'Master Henry'. The latter also bears a strong facial likeness to the handsome square-jawed Lincoln angel with the scroll (S10). Although these common elements are hardly sufficient to prove the actual presence of numbers of London sculptors at Lincoln two decades later, it does seem possible that some master, trained on less important pieces for the royal workshop eventually matured to exert his influence in the Angel Choir.

THE ANGEL CHOIR SPANDRELS

WEST

Bay 5

S15 Virgin	N15 Angel with Crown of thorns
S14 Angel offering up soul	N14 Angel rejecting souls
S13 Angel with book	N13 Angel with spear and sponge

Bay 4

S12 Angel with scroll	N12 Christ showing his wounds
S11 Angel with hawk	N11 Angel with scales
S10 Angel with scroll	N10 Angel with censer

Bay 3

S9 Angel with book	N9 Angel with scroll and sword
S8 Angel with pipe and tabor	N8 Angel with two crowns
S7 Angel with two pipes	N7 Angel with scroll

Bay 2

S6 Angel with scroll	N6 Angel with lute
S5 Angel with scroll	N5 Angel with viol
S4 Angel with pipe	N4 Angel with palm

Bay 1

S3 Angel pointing finger	N3 Angel with harp
S2 King David with harp	N2 Angel with sun and moon
S1 Angel with scroll	N1 Angel with scroll

REFERENCES

1. John Britton, *The Architectural Antiquities of Great Britain* (London 1820), V, 232.
2. John Leland, *The Itinerary, 1535–1542*, ed, L. Toulmin Smith (London 1906), pt XI, 122: 'S. Hughe lieth in the body of the est parte of the chirche above the highe altare', See R. E. G. Cole and J. O. Johnson, 'The body of Saint Hugh', *AASR*, xxxvi (1921), 47–72, who discuss the question at length and place St Hugh's shrine almost directly opposite the Judgment portal.
3. Arthur Gardner, *The Lincoln Angels* (Lincoln 1952), describes this angel as holding a 'wreath'. As the object is identical to that on the head of the spandrel figure of Christ showing his wounds (N12) this seems an unnecessary complication.
4. Willibald Sauerländer, *Gothic Sculpture in France, 1140–1270* (London 1972), 504–5.
5. Francis Peck, *Desiderata Curiosa* (2nd ed., London 1779) bk VIII, 317.
6. James Gairdner, *Letters and Papers of the reign of Henry VIII*, xv, for 1540 (London 1861), 364–5, no. 772.
7. LAO, B. i. 5.16.
8. The Shrine of the Virgin at Tournai has busts of angels in the corner spandrels, Cologne, Kunsthalle, *Rhein und Maas: Kunst und Kultur 800–1400* (Cologne 1972), 323–4.
9. C. Gnudi, 'Il reliquario di San Luigi a Bologna', *Critica d'Arte*, 18 (1956), 535–9.
10. C. Wordsworth, 'Inventories of Plate, Vestments etc., belonging to the Cathedral Church of the Blessed Mary of Lincoln', *Archaeologia*, 53, pt I (1892), 1–82.
11. R. Branner, 'The Grande Châsse of the Sainte Chapelle', *Gazette des Beaux-Arts*, 6th Ser. 77 (1971), 5–18. His identification of Gaignière's '; illustration' . . . is uncertain.
12. Cole and Johnson, op. cit., 62.
13. Sir William Dugdale, *Monasticon Anglicanum*, ed. J. Stevens, VI (London 1849), pt 3, 1278.

The Shrine of Little St Hugh

By David Stocker

The gruesome story of the martyrdom by crucifixion of the boy Hugh by the Lincoln Jews in 1255 was widely known in the Middle Ages and is still told.[1] Both of the principal, medieval sources for the story are agreed that, after its controversial recovery, the child's body was obtained by the Dean and Chapter and given solemn burial in the choir of the Cathedral.[2] Although Edward I was particularly associated with the shrine, and is recorded as having given alms to Little St Hugh in 1299/1300,[3] it does not seem to have had great importance after the early 14th century. What little information we have about the 'shrine' in the later medieval period suggests that the boy saint's influence was thought less and less potent and indeed by 1420/1 only 10½d. was donated during the year.[4] Little St Hugh was never officially canonised, but he does appear in the calendar of Lincoln Use having a feast day on 27 August.[5] No mention is made of a shrine to this saint during the Reformation period, the Cathedral's three main centres of devotion at that date being the two shrines of St Hugh the Bishop and the shrine of Bishop Dalderby in the south-west transept.[6]

The shrine in the south choir aisle, which is the subject of this paper, is next mentioned in two separate but related accounts produced in 1641. The account by Robert Sanderson (subsequently bishop 1660–3) was contained in a manuscript dated September 10th 1641 but is now only preserved in the form of transcriptions made by Browne Willis and his friend the Lincoln antiquary Thomas Sympson.[7] Browne Willis informs us that Sanderson and Sir William Dugdale co-operated in producing descriptions of tombs in the Cathedral and thus a second description of the shrine appears in the *Monasticon*.[8] In both these cases, however, the brief notes misattribute the shrine in the aisle to St Hugh the Bishop.

Browne Willis refers to an illustration of this monument in a 'most curious Mss' which was then in Lord Hatton's library.[9] This manuscript was, according to Browne Willis, used by William Stukeley for his published engraving of what he also erroneously calls 'The Shrine of St Hugh the Burgundian Bishop of Lincoln'.[10]

The monument in the south choir aisle was, therefore, intact in 1641, and by that date a drawing had been made of it. It was, however, destroyed by the early 18th century, very probably demolished along with many other monuments in the Cathedral during the summer of 1644.[11] This monument cannot, however, be that of St Hugh the Bishop; it is inconceivable that the principal saint of the Cathedral would be placed in such a position after the Angel Choir had been built. This was first pointed out by Lethieullier in 1736. He was the first scholar to attribute the monument to Little St Hugh and he also added to the shrine the small headless statue of a figure with wounds in hands, feet and side, which he thought represented Little St Hugh but which must surely represent a better known victim.[12] In 1790, during repaving work, the surviving parts of the monument were dismantled and the skeleton of a child was discovered underneath in a lead coffin. The bones were surrounded by 'a kind of Pickle' which Sir Joseph Banks (the excavator) is said to have tasted.[13]

One fragment of the vaulted canopy of this structure has re-emerged during recent years. It is probably the same fragment which is recorded as present on top of the shrine base in 1906.[14] It has not proved possible to discover where this fragment was found or at what date. There is a drawing of the fragment in a more complete state in the Willson collection,[15] but at that date it was not associated with the monument in the south choir aisle and Willson thought it part of a *sedile*. For the past thirty years at least this fragment has been loose in the

cloister, but it has now been removed from there and is receiving conservation treatment (Pl. XXIIIʙ).

The evidence associating the monument in the south aisle with the shrine of Little St Hugh is not good but it is adequate. We know nothing about the site of the medieval shrine except that it was in the choir. The south choir aisle monument, however, has many characteristics only associated with shrines, and it is constructed over the body of a child who had been buried in a place of considerable honour within the medieval church.

DESCRIPTION OF THE REMAINS

The surviving parts of what is very probably the tabernacle of the shrine of Little St Hugh (Pl. XXIIIA) occupy the central bay of a blind arcade of five bays, which is constructed against the back wall of the choir stalls and is between the second and third piers from the crossing in the south choir arcade. Prior to its construction there was probably a third bay of mid 13th-century blind arcading filling the gap between the two surviving bays to east and west. The arrangements made for the original tomb of Little St Hugh in 1255 are not known, but at the base of the present chest, the purbeck marble slab, which forms a projecting string close to floor level, was originally longer than at present and may be the original cover from the grave, here reused in the new shrine whose dimensions it did not match. As the Angel Choir was already planned at this date, no doubt the original tomb was regarded as temporary. The slab was clearly recut at the south-east and south-west corners when it was incorporated into the new shrine base and it now forms a plinth above which is placed a plain chest of Purbeck marble. The chest carries a projecting lid with a roll and frontal fillet moulding around its edge. The chest projects forward from the wall against which it is placed and forward from the limestone bench of which it forms a southern extension.

The shrine base is thus integrated visually and structurally with the screen wall behind and it seems likely that the whole of the space between the two choir arcade piers was considered to be the shrine, and not only the 'tabernacle' in its centre (Fig. 1). The southern face of the screen wall which forms a backdrop to the shrine is richly ornamented with a flat cornice carrying ballflowers, below which stand five bays of elaborate blind arcading.

All of these bays, except the central one, have gabled and crocketed canopies and heavy terminals with much ballflower decoration. Below the gables a trefoil with pointed lobes is placed above an equilateral arch containing two lights. In the head of each light are two more pointed trefoils, and over both lights, a single rounded trefoil is set within a circle. Each bay of blind arcading is divided from its neighbours by filleted shafts which support foliate capitals. The foliage on the capitals, and also on the gables, terminals and pinnacles, is of 'naturalistic' type. At least three different plant species are detectable. Oak leaves are clearly indicated by their acorns on one pinnacle. Buttercup is probably the model for three capitals and other foliage in the arcading, and another capital may represent maple, bryony or hawthorne.[16] The pinnacles which develop above the capitals are at 45° to the wall plane and thus emerge from it in triangular section. Above the line of the gable ends these pinnacles carry panels of blind tracery with two lights surmounted by quatrefoils. In the easternmost pinnacle the quatrefoil is replaced by a trefoil with 'split' or 'Kentish' cusps. Over each panel is a miniature crocketed gable supported by small carved heads, which allows the development of the pinnacle behind and which is also well provided with crockets.

The central bay in the arcade has the same detailing as the other four except where adaptations have been made to accommodate the 'tabernacle'. The lowest parts of the blind

arcade 'lights' have been truncated to accommodate a large slab of purbeck which formed the back of a projecting upper chest of which only the stubs of the east and west sides survive. They do preserve, however, evidence that each side was pierced with cusped and moulded openings. The spandrels of these openings were elaborately carved but only a slight trace of this carving now survives on the east face. The stub of the lid of this chest has been removed from the screen wall and replaced with a relatively modern blocking. The heads of the lights in the blind arcading provided a backdrop to the space above the chests. Evidence for a large stone canopy projecting forward from the wall over this space is provided by the springing of two moulded arches to the south at east and west ends of the 'tabernacle'. These arches had straight sided gables ornamented with ballflower set over archheads with pierced cusps. The springing of two diagonal vault ribs also survives.

Traces of early paint survive on many surfaces. The upper surfaces of the leaves on the capitals retain traces of yellow paint or gilding, their undersides are painted red and they stand against blue backgrounds. The foliage in the gables was apparently coloured in the same way, the ballflowers being provided with red interiors. All the moulding elements in the screen were picked out alternately in red, blue and green (?). The larger panels in the

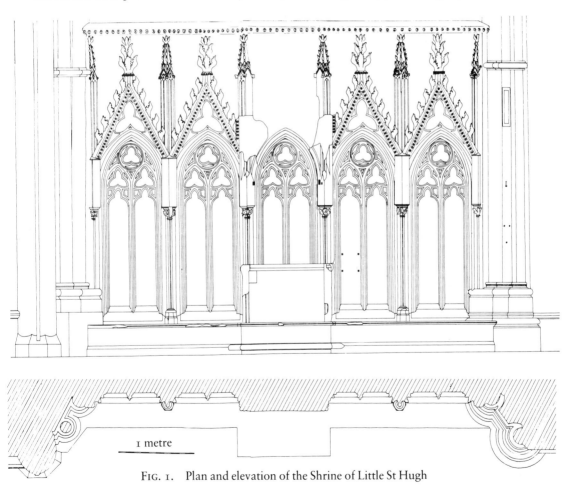

1 metre

FIG. 1. Plan and elevation of the Shrine of Little St Hugh

tracery retain no colour, although the Dugdale drawing indicates that the panels within the tabernacle were blue with a green trefoil above. Where paint survives in the trefoils it suggests a red field over white ground, but the trefoils are shown containing painted shields in outline in a drawing of 1828 by E. J. Willson.[17]

There are also several surviving indications of the former presence of metal fixtures associated with the shrine. A group of four holes immediately to the east of the tabernacle, two of which retain sawn-off iron bars mounted in lead, may represent the mounting for an offertory box. Three filled holes (two on the east and one on the west) at the springing of the canopy arches may indicate where a grille, closing off the east and west arches of the tabernacle, has been removed. In the arcade pier to the east of the shrine there are, or have been, several inserted fixtures. At shoulder height are three blocked sockets which may have supported a second offertory box. Above them is a large iron staple still in place but of uncertain use, and higher still, there is a stone panel let into the face of the pier. The panel is of a single piece of purbeck marble with a precise rectangular depression cut in its surface to a depth of c. 20mm. Its purpose is a mystery, although it is presumably connected in some way with the shrine.

THE RECONSTRUCTION

Reconstruction of the original appearance of the shrine is relatively straightforward (Fig. 1, 2).[18] Most of the information for the eastern and western faces is partly preserved attached to the screen wall. Of the south façade nothing now survives, but there are several views of this side, all of which seem to be copies of the same original drawing in Dugdale's Book of Monuments (Pl. XXIIID).[19] The most accessible copies are the engraving published by Stukeley in 1730 (already mentioned) and the copy in the possession of the Dean and Chapter which is often displayed near the shrine. The second copy was annotated by Archdeacon Bonney and bears the legend 'traced from Lord Winchelsea's book Feb. 17th 1891'. Both copies are essentially the same, although that published by Stukeley is less detailed; details presumably having been lost during engraving.

All three drawings show that the upper part of the south side of the chest was pierced by three moulded and cusped openings with shields bearing arms in the spandrels. The drawings agree that the heavy canopy was supported on two circular shafts in the south-east and south-west corners. The shafts have simple moulded bases and foliate capitals. The line of the supporting columns was carried upwards above the gable-ends by pinnacles, which were apparently of similar type to those surviving in half section against the screen wall, i.e. they were panelled and rotated through 45° relative to the axis of the monument. The vaulted canopy had a wide arch to the south (with four pierced cusps) which was surmounted by a crocketed gable terminated by two large heads and topped by a small terminal. The three gables contained a small decorative vault. Stukeley's engraving provides no detail, but the Dugdale drawing proposes a lierne vault with a ridge rib. This cannot have been the case as the surviving fragments in the screen wall, and the rediscovered vaulting fragment, will only allow a simple quadripartite vault with a central foliate boss (Pl. XXIIIB).

The three gables supported a recessed 'spire' above the centre of the vault. This has a rectangular lower stage with two plain openings to the south above which rose a recessed gable niche containing an elaborate socle.[20] The niche was flanked by tall pinnacles and was enclosed by another crocketed gable behind which rose a crocketed spire, the exact form of which is not clarified by any of the drawings.

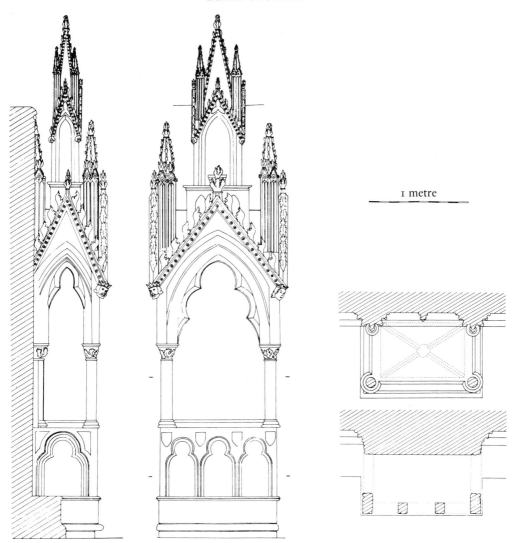

FIG. 2. Reconstruction of the Tabernacle from the Shrine of Little St Hugh

1 metre

DATE AND CONTEXT

As reconstructed this monument has few similarities with other shrines of the same period.[21] Its pecularities are partly accounted for by its unusual size and position; because the saint commemorated here was a boy, the 'tomb chest' itself which forms the lower part of the shrine is much shorter than usual. Furthermore, because the whole structure is placed against the east-west screen wall, it appears to face south, even though it does lie conventionally east-west. Even when thought of in this way, however (as a type of ciborium tomb) no parallels can be found amongst known English tombs or shrines of the period.[22] Indeed this type of structure does not really belong to a sepulchral tradition at all; rather it

seems to derive from architectural tabernacles such as those provided for the principal statues on the Eleanor crosses.

On all three surviving Eleanor crosses the statues are protected by broad canopies supporting free-standing spires of considerable complexity. The originality of the triangular plan of the Geddington cross dictates that the statue canopies here are three-sided, but the rectangular canopies at Waltham and Hardingstone both provide close parallels for the Lincoln shrine structure (Pl. XXIIIc).[23] All three crosses have the same arrangement of straight-sided gables enclosing a small vault. Above the vault a bold spire rises at the junction of the miniature 'roof ridges' behind the gables. The Eleanor crosses appear to have the earliest examples of this tabernacle type in England.

The Waltham cross has particularly close similarities to the shrine. Not only is there the general similarity of structure but here, as at the shrine the uprights are at 45° to the plane of the wall behind and the principal openings have pierced cusps of identical type. Furthermore the panels in the uppermost order of the cross are decorated with blind lancets surmounted by trefoils of very similar type to the screen wall at Lincoln. The foliage at Waltham (as far as can be determined, for example, from engravings in *Vetusta Monumenta*[24]) was also more similar to that on the Lincoln shrine than the foliage on the other two crosses. At Waltham the foliage appears more naturalistic than do the bulbous leaves on the Northamptonshire examples.

The apparent closer similarity between the shrine and the Waltham cross is significant, as we know that Nicholas Dymenge, who was a co-contractor for the Waltham cross between 1291 and 1295, was also engaged at Lincoln Cathedral in 1293 for the production of Queen Eleanor's tomb.[25] On both contracts it seems that he worked closely with the sculptor Alexander of Abingdon. The relationship between these two men and Richard of Stow, who was master mason at Lincoln at the time and who was also engaged by the Crown to produce the Lincoln Eleanor cross, is not known but there must have been a degree of co-operation.[26] The connection of these three men both with the Cathedral and the Eleanor cross programme, combined with the considerable similarity between the shrine and crosses (especially that at Waltham) suggests that one or more of them may have been responsible for the shrine of Little St Hugh. If this was the case then the shrine was most likely designed in the years between 1290 and 1295 when all three were working on the same projects.

Certainly a date in the 1290s suits the remains of the shrine. Split cusps appeared in the North between 1290–5 at Kirkham Priory[27] and Lincoln has been identified as one of the principal routes by means of which such southern ideas reached the North.[28] The nave dado at York Minster, which was started in 1291,[29] is of exactly the same design as the screen wall behind the Lincoln shrine and, furthermore, the buttresses of the York nave also have tabernacles with free-standing spires of precisely the type under discussion. It is usually the French inspiration behind the York building which is stressed but, in the light of these similarities with the Eleanor crosses (particularly remembering the apparent rarity of this tabernacle type in the 1290s) a measure of influence from the English royal workshops ought to be allowed.[30]

Comparison between the shrine and other projects of the 1290s in Lincoln Cathedral itself can also be instructive. These projects included the reconstruction of the cloisters (which was underway in 1296)[31] and the provision of fittings for the Angel Choir, from which the only survivors are the Easter Sepulchre/founder's tomb to the north of the high altar and the fragment of what are probably sedilia opposite on the south side.[32] Both the cloister and the choir fittings share similar naturalistic foliage and this is generally comparable with that on the shrine. But the shrine does have important differences. Bay divisions in both the cloister and the choir fittings are articulated by means of solid panelled

buttresses placed squarely in the wall. The shrine employs much lighter clustered shafts and its panelled pinnacles are not placed square with the wall but at 45° to it which greatly reduces their visual weight. The blind arcades surviving from the choir fittings employ rounded trefoils rather than the pointed trefoils of the shrine and they are set within Y tracery. The 'Easter Sepulchre' does, however, share with the shrine pierced cusps of the same cross-section and, particularly, it also employs intersecting roof ridges, but here, instead of a spire, there is an illogical-looking foliate terminal. It is possible that this terminal was suggested by the shrine, which would reinforce the impression suggested by the presence of Y tracery (not used elsewhere in the choir) that the choir fittings should be placed after the shrine in date.

In addition to all this evidence for the date and context of the shrine, however, there are also conclusions to be drawn from the heraldry — or rather there ought to be, because in fact this evidence proves difficult to interpret. The shrine clearly had four painted shields on its south face in the spandrels of the openings of the upper part of the chest. On the Dugdale drawing this heraldry is indistinct although the first and third shields from the west are clearly *per pale*. The second and fourth shields appear to carry the three leopards of England in a form used by Edward I.[33] Stukeley depicted the first and third shields as England dimidiating France. Archdeacon Bonney, however, thought that the westernmost shield on the original drawing represented England dimidiating Castile and Leon.[34] The original drawing is simply not clear enough to allow any firm identification, and, furthermore, had the heraldry been at all clear in the early 17th century it would surely have been noted by Holles,[35] Dugdale, or Sanderson. The reliability of this heraldry is, therefore, questionable but, if any of it is to be trusted, then it seems that Edward I is referred to. Both Stukeley and Bonney agree that the third shield from the west may represent England dimidiating France, which would imply a date after Edward's marriage to Margaret of France in 1303 and before his death in 1307. Such a date, of course, would represent the completion of the shrine and would indicate that the project may have taken as much as ten years from start to finish.

CONCLUSION

The monument in the south choir aisle is very likely the shrine of Little St Hugh. As reconstructed from original drawings and the surviving fragments it is seen to be an unusual structure, having more in common with architectural tabernacles than with other English shrines. It was designed during the 1290s, perhaps by Nicholas Dymenge, Alexander of Abingdon or Richard of Stow, but may not have been finished until between 1303 and 1307. Even if it is not the work of these royal masons, it displays such close acquaintance with the Eleanor crosses that it has to be considered alongside them.

More generally, it belongs to a group of Edward I's projects which bring with them an element of political progaganda.[36] Furthermore, the political message behind the Eleanor Cross programme has also been the subject of comment.[37] The shrine of Little St Hugh provides another, small-scale example of the same royal policy in operation. Edward clearly wanted the new shrine to be associated with the Crown; not only was he the sole monarch recorded as giving alms at the shrine,[38] but it appears that he may have provided expertise from the royal workshops to create this monument, which may even have been intended to remind pilgrims of the Eleanor Crosses. To reinforce the connection between the Saint and the Crown, the royal arms were prominently displayed.

The political implications of this explicit connection between the Crown and the Saint who had been martyred by the Lincoln Jews would not have been lost on contemporaries. In

1290 Edward had expelled the entire Jewish community from England, and although the real reason was primarily financial, various religious pretexts were stressed at the time.[39] Although it was undoubtedly a popular move, it has been seen by recent historians as 'a piece of independent royal action'.[40] Thus Edward had a strong interest in emphasising both the alleged criminality of the English Jewry and the Crown's position as principal defender of the English Christians. Edward's apparently enthusiastic support for the shrine of Little St Hugh suited this royal purpose very well. Furthermore because the shrine was at least partly the product of a temporary political situation, it is not surprising that interest in it declined once the political geography had changed.

ACKNOWLEDGEMENTS

I am very grateful to A. Smith for the drawings reproduced as Figures 1 and 2.

REFERENCES

1. C. Roth, *A History of the Jews in England*, 3rd ed. (Oxford 1964). Sir F. Hill, *Medieval Lincoln* (Cambridge 1948), 224–9. The most famous of the medieval accounts is probably that contained in 'The Prioress's Tale' in *The Works of Geoffrey Chaucer*, ed. F. N. Robinson 2nd ed. (Oxford 1966), see esp note 684. See also Sir C. H. J. Anderson, *Lincoln Pocket Guide*, 3rd ed. (Lincoln 1892), 117 etc.
2. Matthew Paris, *Historia Majora* (Rolls Ser.), V, 516–18, 522, 546, 552. Annals of the Abbey of Burton on Trent, *Annales Monastici*, ed. H. R. Luard (Rolls Ser. 1864), I, 340–8.
3. *Liber Quotidianus Contrarotulatoris Garderobae* (Soc. of Ants., London, 1787), 37, 39.
4. Ibid.
5. Hill (op. cit.), 228.
6. *Chapter Acts of the Cathedral Church of St Mary of Lincoln 1536–1547.*, ed. R. E. G. Cole (LRS, XIII 1917), 35–7.
7. Browne Willis, *A Survey of the Cathedrals of Lincoln, Ely, Oxford, and Peterborough . . .* (London 1730).
8. Sir W. Dugdale, *Monasticon Anglicanum . . .* new edition (London 1830), 3rd. Part, 1266–1292.
9. Browne Willis, op. cit., 4. There can be little doubt that this Ms. is that referred to as 'Dugdale's Book of Monuments' which is now housed in The British Library as Loan Ms 38.
10. W. Stukeley, *Itinerarium Curiosum*, 2nd ed. (London 1776), pl. 29.
11. Sir Francis Hill, *Tudor and Stuart Lincoln* (Cambridge 1956), 163. *Mercurius Aulicus* for 16th September 1644 describes the recent destruction of monuments quoted in *Lincoln Cathedral an exact copy of all the Ancient Monumental Inscriptions . . .* (Lincoln 1851).
12. 'A letter from Mr Smart Lethieullier to Mr Gale, relating to the Shrine of St Hugh, the Crucified Child at Lincoln'. *Archaeologia*, I (1770), 26–29.
13. Anderson op. cit., 116.
14. E. M. Sympson, *Lincoln* (London 1906), 113, and line drawing.
15. Willson Collection (Soc. of Ants. of London) Ms. 786/A, No. 164. This is an undated drawing but belongs to the 1820s or 1830s.
16. The identifications have been made by comparision with sculpture at Southwell chapterhouse (N. Pevsner, *The Leaves of Southwell*, London 1945) and at York Minster Chapter House (E. A. Gee, *York Minster Chapterhouse and Vestibule*, RCHM England, London 1974).
17. Loc. cit. (note 15), No. 162.
18. There has been at least one attempt at reconstructing this tabernacle before, by Edward Trollope in *AASR*, XV (1879/80), 126–31. The result here was a very top-heavy specimen with many demonstrable inaccuracies.
19. See above note 9.
20. Anderson suggested that the small statue described by Lethieullier came from this niche, op. cit. (note 1), 116.
21. J. C. Wall, *Shrines of British Saints* (London 1905). N. Coldstream, 'English Decorated Shrine Bases', *JBAA*, CXXIX (1976), 15–34. C. Wilson, *The Shrines of St William of York* (York 1977).
22. For such tombs see L. Gee, 'Ciborium Tombs in England 1290–1330', *JBAA*, CXXXII (1979), 29–41. Also P. Biver, 'Tombs of the School of London at the beginning of the Fourteenth Century', *Archaeol. J.*, XVIII (1910), 51–65.
23. R. Allen Brown, H. M. Colvin and A. J. Taylor, *The History of the King's Works, Vol. 1 — the Middle Ages* (London 1963), 479–485.

24. *Vetusta Monumenta*, III (London 1796), plates XII–XVII.
25. R. Allen Brown et al op. cit. (note 23), 481–5.
26. J. H. Harvey, *English Medieval Architects*, 2nd ed. (London 1984), 89, 286.
27. N. Coldsteam, 'York Minster and the Decorated Style in Yorkshire', *Yorkshire Archaeol. J.*, LII (1980), 96.
28. Ibid., passim.
29. J. H. Harvey, 'Architectural History from 1291 to 1558' in *A History of York Minster* ed. G. Aylmer and R. Cant (Oxford 1977).
30. On the influence of the Court Style at York see ibid. Also J. H. Harvey, op. cit. (note 26), 224, 225 and Coldsteam, op cit. (note 27).
31. The cloister is dated by a letter which is published in part by G. A. Poole in 'The Architectural History of Lincoln Minster', *AASR*, IV (1857/8), 42.
32. See J. H. Harvey, *Catherine Swynford's Chantry*, Lincoln Minster Pamphlets, 2nd. Ser. No. 6 (Lincoln nd.), 1–3.
33. See e.g. a drawing of 1297–8 on the Memoranda Roll for that Year. Public Record Office E.368/9, M. 54d.
34. A manuscript note in the margin of the Lincoln Minster copy of the Dugdale drawing.
35. G. Holles, *Lincolnshire Church Notes (1634–42)* ed. R. E. G. Cole (LRS, I 1911).
36. R. Allen Brown et. al. op. cit. (note 23), 370–1.
37. Ibid. 485. See also L. Stone, *Sculpture in Britain — The Middle Ages* (Harmondsworth 1955), 142.
38. See above note 3. For Edward's interest in other shines see A. J. Taylor, 'Edward I and the Shrine of St Thomas of Canterbury', *JBAA*, CXXXII (1979), 22–28.
39. Prof. R. B. Dobson notes that 'Edward I's determination to use the preaching services of the Mendicant Orders . . . as a major element of his campaign to convert the English Jews is well known'. Quoted from 'The decline and Expulsion of the Medieval Jews of York', *Transactions of the Jewish Historical Society of England*, part XI (1979), 44.
40. B. L. Abrahams, *The Expulsion of the Jews from England in 1290* (Oxford 1895), 74. See also R. B. Dobson, op. cit. (note 39).

The Tomb of Christ at Lincoln and the Development of the Sacrament Shrine: Easter Sepulchres Reconsidered

By Veronica Sekules

On the north side of the Angel Choir at Lincoln, close to the high altar, stand two adjacent tomb-like moments built against the inside of the screen enclosing the choir (Pl. IVc). The one to the east has been identified as an Easter Sepulchre, because against the tomb-chest are carved representations of the three sleeping soldiers who guarded the tomb of Christ.[1] To the west the canopy continues over the other tomb; its chest decorated with three indented quatrefoils. Stylistically the tombs are comparable with the cloister arcading at Lincoln, in construction by 1296, and are likely to be of similar date.[2] This dating of the 'Easter Sepulchre' makes it easily the earliest of a small group of early to mid 14th-century stone shrine-like structures carved with scenes relating to Christ's burial and resurrection. The others, which are all set into the north chancel walls of parish churches in the regions around Lincoln, have similarly been identified as Easter Sepulchres. The most complete examples are at Heckingon, Navenby and Sibthorpe in Lincolnshire, Hawton in Nottinghamshire, and Patrington in Yorkshire (Pls XXVIb, XXVIc, XXVIIc, XXVIa, XXVId).[3]

The purpose of this paper is to re-examine the function of these monuments: to consider the body of ideas they represent, to what degree these can be perceived in the structures themselves, and how ideas formed outside the immediate circumstances of their creation affected their form and the way they were used.

EARLY MEDIEVAL COPIES OF THE TOMB OF CHRIST: FORM AND FUNCTION

When Rabanus Maurus consecrated St Michael's chapel at Fulda in 822, he stated that the copy of the tomb of Christ at its centre gave solace to the graves of the monks in the crypt below.[4] The 10th-century chapel of St Mauritius at Constanz, built by Bishop Conrad, contained a copy of Christ's tomb at Jerusalem in which were interred the relics of St Mauritius. Bishop Conrad, like the monks of Fulda, was awarded the spiritual protection of the tomb and relics when his own monument was constructed nearby in the same chapel.[5]

Fewer than twenty examples of copies of the tomb of Christ at Jerusalem are so far known to have been built in Europe between the 4th and the 12th centuries.[6] Fulda and Constanz are unusually well documented, but it is possible to piece together information from other sources which indicates that other tomb copies represented a similar complex of ideas and associations. Apart from sometimes giving spiritual protection to ecclesiastical graves, copies of the tomb of Christ were evidently intended to confer more generally a status of sanctity on the sites where they were constructed. In some cases it is explicitly documented that they were built to increase the devotion of the faithful.[7] Some trouble was taken to ensure and to assert the veracity of the copy in relation to the prototype within the Church of the Anastasis at Jerusalem. A number of tombs, Fulda and Constanz themselves being examples, were constructed within copies of the Anastasis.[8] The tombs at Bologna, Neuvy-St-Sepulchre, Cambrai, Piacenza and Paderborn were built following pilgrimages to the Holy Land, several according to accurate measurements from the Holy Sepulchre itself.[9]

Denkendorf, Eichstätt, Paderborn and Neuvy-St-Sepulchre also contained relics imported from the Holy Land.[10]

The form of the tombs themselves varied considerably. The majority are known from descriptions, excavations or surviving structures to have been tiny centralised buildings reproducing the Anastasis in miniature. However, the precise shape and the interior arrangements were not consistent. Eichstätt for example is a round building containing a tomb chamber with an ante-chamber like the aedicula at Jerusalem (Pl. XXIVA). The 13th-century tombs at Constanz and Magdeburg are both polygonal enclosing open spaces with altars (Pl. XXIVB). A number did not attempt to simulate any obvious feature of the Holy Sepulchre at Jerusalem, but took various forms from a small niche to a two-roomed rectangular chapel. These acted as momentoes of Christ's tomb by association.[11]

The variation in the designs of copies of Christ's tomb is analogous to the situation described by Richard Krautheimer in his 'Introduction to an Iconography of Medieval Architecture', where he discusses relationships between medieval copies of the Rotunda of the Holy Sepulchre and the prototype at Jerusalem, the copies selecting only certain features from the prototype, resulting in, to our eyes, only vague approximations to it. One of Krautheimer's conclusions was that meaning was not conveyed by the appearance of the monument, but by its associations, whether symbolic, religious or more specifically liturgical. In fact he said, referring of course to ecclesiastical buildings: '. . . any medieval structure was meant to convey a meaning which transcends the visual pattern of the structure'.[12]

His conclusion holds good for the copies of Christ's tomb. Variations in the designs meant that recognition of the fact that the monument was intended as a copy of Christ's tomb was something that had to be known by, or conveyed to, the observer. The tombs might represent a body of ideas apart from their direct association with Jerusalem, including, for example, protection for mortal, particularly ecclesiastical burials implying the assured place of the soul in heaven. The presence of relics implied both an elevation of status and increased holiness for the tomb copy. These ideas were clearly crucial to the function of the tombs as liturgical monuments, but they were not obviously conveyed by the structures themselves.

It is possible, though it can by no means be proved, that at least from the 10th century copies of the tomb of Christ played an important part in the annual Easter services, at which time one aspect of their purpose might have been explained.[13] The earliest surviving account of a dramatically embellished Easter liturgy exists in the *Regularis Concordia* which states that the ceremonies described were devised in order to instruct uneducated lay folk and neophytes in the mysteries of Christ's death and resurrection.[14] The text records that a sepulchre was used for a symbolic burial of a cross on Good Friday (the *Depositio*), watched until Easter Sunday, when before matins the cross would be removed and placed upon the altar (the *Elevatio*). During Matins the visit to the sepulchre by the Maries was reenacted by the clergy (the *Visitatio Sepulchri*). The 'Maries' would come to the sepulchre, whereupon the angel would declare it to be empty and they would announce the Resurrection to the congregation.[15] The *Regularis Concordia* is representative of the early versions of these embellishments for the whole of Europe. The host as well as, or instead of, the cross was often used in the *Depositio* and *Elevatio*, which were probably the elements of the service in most widespread use.[16] Despite its early appearance on the *Regularis Concordia*, the dramatic element of the service, the *Visitatio Sepulchri* seems to have been rare in England, although some 400 texts survive from the whole of Europe, many dating to as late as the 16th century. The *Depositio* in particular continued in use in uninterruptedly Catholic areas until the 20th century.[17]

It is important, however, to remember that for none of these customs was it required that the sepulchre should be a permanent structure. According to the *Regularis Concordia* it was a veil stretched in the form of a circle adjacent to the high altar.[18] Normally the sepulchre was temporary, either made up of curtains or screens, or represented by a small receptacle at the high altar, or at another altar in the nave or crypt. All of these were intended for removal at the end of the Easter period.[19] This remained the norm for the whole of Europe for the whole of the Middle Ages. Thus, whenever we find permanent tombs of Christ, they are particularly significant. If the permanent tomb of Christ was not, or only occasionally or incidentally used in the Easter service, obviously one must seek for its principle rôle outside the context of the 'Easter Drama' in which it is usually discussed. We are then drawn back to the implied associations mentioned earlier, for which the fact of its permanence would have been crucial.[20]

THE TOMB OF CHRIST AND SCULPTURAL EMBELLISHMENT

A number of the copies of the tombs of Christ carry sculptured imagery and here we begin to depart from Krautheimer's analysis that the meaning of the monuments transcended their appearance, though of course, to be fair, Krautheimer was only dealing with architectural forms. Some tombs of Christ have indeed been identified as such because of the images they carry, on the assumption that these clarify the purpose of the monument. An example of this is the rock chapel at Horn in Westphalia, the Externsteine, consecrated in 1115. On the face of the rock is carved a Deposition scene and this, in conjunction with the presence inside the chapel of a tiny effigy-shaped cavity has led to the identification of the chapel as a representation of Christ's tomb.[21] Similarly, the two-roomed 11th-century chapel in the south aisle of the nave at Gernrode has been identified as a copy of Christ's tomb on account of the carved figures, including a *Noli me Tangere* on the exterior.[22]

Where images were used on tombs of Christ, they could not only make explicit the meaning of the monument, but extend it. The second tomb of Christ at Constanz, built *c.*1260 to replace the 10th-century one already mentioned, includes Nativity scenes.[23] The visit of the three Magi to Bethlehem appears as a parallel to the visit of the three Maries to the tomb, drawing attention neatly to the significance of the relationship between Christ's birth and resurrection (Pl. XXIVB).

Two fully three-dimensional figures, one of an angel and one of a Mary, recently dated *c.*1170–80, hint at another variation in the representation of the tomb of Christ. Both figures are wooden and half life-size and are thought to have been made in Cologne. The angel, now in the Preussische Kulturbesitz in Berlin, is seated on a chest with the right arm outstretched in greeting, the left hand clasped, probably in order to hold a palm. The Mary, in the Keresztény Museum, Esztergom, stands looking downwards, both hands holding an ointment pot. They have been interpreted as forming part of a 'Visitatio' scene as represented on the early 11th-century bronze doors at Hildesheim where the angel is similarly seated on a chest in front of the empty tomb, addressing the three Maries.[24] Clearly this scene was an important precursor for a new type of permanent tomb of Christ which was to become overwhelmingly popular during the course of the succeeding century, eventually supplanting all other variations in the representation of the tomb of Christ.

From the end of the 13th century a number of individual figures survive, indicating that the use of this new type of tomb was spreading. One of these, a lime-wood figure of a Mary from Adelhausen near Freiburg im Breisgau, now in the Freiburg Augustiner Museum (Pl. XXVC) has been dated to the last quarter of the 13th century.[25] A stone effigy of Christ

dated similarly on stylistic evidence is from Maria Mödingen in Bavaria (Pl. XXVᴅ).[26] This last figure demonstrates that by the 14th century the figured tomb of Christ incorporated an important new concept. This is evident from the earliest ensemble, dating c.1320–30, which has been reconstructed in the south nave aisle at Freiburg Münster (Pl. XXVʙ).[27] Here the meaning is greatly clarified by the imagery. There is no doubt that this is Christ's tomb, because his effigy lies recumbent on the tomb chest, just as it would do in the case of a mortal's tomb. He is guarded beneath by the sleeping soldiers. Standing around the effigy are two angels and the three Maries. The real innovation here, is that the tomb incorporates an effigy of Christ as a permanent feature. The angels are not seated looking towards the Maries as if declaring the tomb to be empty, but are like them, contemplating the body of the Lord.

Scholars have long been aware of the predominance of this design for the tomb of Christ, especially in Germany, in the later Middle Ages. Anne Marie Schwarzweber noted that the centralised structures at Constanz and Magdeburg marked the end of the miniature-building tradition. The new form, she attributed to the growing popularity of the liturgical drama, the *Visitatio Sepulchri*, making it expedient to record its details for the benefit of the congregation in a permanent tomb for the whole year.[28] However, there are problems with this interpretation. Although Schwarzweber records evidence that the tomb was used for the *Depositio* and *Elevatio* — the host being placed in a cavity in Christ's breast[29] — it would be hard to envisage the scene before us as either representing the visit of the Maries to the tomb, or as having been used for the *Visitatio Sepulchri* ceremony. The difficulty is presented precisely by the element which gives the tomb its novelty: the effigy of Christ, for its presence denies the veracity of the Maries' declaration that the tomb was empty. It requires further explanation.

The answer may be sought by examining developments in devotional practise in the 13th century. In 1215, the 4th Lateran Council resolved centuries of argument about the nature of the sacrament with the official announcement of the Doctrine of Transusbstantiation.[30] In other words it was, from then, central to Catholic faith that the bread and wine were transformed during the act of consecration into the real body and blood of Christ. Contemporary with the 4th Lateran Council, a nun, Juliana of Liège, began petitioning for the institution of a special feast for the veneration of Christ's body.[31] By 1264 the feast was established at St Martin's, Liège. Circumstances became favourable for the official adoption of the feast by the Catholic church when a former Archdeacon of Liège became Pope Urban IV in 1261. He announced the feast of Corpus Christi in 1264, by the Papal bull *Transiturus de hoc mundo*, and commissioned an office from the Dominican friar Thomas Aquinas. The Pope died in the following year and the feast had to be announced twice more, by Pope Clement V in 1311 and by Pope John XXII in 1317, before it became universal.[32]

What is remarkable however, is the rapidity with which devotional concern with Christ's body spread as a popular movement during the second half of the 13th century, especially in the Low Countries, the Rhineland and in Hungary.[33] The responsibility was no doubt partly that of the preaching friars and homilists. For example, stories about the host coming to life abound at this period, no doubt in order to teach sceptics or ignorant lay folk the true meaning of the Doctrine of Transubstantiation.[34]

By changing the emphasis of the permanent tomb of Christ from a commemoration of the place of His burial, or from a recreation of the finding of His empty tomb, to an image of Christ's body in the tomb, the form was clarified as a devotional image in accordance with the recent emphasis on the importance of Christ's body. The Maries even demonstrate in what contemplative, sorrowful mood the body Christ should be regarded. It seems that the tomb of Christ was cleverly adapted to transmit new doctrine.

I*

THE TOMB OF CHRIST AT LINCOLN

If the monument identified as an Easter Sepulchre in the Angel choir at Lincoln is reexamined in the light of the traditions discussed so far, it emerges that, like its continental counterparts, it is very much more complex than has been supposed. In fact it is probably not, strictly speaking, an Easter Sepulchre at all, but a tomb of Christ manifesting interesting parallels with German models and incorporating a number of variations, which may have been influential in return (Pl. XXVA). The Easter Sepulchre in England was invariably a temporary structure erected on the north side of the chancel over the Easter week.[35] Indeed, Lincoln itself had such a temporary sepulchre, mentioned as being in the vestry in 1565–6.[36] Whether it was used in conjuction with the tomb, or independently of it, is not known. In any case, the significance of this tomb, like the German examples, was clearly manifest for the whole year and not just at Easter.[37]

The permanent tomb of Christ is very much an oddity in England, this one at Lincoln may be the only one of this type ever built in an English cathedral.[38] It is constructed very much on the model of Gothic effigy tombs. The only indication now that it is Christ's tomb is the presence of the sleeping soldiers at the base, but it is tempting to suggest that the upper part once incorporated figures: an effigy of Christ or a resurrected Christ, the Maries and the angel, which would have covered the messy arrangement of ashlar slabs at the back of the opening.[39] But it differs markedly from the German examples in its position. It is not accessible to the population in the nave or side chapel or ambulatory, as on the Continent, but it is removed to the choir enclosure. So it is not being used here so clearly as a didactic monument to inspire popular devotion, but for another purpose pertinent specifically to clerical devotion. But bearing in mind that one of the original functions of a tomb of Christ was as spiritual protector to a mortal grave, its position next to a burial perhaps holds the explanation of its meaning as a permanent fixture. The adjacent tomb is, without doubt, that of Lincoln's founding bishop, Remigius.[40] Remigius was venerated in Lincoln as a saint but he was never canonised and by the date of the construction of this tomb, appeals to the Papacy had long since ceased.[41] Nevertheless, there are indications that lack of Papal confirmation made little difference to his local veneration. The first of these comes when the Angel Choir was founded, and attention was being turned towards the canonisation of Grosseteste. Matthew Paris stated in 1254 that the coming of Grosseteste as a new and blessed saint had stirred his predecessors St Hugh and St Remigius to a renewed exercise of their dormant powers.[42] On the completion of the Angel Choir, St Hugh's shrine took pride of place behind the high altar; Grosseteste's tomb was in the south-east transept and his canonisation was still expected. The solution for Remigius, was to construct his tomb close to the high altar, with indentations at tomb chest level at the back, so that the faithful could approach his body.[43] Not only that, but adjoining his, was constructed the tomb of Christ. Undoubtedly this proximity was intended to draw attention to his sanctity, the more so as the tombs resemble one another so closely in scale and design. Lincoln preserves the earliest surviving example of this longstanding association of the two tombs and exploits their similarity. That this idea was still current well into the 14th century is apparent from a rare survival of a description of the building of a tomb of Christ, at Strasbourg by Bishop Berthold de Bucheck. He began to build his own tomb in the chapel of St Catherine in 1331 and was ashamed that it was finer than the 12th-century tomb of Christ in the crypt, the traditional burial place of Strasbourg bishops. So he transformed his own sepulchre into a new tomb of Christ and built a simpler tomb for himself in the same chapel, thus as it were, monopolising its protection.[44] The resemblance between the two tombs must, as at Lincoln, have emphasised all the more obviously his physical proximity and spiritual devotion to Christ.

Although we do not have enough information from Lincoln to know for certain, it seems that the feast of Corpus Christi was not yet celebrated when this tomb of Christ was built, *c.*1300 but elsewhere in Eastern England it was well established.[45] What its construction does seem to demonstrate, is that the phenomenon and its associated meanings was well known, at least in ecclesiastical circles, and could be adapted to suit particular local requirements, in this case, specifically to give solace to, and enhance the status of an ecclesiastical tomb.

THE TOMB OF CHRIST IN EASTERN ENGLAND IN THE EARLY 14TH CENTURY
AND THE DEVELOPMENT OF THE SACRAMENT SHRINE

The form of the early 14th-century stone 'Easter Sepulchres' in Eastern England vary considerably from any examined so far and are arguably affected by a further change in devotional practice. The change is evidenced by the appearance of the monuments and the use and placing of the sculpture. The earliest of this small group, of which there are some eight examples, date from the late-1320s at Heckington (Pl. XXVIB) and Navenby (Pl. XXVIC). The latest, from *c.*1350, is at Patrington (Pl. XXVID). All are situated in parish churches. In each case, as well as a tomb of Christ set into the north wall of the chancel, there is a founder's tomb (the ecclesiastical burial connection again), access to a sacristy (Pl. XXVIIE) and, in the south wall, a set of sedilia and a piscina.[46] The sculptured scenes on the sepulchres relate to the Easter period. Hawton is the most elaborate (Pl. XXVIA) with the sleeping soldiers at the base, the visit of the Maries to the tomb, a *Noli me Tangere*, an angel next to the empty tomb within the niche at the centre, and an Ascension scene at the top. Heckington (Pl. XXVIB) has a simpler central register with the Maries visiting the tomb, with the angel standing beside it and the risen Christ above.

The consistent interpretation of these structures as Easter Sepulchres may be partly correct, but can by no means provide a complete explanation of their primary function, as again we have the problem — how to explain their permanence? This is all the more remarkable for their being in parish churches where temporary wooden Easter Sepulchres were very much the norm: some 50 examples in Lincolnshire alone were removed in the 16th century. If they served as Easter Sepulchres, they would certainly have been veiled for most of the crucial period and in any case would probably, like the tomb at Lincoln, have been used in conjunction with temporary screens.[47] Their real significance is suggested by their design. Despite variations in details, they all have certain features in common. For example, the difference between these monuments and the Freiburg/Lincoln type, apart from their scale and shape, is that where the figure of Christ appears here, he is clearly living — the resurrected or ascending Christ (see Heckington, Pl. XXVIB; Sibthorpe, Pl. XXVIIC and Patrington, Pl. XXVID). Furthermore, the tomb from which he rises, the tomb which is visited by the Maries, is not represented by the whole structure, but by an aumbry within the structure. The aumbry is normally a central and prominent feature and in each case, even at Hawton where it is less visible within the large central niche, it was formerly closed by a door or grille. Thus the relationship between Christ's tomb and his living body is made explicit and by implication so is the relationship between Christ's living body and the sacrament for which the tomb/aumbry was intended at Easter.

A lockable aumbry for the sacrament as a permanent feature in the chancel of a parish church calls to mind the injunctions made at the 4th Lateran Council at which the 'Decree *Sane*', as well as defining the doctrine of Transubstantiation, provided instructions for the proper care and respect for the Eucharist. The Council decreed that the sacrament reserved from mass or kept for the *viaticum* should be kept clean and locked in a special, designated

place.[48] This injunction was repeated at provincial synods throughout the 13th century. In 1238, Bishop Grosseteste instructed Lincoln parochial clergy that the Eucharist must be devoutly and faithfully preserved and always honourably laid up '*in loco singulari*', clean and locked.[49] The constitutions of John Peckham made a similar declaration in 1281 for the Archdiocese of Canterbury, that every parish church should be provided with a lockable tabernacle in which the body of the Lord should be placed wrapped in linen.[50] Numerous aumbries survive in English parish churches from the mid-13th century onwards. These are often identified now as Easter Sepulchres but they are much more likely to have served a principal function as safe and permanent receptacles for the Eucharist. Particularly fine 14th-century aumbries survive at Twywell and Pattishall in Northamptonshire (Pl. XXVIID). The aumbry at Pattishall is dated by an inscription above: 'P' Johem Gyllyng'. He was rector from 1317–39. The Twywell aumbry also served as a lectern and presumably contained the books when they were not in use.[51]

The monuments under discussion, at Heckington, Navenby, Hawton, Sibthorpe and Patrington probably combined several functions. They follow the tradition of medieval copies of the tomb of Christ in their association with ecclesiastical burials. In common with the Frieburg/Lincoln type of tomb, their sculpture makes explicit the reference to the events of the Easter period, but they introduce innovatory features stressing the presence in the monument of the living body of Christ. It is undoubtedly not without significance that they were erected precisely at the period when Corpus Christi veneration was taking hold in England. By the early 1320s the feast was universally established as one of the permanent feasts of the Church calendar.[52] We know little about parish customs at this early period but it seems that nearly all the earliest English Corpus Christi guilds were founded in eastern counties. The guilds at Ipswich (founded 1325), Louth (founded 1326) and Lincoln (founded 1328) all bound themselves to carry lights around the portable shrine of the sacrament on Corpus Christi day, the Thursday after Trinity Sunday.[53] The Ipswich guild ordinance also required a Maundy Thursday procession for penitents and the provision of candles at the burial of the dead.[54] The Corpus Christi guild of St Michael at the Hill, Lincoln, was founded in 1350 'In honour of Lord Jesus Christ and of his precious body and of the most holy sepulchre of that most glorious body and of the Virgin Mother and of all the saints of God'. It was bound to provide 'thirteen four-fold candles around the sepulchre on the day of preparation and from that day until the octave they burn on festival days at high mass; three round candles burning continuously from the day of preparation to the Resurrection. A great torch for the Corpus Christi procession . . . the great torch is borne before the body of Christ when being carried to the sick, also it burns at the elevation on six principal days. Four soul candles with others to burn round the hearse of a dead brother . . .'.[55] The connections made here between the feast of Corpus Christi, the feast of Easter, the commemoration of the dead and the reservation of the sacrament for the sick, are precisely those implied by the monuments under discussion.

It seems then, that the development of interest in the feast of Corpus Christi in the early 14th century, provides the explanation for the conversion of the Easter Sepulchre into a monument permanently visible in the chancels of these parish churches in eastern England. As permanent monuments, they fall within the established tradition of the tomb of Christ, but the development of the design to feature an aumbry for the sacrament introduces a new element, implying a principal interest in sacrament reservation in accordance with the 'Decree *Sane*'. Within the framework of the Corpus Christi observance, it is very likely that they were intended as sacrament shrines.

Although this particular configuration of functions and meanings for the new form of the tomb of Christ seems to be an English peculiarity at this date, the phenomenon of the

sacrament shrine in the north wall of the chancel, specifically in response to the new requirements of Corpus Christi celebration, was not. The earliest known sacrament shrine, dating from the late-13th century, survives in the north wall of the chancel at Lenwick St Martin near Brussels (Pl. XXVIIB).[56] It is a niche surmounted originally by a crucifixion flanked by St Mary and St John. Sacrament shrines survive in great numbers in Germany and the Low Countries from the late-14th century onwards, and normally a greater complex of scenes is arranged around the aumbry for the reservation, a central feature of the monuments. At Nuremburg (c.1390, Pl. XXVIIA) we find the entombment below the aumbry, the Trinity above and flanking it, figures of saints.[57] The purpose of these shrines was to provide a suitable and honourable place for continual reservation of the sacrament. The reserved sacrament was honoured as Christ's Real Presence in the church. It was used specifically for the sick and the dying and for weekly processions, when it was taken out and displayed openly to the faithful in a monstrance.[58] On the Continent, sacrament shrines develop quite independently from the tomb of Christ and it is not until the 15th century that there are examples of the conflated form that we find in England a century earlier.[59] In Britain, it has traditionally been thought that the only examples of sacrament shrines were erected in Scotland in the dioceses of St Andrews and Aberdeen in the 15th and 16th centuries.[60] However, it is likely that the monuments under discussion here provide much earlier examples of the same idea, adapting and combining features of pre-existing types of monument. This accords them great importance in the study of liturgical furnishings of the 14th century.

Several observations of a more general nature are possible following from the study of the tradition of the tomb of Christ, which may be pertinent to the study of other forms of liturgical monuments.

It is evident that the phenomenon of the tomb of Christ and its meanings and uses was widely known, at least within the establishment of the Church. Despite changes in appearance at any given time, the associated meanings, for example the protection for ecclesiastical burials, were carried forward from one monument to another over a long period. But, as has been demonstrated, the form and appearance of the monument was not static. It was susceptible to adaptation to suit particular devotional requirements. What seems to happen in the course of the 13th century, is that the form increasingly makes evident the tomb's purpose — it more closely simulates the appearance of mortal tombs and the sculptural imagery clarifies its meaning.

However, looking at the relationship between tombs of Christ and sacrament shrines in England, the Low Countries and Germany, it is clear that it is ideas that are being transmitted rather than details or styles. In each case, artistic style is particular to a locality. Where monuments are similar from one region to another, it is in generalities such as overall design and position. The point of view has been adopted here that such generalities can be conveyed over distances and over time by word of mouth. Should the desire for a particular structure arise, there was at any given time a current vocabulary from which it could be constituted including a whole range of associated functions and properties, which could be permuted to suit local circumstances.[61]

ACKNOWLEDGEMENTS

I would like to record here my great indebtedness to Christopher Hohler who inspired me to work on this topic in the first place and has since supplied me with corrections, references and valuable comments too numerous to mention individually. I am also grateful to my co-editor, T. A. Heslop, for many useful suggestions for improvements to this text.

REFERENCES

SHORTENED TITLES USED

DALMAN (1922) D. Gustav Dalman, *Das Grab Christi in Deutschland* (Leipzig 1922).

KING (1965) Archdale A. King, *Eucharistic Reservation in the Western Church* (London 1965)

KRAUTHEIMER (1942) Richard Krautheimer, 'Towards an Iconography of Medieval Architecture', *Journal of the Warburg and Courtauld Institutes*, 5 (1942), 2–20.

SCHWARZWEBER (1940) Anne-Marie Schwarzweber, *Das heilige Grab in der deütschen Bildnerei des Mittelalters* (Freiburg im Briesgau 1940).

YOUNG (1933) Karl Young, *The Drama of the Medieval Church*, 2 vols (Cambridge 1933)

1. This tomb is mentioned as an Easter Sepulchre in *Vetusta Monumenta*, III (1796), in the notes to Pls 31 and 32, and on page 2 is referred to in passing as the only sepulchre in an English cathedral. The monument is mentioned more fully in A. Heales, 'Easter Sepulchres; their Object, Nature and History', *Archaeologia*, XLI (1869), 263–308, esp. 291–2; E. Mansell-Sympson, 'Notes on Easter Sepulchres in Lincolnshire and Nottinghamshire', *AASR*, XXIII (1895–6), 290–6; E. Woolley, 'Some Notts and Lincs Easter Sepulchres', *Thoroton Society Transactions*, XXVIII (1924), 69–72, and Laurence Stone, *Sculpture in Britain: The Middle Ages* (Harmondsworth 1972), 168–9. P. Sheingorn, 'The Sepulchrum Domini: A Study in Art and Liturgy', *Studies in Iconography*, 4 (1978), 46–8.

2. *Giraldi Cambrensis Opera*, ed. J. F. Dimock (Rolls Series, London 1877), VIII, Appendix E, 'Lives of the Bishops of Lincoln', by John de Schalby, 209–19 and note 3 quoting letter from Bishop Sutton to Philip the Dean indicating that the south side of the cloister was far advanced by 1296.

3. Other examples in the region, dating from the early-mid 14th century: *Arnold, Notts*. A monument in the north wall of the chancel, similar in outline to Heckington, but minus all its figures (E. Woolley, op. cit., Pl. VIII; E. Mansell Sympson, op. cit., 295). *Fledborough, Notts*. Fragmentary relief panels reset in north-east aisle wall: three sleeping soldiers beneath ogee-headed arches, ascending Christ, Mary, angel swinging censer (E. Woolley, op. cit., Pl. IX; E. Mansell Sympson, op. cit., 295). *Irnham, Lincs*. The mid 14th-century monument, now at the east end of the north aisle was formerly situated in the bay west of the high altar to the north side of the central vessel. It has been identified both as the tomb of Geoffrey Luttrell (d. 1345) and as an Easter Sepulchre. The arms of Geoffrey Luttrell and his wife Agnes Sutton are both carved on the canopy. The identification as an Easter Sepulchre has been proposed because of its original position and because of the fact that a tiny crucifixion is carved on the finial above the left hand niche and a Virgin and Child on the central finial. (E. Woolley, 'Irnham and Hawton', *JBAA*, 2nd Ser. XXXV (1929), 208–46; *Vetusta Monumenta*, vol. cit., Pl. 32; Mansell Sympson, op. cit., 290; E. Woolley, op cit., 70 and Pl. IV). The earliest authority to mention Irnham, Francis Thynne in his Lincolnshire church notes, describes it as 'Tumul lapidea iuxta capella in cancello' (British Library Add. Ms 36295 f. 53). I would tend to agree with his more cautious view.

4. 'Hoc altare Deo dedicatum est maxime Christo,
 Cuius hic tumulus nostra sepulchra juvat'
 Dalman (1922), 26; Schwarzweber (1940), 2.

5. Dalman (1922), 30–4; Schwarzweber (1940), 2–3.

6. Copies of the tomb of Christ are discussed in: Dalman (1922); Schwarzweber (1940); N. C. Brooks, *The Sepulchre of Christ in Art and Liturgy* (Urbana, University of Illinois 1921); Geneviève Bresc-Bautier, 'Les imitations du Saint-Sepulchre de Jerusalem (IX–XV siecles), archéologie d'une devotion', *Revue d'histoire de la Spiritualité*, 50 (1974), 319–42. I am grateful to Neil Stratford for making this article available to me.

7. Cambrai, *c*.1064 (Dalman (1922), 23). Piacenza, 1055; San Sepulchro, Milan, *c*.1099; Paleva, Catalonia, 1085: (Bresc-Bautier, op. cit., 322) St Hubert, 1076 (Lehmann-Brockhaus, *Schriftquellen zur Kunstgeschichte des 11 und 12 Jahrhunderts* (Berlin 1938), no. 1776).

8. E.g. Sto Stephano at Bologna, 12th century (R. G. Ousterhout, 'The Church of Santo Stephano: a 'Jerusalem' in Bologna', *Gesta*, XX/2 (1981), 311–21); Neuvy-St-Sepulchre (Jean Hubert, 'Le Saint-Sepulchre de Neuvy et les Pelerinages de Terre-sainte au XI siecle', *Bull. mon.*, 90 (1931), 91–100).

9. Bologna (R. G. Ousterhout, op. cit., 312 and Krautheimer (1942), 17–19); Neuvy St Sepulchre (Jean Hubert, op. cit., 91 ff.); Piacenza (Bresc-Bautier, op. cit., 323). Cambrai, erected 1063, was built 'rotondo schemate in modum scilicet sepulchri quod est Jerosolimis. Unde et marmor superpositum sepulchro cameracensi habet longitudinem 7 pedum quonicum et locus, ubi positum fuit corpus Domini eiusdem longitudinis existit' (Lehmann-Brockhaus, op. cit., no. 1670). In what is now the Busdorfkirche in Paderborn, Bishop Meinwerk founded a sepulchre chapel containing a tomb copy in 1036, according to measurements brought back from Jerusalem by Abbot Wino. The structure contained a portion of the wall of the Holy Sepulchre at Jerusalem (Schwarzweber (1940), 3).

10. Denkendorf *c*.1120: a particle of the True Cross was brought from Jerusalem (Schwarzweber (1940), 3); Eichstätt: a cross reliquary was brought from the Holy Land by Provost Walburn (Schwarzweber (1940), 4;

Dalmann (1922), 56–65). When the copy of the tomb of Christ at Neuvy-St-Sepulchre was demolished in 1806, an inscription was found attesting to the presence of relics of the Sepulchre and Calvary (Jean Hubert, op. cit., 97–9). For Paderborn see ref. in note 9.

11. The tombs at Sélestad, Denkendorf and Gernrode are all two-roomed rectangular chapels (Schwarzweber (1940), 1–7). The Externsteine at Horn in Westphalia contains a small effigy shaped niche, thought to represent the tomb of the Lord (Dalmann (1922), 37–41). The 15th-century tomb at Bebenhausen was represented merely by three intersecting lines on a cloister wall recording its measurements (Dalmann (1922), 90).

12. Krautheimer (1942), 20.

13. Young (1933), II, 509 states 'Although the Western imitations of the Holy Sepulchre must have served often as *mise en scene* for the dramatic ceremonies of Easter and Holy Week, the instances in which recorded or extant examples of these structures can be definitely associated with particular versions of the *Depositio, Elevatio* and *Visitatio Sepulchri* are not numerous'. He accepts, however, that the monument at Aquileia was used. Bresc-Bautier, op. cit. in note 6, 326–8, also rejects the idea that permanent tombs of Christ were erected primarily as a focus for the *Depositio* at Easter.

14. 'Nam quia ea die depositionem corporis salvatoris nostri celebramus, usum quorundam religiosorum imitabilem ad fidem indocti vulgi ac neophytorum corroborandam...', *Regularis Concordia*, ed. Dom Thomas Symons (Nelson, Oxford 1953), 44.

15. Ibid., 49–50.

16. The life of St Ulrich of Augsburg dating from the mid-10th century alludes to the *Depositio* using the host, Young (1933), I, 121 and 553 n. 6. For general remarks and a survey of the ceremonies of the burial of the host and cross see ibid., I, 122–48. The *Depositio* is discussed by Solange Corbin in *La Deposition liturgique du Christ au Vendredi Saint, sa place dans l'histoire des rites et du théâtre religieux* (Collection Portuguaise, Paris/Lisbon 1960). She makes the distinction which is unclear in Young's studies, that the *Depositio* and *Elevatio* are liturgical, whereas the *Visitatio* is a dramatic elaboration. She lists all the surviving examples of *Depositio* texts (42–96) in Europe. They are fewer in number (around 100) than *Visitatio* texts, but for example, the inclusion of the *Depositio* in the Sarum rite, indicates that it was probably much more widespread in England than would otherwise appear from the number of texts which survive from other English centres.

17. Young (1933), I, 239–410. For evidence for the *Visitatio Sepulchri* in England see D. Dolan, *Le Drame Liturgique de Paques en Normandie et en Angleterre au Moyen Age* (Paris 1975), 173 ff. Solange Corbin (op. cit., 49–69) lists 20th-century examples of the *Depositio* in Germany, France, Poland and Portugal.

18. Ed. cit., 44.

19. The rubrics for liturgical texts sometimes indicate the position of the sepulchre. An altar was used at Montecassino, Piacenza, Benevento (Young (1933), I, 214–17) at Tours (ibid., 224), Clermond Ferrand (ibid., 244) and Senlis (ibid., 295). A tabernacle on the altar served as the sepulchre at Brescia (ibid., 221) and perhaps at Sénanque (Schwarzweber (1940), 5–6). At Parma a temporary sepulchre was erected near the high altar (Young (1933), I, 125). The rubrics for Monza, Vienne and Narbonne describe small box-like structures serving as the sepulchre (ibid., 28–9, 284–6). At Toul, Coutances, Rouen, Barking and Fritzlar the sepulchre was large enough for at least two people to enter (ibid., 265–6, 408–10, 370–2, 381–4, 257). Especially in Germany the sepulchre was often situated outside the choir: at Regensburg, Halle and Prüfening it was at the altar of the Holy Cross (ibid., 295, 340–2, 159–61); at Wurzburg and Trier it was in the crypt (ibid., 257–8, 142–3). At Essen the sepulchre was in the Westwork (ibid., 333–5); at Speyer and Eichstätt, it was outside the church (ibid., 247, 283).

20. The possibility that the permanent tomb of Christ was sometimes used for continual reservation of the sacrament cannot be entirely ruled out, though it is difficult to find proof for this early period.

21. Dalman (1922), 37–41.

22. Ibid., 65–69; Schwarzweber (1940), 7–8.

23. Schwarzweber (1940), 8–10.

24. The figures were published together by Anton Legner in *Monumenta Annonis: Köln und Siegburg Weltbild und Kunst im hohen Mittelalter* (Köln 1975), 224–8. I am grateful to Professor Willibald Sauerländer for drawing my attention to this reference.

25. Augustinermuseum, Freiburg, *Ausstellung zur 850-Jahrfeier* (Freiburg 1970), 38–9 and Pl. 3. Werner Noack, 'Ein erstes Heiliges Grab in Freiburg', *Zeitschrift für Kunstgeschichte*, 23 (1960), 246 ff.

26. Werner Noack, op. cit., 246 ff. Two more wooden figures of Maries from Hochdorf near Freiburg dating c.1300 are in Freiburg Augustinermuseum, mentioned by Werner Noack and in *Ausstellung zur 850 Jahrfeier* (Freiburg 1970), 77. Another pair of wooden Maries and a figure of Christ from the church of St John at Ems in Switzerland have been dated to the last decade of the 13th century by H. Mahn, 'Ein "Heilig Grab" vor 1300', *Oberrheinische Kunst*, IV (1929–30), 130–3.

27. Werner Noack, op. cit., 251, suggests that there was a pre-existing tomb of Christ at Freiburg c.1230–40. The 14th-century tomb is discussed by Schwarzweber (1940), 10–13; the tomb was known to be in its present

position within a chapel west of the south transept in 1733. In 1913, three Maries and two angels were discovered and presumed to come from this tomb. The reconstruction as a canopy tomb dates from then, by analogy with slightly later canopied tomb of Christ from St Etienne, Strasbourg.

28. Schwarzweber (1940), 7–10. She cites Magdeburg and Gernrode as precursors for the figure tombs of Christ.

29. Schwarzweber (1940), 12. The *Depositio* and *Elevatio* date from 1669. However, she assumes that this represents the 14th-century ceremony.

30. P. Browe, *Der Verehrung der Eucharistie im Mittelalter* (Herder Rom 1967), 70–88 gives a good account of developments in Eucharist veneration in the 13th century.

31. Ibid., 70–4.

32. Ibid., 73–7.

33. Ibid., 78–9.

34. The most famous was the miracle at Bolsena in 1263 which was one of the factors which is said to have led to the institution of the feast of Corpus Christi in the following year. Ibid., 74–5. An extensive list is in P. Browe, *Die eucharistischen Wunder des Mittelalters* (Breslau 1938), 139–59.

35. The Sarum customary representing widespread use in England in cathedrals, colleges and parish churches from the 14th century states that the sepulchre should be censed daily at vespers and that it should be removed on the Friday of Easter Week, W. A. Frere, *The Use of Sarum* (Cambridge 1898), I, 220. Alfred Heales, who in his important article in *Archaeologia* for 1869 examined the English evidence in some detail stated 'There can be little or no doubt that it (the Easter Sepulchre) was a temporary wooden structure, framed so as to be easily put up when required, and afterwards removed, . . .', op. cit., 288.

36. 'Now remaynyng in the olde revestrie j altersone (black) a sepulchre a . . . a crosse for candelles called Judas crosse and other Furniture belonging to the same sepulchre, the pascall with the images in Fote belonging to the same sepulchre and a candlestike of wodde': in the certificate of ornaments to the Queen's Commissioners 1565–6: Rev. C. Wordsworth, 'Inventories of Plate, Vestments, etc. belonging to the Cathedral Church of the Blessed Mary of Lincoln', *Archaeologia*, LIII (1892), 81. Also listed in the 'Inventory of the Revestry', 11 May 1557, is a 'white steyned cloth of damask sylke for the sepulchre', ibid., 76. Another piece of evidence that Lincoln used a temporary sepulchre is the fact that a silver-gilt Resurrection image used as a monstrance is listed in several inventories, the earliest from the 15th century 'Item j imago xpi de argento deaurato aperta seu vacua in pectore pro sacramento imponendo tempore resurrectionis stans super vj leones et habet unum birellum et unum diadema in posteriore parte capitis et crucem in manu pondere XXXVII unc', ibid., 4. Such an image 'a marvelous beautifull Image of our Saviour representinge the resurrection, with a crosse in his hand, in the breast whereof was enclosed in bright christall the holy Sacrament of the Altar, throughe the which christall the Blessed Host was conspicuous to the beholders' was used at Durham in conjunction with a temporary sepulchre erected to the north of the High Altar on the morning of Good Friday. This image was buried in the Sepulchre on Good Friday at the same time as the crucifix which had been used for the ceremony of the Creeping to the Cross, *Rites of Durham* (1593), ed. James Raine, Surtees Society, XV (1847), 9–10. Alfred Heales's explanation of permanent 'sepulchres' was that they were enclosed by temporary sepulchres and served as 'the sepulchre itself', op. cit., 288. Francis Bond in *The Chancel of English Churches* (Oxford 1916), 236, also says of permanent sepulchres: 'It must be borne in mind that they are only pedestals on which the temporary wooden framework of an Easter Sepulchre was placed'. This is borne out by 15th-century examples, mostly wills, quoted by both authorities requesting mortal tombs to be built so that they could support the sepulchre when it was in use. The significance of a mortal tomb in a permanent position is self evident. The tomb of Christ is a different matter and has quite different implications and was undoubtedly more than just a 'pedestal'.

37. Unfortunately no Ordinal survives for Lincoln, so we are entirely ignorant about the use of the sepulchre. However a very full account exists, in the 13th-century Ordinal of Bayeux, of the use of what seems to be some kind of permanent sepulchre. We don't know what the Bayeux sepulchre looked like, but the method of use might have some significance for Lincoln. The sepulchre was situated 'juxta altare in parte sinistra' (*Ordinaire et Coutumier de l'eglise Cathedrale de Bayeux*, ed. U. Chevalier (Paris 1902), 402). It was prepared with pure linen and precious palls at Lauds on Good Friday. At Vespers, the pyx containing the presanctified host, a cross, chalice and paten were enclosed within it and watched until Easter Sunday, when before Matins they were removed with great reverence by the bishop (ibid., 130–9). Thereafter the sepulchre was visited processionally at Vespers until Ascension day. This far, the customs are not particularly unusual. What is interesting, however, is that the ordinal also relates that the sepulchre should be visited processionally during Matins on Sundays from the Octave of the Trinity until Advent, for the singing of the antiphon 'Surrexit Dominus' (ibid., 98, 373, 429). It was also visited processionally on St Stephen's day and St John's day on the 26th and 27th December. This seems to have been another sepulchre quite separate from that used at Easter and it seems to have been used in order to make Christ's presence, or the remembrance of his death to a more vivid part of the proceedings at points in the Church calendar other than Easter. I am grateful to Christopher Hohler for drawing my attention to this Ordinal.

38. The nearest equivalent is the 12th-century Chapel of the Holy Sepulchre off the crossing at Winchester Cathedral and though we know nothing about how it was originally used it seems to belong to the tradition of the early medieval sepulchre chapels on the Continent discussed above. According to L. Weever, *Ancient Funeral Monuments within the United Monarchie of Great Britain and Ireland* (London 1631), 118, the Knights Templars had a representation of Christ's sepulchre in the church of the Old Temple. It was probably not a figure tomb but a miniature building or chapel. He recorded the inscriptions.

39. If there was already a figure of Christ on the tomb slab, this may explain why there is no mention of a crucified Christ image to be buried in the sepulchre listed amongst the sepulchre furnishings (see above, note 34). It might indeed also explain why a separate temporary sepulchre was needed at Easter when the images on the tomb would have been veiled. P. Sheingorn, op. cit., 46, believes that there were never figures in the Lincoln tomb: 'It is however this very incompleteness which expresses the central hope and belief of the Christian religion.'

40. According to Giraldus Cambrensis, masonry from the tower at Lincoln fell in 1123 as a result of a fire, breaking Remigius's tomb, which was before the altar of the Holy Cross, in two. It was moved to a safer position further north, *Giraldi Cambrensis Opera*, ed. J. F. Dimock (Rolls Series, London 1877), VII, 25–6 and Rev. A. Poole, 'The Tomb of Remigius', *AASR*, XIV (1877–8), 21–6. Its new position is not mentioned, but it is possible that it was intended to be placed in the chevet of St Hugh's Choir (Peter Kidson, this vol., 34). However, during the episcopate of Richard Gravesend, a new set of Lincoln customs was written, presumably to set down such alterations to the liturgy as were made necessary by the building of the Angel Choir (*Lincoln Cathedral Statutes*, ed. H. Bradshaw and C. Wordsworth (Cambridge 1892), I, 62 ff. and 363 ff.). At high mass on double feasts, the tomb of Remigius was to be censed immediately after the high altar, which indicates that by this time his tomb was close by (ibid., 368). In 1926 the tomb was opened and revealed a lead coffin containing the remains of a bishop with chalice, ring and crozier. (I am grateful to the Sacrist for showing me a press cutting of 1926 reporting on the opening of the tomb.)

41. J. F. Dimock, ed., op. cit., VII, 6.

42. Matthew Paris, *Chronica Maiora*, ed. H. R. Luard (Rolls Series, London 1872–80), V, 90. R. E. G. Cole, 'Proceedings Relative to the Canonisation of Robert Grosseteste, Bishop of Lincoln' *AASR*, XXXIII (1915–16). 1–34.

43. The placing of St Hugh's shrine is discussed by P. B. G. Binnall, 'Notes on the Medieval Altars and Chapels in Lincoln Cathedral' *Antiquaries Journal*, XLII (1962), 68 ff. The indentations at the back of Remigius's tomb are not mentioned in print, but take the form of shallow indented quatrefoils at tomb chest level facing into the north choir aisle.

44. Bishop Berthold de Bucheck started building the chapel of St Catherine off the south transept in 1331 to contain his tomb. According to a 1349 chronicle by Prebend Closener, when the Bishop saw that his own tomb was finer than that in the crypt where the body of the Lord was laid on Good Friday he was ashamed and converted it into the new tomb of Christ and had a simpler tomb built nearby for himself, Victor Beyer, *La Sculpture Strasbourgeoise au Quatorzieme Siecle* (Strasbourg and Paris 1955), 29 and Schwarzweber (1940), 57–8. This reference also provides evidence that the earlier tomb of Christ was used for the *Depositio*. It also implied that the new tomb replaced it as the locus for that ceremony. Karl Young prints a 16th-century *Visitatio* from Strasbourg the rubrics of which indicate that the sepulchre was veiled, providing an enclosure large enough for two clerics to enter (Young (1933), I, 255). If this ceremony also took place at the tomb of Christ in this form in the 14th century, it may throw light on the way that figured tombs of Christ were used. Certainly the presence of a dead Christ image would present problems particularly during the *Visitatio* as the Maries could hardly truthfully declare the tomb to be empty. If, in common with other images, the tomb was veiled during Lent, this problem would be overcome to some extent. The Lenten veil is discussed in H. J. Feasey, *Ancient English Holy Week Ceremonial* (London 1847), 13–31. Several fragments from Bucheck's Tomb of Christ survive in the *Musée Lapidaire de l'œuvre de Notre Dame* and are illustrated by Beyer, op. cit., Pl. XIII.

45. The feast of Corpus Christi is listed as newly ordained in a Lincoln *Festa Ferianda* list dated by Bradshaw and Wordsworth earlier than 1328 on account of its not containing the feast of the Conception of the Virgin which was made obligatory in that year, Bradshaw and Wordsworth, op. cit., 2ii, 542–6. The feast was established by 1278 at the Collegiate Church of St Mary, Norwich. The chaplains were bound to have a solemn procession and mass on Corpus Christi day and each was enjoined to sing a daily antiphon of Corpus Christi with versicle and collects, H. F. Westlake, *The Parish Guilds of Medieval England* (London 1919), 201.

46. The chancel of Heckington church was built by the rector Richard de Potesgrave, according to an inscription recorded in the east window by Gervase Holles, c.1675 (British Library Harley 6829 f. 254). Potesgrave was rector from 1308–45. In 1328 he had licence to alienate a messuage, etc. to found a chantry at the altar of St Nicholas (Cal. Pat. Rolls, 2 Ed. III, May 20) which was operational in 1336 when he appointed a chaplain (Reg ii ff. 39d–40d, Lincoln Record Office). In fact the chancel was probably complete before this, as the date 1333 was recorded in the east window by Francis Thynne in his church notes (British Library Add. Ms 36295

f. 40). The furnishings are integral with the building and all of one date, *c*.1330. Richard de Potesgrave was a wealthy chancery clerk and chaplain to Edward II (E. Nottingham, 'Richard de Potesgrave', *AASR*, XIX (1887–8), 199 ff.).

The tomb of Christ at Navenby was made by the same masons who made the furnishings at Heckington. No documents or antiquarian notes exist recording any dates for Navenby. The manor was granted to the Dean and Chapter of Lincoln by the Abbot of Fécamp, 1292–3 (Cal. Pat. Rolls 21 Ed. I, Apr. 25). The right of presentation to the church belonged to the Abbey of St Martin, Séez. In 1325 while the King held the temporalities of the abbey he presented his Chancellor and Keeper of the Privy Seal, William of Herlaston to the benefice (Cal. Close Rolls, 19 Ed. II, Nov. 20). Herlaston was immediately granted lands in the vicinity of the rectory and elsewhere in the town indicating that he was probably about to build (Cal. Close Rolls, 19 Ed. II, Nov. 20). He was no doubt responsible for initiating the building of the chancel. Herlaston became a Canon of Llandaff and was succeeded *c*.1329 by John de Fenton who in that year travelled to France on the King's business with the Bishop of Norwich (Cal. Pat. Rolls, 2 Ed. III, 25 September). He was succeeded, probably on his death by William de Kelleseye (Cal. Pat. Rolls, 5 Ed. III, 1 April). The tomb at Navenby is in a different style from the rest of the furnishings and is likely to be John de Fenton's, rather than that of his successor who died in 1358 and established a chantry in South Kelleseye church (Cal. Pat. Rolls, 32 Ed. III, 4 August). The tomb of Christ, sedilia and piscina probably date therefore from the late 1320s.

There is no satisfactory documentary evidence which might help with the dating of Hawton. It is normally stated following an article by F. H. Burnside, that the chancel was built by the lord of the manor, Robert de Compton, for his father Robert de Compton who died in 1330 and was buried in the tomb in the chancel north wall (F. H. Burnside, *Trans. Thoroton Soc.*, 29 (1925), 181 ff.). However, Burnside misread a reference to charter of 1330 assuming it to state that Robert de Compton died, while in fact it recorded an agreement between Robert de Compton and the parson of Hawton, confirming Compton's rights to the manor and advowson of the church, thereafter to be passed to his sons Robert, John, Ralph and James successively (VCH, *Nottinghamshire*, II (1910), 122). Compton pedigrees (of Fenny Compton in Warwickshire) are given by R. Thoroton (*History of Nottinghamshire* (1790), I, 353) and Drummond (*Histories of Noble British Families* (London 1846), I, 12) neither giving a death date of 1330 for Robert. Furthermore the tomb in the chancel in the north wall, contains an effigy of a knight with Compton arms on the shield (sable, 3 heumes or) but the effigy has been cut down and is not in its original position (Rev. H. Lawrence and T. E. Routh, 'Military Effigies in Nottinghamshire', *Trans. Thoroton Soc.*, 28 (1924), 123). The tomb and the adjacent doorway to the sacristy are both surmounted by figures of archbishops and it is likely that a senior cleric attached to Southwell or York Minster was responsible for the building and its furnishings. It probably dates from the late 1330s or early 1340s and the sculpture is by the same masons who built the pulpitum at Southwell. Its similarity with the tomb of Christ at Heckington is notable, but it was clearly not made by the same hand.

The church at Sibthorpe belonged to the Knights Templars and on the destruction of their order it was made over to Thomas de Sibthorpe (R. Thoroton, op. cit. (1790), I, 326 ff.). He began enlarging the church in 1324 when he obtained licence to alienate a messuage, etc. for the foundation of a chantry in a chapel to be built on the north side of the church (VCH, *Nottinghamshire*, II (1910), 150). By 1335 he increased the endowments in order that the church should assume collegiate proportions with a warden, two chaplains and a clerk serving the chapels (Cal. Pat. Rolls, 9 Ed. 3, 28 May; Knowles and Hadcock, *Medieval Religious Houses* (London 1971), 439). Thomas de Sibthorpe was also a King's clerk (Cal. Pat. Rolls., 9 Ed. 3, 28 May).

Patrington appears to be the latest of the group. Again, it is undocumented, but the tomb is likely to have been commissioned by Michael de Wath presented by the King in 1335. He was another King's clerk who was involved in the rendering of accounts in connection with proving the will of Archbishop Melton in 1340 and held the benefice until 1350/1 (E. W. Crossley, 'Patrington Church', *Yorkshire Archaeological Journal*, XX (1909), 141). I am also grateful to Keith Allison for giving me references to incumbents of Patrington in the 14th century.

47. E. Peacock, *English Church Furniture, Ornaments and Decorations at the Period of the Reformation. As exhibited in a list of goods destroyed in certain Lincolnshire churches, AD 1566* (London 1866). Most of the sepulchres mentioned by Peacock were broken up and burnt or sold for conversion to items of domestic furniture. Unfortunately Heckington and Navenby in Lincolnshire are not listed at all. However, Horbling which has a permanent stone tomb of Christ in the north wall of the chancel (late 15th or early 16th century showing Christ rising from the tomb) is listed as having a temporary sepulchre: 'item. The sepulchre was sold to Robert Lond and he saith he hath made a presse thereof', Peacock, op. cit., 108.

48. J. D. Mansi, *Sacrorum Conciliorum Nova Collectio* (Venice 1776), XXII, Col. 1007; King (1965), 67.

49. *Roberti Grosseteste Epistolae*, ed. H. R. Luard (Rolls Series, London 1861) Epist. LII, 155; King (1965), 68.

50. D. Wilkins, *Concilia Magnae Britanniae et Hiberniae* (London 1737), II 52; King (1965), 52; T. E. Bridgett, *History of the Holy Eucharist in Great Britain* (London 1881), II, 86.

51. King (1965), 87: 'Many of the aumbries to be met with in parish churches and cathedrals would have served as Easter sepulchres, reliquaries or receptacles for books and sacred vessels'. The purpose of the reserved

sacrament was, according to some authorities, to keep it until such time as it could be administered to those who were unable to attend divine service, i.e. the sick and dying. See King (1965), ch. 1 'Purpose of the Reserved Sacrament', 3–18. Edmund Bishop, 'The Christian Altar' in *Liturgica Historica* (Oxford 1918), 35–6, stated that the purpose of reservation in the Middle Ages was not worship, but Viaticum. 'During the whole Middle Ages the usual place of reservation was some recess, or as it were, cupboard, often closed with iron bars, sometimes fairly high up on the wall of the Gospel, and more rarely the Epistle, side of the altar . . . any idea, if it exists that the 'suspension' was the universal discipline, even throughout France, needs, I think, revision.' However, at least one late medieval source contradicts this view entirely. The *Merita Missae c.*1470, urges the worshipper on entering the church to 'lok to the hy auter and pray to hym that hangythe there', Early English Text Society, OS 71, 1879, 389. The question as to whether the sacrament was reserved as a rule in an aumbry or over the altar in a hanging pyx has provoked much argument. See also Gregory Dix, *A Detection of Aumbries* (London 1942), and the response favouring suspension, from S. J. P. Van Dijk and J. H. Walker, *The Myth of the Aumbry* (London 1957). Evidence for both methods is given by King (1965), Ch. 10, 65–101. His opinion was that suspension was the rule in England but he gives a number of examples of aumbries used for reservation in parish churches (ibid., 95–9), where certainly it was Edmund Bishop's view that aumbries were used more often than the pyx for reasons of security (op. cit., 36–7).

52. By 1318 the feast was celebrated in the Diocese of Bath and Wells and it was probably celebrated at Salisbury at the same date, W. H. Frere, *The Use of Sarum* (Cambridge 1898), II, xviii. It may have been celebrated at St Paul's Cathedral somewhat earlier, as it is referred to in Ralph Baldock's statutes (elected Dean 1294; Bishop 1303/4–1313). *Registrum Statutorum et Consuetudinum Ecclesiae Cathedralis Sancti Pauli Londiniensis*, ed. W. Sparrow Simpson (London 1873), 141.

53. H. F. Westlake, op. cit., 48, 201, lists seven known guilds devoted to Corpus Christi dating earlier than the Black Death, of which all but one were in Eastern England: Norwich f. 1278 (see note 45); Bury St Edmunds, f. 1317; Ipswich f. 1325; Louth f. 1326; Taylor's Guild, Lincoln, f. 1328; Coventry f. 1343 and Tyler's Guild, Lincoln, f. 1346.

54. Ibid., 51–2.

55. Ibid., 167. The Corpus Christi guild at Castor f. 1376 provided lights from the 'Day of preparation on which the body of Christ is placed in the shrine by the priest until the Resurrection'. It also provided lights for the Corpus Christi procession and at funerals (ibid., 158).

56. Joseph Destrée, 'Partie Supérieure d'un tabernacle ou armoire du Saint-Sacrement', *Bulletin des Musées Royaux d'art et d'Histoire* 3ième Ser. Deuxième Année, no. 5 Sept. (1930), 119–23.

57. J. Hertkens, *Die mittelalterlichen Sakramentshäuschen* (Frankfurt 1908), King (1965), 104–10. W. H. Forsyth, *The Entombment of Christ* (Harvard 1970), 18 ff.

58. Edmund Bishop, op. cit., 6; King (1915), 104–7. A reference to another early sacrament house is made in 'De actis judeorum sub duce Rudolpho' by Fratrer Ambrosius de Sancta Cruce, where a story of host miracles which took place at the church of St Michael, Vienna in 1307–10 is related: 'Quidam rusticus malignus venit ad ecclesiam Sancti Michaelis Wienne et accessit ad illum cancellum, sive ad clausuram in muro factam secus altare, in qua servatur corpus domini pro infirmis. Et quia invenit locum illum non fera firmatum, aperuit eum et sustulit exinde pixidem cum corpore domini . . .' Th. von Karajan, *Kleinere Quellen zur Geschichte Österreichs* (Vienna 1859), 7–10.

59. Schwarzweber (1940), 27–45, lists examples at Detlingen, 1470–80; Eichsel, 1478; Mappach, 1470–80; Riedlingen *c.*1500; Schönau, *c.*1500. They are all situated in the north wall of the chancel and were used at Easter and for reservation during the rest of the year. They are surrounded with images normal for a tomb of Christ except that they never include a figure of the dead Christ, but have at the centre the door to the shrine to contain the host.

60. F. Bond, *The Chancel of English Churches* (Oxford 1916), 215–18.

61. It is important to bear in mind that the same historical circumstances as discussed in this article do not prevail when later English Easter Sepulchres are considered. Where there are permanent monuments in the north wall of the chancel after the end of the 14th century they are normally primarily secular tombs (many examples are given by A. Heales, op. cit., 289–92, 295, 307–8), which are ordered to be placed there in order to be near to Christ at Easter, when the sepulchre was erected. Their function as monuments commemorating Christ's body thus takes quite a different and lesser emphasis. The sacrament shrine never seems to have become popular in England.

The Glazing of the South Rose
of Lincoln Cathedral

By David J. King

The motif of the rose window was not common in English medieval architecture and the north and south roses at Lincoln remain the two most important extant examples.[1] The 'Dean's Eye' on the north side of the main north transept was part of the original structure of *c*.1200, and still contains rather less than two-thirds of its original glazing depicting the Last Judgement.[2] The 'Bishop's Eye' opposite, however, is not the original early 13th-century window, but was rebuilt in curvilinear style in *c*.1325–50. Its unique pattern of stonework has often been admired, but the present glazing has hitherto been dismissed by writers, apart from the identification of an odd figure or detail, as an incoherent jumble of fragments, although Pevsner hints that a closer examination might yield 'thrilling discoveries'.[3] It is the purpose of this article to put forward and discuss the results of such an examination, carried out during the 1982 BAA Conference with the aid of a high-powered telescope. This revealed that, in addition to the many mainly 13th-century fragments alienated from other windows in the cathedral in the 18th-century alterations to the glazing,[4] there are to be seen in the south rose, albeit very corroded and fragmentary, significant remains of the original 14th-century glazing of this huge window. It should be added at this point that what follows is the writer's own interpretation of what he saw through a telescope and subsequently on slides and photographs taken with a telescopic lense, and that any study of the glass from a scaffolding, or better still, in the studio, will certainly add to what can be seen at present, and may well change details of it.

A detailed inventory of the contents of the south rose is to be found in an appendix at the end of this article; from it I have extracted a list of the main identifiable parts of the original glazing. In addition to those listed here and the minor fragments in the inventory, it is clear from the several surviving examples that the lesser eyelets were filled with coloured discs set on a background of another colour.

The numberings of the tracery openings given here and elsewhere relate to the diagrams in Figures 1 and 2. The Roman numeral indicates the sector as in Figure 2 and the remaining letter and number the position within the sector as in Figure 1.

> Christ among the Candlesticks (II, J2) (Pl. XXVIIIA)
> Head of Christ with Cross Nimbus (IV, B3)
> Seated King with Sceptre and Crown (II, F5) (Pl. XXVIIIB)
> King's head (II, F2)
> Seraph (II, C3) (Pl. XXVIIIC)
> Seraph (III, G2)
> Angel's wing (IV, B3)
> Angel's wing (IV, C1)
> Hand holding Trumpet (II, H2)
> St Andrew with Saltire Cross (II, G2) (Pl. XXVIIID)
> St Paul with Sword (II, H2) (Pl. XXIXA)
> St James the Greater with Scallop, Hat, Staff and Scrip (II, H3) (Pl. XXIXA)

Top half of seated Apostle (?) (II, F4)

Angel playing Cymbals (IV, A1)

Shrouded female head, hands raised in supplication (III, C6)

Top half of Monk, hands raised in supplication (III, D2)

Two resurrecting figures and two coffin lids (III, E4)

Bearded man, hands raised in supplication (III, F5)

Top half of female shrouded figure with raised hands (III, G6)

Lower part of naked figure (III, H2)

Naked monk with flesh-hook (IV, C1) (Pl. XXIXB)

Coffin lid, and hands raised in supplication (II, F3)

Coffin lid (I, A4)

Coffin lid (I, A6)

Coffin lid (III, C3)

Monk in white habit, hands raised in supplication (II, F3) (Pl. XXIXC)

Green and blue devil (III, F3)

Male bearded face (II, F3) (Pl. XXXA)

It is not hard to draw the conclusion from this list of subjects that the original glazing of the south rose consisted of a depiction of the Last Judgement, including the General Resurrection. This is of course the same basic iconography as that of the earlier north rose glazing, but in a window of very different period and design.[5]

The 14th-century refurbishing and reconstruction of the south transept of which the south rose with its glazing was part has normally been dated by reference to events associated with the efforts to secure the canonisation of Bishop John Dalderby.[6] John was elected bishop on 15 January 1300 and became known for his piety, knowledge, generosity and good administration. He died on 12 January 1320, having attained as John de Schalby put it, 'the heavenly state'.[7] He was buried before the altar of St John the Evangelist in the south transept at Lincoln,[8] and by December 1322, miracles were being attested at his tomb, although it is said that he was already revered as a saint immediately after his death,[9] and in 1321 indulgences were granted to people praying at his tomb.[10] Two guards for his tomb were appointed, indicating that pilgrims were leaving large sums of money.[11] A petition from ten English bishops to the Pope requesting his canonisation was refused in 1328,[12] and in 1330 John de Haghe claimed payment for having for a third time addressed the Pope on this point.[13] However, it appears that despite official refusal of Dalderby's sainthood, his tomb retained its popularity right up to the Reformation, and antiphons were composed for use on the festal day of 'Saint John Dalderby'.[14]

Thus it would seem that income at Dalderby's tomb from pilgrims and interest in his canonisation would have been at their height between 1325 and 1330, or a little later, during which time it is probable that the refurbishing of the south transept, including the glazing of the new south rose, was carried out. This window had been associated with the bishop from c.1220–35 at least, when the 'Metrical Life of St Hugh' was written, and it may well be that Dalderby's successor in this office, Henry Burghersh, took an active part in its reconstruction; indeed the whole south transept rebuilding may have been connected with the campaign on the adjacent Bishop's Palace, indicated by the licence to crenellate and turrellate the residence granted to Burghersh by the King in September 1329 'in consideration of his profitable services and the great place he holds in the direction of the King's

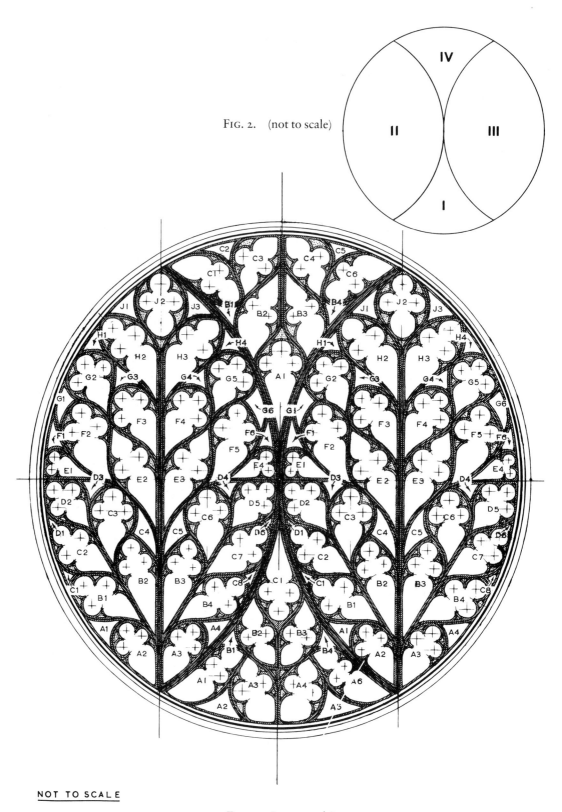

FIG. 2. (not to scale)

NOT TO SCALE

FIG. 1. (not to scale)

affairs'.[15] Henry had fallen out of royal favour early in his episcopate, but in 1328 he was appointed successively Royal Treasurer and Chancellor. From 1328 until he was deprived of the chancellorship in November 1330 was the period of his greatest successes, and if he was instrumental in the south transept rebuilding it was most probably during this time, although we should also take into account the years 1334–7 when he was once again Treasurer.[16]

It is perhaps likely that at least some part of the financing of this work would have come from the offerings of pilgrims at what by then would have been the shrine of John Dalderby, and this may have affected the choice of subject for the glazing of the south rose. Pilgrims praying at the shrine may have been encouraged by the eschatological happenings in the window above to dig more deeply into their purses to salve their souls. They may well of course have already passed through the Last Judgement portal on the south side and would have faced the same subject in the north rose, but the brand-new version in the Bishop's Eye, with its accent on the General Resurrection and the tortures of Hell, set in the flaming and twisting shapes of the curvilinear tracery, would have had a more immediate impact on the minds of the waiting pilgrims than the splendid, but more archaic and remotely scholastic version in the Dean's Eye opposite.

As has already been stated, rose windows were not common in medieval England, and the Bishop's Eye in Lincoln is not only a rare example, but is unique in that its design does not focus on the centre of the circle. Lincolnshire is famous for the richness of its curvilinear traceries, and this window is the largest example. Its exceptional character derives from the fact that its shape was already fixed by that of the 13th-century window which it replaced. Since curvilinear tracery forms in England are almost always contained within a pointed arch or a square-headed window, the prospect of constructing a large tracery network within a circle must have posed problems to the mason responsible for this window. The much later examples of centrally orientated radiating windows with curvilinear forms of the French style were not available as patterns; the solution adopted here was to subdivide the window into shapes which are far more suitable for containing the conventional tracery forms of the period than is a circle. From each horizontal extremity of the circumference an arc was drawn through the centre to form two vesica shapes each half of which was the same shape as the head of a normal window of that period. The remaining pair of curved triangular forms are shapes also commonly found in more normal windows of this style, if of course on a much smaller scale. It was then a relatively simple task to fill these four main shapes with traditional decorated forms, mainly quatrefoils.

If the task of the mason here was more complex than normal, that of the glazier was if anything even more so. The irregular, asymmetric openings of many decorated tracery designs were difficult to fill with figured glazing, and often foliage patterns or roundels set on plain or diapered backgrounds were resorted to. Another solution was that of 'reduced' iconography, as at Great Walsingham church, Norfolk, for example. Here, in a tracery design characterised by sub-reticulation giving many very small openings, a representation of the Coronation of the Virgin is conveyed merely by the portrayal of the head and hands of the two figures.[17] At Lincoln, there was no need for reduction; the problem was how to fill the well over one hundred spaces with a coherent design. What was needed was an iconographic subject based on a large number of single figures. Most programmes based on single figures are not extensive enough, for example, the twelve Apostles or even combined series of various kinds of saints; most subjects of a more extended nature such as the Apocalypse, Creation, Old or New Testament cycles involved individual scenes, each with several figures which would not easily fit into the available openings. Such programmes do appear in more conventional radial rose windows, but these tend to have larger and more

regular areas of glazing. A Last Judgement depiction, however, has all the right ingredients for solving at least some of the problems posed by this window design. It does consist largely of single figures, is not rigid in the number of them which can be shown, and indeed can be extended almost indefinitely and does, or at least can have, not only the strong upward and downward movement but also left–right division which is implicit in the window design here. In fact, the potential for coherent spatial relationships between the elements of a Last Judgement — Heaven and Hell, the Saved and the Damned — is much greater in this window than in the more usual version in the north rose. Of course, too much of the original *c*.1325–50 south rose glazing is missing or moved for it to be possible to assess in any detail how successful was the design of the overall iconographic programme. But, anticipating for a moment the discussion of the individual figures which are extant, it will be seen that they display a clarity of design based on a combination of strongly modelled heads and drapery and contrasting but simple coloured backgrounds. This, and the factors mentioned above, suggest that the complete window would have presented a complex but readable and impressive whole.[18]

We turn now to assess perhaps the most difficult aspect of the window, the style and design of the individual surviving figures. Here it will be possible to make only provisional statements based on colour slides and black and white photographs, and only the best of the extant figures will be discussed.

The most complete human figure is that of St Paul (II, H2) (Pl. XXIXa), although his head is badly obscured by repair leads and a saddle bar. He sits on a bench in the lower lobe of a large quatrefoil opening which may or may not have been the original position, but which would have been large enough for two figures. In his right hand is a sword pointing upwards; his left hand holds a book. His large head set on a long neck looks up to the right. The face is long, thin and bearded. He wears a pot-yellow robe under a pale yellow-green mantle. The drapery is highly modelled with smear-shading and relieved highlights; the left leg is foreshortened, and a recessed arch in the front of the bench is shown in perspective. The whole appears to be set on a plain blue background, and the background of the other surviving apostles suggests that they at least were set on counterchanged blue and ruby.

Of the figure of St Andrew (II, G2) (Pl. XXVIIId), only the head, neck, nimbus and saltire cross emblem survive in any coherent form, but the jumbled fragments below indicate that the apostle wore a pot-yellow mantle over a blue robe. The figure is set on a plain ruby ground with a white fillet and is possibly in its original position. The head is complete; it is painted on white glass, again has a long neck and looks to the right. There is a blue nimbus. In comparison with other less complete faces here, it seems that some of the modelling may have worn away, but an individual facial delineation still remains visible. It is again a long face, with a long but bulbous nose, protruding lower lip, eyes wide open with high, arched eyebrows, heavily modelled under the brows, and wrinkled forehead. The hair is swept back off the forehead and falls down the back of the neck. The beard grows from either side of the mouth and joins under the chin, as with St Paul. The mouth turns down slightly at the corners to give a rather lugubrious expression.

Of the figure of St James the Greater (II, H3) (Pl. XXIXa), only the pilgrim's hat, with scallop and strap, and the face survive in any detail. The upper part of the staff is there, but the body is only a vague suggestion of white glass and lead lines. The face is strongly shaded in brown paint with highlights on the nose. The eyes are obscured by a repair lead, but the mouth is markedly down-turned and there is part of a beard visible. Again, the neck is long.

The heavy modelling in brown paint also appears on two other incomplete male heads, in II, G2 and II, F3 (Pls XXVIIId and XXXa). The former has an even more bulbous nose, long neck and slightly modelled eyes, and the latter, just a face, is even more finely painted. In the

same light are the head, neck, upper torso and raised right arm of a tonsured monk who looks up to the right (Pl. XXIXc). Most of the paint is missing from the face, but the mouth is slightly open. The white glass of the habit is, however, deeply modelled with folds in brown smear shading.

A different head type is seen in the fragmentary figure of a seraph in II, C3 (Pl. XXVIIIc), a young man in profile. The nose and neck are again long, the mouth small and the chin receding. The eye is almond shaped and the hair swept back off a high and prominent forehead. The remains of three pairs of wings are to be seen, as befits a seraph; two are green and one white. The drapery is lost, but most of the ruby ground with white fillet survives and the figure appears to be *in situ*.

Despite the caveats concerning the damaged and incomplete state of the glass and the difficulty of examining it, it is possible to draw some conclusions about the style of the glass based on the above description of the main surviving figures. The use of smear shading leading to a high degree of plasticity in the rendering of the drapery and head types would agree with the suggested historical dating of *c.*1325–50, but is more probably at the end of that period. The introduction of the technique at this time was part of a general increase in the depiction of three-dimensional spatial forms in stained glass and other media such as seals and manuscript painting in England and on the continent.[19]

The best known examples of this new mode of painting in glass are at York: the re-set glass of *c.*1335 from the old choir of the Minster, the three west windows of the nave, and certain panels in parish churches, all of which show the influence of glass from Normandy and also French and English manuscript painting.[20] Different versions of this style, not necessarily under the direct influence of York, are also seen in many other parts of the country. The best of this glass is of excellent quality, especially in the carefully modelled drapery forms and delicately relieved background patterns. The Lincoln glass under discussion here is clearly related to this general stylistic framework. The background patterns are largely omitted, or missing, perhaps for reasons of clarity, but the drapery is painted in a similar way, and the profile head of the seraph in II, C3 (Pl. XXVIIIc) is very similar to many others in this overall style, which also have almond eyes, small mouths and chins and a large forehead. However, the modelling of the seraph's head has worn, and when we look at some of the better preserved heads described above, a significant difference between the Lincoln south rose glazing and the general style becomes evident. One feature of the so-called 'York' type of glass of this period is that although it achieves a greater degree of realism through the increased plasticity of the drapery and the architectural forms, it often still leans heavily on a conventionalised facial drawing. There is more shading than before on certain areas of the face such as the brow, but the actual trace-line drawing of the fact is very often highly stylised (Pls XXIXd and XXXb). The Lincoln heads are very different, much more painterly and with a greater degree of realism and variety, if often rather crude and inaccurate. Contemporary parallels are difficult to find. The uncompromising ugliness of the heads here, which contrasts strongly with many of the conventionally sweet York faces (there are exceptions), makes one think not only of the expressionist eccentricities of certain English art of the 1340s, such as the Luttrell Psalter,[21] but even of the much later work of John Thornton in the York Minster east window of 1405–8. All this indicates that we have here the remains of a work by a rather crude but vigorous glass-painter, well up-to-date in the mode and technique of his work, and that the glass at least, if not the stone work, was more probably made towards the end of the suggested period of *c.*1325–50.

APPENDIX I

The majority of the glass at present to be found in the south rose does not belong to this window and has been moved here from other positions in the cathedral. Among the many fragments are some which are worthy of individual mention; fuller descriptions will be found in the inventory. References to border types relate to Morgan (1983), Fig. B.

Thirteenth Century

Virgin and Child, under trefoil-headed arch (I, A1) (Pl. XXXD).
Complete circular ornamental foliage medallion (I, B3).
Sections of Type B border (I, C1; II, E2; III, E3).
Head, mitre and staff of bishop (II, B3).
Seven large pieces of background to a medallion window (II, D2; II, E2; II, E3; III, D2; III, E2; III, E3; III, F2) (Pl. XXXC). The shapes of these sections imply that they are from a window containing alternate circular and diagonally placed square medallions, as in window nVI of the Trinity Chapel ambulatory, Canterbury Cathedral, dated probably before 1207. Detailed measurements are needed to verify this suggestion.[22]

Fourteenth Century

Several fragments of leaf ornament from the west window glazing. Part of a gittern, also from the west window (IV, B2).[23]
A heater shaped shield, now incomplete, but which formerly bore: *argent a fesse between two bars gemel gules* (II, A3) (Pl. XXXE).[24]

Fifteenth Century

Part of a small Crucifixion or Trinity (I, B2).
Border fragments bearing the arms of Mablethorpe (I, B3; III, B4; III, F4).[25]

APPENDIX II

INVENTORY OF THE SOUTH ROSE WINDOW, LINCOLN CATHEDRAL

14th-century glass original to this window in **bold** type.

Sector I

A1. 13th century: seated crowned figure of Virgin and Child, who hold hands, surmounted by a trefoil-headed arch. Figures have lost heads. Pot-yellow crown and mantle, pot-yellow robe for Virgin, green garment for child. Blue background. Blue, white, ruby and pot-yellow rinceaux. C.1370–80: white and green foliage from west window.

A2. 13th century: white, green and pot-yellow drapery. **Piece of eyelet** (inside out).

A3. 13th century: white drapery, grisaille fragments with stiff-leaf and cross-hatching, and pot-colours. 14th century: bright green leaf. 15th century: fragments with yellow stain and two black-letter initials *K*.

A4. 13th century: white, ruby and pot-yellow drapery, grisaille fragments with stiff-leaf and cross-hatching, part of pot-yellow censer, pot colours. 14th century: part of green masonry. 19th century: white vine leaf.

A5. 13th century: pot-yellow drapery, pot-colours, **green drapery.**

A6. 13th century: white, pot-yellow and purple drapery, grisaille fragments with stiff-leaf and cross-hatching, pot colours. 14th century: green border piece, blue masonry or **coffin lid.**

B1. 13th century: green drapery, piece of blue.

B2. 13th century: white, pot-yellow and purple drapery, white, ruby and blue fragments of grisaille. C.1370–80: white foliage with yellow-stain from west window. 15th century: fragment with head, nimbus and arm on white glass with yellow-stain, from Cruxifixion or Trinity.

B3. 13th century: white, pot-yellow and green grisaille fragments and complete circular ornamental medallion consisting of four double petal shapes in ruby and white glass set on a ruby ground with blue barbs and in the centre a white quatrefoil with green surround and four radiating pot-yellow stiff leaves. A bearded head facing three-quarters right in white glass. 13th or 14th century: the back half of an animal, perhaps a lion, in pot-yellow glass. 15th century: border fragments with arms of Mablethorpe, *argent a chevron between three crosses crosslet sable within a border of the last charged with eight besants*. One piece is inside out.

B4. 13th century: blue drapery, ruby and purple pot-colour.

C1. 13th century: white, green and murrey drapery, white grisaille fragments, good piece of border, type B. 14th century: blue wing, **part of green coffin lid,** 19th century: fragments of grisaille.

Sector II

A1. 13th century: good male head facing left, pot-colours.

A2. 13th century: fragment of blue grisaille. C.1370–80: white glass with yellow stain foliage on murrey ground, from west window.

A3. 13th century: white and green drapery, fragments of white and blue grisaille. 14th century: heater shaped coat of arms, patched in places, originally bearing *argent a fesse between two bars gemel gules*. The *argent* field has a thin matt wash picked out with a foliage pattern and the shield is set on fragments of blue glass. 15th century: piece of canopy.

A4. 13th century: pot-yellow fragments. 19th century: blue fragments.

B1. 13th century: white and green drapery, fragments of white grisaille and ruby glass with possibly flames. **Top half of female head, and foot.** C.1370–80: white foliage from west window. 14th century: canopy fragments. 15th century: fragments of black-letter inscription (illegible).

B2. 13th century: crozier with pot-yellow drapery, more pot-yellow and white drapery, fragments of green grisaille and white fictive wall. **Pot-yellow coffin lid with white praying hands.**

B3. 13th century: part of bishop with pink face, white mitre, hand and book, fragments of white grisaille, pot-colours. **Top of male head, green coffin lid.** C.1370–80: white foliage from west window.

B4. 13th century: male head, possibly tonsured, part of angel with white and pot-yellow wing and green mantle, part of building with white walls and purple roof, fragments of white and green grisaille, green and murrey drapery and blue and ruby pot-colour. 14th century: pot-yellow leopard's face and fragments of beaded fillet in pot-colour. **Male head facing left.**

C1. 13th century: green, murrey and blue pot-colour.

C2. 13th century: two small heads, fragments of white grisaille, pot colours. 13th or 14th century: pot-yellow leopard's face. 14th century: pot-blue with relieved trefoil pattern. **Scourge.** Unknown date: large wheel on white glass.

C3. 13th century: green drapery. **A seraph; six winged figure standing facing right with face in profile with alternate green and white wings, red drapery (not original to this figure) and** *in-situ* **ruby background with beaded fillet decorated with yellow stain.** C.1370–80: white foliage from west window.

C4. 13th century: fragments of white grisaille (inside out).

K

C5. 13th century: fragments of white grisaille. **Fragment of pointing monk.**

C6. 13th century: two green, white and pot-yellow rinceaux terminations on a ruby ground, fragments of white drapery and grisaille. 14th century: green angel's wings and light-blue fictive wall. **Ruby drapery.**

C7. 13th century: green, pot-yellow and blue rinceaux. **Male head facing front, top missing, possibly pink glass.** 15th century: lower half of border initial and crown in white glass and yellow-stain.

C8. 13th century: fragments of white grisaille. 15th century: fragments with yellow-stain.

D1. Small fragments.

D2. 13th century: section of background to medallion window; blue leaf roundels separated by small white discs and set on a ruby ground. **Shrouded female head.** C.1370–80: white foliage from west window. (N.B. in adjacent small unnumbered eyelet is a good piece of 15th-century drapery with yellow-stain.)

D3. **Pot-yellow disc, blue background.**

D4. **Opaque disc, pot-yellow background.**

D5. **Ruby and pot-yellow drapery and hand.** C.1370–80: white foliage from west window. Post-medieval: part of right foot.

D6. Plain white glass.

E1. 13th century: fragments of white grisaille. **Bearded head.** C.1370–80: white foliage from west window. 15th century: purple glass with relieved foliage pattern.

E2. 13th century: section of border, type B, section of background as in D2 of this sector, fragments of white grisaille. 14th century: parts of fictive wall, vault and niche from canopy. **Male head looking left.** 14th or 15th century: Crown from border with yellow-stain.

E3. 13th century: section of border, type B, section of background as in D2 of this sector. **Head. Fragments of Angel.** 14th-century: canopy fragments. C.1370–80: white foliage from west window. 15th century: canopy fragments.

E4. **Semi-reclining figure with pot-yellow garment (possibly** *in-situ*), **holding a white disc and set on a ruby ground. Female head.**

F1. **Murrey disc, purple background.**

F2. 13th century: pot-yellow drapery. **Outline of standing figure, green drapery, male head, king's head facing right in white glass with pot-yellow crown, male frontal head, crown.**

F3. 13th century: white fragment. **Tonsured monk in shroud with hands raised in supplication. Blue diaper, pot-yellow crown, white male bearded head, pot-yellow mitre, fragments, possibly of a standing figure, green diaper.** 14th century: recessed window with quatrefoils picked out, with yellow-stain.

F4. 13th century: white grisaille fragments. **Remains of a figure, possibly an apostle, with beard, amber mantle, blue robe, blue and white fragments.**

F5. **Seated figure of king with pot-yellow crown, with left hand holding sceptre and right hand raised, green mantle, blue robe, pot-yellow morse, facing three-quarter left, ruby ground and white fillet, white and pot-colour fragments, blue tomb lid, head and hands.**

F6. 13th century: white grisaille fragments, blue and ruby fragments.

G1. 14th century: small white head, possibly inside out. **Blue background with white fillet, pot-yellow fragment.**

G2. **St Andrew: a male bearded figure facing three-quarter right with fragmentary blue and amber drapery, blue nimbus, green saltire cross and ruby background. Two further heads.** C.1370–80: foliage from west window.

G3. 13th or 14th century: white drapery.

G4. Fragments, including one post-medieval.

G5. **White wings, purple drapery, blue background with white fillet.** C.1370–80: foliage from west window.

G6. **Head facing left.** Purple and ruby fragments.

H1. **Pot-yellow disc.** 15th century: canopy fragment.

H2. **St Paul: a male bearded seated figure facing three-quarter right, holding an upright sword in his right hand. His head, hand and sword are white, the robe is pot-yellow and the mantle bright green. He sits on an arcaded bench. Also a hand holding a pot-yellow trumpet and two feet, with green drapery and blue background.** C.1370–80: foliage from west window. 14th or 15th century: crowned initial *R* from border.

H3. **St James the Greater: a seated male figure facing three-quarter left, holding a staff in his left hand (hand missing) and a book in the left, with white face, book, hand, pilgrim's hat with scallop, and mantle, light-green robe and green background. Also another head and parts of young male figure facing-three quarter left holding palm branch, possibly St John the Evangelist. Blue patterned background. Pot-yellow feathers.** 14th century: covered cup from border, pot-yellow fleur-de-lys with animal mask. C.1370–80: foliage from west window.

J1. **Pot-yellow disc on green ground.**

J2. **Christ among the candlesticks: seated figure wearing crown with white relieved foliage pattern at top. On the left, three pot-yellow candles in white candlesticks decorated with yellow-stain, on a blue background. On the right, two similar candlesticks.**

J3. **Ruby disc** and fragments.

Sector III

A1. Ruby and blue fragments.

A2. 13th century: fragments of white and pot-yellow grisaille. **Possibly part of green devil.** 14th century: decorated pot-colour fillet, with alternating cross-hatching and flowers. *SR* in Lombardic script.

A3. 13th century: fragments of white grisaille. 14th century: fleur-de-lys from border. **Pot-yellow head facing left.** 15th century: pink and green patterned background.

A4. Pink and blue pot-colours.

B1. 13th century: green, white and murrey drapery. 15th century: purple drapery and green patterned background.

B2. 13th century: white grisaille fragments, green drapery, two small male heads facing three-quarter right, small bearded head facing right. **Blue patterned background, white hand coming from green sleeve.** Pot-colour fragments.

B3. 13th century: small pink male head in profile facing right, another head, ruby drapery, fragments of white grisaille. **Blue patterned background, head and two raised arms, figure in profile facing left, naked figure looking left with arms outstretched.** Pot-colour fragments.

B4. 13th century: green drapery and blue stiff-leaf. **Blue patterned background and green drapery.** 14th century: crowned initials. 15th century: murrey wing and border fragments with the arms of Mablethorpe. Pot-colour fragments.

C1. 15th century: green glass with leaves. Pot-yellow and ruby fragments.

C2. 13th century: fragments of white grisaille, green stiff leaf, blue and green drapery and part of stool. 13th or 14th century: ruby glass with painted hair. 14th century: canopy fragment, cup, small head, pot-colour fragments. **Blue patterned background, arm.**

C3. 13th century: fragments of white grisaille and stiff leaf. **Grey-blue, green and ruby coffin lids, figure with arm raised, monk's head and raised arm.** 14th or 15th century: fleur-de-lys, probably from border, canopy fragments. 15th century: foot with wound — part of Crucifixion.

C4. 13th century: large rinceau on ruby ground in white, amber and green glass, white and blue grisaille fragments, white drapery. 14th century: crown from border.

C5. **Blue patterned background.** White, blue, ruby and pot-yellow fragments.

C6. 13th century: white grisaille fragments, small young head facing three-quarter left. **Blue patterned background, female shrouded head facing right with praying hands, another hand, a green coffin lid.**

C7. 13th century: two small heads facing right, one is bearded and has ruby and white cross nimbus. **Foot.** Pot-colour fragments.

C8. 14th or 15th century: fleur-de-lys with yellow-stain. Pot-colour fragments.

D1. 13th or 14th century: ruby drapery.

D2. 13th century: section of background, as in D2 in sector II, green drapery, fragments of white grisaille. **Top half of monk with hands raised facing right, blue patterned background, foot.** 14th century: canopy fragment. C.1370–80: foliage from west window.

D3. **Opaque disc on pot-yellow background.**

D4. Pot-colour fragments.

D5. 13th century: blue, white, pot-yellow and green large rinceau on ruby background. Fragments of Lombardic lettering, bearded head. C.1370–80: foliage from west window. Uncertain date: censer. Post-medieval: blue drapery.

D6. Fragments of painted blue.

E1. 13th century: a torso with an arm, white and pot-yellow drapery, a bearded head facing three-quarter right, a young man's head with Jew's cap. 14th century: large serrated white leaf. 14th or 15th century: canopy fragments. Ruby fragments.

E2. 13th century: section of background as in D2 of sector II. White drapery. **Fragments of green coffin lids.** 14th century: painted quarry. C.1370–80: foliage from west window. 15th century: fragments of black letter inscription, including *vel*.

E3. 13th century: section of background as in D2 of sector II, piece of border, type B, fragments of white grisaille. **Green tomb lids, female head looking up to left, head and hand of figure in profile looking left, another hand.** 14th century: angel's head. C.1370–80: foliage from west window.

E4. **Two resurrecting souls, green and blue tomb lids, ruby background.** C.1370–80: foliage from west window.

F1. **Pot-yellow disc and part of blue background.** C.1370–80: foliage from west window. 14th or 15th century: piece of white glass with three relieved crescents.

F2. 13th century: section of background as in D2 of sector II, piece of border, type B, fragments of white grisaille. **Green coffin lid.** 14th or 15th century: piece of white glass with three relieved crescents. Pot-colour fragments.

F3. **Male head facing right, pot-yellow drapery, blue patterned background.** 14th century: piece of fictive wall and head of beast. C.1370–80: foliage from west window. 14th or 15th century: piece of white glass with three relieved crescents.

F4. 13th century: pot-yellow-stiff-leaf, fragment of white grisaille, green drapery. C.1370–80: foliage from west window. 15th century: border fragment with arms of Mablethorpe.

F5. 13th century: green foliage. **Kneeling bearded man facing left with hands raised in supplication, with ruby background, devil with green body and hooves and blue head with horns (one missing) and collar, holding yellow curved object.** C.1370–80: Foliage from west window. 14th or 15th century: wavy star motif.

F6. **Pot-yellow disc.** Fragments

G1. Pot-colour fragments.

G2. **Parts of seraph with four green and two white wings.** 14th century: relieved leaf pattern, pot-yellow quatrefoil band, oak leaf. C.1370–80: foliage from west window.

G3. Fragments.

G4. Fragments.

G5. **Pair of green wings.** 14th century: blue patterned background, acorn and oak leaf.

G6. **Female shrouded figure with hands upstretched and ruby background.**

H1. **Ruby disc.** Fragments.

H2. 13th century: white and green rinceaux on blue background. **Lower part of naked figure. Outline of figure rising from coffin.** C.1370–80: foliage from west window. 15th century: hands, quarry.

H3. **Beardless head facing left, wing, pot-yellow crown, blue patterned background.** 14th century: probably made-up fragmentary shield of arms with *azure a chief or.* C.1370–80: Foliage from west window. Post-medieval fragments.

H4. **Pot-yellow disc, blue background.**

J1. **Pot-yellow disc, blue background.**

J2. 13th century: blue and green stiff-leaf. **White drapery and neck of figure.** 14th century: canopy fragment. 15th century: piece of wood.

J3. **Pot-yellow disc, blue background.**

Sector IV

A1. 13th century: pink piece with four male bearded heads, white and green fragments. **Half of young woman facing left holding cymbals. Green coffin lid.** 14th century: piece of canopy niche.

B1. Fragment of pink glass.

B2. 13th century: fragments of blue grisaille. **Pot-yellow disc.** 14th century: blue relieved hawthorn pattern. C.1370–80: foliage and parts of heads of angels, fragments of wing, parts of a stringed instrument, from west window. Fragments.

B3. 13th century: frontal head. **Angel's wing with blue and amber cross nimbus.** 14th century: blue relieved hawthorn pattern, green relieved leaf pattern. C.1370–80: foliage from west window.

B4. 13th century: fragments of blue and white grisaille, green drapery. 14th century: fragments of fictive wall.

C1. 13th century: ruby disc. **Torso of naked monk with flesh-hook, two tabors with drum-sticks, piece of wing, ruby and blue fragments.** C.1370–80: foliage from west window.

C2. 13th century: ruby disc, white rinceau on blue ground. 14th or 15th century: initial.

C3. **Top half of young female figure facing three-quarter right.** 14th century: blue patterned background. C.1370–80: foliage from west window. Amber, pink and blue fragments.

C4. 13th century: white stiff-leaf. **White drapery, foot, top of head.** Blue, green and ruby fragments.

C5. **Hand, two pieces of pot-yellow wing.** C.1370–80: foliage from west window. Blue and white fragments.

C6. **Figure playing cymbals, resurrecting soul.** 14th century: bearded head with yellow-stain on hair and beard, young beardless head, hand, drapery, crowned *MR* monogram, crown from border, another crown, not from border. C.1370–80: foliage from west window.

ACKNOWLEDGEMENTS

I would like to thank warmly Mr Nigel Morgan of the Princeton Index of Christian Art who generously lent me his, then unpublished, manuscript on the Lincoln Cathedral Medieval Glass when I gave a paper on the glass to the 1982 BAA Conference at Lincoln; the paper was largely based on his findings. The survival of some of the original glazing of the south rose and the elucidation of its iconography were briefly dealt with by him in his subsequently published book, N. J. Morgan, *The Medieval Glass of Lincoln Cathedral*, Corpus Vitrearum Medii Aevi, Great Britain — Occasional Paper III (London 1983), 20. I am also grateful to the Cathedral authorities for their help in gaining access to the south rose, to Mr Michael Brandon Jones for his photography, to Mr Don Johnson for the drawings of the tracery and to Mr T. A. Heslop, Miss Veronica Sekules and Miss Jill Kerr for their practical help and encouragement.

REFERENCES

SHORT TITLE USED

MORGAN (1983) N. J. Morgan, *The Medieval Glass of Lincoln Cathedral*, Corpus Vitrearum Medii Aevi, Great Britain — Occasional Paper III (London 1983).

1. For further examples see A. Clifton-Taylor, *The Cathedrals of England* (London 1967), 174. For a general treatment of the rose window and bibliography, see H. J. Dow, 'The Rose Window', *Journal of the Warburg and Courtauld Institutes*, xx (1957), 248–97.
2. For a full discussion of the north rose glazing, see Morgan (1983), 14–17, 27–28, 43–45, 47.
3. B/E, *Lincolnshire* (Harmondsworth 1964), 111.
4. For the various vicissitudes and restorations of the glass, see Morgan (1983), 1, 2.
5. The exact reason for duplicating the iconography will probably remain unknown. It is possible, but not at all probable, that the 14th-century glaziers were copying the subject of the early 13th-century window they were replacing. Although the Latin verse life of St Hugh, of c.1220–35, contrasts the two roses in metaphorical terms of the Sun and Moon, Bishop and Dean, Salvation and Damnation, it also refers to them as a closely linked pair of windows, twin eyes on the brow of the church. For a translation of the relevant parts of the poem and a discussion of their significance for the Lincoln roses, see Dow, op. cit., 280–90. See also F. Nordström, 'Peterborough, Lincoln and the science of Robert Grosseteste', *Art Bulletin*, xxxvii (1955), 241–72.
6. For example, A. F. Kendrick, *The Cathedral Church of Lincoln* (London 1899), 96. Here the window is dated to 'soon after the middle of the fourteenth century'.
7. *The Book of John de Schalby*, ed. J. H. Srawley (Lincoln 1966), 18.
8. *The Registrum Antiquissimum of the Cathedral of Lincoln*, II, ed. C. W. Foster, LRS, xxviii (1933), 134.
9. *Dictionary of National Biography*, v, 383–4.
10. See note 8.

11. G. Ayliffe-Poole, 'The Architectural History of Lincoln Minster', *AASR*, IV, part 1 (1857–8), 33.

12. See note 9.

13. See note 11.

14. D. M. Owen, *Church and Society in Medieval Lincolnshire* (Lincoln 1971), 126. Regular payments occurred in the Middle Ages to the chapter clerk at Lincoln on the feast of the 'blessed John Dalderby', 13 January. See K. Major, 'The Office of Chapter Clerk at Lincoln in the Middle Ages', *Medieval Studies Presented to Rose Graham*, ed. V. Ruffer and A. J. Taylor (Oxford 1950), 172.

15. *Calendar of Patent Rolls, Edward III, 1327–30*, Part III, 453–4 (28 September 1329).

16. *Dictionary of National Biography*, VII, 335–8.

17. D. J. King, *Stained Glass Tours around Norfolk Churches* (Norwich 1974), 13–14.

18. Dow, op. cit., 293–5, has a general survey of the glazing of rose windows. For a useful collection of illustrations, see P. Cowen, *Rose Windows* (London 1979). Pl. 19 is a colour illustration of the Lincoln south rose.

19. The best discussion of this development remains that in chapters 2–5 of P. A. Newton, *Schools of Glass Painting in the Midlands 1275–1430*, unpublished doctoral thesis (University of London 1961).

20. See T. W. French, 'Observations on some Medieval Glass', *The Antiquaries Journal*, LI (1971), 86–93, for the York–French glass comparison and, briefly, R. Marks and N. Morgan, *The Golden Age of English Manuscript Painting 1200–1500* (New York 1981), 83, for the manuscript comparison.

21. E. G. Millar, *The Luttrell Psalter* (London 1932).

22. M. H. Caviness, *The Windows of Christ Church Cathedral Canterbury*, Corpus Vitrearum Medii Aevi, Great Britain, II (London 1981), 176 and pl. III, fig. 243.

23. Morgan (1983), 25, 35, 48.

24. This coat is recorded in the rolls for 'Badlesmere' (for example in the Dering Roll, *c*.1275), and was noted at Lincoln in British Library, MS Add. 17506, f. 13, 'in a syde chapell' to the right of another coat of arms, *ermine a cross engrailed gules*, labelled 'Norwood'. This may well be the original context of the coat now in the south rose (though in which chapel it is not clear), and there are sound reasons for linking the families of 'Norwood' and Badlesmere with each other and to Lincoln Cathedral in the first half of the 14th century, which would appear clearly to be the date of the extant heraldic glass. According to a note in the front of Add. 17506 by a Mr Brooks at the College of Heralds, dated 1792, this part of the manuscript was by Richard Lee, Clarenceux King of Arms, at his Visitation in 1592. Lee and also Holles (British Library, MS Harley 6829, p. 65. Printed edition: *Lincoln Church Notes 1634–42*, LRS, I (1911), 66, and Dugdale (British Library Loan MS 38, *Collection of Monuments in Various Counties*, by Sir William Dugdale 1640–41, f. 109v.) record the Badlesmere coat in another window, probably s.XXXVII, but in a 15th-century context belonging with the tomb of John Mackworth, Dean of Lincoln, who died in 1451. No other antiquarian description I have seen records the 'Norwood' — Badlesmere heraldry, suggesting that it was lost or damaged by the time the 17th- and 18th-century surveys were made, some of which were very extensive. The 'Norwood' coat is in fact that of Northwood (as on the Dering Roll, *c*.1275, printed in *The Reliquary*, XVI, 1875, 237). The link between the Northwood and Badlesmere families was possible at two points. Firstly, John de Northwode, Baron of Northwood (1254–1319) was married to Joanna, sister or aunt of Bartholomew de Badlesmere (*c*.1275–1322). Secondly, the wardship and marriage of John's grandson, Roger, whose father, John, died before 8 September 1318 when he was still a minor, were bought by Bartholomew de Badlesmere for 700 marks in July 1319. Whether or not the Lincoln heraldry commemorates either of these events is uncertain, but it is almost certainly a little later than either of them, as their link with the cathedral is through Henry de Burghersh, who was not appointed as bishop to Lincoln until 20 July 1320. Henry was Bartholomew's nephew, by the marriage of his father, Sir Robert Burghersh, to Maud, sister of Bartholomew de Badlesmere. Perhaps the most likely reason for the insertion of the heraldry was Henry's wish to thank his uncle for his help in persuading the Pope at Avignon to overrule the election of Anthony Beck as bishop of Lincoln and substitute Henry by papal provision. If the heraldry is probably post July 1320 it is also very likely before the defeat of the Lancastrian rebellion at Boroughbridge in March 1322, which was supported by Bartholomew who was executed for treason later that year (Sources: *Calendar of Fine Rolls*, III, 1319–27, 3; G. E. Cockayne, *The Complete Peerage*, second edition, I, 371–4, II, 425; *Dictionary of National Biography*, VII, 385, XLI, 205).

25. *Argent a chevron between three crosses croslet sable within a border of the last charged with eight besants.* Similar fragments were to be found until recently *in situ* in the third window from the east in the north choir aisle (Morgan, 1983, 38). This was presumably the window described, for example, in British Library, MS Add. 17506, f. 11v–12r, next to the tomb of Thomas Fitzwilliam de Mablethorpe, died 20 June 1463. In the window were seven coats, including a centrally placed one of *quarterly Mablethorpe and Staynes impaling Marmion*, flanked on the left by a figure of the husband, and by one of the wife on the right. The borders of the window were 'garnished' with the arms of Mablethorpe and seven other coats. All this indicates that the glass was connected with Thomas, the son of Thomas Fitzwilliam who married Joanna, daughter of William de Steyn, rather than with the parents, as Nigel Morgan suggests.

Houses in Minster Yard Lincoln: Documentary Sources

By Kathleen Major

The archives of the Dean and Chapter of Lincoln, deposited in the Lincolnshire Archives Office are the main source of information about the houses. The sites, usually with houses already on them, were acquired at various dates between 1072 and c.1300. The title deeds for nearly all of them survive in the splendid collection of charters and have for the most part been printed in *The Registrum Antiquissimum of the Cathedral Church of Lincoln*, vols 1–3, 9–10, edited by C. W. Foster and Kathleen Major, Lincoln Record Society nos 29–31, 62, 67. The houses fall into five categories.

1. The houses of the dean, sub-dean, precentor and chancellor. These were the responsibility of the dignitary, and information is usually only available during a vacancy in the office, when their houses were let and repaired by the Chapter. For the Chancery and Precentory this occurred in the 14th century when the emoluments of the office were too small to attract holders.

2. The greater number were the property of the Common Fund and were allotted to would-be residentiaries by the Chapter. The latter were also responsible for repairs when unoccupied, and the accounts, which survive for the greater part of the 14th century, give information about occupants, the buildings and the rents. For the 15th century not only are the surviving accounts fewer but repairs were rarely recorded in detail. The Chapter alone could authorise the taking down of dilapidated or superfluous buildings and much is recorded in the Chapter Acts, beginning in 1306, but with a gap between 1356 and 1384. Several of the houses belonging to the chantries were administered by the Chapter and their accounts were included at the end of the Common Fund Accounts from c.1330.

3. The Fabric Fund owned several houses within the Close Wall but unfortunately all their medieval records apart from some charters are lost, with the exception of a full rental for the city in 1440 and a fragmentary one for the parish of St Margaret in the Close and of part of St Mary Magdalene for 1412–3.

4. The Vicars Choral had one large house on Greestone Stairs and a few other properties in the close some of which were merged with other houses or exchanged. An excellent cartulary with detailed descriptions of the property they acquired was compiled about 1350 but this is the only part of their medieval records that has survived.

5. Other houses. The Works chantry, the Cantilupe chantry, and the Burton chantry all had their own houses, as did one or two of the smaller ones which were later absorbed into the gardens or larger dwellings. The Burghersh chantry during the whole of its existence rented its house from the Chapter for twenty-four shillings a year.

The Choristers House (10 Minster Yard) was administered by the Chapter. The Poor Clerks Hall later passed to the Vicars Choral.

Whereas in the 14th century there were as many, or more canons wanting houses as there were such available, in the 15th century there were fewer would-be occupants: this resulted in reduction of rents in some cases or in the letting of some to laymen or even laywomen. Even in the 14th century the Chancery, in the prolonged vacancy of the office, was let to Katherine Swinford.

The Reformation changed the pattern of life in Minster Yard. Fewer clergy resided and more houses were let to the laity. The practice of granting leases greatly developed and large

numbers survive from 1550 onwards. These have been intensively worked on by Mrs Varley and have yielded much information on the houses themselves as well as on their occupants and the rents. In 1649–51 Parliament ordered a survey of Chapter property: much of it was disposed of though it was restored in 1660. This survey gives very valuable descriptions of the houses as they were at that time, but many had suffered during the Civil War. The survey was printed by Precentor Venables in the Associated Societies Reports and Papers in 1887.

Probate inventories and testaments, which became secular records in 1857, often give useful information in the 16th and 17th centuries. They have now been transferred from the District Probate Registry to the Lincolnshire Archives Office.

There are collections of plans and drawings made by E. J. Willson in the early 19th century: some of these are in the Chapter library, others at the Society of Antiquaries and still others in private hands. They have recently been micro-filmed in the Lincolnshire Archives Office and a complete catalogue has been prepared.

REFERENCES

For a fuller account see S. Jones, K. Major and J. Varley, *The Survey of Ancient Houses in Lincoln*, fascicule 1, *Minster Yard, Priorygate to Pottergate* (Lincoln Civic Trust 1984), pp. 106 with 93 photographs and plans (£9.50 plus £1.50 postage and packing) and fascicule 2, *Minster Yard, houses on the south side of the Minster and west to 23 Minister Yard* (forthcoming); available from Lincoln Civic Trust, St Mary's Guildhall, High Street, Lincoln.

The Architectural History of Lincoln Cathedral from the Dissolution to the Twentieth Century

By Thomas Cocke

The architectural history of Lincoln Cathedral from the Reformation to the 20th century is more than 'a mere recapitulation of the doings ... of more or less deeply incriminated fanatics and restorers'.[1] The building has been spared drastic interference from either foe, or, as fatally, from friend. The architects who have worked on the fabric, although they include Gibbs and Essex in the 18th century and J. C. Buckler and Pearson in the 19th, have been relatively modest in their impact.

At the very time of the Reformation the building suffered a major disaster; some suggested a direct link between the two. In January 1547/8 the great timber and lead spire on the central tower, which, with a height of over five hundred feet, had been second only to St Paul's, collapsed after exceptionally high winds. (The exposed position of the Minster has meant that parapets and pinnacles on the towers and gables have been blown down on several occasions.) Although the spire seems to have telescoped in on itself there must have been damage not only to the roofs and crossing tower but also to the upper parts of the transept. This was apparently soon repaired but later restorers such as Sir Francis Fox in the 1920s have considered that the disaster exacerbated faults in the tower itself and reinforced the tendency of the transept to fall away from the tower.[2]

The next serious threat to the Cathedral came almost a century later, during the Civil Wars. Lincoln was assaulted twice in four years, once in 1644 by the Parliamentarians under the Earl of Manchester and again in 1648 by the Royalists. On the first occasion it was the interior of the building that suffered, especially the tombs and stained glass. John Evelyn on his visit in 1654 was told that 'all or most of the Brasses' had been torn up.[3] Thanks to the prescience of the antiquaries of the Hatton circle, *Antiquitas Rediviva*, William Dugdale and Robert Sanderson, prebend and later Bishop of Lincoln, had taken surveys of the monuments and stained glass in the building in 1640–1, so not only has their site been preserved but also, in some cases, their appearance.[4] The Royalists, when they were temporarily in control of the city in 1648, were equally destructive. The Bishop's Palace, recently restored by Bishop Williams, was severely damaged and was never repaired.

The Cathedral and the precinct buildings, however, survived the Interregnum relatively intact. The Cathedral was directly threatened in the early 1650s when it was mooted that cathedrals should be demolished and their materials sold off. Lincoln is said to have been defended by Original Peart, mayor in 1650 and MP for the city in 1654 and 1656 so no Royalist, who complained to Cromwell that 'if the Minster were down, Lincoln would soon be one of the worst towns in the county'.[5]

The Cathedral needed extensive repair at the Restoration. In 1661 the Chapter gave £1,000 to the fabric; in 1664 they had to lend a further £100 and prepared, though never used, an appeal to the public for further funds.[6] The administration of the fabric was revived without incident. Henry Mansford, the Clerk of the Works before the Civil War, resumed the accounts from the Feast of the Holy Cross (14 September) 1660 without a mention of the troubles of the last twenty years. In 1664, however, a dispute arose between Mansford and the Masters of the Audit, the Chancellor and the Precentor, about certain arrears for 1631 and 1642 which appeared to have been paid to the Clerk but not accounted for. Mansford was suspended from office and the Chancellor made up the accounts until 1669

when William Burnett took over first as deputy to Mansford and then, in 1670, as Clerk himself. In the accounts for 1667/8 the arrears were still listed 'as were antiently paid to John Parker, Clerk of the Fabric Anᵒ Dom̄ⁱ 1631 and Henrie Mansford Anᵒ Dom̄ⁱ 1642 of w[hi]ch nothing hath been rec[eive]d since ye K[ing's] returne', but they never seem to have been recovered.[7]

This episode gives some idea of how the repair of the fabric was financed. The basic source for the everyday maintenance of the building was the income and fines from the fabric estates. These were scattered in tiny parcels yielding correspondingly small rents: for example, from the parish of St Michael in the Mount were received one sum of 4d. and another of 1s. 8d. The totals per annum varied between £150 and £250 in the years between 1660 and 1700, except in 1661/2 when they amounted to £1,001 12s. 3d., as a result of the payment of arrears from the Civil War years.[8] In the first half of the 18th century receipts sometimes rose to £400. The money was disbursed either in small bills for so many days work by the mason, glazier or smith or in large sums for basic raw materials such as coal, iron or lime. Although Lincoln was fortunate in having a modicum of endowment for the fabric, funds could become insufficient. In 1667/8 it was recorded that the usual pensions and wages were 'not p[ai]d this year'.[9] As a rule the endowments were adequate for relatively minor repairs, such as in 1685 'when the north battlements fell' and were reinstated at the cost of £27[10] but not when more ambitious work was required. Then as in other cathedrals, funds from outside were needed, whether from the Dean and Chapter themselves, the Bishop or from the wider public. In urgent cases the Chapter loaned the fabric money, as in 1664 or again in 1731.

In the late 17th and 18th centuries it was the senior clergy who took the lead in refurbishing the Cathedral. Bishop Fuller, who was translated from Limerick in 1667, assisted in repairing the damage done during the Civil Wars, especially to the ancient tombs. He erected a simple table tomb over the supposed site of St Hugh's body just east of the altar screen. His own body was laid under a similar tomb to the south; it was later joined by two more tombs of the same design. Bishop Fuller was also probably responsible for the classical cornice added to the canopy of the Swynford tomb, in place of the pinnacles which must have crowned the monument before the Civil Wars. It is an unobtrusive anachronism, very different from the spiky archaeological restoration proposed by Pearson in 1872.[11] In the next century Bishop Thomas (1734–61) set a yet more positive example by himself putting aside a tenth of his income from fines for the repair of the church and inducing the Dean and Chapter to do likewise. His successor, Bishop Green, continued the practice.[12] The most generous of the deans was Michael Honywood (1660–81) who had a new library built in 1674 on the north side of the cloisters, derelict since the 15th century. The medieval library had been over the eastern walk of the cloister but had been damaged by fire in 1609. Its remains were finally removed in 1789, except for a small part which acts as a vestibule to the new library. The new building, of eleven bays and two storeys with a Tuscan arcade below, was constructed at a cost of £780 according to Sir Christopher Wren's 'directions' and 'Mr. Tompson's model' by a builder called Evison, the traditional attribution to Wren for once correct.[13]

By the early 18th century major work was necessary on the Cathedral. It was just in time for, according to Lord Harley in 1725, the building had 'all the tokens of entire ruin approaching'.[14] The condition of the west front in particular was giving rise to serious concern (as it has on several later occasions) since the weight of the towers appeared to be forcing the walls below outwards. The Chapter called in two prominent architects, first James Gibbs in March 1724/5 and then John James as a second opinion the next year, to survey the building and suggest what could be done.[15] Gibbs reported that the whole

Cathedral was very much out of repair. He had been inside the roof with Ryall, the Cathedral carpenter, and found every part in such a poor state, especially on the south side, that '£10,000 would not be enough' to restore it.[16] To secure the west end, the most urgent task, he proposed increasing the solidity of the lower part and giving increased support to the towers by the construction of screen walls across the whole width of the westernmost bay of the nave, under the towers, and between the west front and the first piers of the nave arcades, thus forming three vestibules. James did not dispute the structural alterations proposed by Gibbs — indeed James considered them 'absolutely necessary' — but he did question the style of the openings in the new walls. Their detailing as proposed by Gibbs and as built, was unostentatiously classical, with round-headed arches of a Tuscan order and oculi above: James preferred them to have a 'pointed, angular arch (if I may so call it) after the Gothick manner in which ye whole church is built'.[17] His advice was ignored but he was vindicated fifty years later when James Essex was commissioned to refashion the principal arch in Gothic 'in order to correct the disagreeable appearance of this wall' (Pl. XXXIA).[18] The work was begun in 1726 and presumably was completed by 1730, since the walls are shown on the plan of the Cathedral in the volume of Browne Willis's *Survey of the Cathedrals* published that year.[19]

Gibbs, again supported by James, also recommended the removal of the wood and lead spires which capped the west towers. Both agreed that the spires endangered the towers by their weight and wind resistance and furthermore looked 'ill', like 'so many Extinguishers set upon great candles'.[20] Gibbs proposed replacing them with 'small cupolettos' to which James again preferred less classical 'pyramidal acroteria' on the corners 'in the Gothic manner'.[21] However, when work began in the autumn of 1726, the local populace burst into the precinct and raised a riot so violent that it became a matter of Government concern. The Cathedral authorities abandoned the attempt to take down the spires. The Bishop suspected an anti-government plot; the Hanoverian succession was only ten years old. More probably people thought that the towers were coming down as well.[22] A former Mayor of Lincoln reckoned 'that the people could rise twenty miles round in defence of their spires, and that the Gentlemen of the County were for preserving the spires'.[23] One of these gentlemen, Sir William Monson, found it extraordinary that the masters should be destroying the Cathedral and the 'mob' opposing them.[24] It is a most unusual case, for it is hard to discover whether ordinary people in the 17th or 18th century felt any concern for the great buildings in their midst.[25] For the spires it was only a reprieve. Later in the century Essex reaffirmed that the spires were endangering the towers, quite apart from themselves being in a very decrepit state. They were removed in 1807 with little protest.[26]

The other contribution of these years to the Cathedral was more decorative. In Dugdale's 1641 survey of the monuments, the tombs of the 12th-century Bishops Robert Bloet, Alexander, Robert de Chesney and William de Coutances were shown in the north-east transept but these presumably disappeared during the Civil War. In 1728 a travelling Venetian artist called Vincenzo Damini was commissioned to paint four full-scale commemorative portraits of the Bishops on the south wall of the transept, set under fictive Gothic arches (Pl. XIIID).[27] They are one of the few English equivalents, in a Cathedral as opposed to a private chapel, to the great contemporary Baroque decorative schemes in churches abroad. As such they possess great value over and above the intrinsic qualities of vigour and style they retain despite two centuries of neglect.

The precarious state of the whole fabric obviously led to much small-scale repair work all over the building even before the major restoration by Essex in the latter part of the century. Recent analysis of roof timbers has shown that there were repairs to the roof of the Angel Choir *c.*1710 and to the roof of St Hugh's Choir *c.*1725 and *c.*1745–50.[28]

As Gibbs had pointed out, the western towers at Lincoln were only the most threatened part of a building altogether dilapidated. Loveday in 1732 described the Cathedral as dirty, with broken glass in the windows. The previous year, the Dean and the canons had each made a loan of £12 10s. 0d. to the fabric fund to relieve its debts and had re-opened a quarry to provide stone for urgent repairs. Fortunately Thomas Sympson, the 'Master of the Fabric or (if you choose it rather) Clerk of the Works' from 1728 till his death in 1750, was an intelligent and dedicated man, by profession a schoolmaster and by inclination an antiquary.[29]

The details of Sympson's repairs are hard to establish because so conservative but his letters to the great antiquary and churchman Browne Willis, which are preserved only from 1739, reveal that in 1740 the roof was being repaired, in 1742 the 'great leaden spire', presumably on one of the two towers, and in 1743 the pinnacle at the south-west corner of the west front, which carries a statue of St Hugh.[30] This last gave Sympson particular satisfaction. He secured special donations of £40 from the Dean and five guineas from the Archdeacon, so the work could be carried out properly. Special 'ex gratia' payments were given to the workmen, 3s. 6d. at the taking down of the pinnacle and 5s. at the statue's re-erection.[31] Sympson felt able to boast that he had done more than his predecessors 'in two (sic) years' than 'in an age before'.[32]

Only twelve years later, in 1751, the major 18th-century restoration programme, inspired by the gift of tenths by the Bishop and Chapter, was launched. A survey that year estimated the cost of repairs at £12,000 and that of 'beautifying' (cleaning and polishing) at £3,000.[33] The Bishop and the Dean and Chapter continued their self-denying ordinance until 1788 by which time they had given £9,698 to the fabric fund — not far off the estimated cost of repairs — and had invested enough to bring in £68 a year. They were ready to invest another £1,000 at 5% to make the fabric revenue sufficient.[34] The annual rents from the fabric estates at this period brought in £110 18s. 3½d., while the average annual receipts from fines were just over £175.[35] Since over £60 went on standard fees and wages, extra funds were clearly essential in order to cover the £520 on average spent on repairs each year between 1755 and 1779.

The Cambridge architect, James Essex, was commissioned to survey the building in 1761 and 1764 and again, for the specific problem of 'Mr. Gibbs' wall', in 1775. He remained the Chapter's consulting architect until his death in 1784. He was perhaps originally chosen because of his work at Ely cathedral from 1757 onwards, where he rescued the east end and the lantern from threatened collapse.[36] Essex's appreciation of medieval architecture, though remarkably advanced for his period, was kept this side of idolatry. Although he valued original detail he was equally attentive to economy and practicality, fundamental qualities in the 18th century's attitude towards churches. As his Victorian successor at Lincoln, J. C. Buckler, remarked, his 'taste and parsimony were nearly equally matched'.[37]

Essex was involved in a wide range of work during the wellnigh quarter of a century that he worked at Lincoln. His initial survey of 1761 dealt principally with the roofs and vaults. Although his general conclusion was that 'few Great Buildings are better covered' there were many urgent repairs required; most of them were carried out in 1763–5.[38] Much more conspicuous was his reconstruction of the chapter-house roof in 1761–2 where he truncated the original cone into a curious hipped form to economize on timber 'which looked very awkwardly'.[39] The new carpentry was first-class and was retained when the original pitch was restored in 1799–1800.[40] In 1769 Essex designed a three-gabled reredos, based on the de Luda tomb at Ely, to stand behind the High Altar and traceried panelling for the flanking walls (Pl. XXXIB). Three years later the square east end to the northernmost chapel of the east transept, which had been added in the 13th century but was now falling away, was

replaced by an apse exactly similar to its neighbour.[41] At the same period Essex had to withstand a plan by the Dean to raise a stone spire on the central tower. Essex pointed out the structural problems that would be created and instead erected four corner pinnacles with a traceried parapet between.[42] In 1775–6 his attention was turned to Gibbs's west wall to increase its strength and to 'correct its disagreeable appearance'.[43] The first Essex achieved by blocking up some of the internal passages within the west front; the second, by rebuilding the Tuscan screen across the nave as a tall Gothic arch flanked by two blind arches, complete with Purbeck shafts (Pl. XXXIA). The walls across the aisles and the interior of the vestibules he left alone. In contrast he designed in 1776 a reconstruction of the canons' vestry with new doors and cupboards of an economical simplicity more fitting for churchwardens than for prebends[44] and, in 1779, the much more elaborate Bishop's throne (Pl. XXXIIA).[45] His last designs were for decorative screens or cresting to conceal the tie-beams across the arches between the east transept and the choir (Pl. XXXIIB) and for the re-paving of the cathedral in 1780–3, for which a grateful Chapter presented the dying Essex with an inscribed silver salver.

The restoration of the west front appears to have begun in 1778, when the mason John Hayward submitted an estimate for a whole series of repairs, including 'making good' capitals, bases and heads of arches, 'cog'd or tooth stonework' between shafts and no fewer than seventy-four new shafts[46] but a further estimate of 1787 shows that the bulk of the work was still to be carried out.[47] Thus many of the repairs and alterations to the west front attributed to Essex by J. C. Buckler and other later writers must date from after his death.

The same caution must be observed even with work carried out during Essex's lifetime. Essex was very much a consultant architect, making occasional visits to Lincoln but preparing his designs and answering queries in Cambridge. In 1778 the Chapter requested Essex's aid as to the repaving of the Cathedral 'either in person or aided by Workmen sent to him; or in this manner of correspondence'.[48] Even with such a prominent commission as the altarpiece Essex prepared the designs in 1767 and advised by letter on its erection two years later but he did not actually see the finished effect until afterwards. He thus needed to have gifted craftsmen on the spot who could interpret his instructions and work on their own initiative. The principal members of his team were Thomas Lumby the carpenter, later assisted by his son William, John Hayward the mason and William Pink the carver. Both Lumby and Hayward, like Essex himself, engaged in general building as well as their specific trades and could act on occasion as surveyors. Essex had an especially high regard for Thomas Lumby, selecting him in 1775 despite his recent bankruptcy, for the work on the central tower, a job of 'much difficulty and some danger'.[49] William Lumby, who succeeded Essex as surveyor to the fabric, displayed a precocious talent for authentic Gothic design. Hayward was a member of a family prominent in Lincoln building for a century. Essex approved his bid for the repaving contract as not only were Hayward's estimates reasonable but he was so constantly employed in the Cathedral that he would risk forfeiting 'not only his reputation, but his business also' by a poor performance.[50] James Pink was the 'master workman in erecting the altar and doing many curious reparations of carved work', such as the Bishop's throne (Pl. XXXIIA) and the restoration of the pulpitum.[51] His Gothic detail is so good that much of his activity can hardly be distinguished from the original.

It was partly the technical skills of these men that helped to give Essex's restoration of the Cathedral a stylistic authenticity rare before the mid 19th century. But the chief credit must go to Essex himself who combined an antiquarian interest in Gothic with an architect's concern for the techniques of actually building in the style. He was as concerned to clear earth away from the base of walls or to stop the Cathedral carpenters' slack practice of resting roof timbers on the vault as to choose 'handsome' detail for the new altarpiece.[52] His

greatest achievement as a restorer was to attempt to think himself into the minds of the original builders. In 1774 he wrote that he had made a design for the cresting on the central tower 'as near as I could agreeable to the ideas of the architect who built the tower' and again the next year, in his survey of the west end, that 'I was desirous of tracing the original state of this part of the church and if possible restore it to the state which the builders intended it'.[53] His archaeology at these points may not be faultless but the visual effect of his contributions has proved acceptably authentic (Pl. I).

The programme of work initiated by Essex continued, according to Buckler, until the year 1817.[54] A general survey of 1799 by William Hayward who had succeeded the sickly William Lumby as surveyor confirmed that the roofs and gutters were in general in a good state but that the pinnacles and the transept gable on the south side were perished.[55] The latter had to be rebuilt in 1804 together with its cresting after it had been blown down. Other works of interest at this time were the restoration of the Chapter House roof to its original form in 1800, and the discovery of the curious canted east end of St Hugh's Choir, when the presbytery was repaved in 1791.[56]

The Victorian restorations of the Cathedral differed from contemporary work in other cathedrals by being carried out, as before, over many years rather than in a few dramatic campaigns. Between 1841 and 1857 £19,073 was spent, £1,824, the highest amount, in 1848, £681, the lowest, in 1855. Over the next sixteen years expenditure dropped to £17,481 with the annual figures varying in the same range as before.[57] There was no sweeping removal or rebuilding of any feature, so the 18th-century contributions to the fabric survive, in contrast to Ely where Essex's work was completely destroyed by the rebuilding of the lantern and the moving and re-fitting of the choir by Scott.

J. C. Buckler who was in charge of the mid-century restoration was the son of John Buckler the antiquarian artist. He was a generation older than the High Victorian architects such as G. G. Scott and he conducted his restoration on traditional lines, content to establish the guidelines and then to supervise from Oxford, rather as Essex had done from Cambridge. His methods aroused fierce controversy as to the treatment of the masonry, especially on the west front. Buckler claimed that he was doing no more than cleaning the stonework, while Scott and Street alleged that he was scraping the stone surfaces and recutting the sculpture.

Buckler dealt mainly with the exterior of the building, although in 1857 he reorganised Essex's altar screen, removing the painting of the Annunciation by the Rev. W. Peters which had been inserted in the central arch and adding 'Decorated' tracery (Pl. XXXIB).[58] In theory his was a programme of reinstatement, including the cleaning and replacement of worn stone. The techniques employed were described by the master mason Sandall: 'the way that we now scrape to clean it [the stone] was carried on before I had anything to do with the cathedral. I came as a journeyman in 1846, and was made master-mason in 1851; and my order was to carry on the restorations as they had previously been done — to wash and scrape away the dirt from the sound stone, cut away the bad and insert new stone and to point the joints'.[59] Scott in a letter of protest which he sent to the Dean and Chapter in 1859 admitted that scraping was an old-established practice at Lincoln but hoped that it would now be thought out-dated.

The most controversial part of Buckler's restoration dealt not so much with the treatment of the masonry in general but with that of the carved detail, especially around the Judgment porch and the western portals. Scott complained in his letter of 1859 that not only had the statues of the Judgment porch itself been restored, but also the statues 'which exist near to this portal'.[60] The Dean replied that the portal and its sculpture were untouched but 'the two or three [sic] statues to which you allude have been restored by the hand of an eminent

sculptor, under the advice of a well-known architect'.[61] Buckler himself defended the restoration of 'two of the headless figures' at Lincoln on the grounds that restoration is permissible where the subjects are 'readily definable whether as forming parts of a group of sacred character, or connected with an event in English history'.[62]

There was certainly much activity on the west front of the Cathedral in Buckler's time. The recesses at the north and south ends of the Romanesque west front which corresponded with the great portals were unblocked, the plain pillars inserted by Essex or his successors were replaced in the north and south portals by carved ones, and the missing pillars supplied in the outer order of the central doorway.[63] As to the carving, Buckler declared that no 'single ornament' had 'been renewed, except from ancient authority side by side with the imitation'.[64] No capital was replaced but the 'extraneous and parasitic matter' clogging them was removed, a seemingly innocuous process considered by Street as bad as re-cutting.[65] The chevron and the beakhead in the arches were however largely replaced as a 'severe but necessary measure'. Buckler admitted that 'numerous blocks in consecutive order have been taken away and replaced', in spite of his claims that he left alone even the 18th-century repairs.[66]

It was unfair to accuse Buckler of compromising the character of the Cathedral.[67] As he himself pointed out, he was far less drastic than his arch-critic Scott had been at Wakefield Bridge or St Mary's, Stafford. The details of the building, even where they were reworked, seem to have accorded with what had been there.

The later years of the 19th century saw an important but less controversial programme of works on both the structure and the decoration of the Cathedral. It is described and discussed stage by stage in the annual reports of the Lincoln Diocesan Archaeological Society, an ecclesiologically inclined body which had hardly mentioned Buckler's restoration, perhaps because it aroused such dispute. The architect in charge from 1875 was J. L. Pearson, who had been popular with the Society ever since his bold restoration of the partly Saxon church of Stow in 1865. He repaired and cleaned the whole Cathedral from the great transept eastwards in a manner so restrained that contemporary visitors could hardly believe that these parts had been restored at all[68] although by the 1920s Pearson's replacement of damaged mouldings seemed too drastic.[69] He reordered the choir, removing the last remnants of the 18th-century stalls and placing statues in the canopies of the medieval stalls. Essex's throne, 'the present erection, altogether unworthy of its purpose or situation', he hoped to replace by one more archaeologically correct, but he had to be content with enriching the design with carving and statuary (Pl. XXXIIA).[70] It was at the same period that the more prominent of the tombs, such as that of Queen Eleanor, were restored to something approaching their original form. The Cathedral interior became the one we recognise today.

Pearson's work on the fabric was concentrated on the Chapter House and cloisters, and on the western towers, which were again causing concern. He restored the Chapter House thoroughly inside and out, rebuilding several of the great buttresses; he had to reconstruct the cloisters totally, taking them down part by part and rebuilding them. The 13th-century entrance to the Chapter House was revealed which had been ruthlessly defaced when the cloisters were erected later. This was now made permanently visible.

As to the western towers, it was the southern on which Pearson concentrated most of his attention. Not only did it lean more than its fellow, but it also housed the bells with their dangerous vibration. Pearson built up the arcadings with ashlar,[71] and inserted bonders wherever possible; he also created a self-contained timber bell-cage. The technology of his time did not permit him to penetrate deeper into the underlying faults within the front and his interventions alleviated rather than solved them. It is said that when the shores were

removed after the restoration there was an awesome crack and the west front moved forward over an inch before coming to a halt.[72]

By 1921 the long drama of the west front seemed near its crisis. The façade was about to fall away from the towers which were themselves out of vertical. Tell-tales inserted in the north tower broke in a day, while the ribs in the north-west vestibule had fallen into a convex, rather than concave, form. The central tower was also in a dangerous condition. The solution adopted by Sir Charles Nicholson, the cathedral architect, and Sir Francis Fox, who had superintended the engineering of the dramatic Winchester restoration of the 1900s, was to strengthen the core of the building by the use of grouting machines to force concrete into the depths of the masonry. Jackhammers driven by compressed air were used for the first time on such a job to save time and to avoid too much vibration. Delta metal replaced iron for ties as being less subject to corrosion.

The restoration, which cost eventually £140,000 instead of the £50,000 which had been the target of the appeal, ended in 1932. Embarrassingly, a fall of stone from the east end of the Angel Choir only three years later revealed that the east wall was falling outwards and that the great east window was in especial danger. Concrete beams had to be inserted across the front below the sill of the window, and along the clerestory on both north and south sides of the choir.

The work of restoration continues to this day, perhaps better recorded and less controversial than in the past, and certainly costing sums which would have astounded 18th-century or even 19th-century prebendaries. So is ensured the survival of this great Cathedral which, in the words of a distinguished critic not known for his sympathy with medieval architecture, Lord Burlington, is 'the noblest Gothic building in England'.[73]

REFERENCES

1. C. H. B. Quennell, *The Cathedral Church of Norwich* (London 1900), 19.
2. C. Nicholson and F. Fox, 'Lincoln Cathedral', *RIBA Journal*, XXXIII, no. 6 (1926), 172.
3. J. Evelyn, *Diaries*, ed. E. S. de Beer (Oxford 1955), III, 132.
4. The record of 163 monumental inscriptions by Canon (later Bishop) Sanderson, edited together with Dugdale's survey, is printed in F. Peck (ed.), *Desiderata Curiosa* (London 1779), liber VIII, 294–320. The MS prepared for Lord Hatton including coloured drawings of some of the Lincoln tombs by William Sedgwick is now British Library Loan MS 38. For brief notes on the *Antiquitas Rediviva* circle, see T. H. Cocke, 'Rediscovery of the Romanesque' in *English Romanesque Art 1066–1200* (Arts Council 1984), 361 and 367.
5. A. F. Kendrick, *Lincoln Cathedral* (London 1898), 39.
6. LAO, Dean and Chapter Bj/1/8 entries for 1661: J. H. Scrawley, *Michael Honywood, Dean of Lincoln 1660–81* (Lincoln 1950), 13–14.
7. LAO, Bj/1/8, p. 1 of entry for 1667/8.
8. LAO, Bj/1/8, p. 2 of entry for 1661/2.
9. LAO, Bj/1/8, p. 28 of entry for 1667/8.
10. LAO, Bj/1/8, p. 30 of entry for 1684/5.
11. LAO, A/4/15 item 15. The drawing is reproduced in J. H. Harvey, *Catherine Swynford's Chantry* (Lincoln n.d.), fig. 10.
12. See below, p. 151. The Bishops were of course not obliged to contribute to the Cathedral's maintenance and repairs which were, and are, the responsibility of the Dean and Chapter.
13. H. M. Colvin, *A Biographical Dictionary of British Architects, 1600–1840* (London 1978), 924.
14. Historical Manuscripts Commission, *Portland* (London, 1901), vi, 84.
15. The original surveys have not survived but, because of the riot provoked by the attempted removal of the spires, copies were forwarded by the Bishop to London in order to justify the Chapter's action, and they remain in the PRO as State Papers Domestic (George I) 35, 63 no. 51(2) and (3).
16. PRO, op. cit.
17. Ibid.
18. LAO, A/4/13 item 11.

19. The cost was defrayed by a public subscription, which raised £1797, including a notable £500 from 'Dame Margaret Thorold' (LAO A/4/19–1). Bishop Reynolds gave stone from his ruinous Palace and his arms were set on the central arch of Gibbs' screen (now in S. W. vestibule): LAO, Faculty C iij 3.2/5a.
20. PRO, State Papers Domestic (George I) 35, vol. 63, no. 51(2) and (3).
21. Ibid.
22. Not only the ignorant populace but even Sir William Monson thought this: he considered cancelling a legacy for the repair of the cathedral; J. W. F. Hill, 'The Western Spires of Lincoln Minster', in *Reports of the Lincs Architectural and Archaeological Soc.*, new series V (1953), 103. In 1732 Loveday was assured that the Chapter had either to insert the walls or to demolish the towers; J. Loveday, *Diary of a Tour in 1732*, ed. J. E. T. Loveday, Roxburghe Club (Edinburgh 1890), 205.
23. J. W. F. Hill, op. cit., 115.
24. Op. cit., 103.
25. A similar attempt in 1748 to remove the spire from the west tower of Ely Cathedral provoked similar outrage.
26. According to E. J. Willson, the spires were condemned because they had become 'unfashionable among pretenders to taste' and opposition was limited to 'grumbling murmurs and increased prejudice' except for Sir Joseph Bankes who tried to get even the King to intervene but was frustrated by the King's final insanity; Willson papers, Society of Antiquaries, 786/1, 634.
27. Damini painted another work in Lincoln, the Ascension, in the chancel of St Peter's at Arches. Both church and painting have alas been destroyed but a modello for the painting survives in the vestry of St Giles, Lamb Gardens, a church which is in part a rebuilding of St Peter's.
28. I owe this information to the kindness of G. Simpson of Nottingham University.
29. The description of Sympson was made by Charles Lyttelton in a letter of 1762 to Horace Walpole: H. Walpole, *Correspondence*, ed. W. S. Lewis (New Haven 1980), XL, 233.
30. E. Mansel Sympson, 'Notes on Thomas Sympson', *Lincolnshire Notes and Queries*, IX (1907), 72, 83.
31. LAO Bj/1/13 entries for 1743.
32. E. Mansel Sympson, op. cit., 83.
33. LAO, A/4/13 item 3. Of the repairs £320 was for eight pinnacles on the west front, £500 for the stonework of the chapter house and £2,850 for re-paving.
34. LAO, Faculty 4/27 and 27b.
35. LAO, A/4/13 item 33.
36. See T. H. Cocke, 'The Architectural History of Ely Cathedral from 1540–1840', *Medieval Art and Architecture at Ely Cathedral*, BAACT 1976 (1979) 71–7.
37. J. C. Buckler, *A Description and Defence of the Restorations of the Exterior of Lincoln Cathedral* (Oxford and Lincoln 1866), 259.
38. One copy of Essex's survey has annotations by the Precentor Richardson stating which of the recommendations had been carried out and when; LAO, Ark 22/7.
39. Willson Collections, Society of Antiquaries, 786/1 p. 639. Drawings for it are in BL Add MS 6772 ff 260, 265. See also D. Yeomans, 'Structural Understanding in the 18th Century: James Essex and the Roof of Lincoln Cathedral Chapter House', *Design Studies*, 5, no. 1 (Jan. 1984), 41–8.
40. Willson Collections 786, XIII, 54.
41. The chapel now called St Hugh's chapel was at this period known as the chapel of St Mary or of St Mary Magdalene.
42. Part of Essex's correspondence with Dean Yorke is preserved in LAO, A/4/13 items 7–10.
43. LAO, A/4/13 item 11.
44. LAO, A/4/16 1–5. The execution of the work and perhaps some of the detailing were by Thomas Lumby.
45. LAO, A/4/15 item 5.
46. LAO, A/4/13 item 18.
47. LAO, Ark 22/8.
48. LAO, A/4/16 'A' item 24.
49. LAO, A/4/13 item 9.
50. LAO, A/4/16 'A' item 26.
51. Willson collections, Society of Antiquaries 786/1, 637.
52. LAO, Ark 22/7: BL Add MS 6772, f. 282.
53. LAO, A/4/13 items 7 & 11.
54. J. C. Buckler, op. cit., 256 & 282 note m.
55. LAO, Ark 22/6.
56. It was recorded in a drawing by the Rev. John Carter, a master at Lincoln grammar school, not by his namesake, the antiquary.
57. LAO, A/4/16 'B' un-numbered MS summary of expenditure on the Cathedral 1841–74.
58. J. C. Buckler, op. cit., 100 note g.

59. Ibid, 24.
60. Ibid, 11.
61. Ibid, 13.
62. Ibid, 75.
63. G. Zarnecki, *Romanesque Sculpture at Lincoln Cathedral* (Lincoln, 2nd revised edition, 1970), 14–17.
64. J. C. Buckler, op. cit., 91.
65. Ibid, 262.
66. Ibid, 212, 225.
67. Sir Charles Nicholson considered that Lincoln had been lucky to be in the hands of 'so modest an artist': Nicholson & Fox, op. cit., 166.
68. *AASR*, XXI (1891), vii.
69. Nicholson and Fox, op. cit., 168.
70. LAO, Ark 22/13.
71. Essex had attempted to improve the stability of the towers by filling in some of the interior stairs and passages.
72. Nicholson and Fox, op. cit., 168.
73. Quoted by J. Essex, 'Some Observations on Lincoln Cathedral', *Archaeologia*, IV (1786), 158.

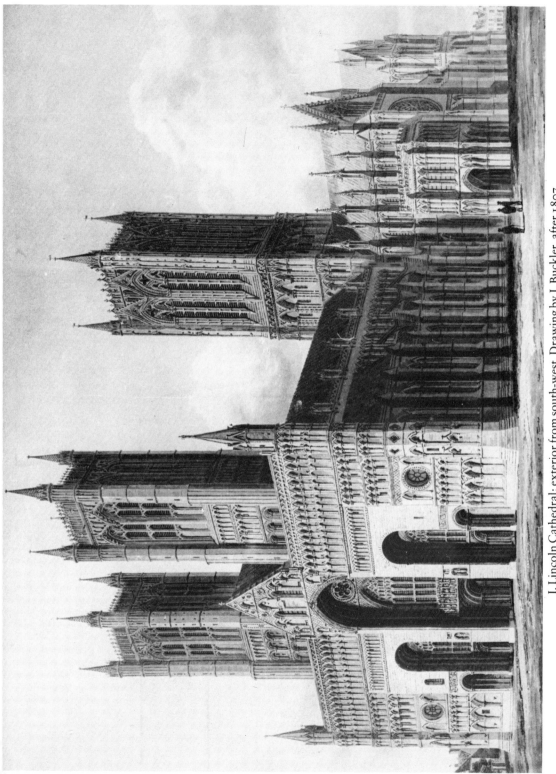

I. Lincoln Cathedral: exterior from south-west. Drawing by J. Buckler, after 1807

Photo Courtesy Courtauld Institute of Art

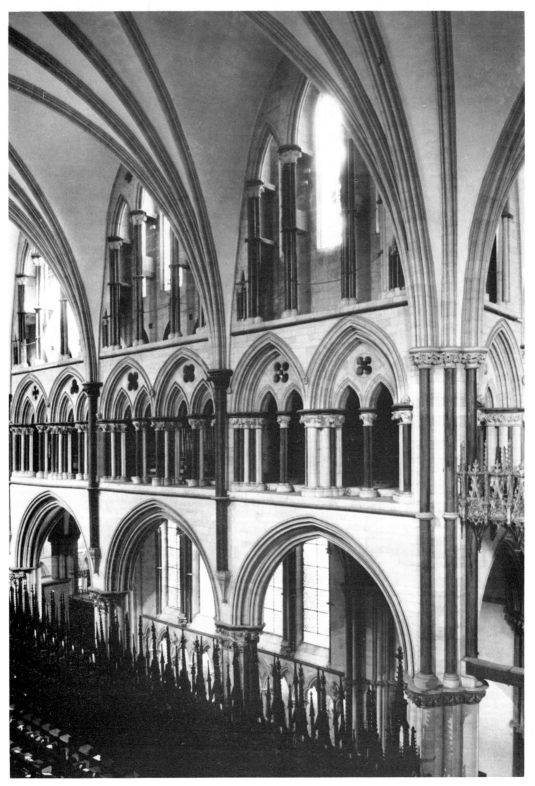

II. Lincoln Cathedral: St Hugh's Choir, north elevation
Copyright C. Wilson

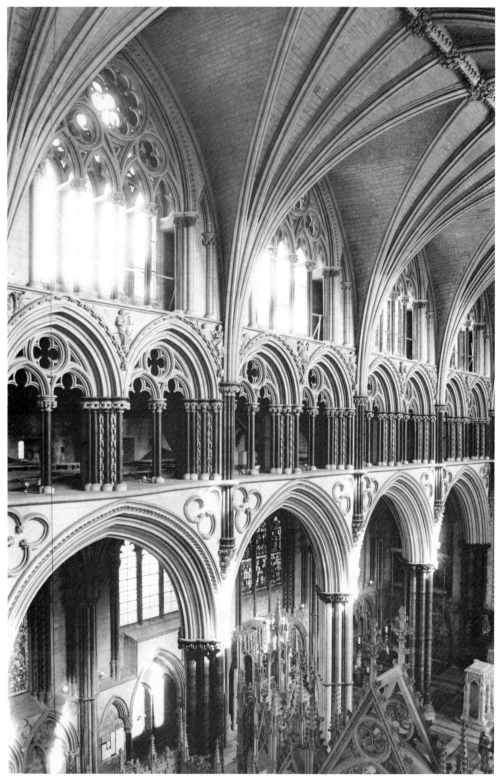

III. Lincoln Cathedral: Angel Choir, north elevation
Copyright C. Wilson

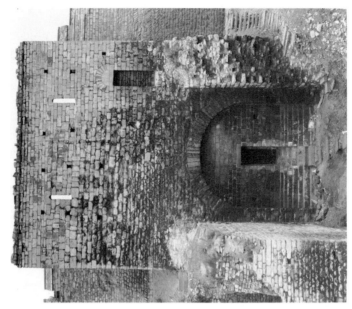

IVB. Lincoln Castle: west gate, surveyed 1983

IVA. Lincoln, Flaxengate: excavations in progress on the medieval levels, 1974

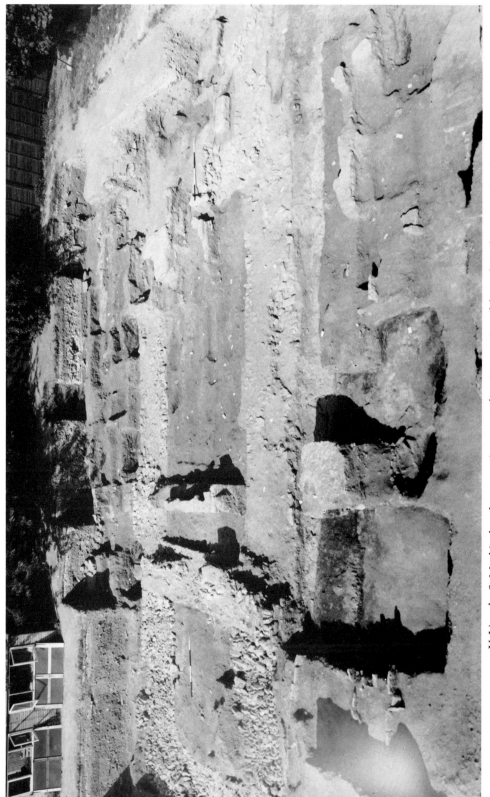

V. Lincoln, St Mark's church: excavations 1976 showing remains of the 11th/12th-century church

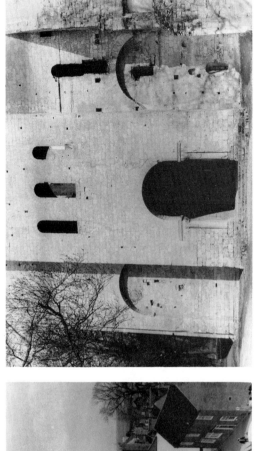

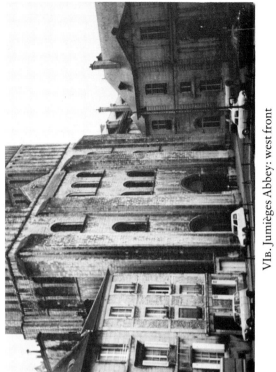

VIB. Jumièges Abbey: west front

VID. Caen, St-Etienne: west front

VIA. Lincoln Minster: west front seen from the Observatory Tower of the Castle

VIC. Lincoln Minster: west front

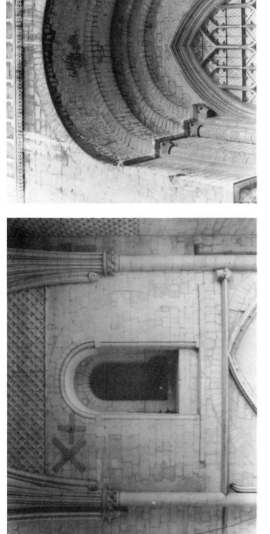

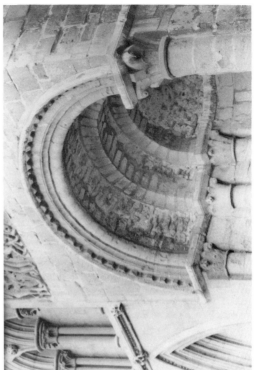

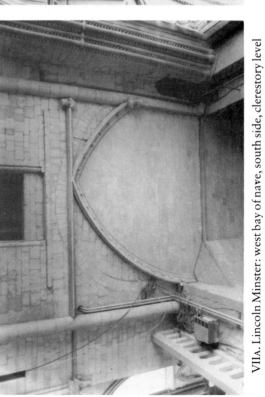

VIIB. Lincoln Minster: west front, north major arch, detail

VIID. Lincoln Minster: west front, concave niche at north-west angle

VIIA. Lincoln Minster: west bay of nave, south side, clerestory level

VIIC. Lincoln Minster: west bay of nave, south side, gallery level

VIIIA. Lincoln Minster: window lighting first-floor chamber at north-west angle

VIIIB. Lincoln Minster: loop in south major arch

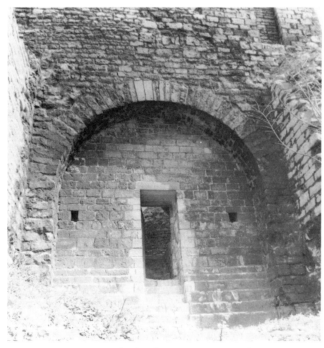

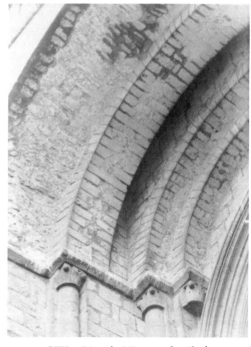

VIIIc. Lincoln Castle: west gate, outer face

VIIID. Lincoln Minster: detail of machicolation in north major arch

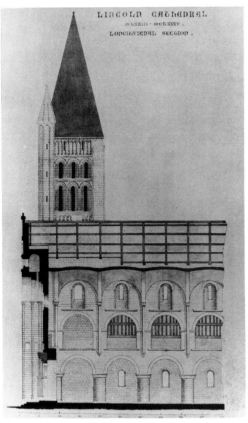

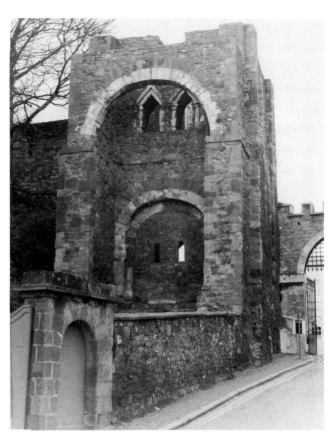

IXA. Lincoln Minster: reconstructed section through west end of 12th-century church by J. T. Smith (the section differs in some details from that advanced in this paper)

IXB. Exeter Castle: east gate, outer face

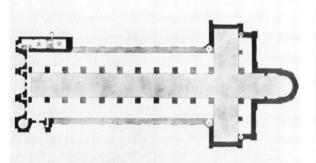

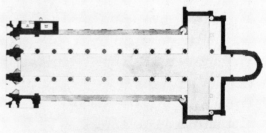

IXc. Lincoln Minster: reconstructed plan of Romanesque church by J. T. Smith; first-floor level

IXD. Lincoln Minster: reconstructed plan of Romanesque church by J. T. Smith (1905–06); ground-floor level (the plan must be corrected following Bilson, 1911)

XA. Angel Choir roof. The middle collar of frame 38 is a re-used collar from a scissor-braced roof. The joint-bed is too wide for the head of the soulace and has been reduced by insertion of a pad

XB. Chapter House roof: part of the double decagonal ring-beam at the base of the roof. The lower timber of James Essex' building (1762) is pierced by a forelock bolt and the upper timber of c. 1800 by a screw-threaded bolt secured with washers and nut

XC. Angel Choir roof: base of queen-post, frame 52, with lap-dovetail joint to the tie-beam. The iron stirrup is 19th-century

XD. Angel Choir roof: original queen-post with lap-joint to an original (later inverted) tie-beam, frame 7. The inverted (filled) joint-bed is original and the upper (actual) joint-bed and iron stirrup are a result of 19th-century repairs

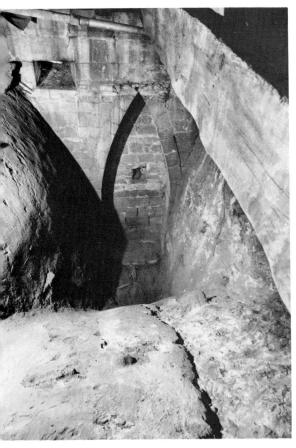

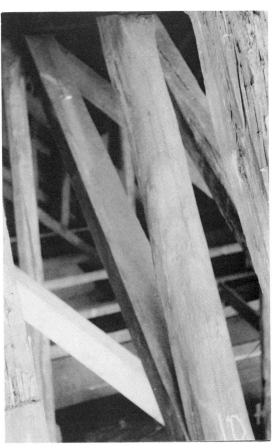

XIA. St Hugh's Choir: view over the top of the vaults looking south showing the line between the original work (left) and the rebuilt vaulting following the collapse of the tower *c.* 1238 (right). The tie-beam of frame 27 runs across the top right corner of the picture

XIB. Angel Choir roof: secondary rafter on the south side of frame 46 showing its roundwood profile

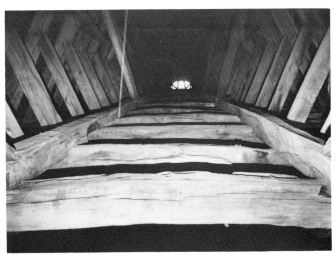

XIC. North-east transept roof: pit-saw marks on the face of the lower collar, frame 11

XID. Angel Choir roof: the middle collars showing their cambering. Note the purlin (left) which is a re-used timber

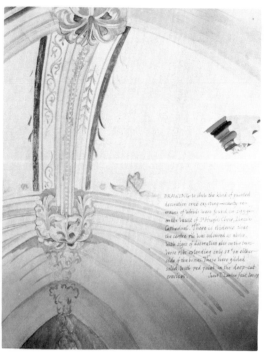

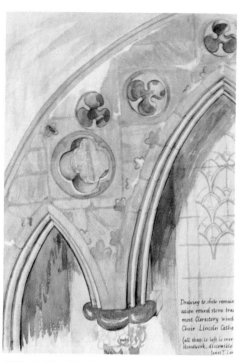

XIIA. St Hugh's Choir: painting found on vault in 1959.
Copy by Janet Lenton
© Dr E. Clive Rouse

XIIB. St Hugh's Choir: painting on clerestory.
Detail of copy by Janet Lenton
© Dr E. Clive Rouse

XIIC. South-west transept: detail of painting on vault
© RCHM (England)

XIID. South-west transept: head of bishop on vault
© RCHM (England)

XIIIA. Nave vault: detail of painting
© *RCHM (England)*

XIIIB. Ringers Chamber: painting on east wall
© *RCHM (England)*

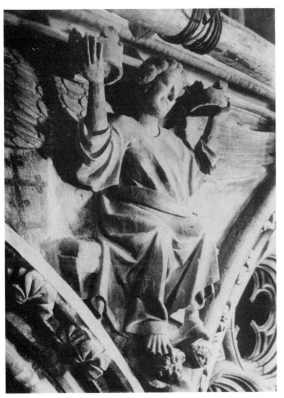

XIIIC. Angel Choir: painted background to angel
© *RCHM (England)*

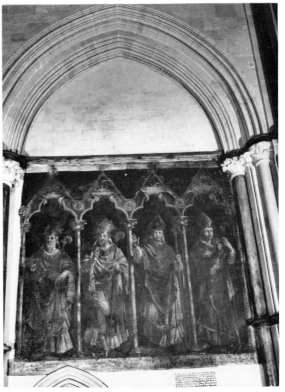

XIIID. North-east transept: painting of bishops by
Vincenzo Damini (1727 or 1728)
© *RCHM (England)*

XIVb. Lincoln Cathedral: interior of west window, capitals

XIVc. Lincoln Cathedral: interior of west window, bases on

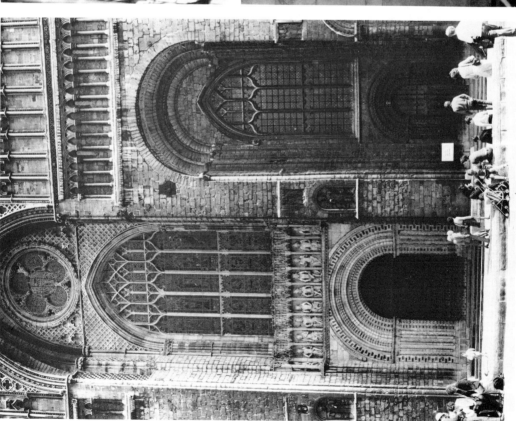

XIVa. Lincoln Cathedral, west front

XVB. Newstead Abbey: reconstruction of west window by Peter Kidson

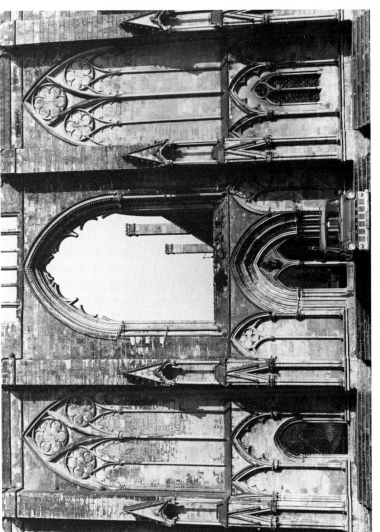

XVA. Newstead Abbey: west front

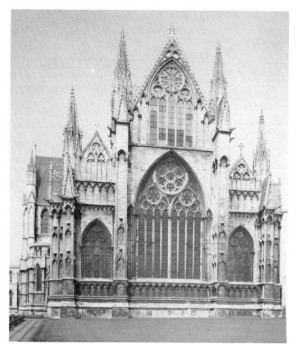

XVIA. Lincoln Cathedral: east window of Angel Choir

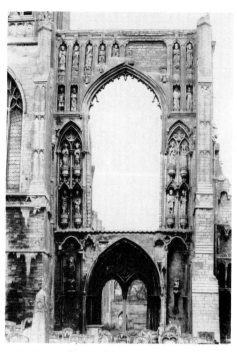

XVIB. Croyland Abbey, Lincs: west front

XVIC. Westminster Abbey: Dickinson's drawing
of the north transept facade

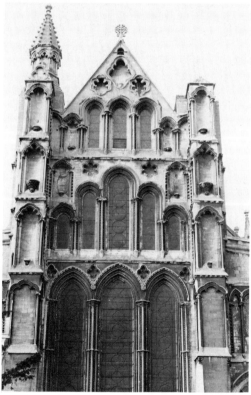

XVID. Ely Cathedral: retrochoir, east facade

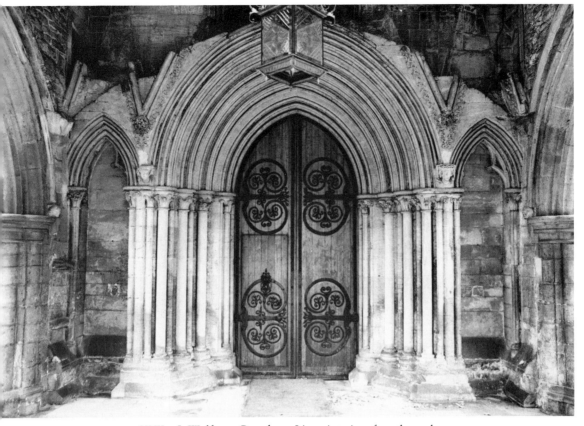

XVIIA. St Wulfram, Grantham, Lincs: interior of north porch

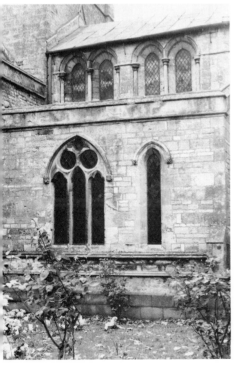

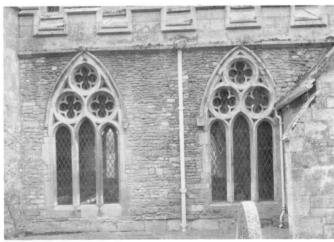

XVIIC. Irnham, Lincs: windows in north nave aisle

XVIIB. Sutterton, Lincs: south transept, aisle windows

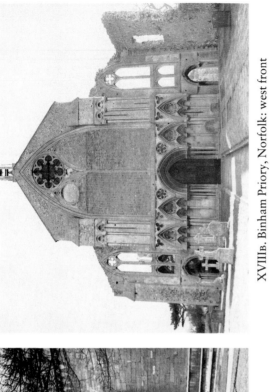

XVIIIA. St Wulfram, Grantham, Lincs: north aisle

XVIIIB. Binham Priory, Norfolk: west front

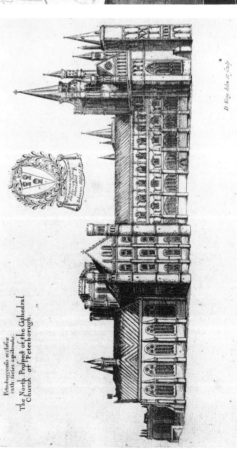

XVIIID. Swaton, Lincs: east window

Petroburgensis ecclesiæ
cath. facies aquilonalis.
The North Prospect of the Cathedral
Church of Peterborough.

D. King delin. et sculp.

XVIIIc. Peterborough Cathedral: north exterior, from a 17th-century
engraving by Daniel King

XIXB. Lincoln Cathedral: scrollwork in the spandrels of the blind tracery in the aisle of the Angel Choir

XIXc. Southwell Minster, Notts: blind arcading in the chapter house

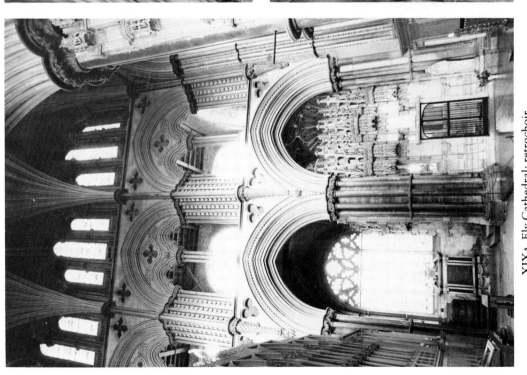

XIXA. Ely Cathedral: retrochoir

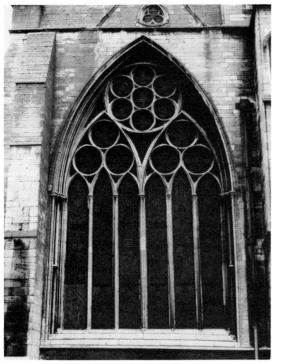

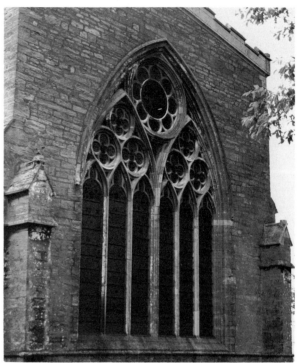

XXA. St Wulfram, Grantham, Lincs: west window

XXB. Raunds, Northants: east window

XXC. West Walton, Norfolk: window in south nave aisle

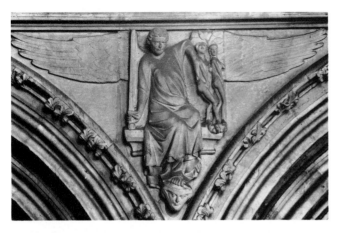

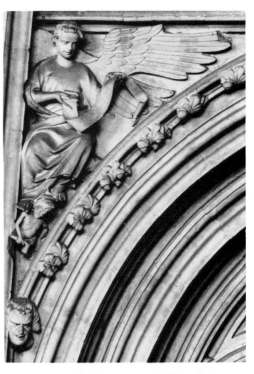

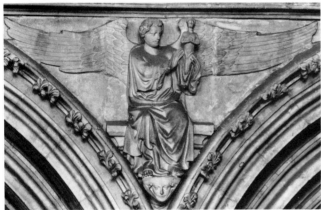

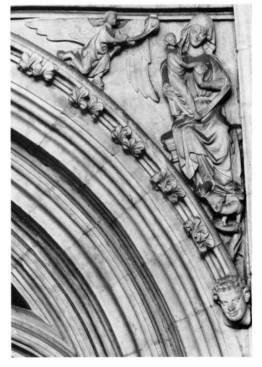

XXIA. Angel Choir: angel of the expulsion (N 14)
Photo courtesy Courtauld Institute of Art

XXIB. Angel Choir: angel with scroll (S 10)
Photo courtesy Courtauld Institute of Art

XXIC. Angel Choir: angel with blessed soul (S 14)
Photo courtesy Courtauld Institute of Art

XXID. Angel Choir: Virgin and Child with censing angel (S 15)
Photo courtesy Courtauld Institute of Art

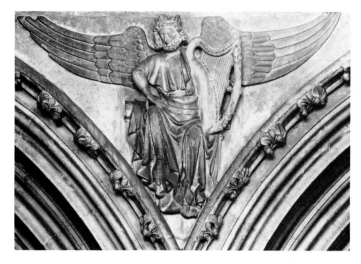

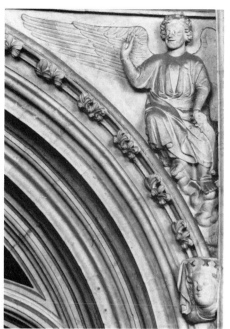

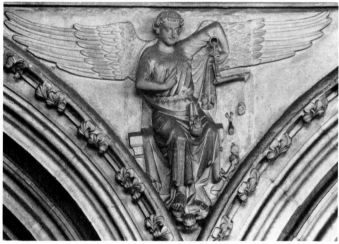

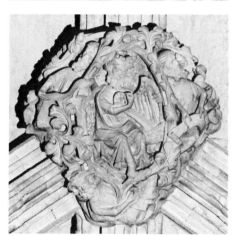

XXIIA. Angel Choir: King David (S 2)
Photo courtesy Courtauld Institute of Art

XXIIB. Angel Choir: angel with scroll (S 3)
Photo courtesy Courtauld Institute of Art

XXIIC. Angel Choir: St Michael weighing souls (N 11)
Photo courtesy Courtauld Institute of Art

XXIID. Angel Choir: boss in south aisle, Tree of Jesse

XXIIE. Angel Choir: boss in south aisle, combat of man and monster

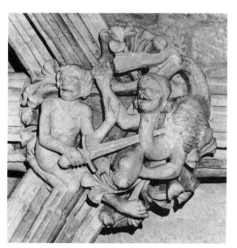

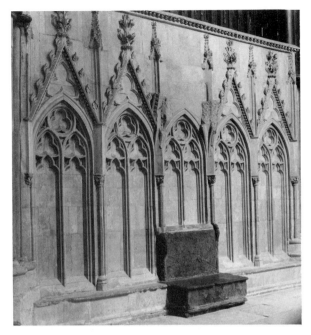

XXIIIA. The shrine of Little St Hugh from the south-east
Copyright Trust for Lincolnshire Archaeology

XXIIIB. Fragment from Tabernacle vault from shrine of Little St Hugh
Copyright Trust for Lincolnshire Archaeology

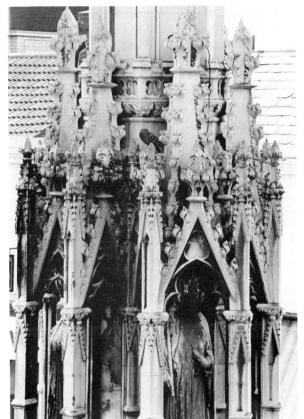

XXIIIc. Detail of Statue Canopies at the Eleanor Cross at Waltham, Herts.
Copyright D. A. Stocker

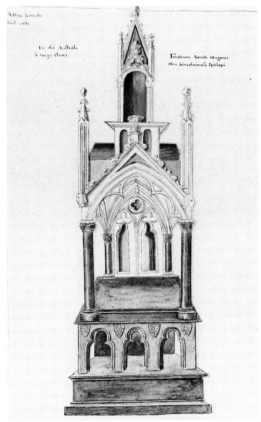

XXIIID. The shrine of Little St. Hugh: copied from a drawing of 1641 in 'Dugdale's Book of Monuments' (British Library, Loan MS 38)
Lincolnshire Archives Office

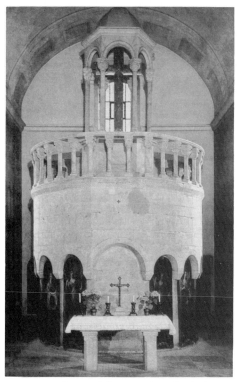

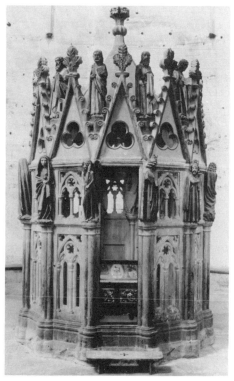

XXIVA. Eichstätt, Hl. Kreuz: Tomb of Christ, 12th-century

XXIVB. Konstanz, Munster: Tomb of Christ, c. 1250

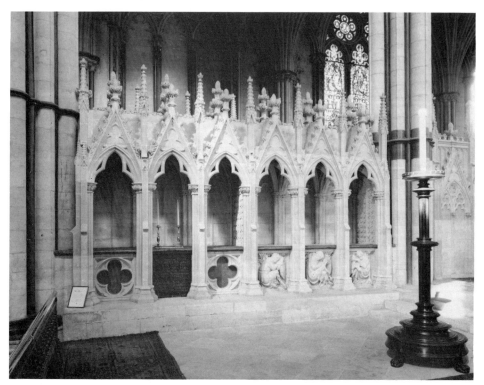

XXIVc. Lincoln Cathedral: Tomb of Christ and tomb of Remigius c. 1300
Photo courtesy Courtauld Institute of Art

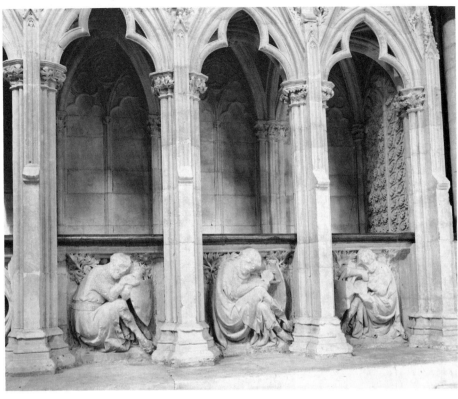

XXVA. Lincoln Cathedral: Tomb of Christ, *c.* 1300
Photo courtesy Courtauld Institute of Art

XXVB. Freiburg-im-Breisgau, Munster: Tomb of Christ, *c.* 1320

XXVC. Freiburg-im-Breisgau, Augustiner Museum: figure of Mary from a Tomb of Christ at Adelhausen, *c.* 1270
Photo courtesy Bildverlag Freiburg-im-Breisgau

XXVD. Maria Mödingen: figure of Christ from a Tomb of Christ, *c.* 1270

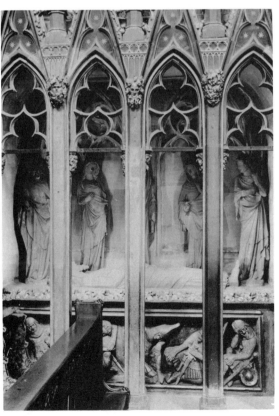
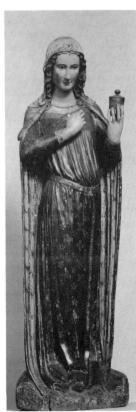

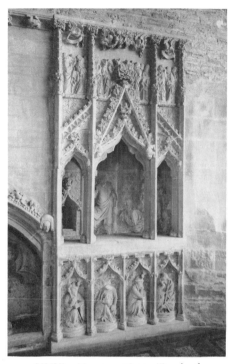

XXVIA. Hawton, Notts: Tomb of
Christ/sacrament shrine, *c.* 1340

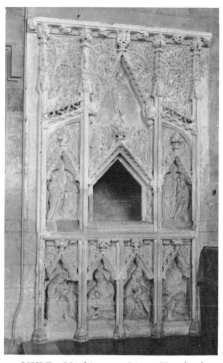

XXVIB. Heckington, Lincs: Tomb of
Christ/sacrament shrine, *c.* 1330

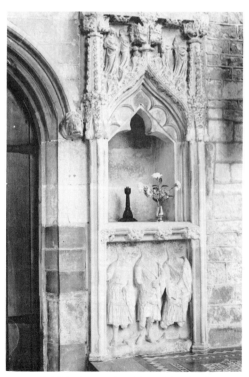

XXVIc. Navenby, Lincs: Tomb of
Christ/sacrament shrine, *c.* 1325–30

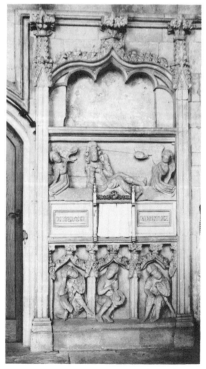

XXVID. Patrington, Humberside:
Tomb of Christ/sacrament shrine,
c. 1350

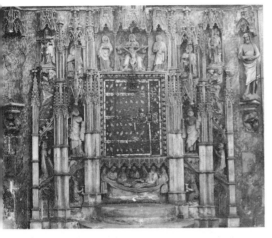

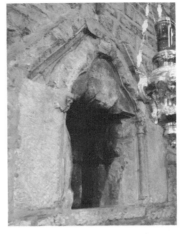

XXVIIA. Nuremburg, St Sebald: sacrament shrine, *c.* 1400
Photo courtesy Courtauld Institute of Art

XXVIIB. Lennick-St-Martin: sacrament shrine, *c.* 1290
Photo Sebastian Birch

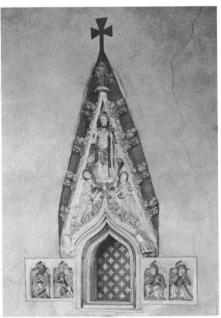

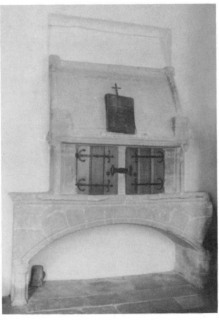

XXVIIc. Sibthorpe, Notts: Tomb of Christ/sacrament shrine, *c.* 1335–40

XXVIID. Twywell, Northants: aumbry, *c.* 1320

XXVIIE. Hawton, Notts: chancel looking north showing tomb, sacristy doorway and Tomb of Christ/sacrament shrine

XXVIIIA. Lincoln Cathedral: south rose, original glazing, *c.* 1325–50. Christ among the Candlesticks (II, J2)
UEA, School of Art History and Music

XXVIIIB. Lincoln Cathedral: south rose, original glazing, *c.* 1325–50. Seated King with sceptre and crown (II, F5)
UEA, School of Art History and Music

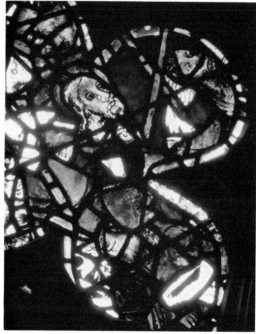

XXVIIIC. Lincoln Cathedral: south rose, original glazing, *c.* 1325–50. Seraph (II, C3)
UEA, School of Art History and Music

XXVIIID. Lincoln Cathedral: south rose, original glazing, *c.* 1325–50. St Andrew (II, G2)
UEA, School of Art History and Music

XXIXA. Lincoln Cathedral: south rose, original glazing,
c. 1325–50. St Paul (II, H2) and St James the Greater (II, H3)
UEA, School of Art History and Music

XXIXB. Lincoln Cathedral: south
rose, original glazing, c. 1325–50.
Naked monk with flesh-hook (IV, C1)
*UEA, School of Art History and
Music*

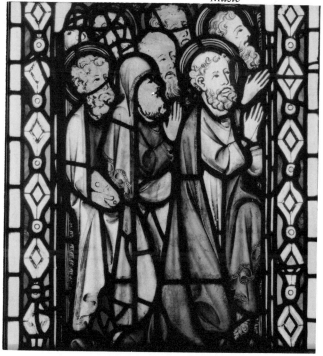

XXIXC. Lincoln Cathedral: south rose, original
glazing, c. 1325–50. Monk in white habit with
hands raised (II, F3)
UEA, School of Art History and Music

XXIXD. York Minster: Great West Window,
1339. St John the Evangelist, wI,6c.
NMR

XXXA. Lincoln Cathedral: south rose, original
glazing, *c.* 1325–50. Male bearded face (II, F3)
UEA, School of Art History and Music

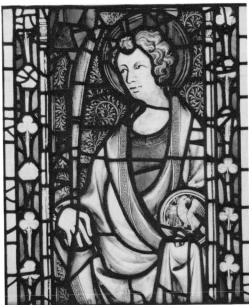

XXXB. York Minster: Great West Window, 1339.
Part of Ascension, wl,8g.
NMR

XXXC. Lincoln Cathedral: south rose, early
13th century, background to medallion window
(III, E2, E3)
UEA, School of Art History and Music

XXXE. Lincoln Cathedral: south rose, *c.* 1370–80,
foliage from west window (II, A2); first half of 14th
century, shield with arms of Badlesmere (II, A3)
UEA, School of Art History and Music

XXXD. Lincoln Cathedral: south rose, early 13th
century, Virgin and Child (I, A1)
UEA, School of Art History and Music

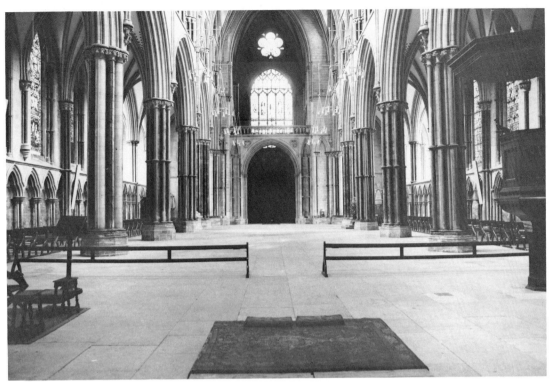

XXXIA. Lincoln Cathedral: nave looking towards screen wall by Gibbs 1726–30, and Essex 1775–76

XXXIB. Lincoln Cathedral: Angel Choir looking east towards high altar reredos by Essex 1769, modified by J. C. Buckler 1857

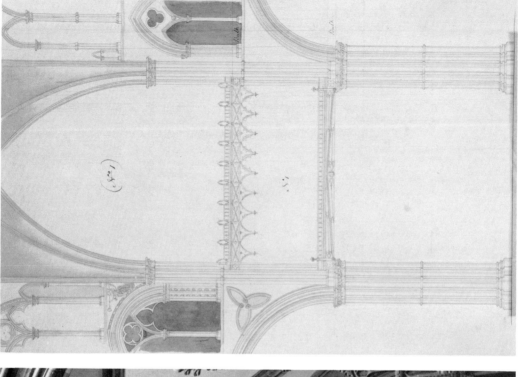

XXXIIb. Lincoln Cathedral: cresting to conceal tie beams between east transept and Angel Choir, designed by Essex 1780. Drawing by William Lumby

Courtesy Lincoln Record Office

XXXIIa. Lincoln Cathedral: canopy of Bishop's Throne designed by Essex 1779, statues inserted *c.* 1882